Artificial Intelligence for Art Creation and Understanding

AI-Generated Content (AIGC) is a revolutionary engine for digital content generation. In the area of art, AI has achieved remarkable advancements. AI is capable of not only creating paintings or music comparable to human masterpieces, but it also understands and appreciates artwork. For professionals and amateurs, AI is an enabling tool and an opportunity to enjoy a new world of art.

This book aims to present the state-of-the-art AI technologies for art creation, understanding, and evaluation. The contents include a survey on cross-modal generation of visual and auditory content, explainable AI and music, AI-enabled robotic theater for Chinese folk art, AI for ancient Chinese music restoration and reproduction, AI for brainwave opera, artistic text style transfer, data-driven automatic choreography, Human-AI collaborative sketching, personalized music recommendation and generation based on emotion and memory (MemoMusic), understanding music and emotion from the brain, music question answering, emotional quality evaluation for generated music, and AI for image aesthetic evaluation.

The key features of the book are as follows:

- AI for Art is a fascinating cross-disciplinary field for the academic community as well as the public.
- Each chapter is an independent interesting topic, which provides an entry for corresponding readers.
- It presents SOTA AI technologies for art creation and understanding.
- The artistry and appreciation of the book is wide-ranging – for example, the combination of AI with traditional Chinese art.

This book is dedicated to the international cross-disciplinary AI Art community: professors, students, researchers, and engineers from AI (machine learning, computer vision, multimedia computing, affective computing, robotics, etc.), art (painting, music, dance, fashion, design, etc.), cognitive science, and psychology. General audiences can also benefit from this book.

Multimedia Computing, Communication and Intelligence
Series Editor
Chang Wen Chen

For more information about this series, please visit: https://www.routledge.com/Multimedia-Computing-Communication-and-Intelligence/book-series/CRCMULCOMCOM

Artificial Intelligence for Art Creation and Understanding

Edited by
Luntian Mou

CRC Press
Taylor & Francis Group
Boca Raton London New York

CRC Press is an imprint of the
Taylor & Francis Group, an **informa** business

First edition published 2025
by CRC Press
2385 NW Executive Center Drive, Suite 320, Boca Raton, FL 33431

and by CRC Press
4 Park Square, Milton Park, Abingdon, Oxon, OX14 4RN

CRC Press is an imprint of Taylor & Francis Group, LLC

© 2025 selection and editorial matter, Luntian Mou; individual chapters, the contributors

ISBN: 978-1-032-52360-6 (hbk)
ISBN: 978-1-032-52361-3 (pbk)
ISBN: 978-1-003-40627-3 (ebk)

DOI: 10.1201/9781003406273

Typeset in Times
by SPi Technologies India Pvt Ltd (Straive)

Dedication

For my wife Rebecca, my daughter Emmy, and Yanni

Contents

About the Editor

Luntian Mou received his Ph.D. in computer science from the University of Chinese Academy of Sciences, China, in 2012. He worked as a postdoctoral researcher with the Institute of Digital Media, Peking University, China, from 2012 to 2014. From 2019 to 2020, he served as a visiting scholar at Donald Bren School of Information and Computer Sciences, University of California, Irvine, USA. He is currently an associate professor with the Beijing Institute of Artificial Intelligence, Beijing University of Technology, China. His research interests include artificial intelligence, machine learning, pattern recognition, affective computing, multimedia computing, and brain-like computing. He has published in renowned journals such as IEEE Transactions on Affective Computing (TAFFC), IEEE Transactions on Multimedia (TMM), ACM Transactions on Multimedia Computing, Communications, and Applications (TOMM), and Expert Systems With Applications (ESWA). He is the recipient of the Beijing Municipal Science and Technology Advancement Award, IEEE Outstanding Contribution to Standardization Award, and AVS Outstanding Contribution on 15th Anniversary Award. He serves as a guest editor for Machine Intelligence Research and a reviewer for many important international journals and conferences such as IEEE Transactions on Image Processing (TIP), TAFFC, IEEE Transactions on Circuits and Systems for Video Technology (TCSVT), IEEE Transactions on Intelligent Transportation Systems (TITS), and AAAI. He is a senior member of IEEE and CCF, and a member of ACM. He is the chair of the organizing committee of the 2023 CSIG Conference on Emotional Intelligence (CEI). He is the Founding Chair of the IEEE Workshop on Artificial Intelligence for Art Creation (AIART).

Contributors

Jack Armitage
Iceland University for the Arts
Reykjavík, Iceland

Berker Banar
Queen Mary University of London
London, UK

Hongjian Bo
Shenzhen Key Laboratory of
 Brain-Computer Interface and
 Brain-Inspired Intelligence
Shenzhen, China
Shenzhen Academy of Aerospace
 Technology
Shenzhen, China

Nick Bryan-Kinns
University of the Arts London
London, UK

Jing Chen
Brain-Inspired Intelligence and Neural
 Engineering Research Center, Harbin
 Institute of Technology
Harbin, China

Julie Dorsey
Yale University
New Haven, USA

Corey Ford
Queen Mary University of London
London, UK

Feng Gao
School of Arts, Peking University
Beijing, China

Mingyue Gao
Tsinghua University
Beijing, China

Wenhao Gao
School of Electrical and Information
 Engineering, Zhengzhou University
Zhengzhou, China

Ruichen He
Beijing University of Technology
Beijing, China

Heng Huang
Beijing Electronic Science and
 Technology Institute
Beijing, China

Ramesh Jain
University of California, Irvine
Irvine, USA

Xin Jin
Beijing Electronic Science and
 Technology Institute
Beijing, China

Haifeng Li
Brain-Inspired Intelligence and Neural
 Engineering Research Center, Harbin
 Institute of Technology
Harbin, China

Hanxuan Li
Tsinghua University
Beijing, China

Hongwei Li
Brain-Inspired Intelligence and Neural
 Engineering Research Center, Harbin
 Institute of Technology
Harbin, China

Juehui Li
Pandora
New York, USA

Jueying Li
Cornell University
New York, USA

Rongfeng Li
Beijing University of Posts and
 Telecommunications
Beijing, China

Xiaobing Li
Music AI and Information
 Technology, Central Conservatory
 of Music
Beijing, China

Xiaodong Li
Beijing Electronic Science and
 Technology Institute
Beijing, China

Xiqiao Li
Beijing Electronic Science and
 Technology Institute
Beijing, China

Xinning Li
Beijing Electronic Science and
 Technology Institute
Beijing, China

Zijin Li
Music AI and Information
 Technology, Central Conservatory
 of Music
Beijing, China

Beituo Liu
Tsinghua University
Beijing, China

Jiaying Liu
Peking University
Beijing, China

Mengting Liu
Advanced Institute of Information
 Technology, Peking University
Hangzhou, China

Yuhang Liu
Beijing University of Technology
Beijing, China

Di Lu
Music AI and Information Technology,
 Central Conservatory of Music
Beijing, China

Yao Lu
Tsinghua University
Beijing, China

Lin Ma
Brain-Inspired Intelligence and Neural
 Engineering Research Center, Harbin
 Institute of Technology
Harbin, China

Lin Ma
Key Laboratory of Media Audio &
 Video, Communication University
 of China, Ministry of Education
Beijing, China

Haipeng Mi
Tsinghua University
Beijing, China

Luntian Mou
Beijing Institute of Artificial Intelligence,
 Beijing University of Technology
Beijing, China

Ellen Pearlman
Fulbright Poland/University of Warsaw
Warsaw, Poland
RISEBA University Latvia
Riga, Latvia
NYU Tandon School of Engineering
New York, USA

Lin Qi
School of Electrical and Information
 Engineering, Zhengzhou University
Zhengzhou, China

Courtney N. Reed
Loughborough University London
London, UK

Qirui Sun
Tsinghua University
Beijing, China

Yihan Sun
Beijing University of Technology
Beijing, China

Yiqi Sun
University of Regensburg
Regensburg, Germany

Yunhan Tian
Beijing University of Technology
Beijing, China

Jiessie Tie
Department of Computer Science,
 University of Toronto
Toronto, Canada

Yun Tie
School of Electrical and Information
 Engineering, Zhengzhou University
Zhengzhou, China

Hongfei Wang
Key Laboratory of Media Audio &
 Video, Communication University of
 China, Ministry of Education
Beijing, China

Tuanfeng Y. Wang
Adobe Research
London, UK

Wenjing Wang
Peking University
Beijing, China

Zeyu Wang
The Hong Kong University of Science
 and Technology (Guangzhou)
Guangzhou, China

Chaoen Xiao
Beijing Electronic Science and
 Technology Institute
Beijing, China

Zhengbo Xu
Peking University
Beijing, China

Shuai Yang
Peking University
Beijing, China

Yuan Yao
Beijing Jiaotong University
Beijing, China

Zhihao Yao
Tsinghua University
Beijing, China

Long Ye
State Key Laboratory of Media
 Convergence and Communication,
 Communication University of China
Beijing, China

Qin Zhang
State Key Laboratory of Media
 Convergence and Communication,
 Communication University of China
Beijing, China

Yixiao Zhang
Queen Mary University of London
Beijing, China

Zexi Zhang
Beijing University of Technology
Beijing, China

Wei Zhong
State Key Laboratory of Media
Convergence and Communication,
Communication University of China
Beijing, China

Tiange Zhou
School of Future Design, Beijing
Normal University
Zhuhai, China

Qingwen Zhou
Music AI and Information
Technology, Central Conservatory
of Music
Beijing, China

Ying Zhou
School of Electronic and Computer
Engineering, Shenzhen Graduate
School, Peking University
Shenzhen, China
Peng Cheng Laboratory
Shenzhen, China

1 Explainable AI and Music

Nick Bryan-Kinns
University of the Arts London, London, United Kingdom

Berker Banar and Corey Ford
Queen Mary University of London, London,
United Kingdom

Courtney N. Reed
Loughborough University London, London,
United Kingdom

Yixiao Zhang
Queen Mary University of London, London,
United Kingdom

Jack Armitage
Iceland University for the Arts, Reykjavík, Iceland

> With few exceptions, music has been for some centuries the art which has devoted itself not to the reproduction of natural phenomena, but rather to the expression of the artist's soul, in musical sound.
>
> (Kandinsky, 1912)

1.1 INTRODUCTION

Music is a fundamental element of intangible cultural heritage and a form of artistic expression found in all cultures. It has been an application of Artificial Intelligence (AI) since before the birth of digital computers with the potential of computing machines to create complex music noted as early as 1843 by Ada Lovelace (1843).

AI is now deployed across all the culture cycle stages (Pessoa & Deloumeaux, 2009) of music creation, production, dissemination, exhibition/reception/transmission, and consumption/participation. In this chapter we focus on AI for music creation (generation) rather than its role in other culture cycle stages such as automated mixing (De Man, Reiss, & Stables, 2017) in music production.

DOI: 10.1201/9781003406273-1

Early uses of AI for music creation typically employed probabilistic models to compose music offline, e.g., the Illiac Suite composed by AI created by Lejaren Hiller and Leonard Isaacson in 1957 (Hiller & Isaacson, 1957). Increased computing power and speed over the following decades opened up opportunities for real-time music generation by AI and human-computer interaction with probabilistic AI models (Pachet, 2003). Machine Learning, and, more specifically, Deep Learning models have gained popularity in recent years as larger datasets and more computational power are increasingly available. Although Deep Learning generative AI models have been shown to produce compelling music (e.g., Dinculescu, Engel, and Roberts [2019]'s MidiMe), they require large amounts of training data (usually more than 1m musical notes) and computational time (often days) and are typically difficult to control in meaningful ways (Bryan-Kinns et al., 2021). In contrast, probabilistic approaches such as multi-order multi-feature Markov models, e.g., Whorley and Laney (2020), offer more controllable music generation with lower dataset and computational requirements with more opportunity for real-time interaction, but their outputs are often less novel.

Regardless of the underlying AI paradigm, the complex nature of generative AI models typically requires users have in-depth knowledge of AI techniques to successfully manipulate the models to create new content beyond trial and error. Compounding this problem, generative music models typically do not offer user interfaces that provide insight into how the music is generated or how the generation can be controlled or influenced. The result of this is that many generative models leave musicians feeling disconnected from the creative process, making them inaccessible to anyone besides the creator, much as is found with Digital Musical Instruments (Benyon & Macaulay, 2002; Morreale & McPherson, 2017; Wallis, Ingalls, Campana, & Vuong, 2013). Without an understanding of their input or succinct ways to influence models, artists may also be unable to find or own their own role in the creative process—whether as collaborator, controller, designer, or merely recipients of generated output (Long, Padiyath, Teachey, & Magerko, 2021; Louie, Cohen, Huang, Terry, & Cai, 2020b).

In this chapter we explore how generative music models can be made more understandable and controllable by users, especially users who are musicians. We focus on the *use* of AI rather than creation of new AI models per se and engage directly with discourse on Human-Centered AI (HCAI) (Garibay et al., 2023), specifically the concerns of eXplainable AI (XAI [Gunning, 2016]) and how AI models can be created that are more interpretable by humans. First, we outline XAI and HCAI research and their potential to inform more human-centered generative AI music systems. We then summarize a systematic review of the explainability of 100 generative AI models for music to illustrate state-of-the-art. Following this review, we introduce our implementation of an XAI generative music system and use this to illustrate the potential of XAI for music. We conclude by identifying key research challenges in XAI for music generation, and XAI for the Arts more (XAIxArts) broadly.

1.2 RELATED WORK

Music is made and appreciated by humans and can be generated by AI. Whilst approaches such as Computational Creativity (Colton & Wiggins, 2012) explore the use of AI to autonomously generate music (Carnovalini & Rodà, 2020), there

is notably less research on how AI is designed and used for music making. This manifests itself in an emphasis on AI autonomy and agency with little or no consideration for human agency and value in the fundamentally human and socially constructed endeavor of music making. For example, there is a lack of research on how generative AI is used in music making practice (Xambó, 2022) or as new forms of musical instruments (Pelinski et al., 2022), and a lack of research on how human and AI agency might contribute co-creation of music. To address this gap, Jourdan and Caramiaux (2023a, 2023b) recently published initial surveys of AI/ML in the New Interfaces for Musical Expression (NIME) community, kicking off an important process of exploring the role of AI in music. A promising route to redress this imbalance is to draw on research from Human-Centered AI (HCAI; Garibay et al., 2023; Shneiderman, 2022), given the inherently human-centered nature of music and music making. HCAI aims to ensure that "advances in AI augment rather than replace humans and improve their environment" (Garibay et al., 2023), with the goal to "amplify, rather than erode, human agency" (Shneiderman, 2022). However, to date, HCAI research has predominantly focused on task-oriented AI applications such as medical decision making or self-driving cars, and there is little research on HCAI for more open-ended activities such as the arts or creative practice. In this chapter we explore the potential for HCAI approaches to make generative AI more human-centered. In particular, we explore one of the grand challenges of HCAI (Garibay et al., 2023): how to design more human-centered Human-AI Interaction.

A key issue for designing Human-AI Interaction is the increasing complexity and obtuseness of AI models. This is a challenge that eXplainable AI (XAI) (Gunning, 2016; Kozierok et al., 2021) sets out to tackle by making complex and difficult to understand AI models such as neural networks and deep learning models more straightforward. In our view, increasing the explainability of a generative music model supports increased human agency in music making with AI through, for example, increased sense of control and influence over the AI music generation and increased levels of understanding and engagement with the music output and the AI itself. In this view, AI is framed as a semi-autonomous generative agent/tool/instrument for cocreating music rather than as an opaque and autonomous music generating system. XAI approaches include generating understandable explanations of AI model behavior, structuring and labeling features of AI models to make them more understandable, and creating simpler, more understandable models that approximate the behavior of complex AI models (Gunning, 2016; Kozierok et al., 2021). However, as with HCAI more broadly (Garibay et al., 2023), XAI research has predominantly examined the explainability of task-oriented AI systems such as AI medical diagnosis (Quellec et al., 2021), autonomous vehicles (Du et al., 2019; Shen et al., 2020), and AI models of consumer behavior (Sajja et al., 2021) with no research exploring XAI for the arts and creativity to date.

Unfortunately, the term *explanation* is ambiguous and variously defined in XAI research, but nevertheless a brief review of a few noteworthy definitions helps to contextualize the idea as used in this chapter. Ciatto, Schumacher, Omicini, and Calvaresi (2020) define *explaining* as being "the activity of producing a more interpretable object X' out of a less interpretable one, namely X'' where *interpreting X* is the activity of "assigning a subjective meaning to X'' (Ciatto et al., 2020). This aligns

with Guidotti et al. (2018)'s definition of the *interpretability* of an AI model as the ability "to provide the meaning in understandable terms to a human". Nyrup and Robinson (2022) focus on the context of explainability:

> In the conversational context C, a given phenomenon (model, system, prediction, …), P, is explainable by an explainer, S, to an audience, A, to the extent S can convey information to A that enables A to draw inferences about P needed to achieve the purposes salient in C.
>
> (Nyrup & Robinson, 2022)

They emphasize explanatory *pragmatism*, arguing that explanations can never be generalized, and instead must be culturally and socially situated and context-sensitive. For music, XAI should thus enable understandings of AI meaningful within the musical culture and its broader context, balancing human control and AI autonomy to augment – rather than replace – musicians and their tools (Shneiderman, 2022). In this chapter we focus on how to make generative AI models more interpretable so that humans, and especially musicians, can better understand and control the music generation of an AI.

There are few XAI systems for music and the arts in general, which means there is little indication of what makes a good XAI for music or how XAI might support more co-creative generative systems. Moreover, there are three key challenges to applying XAI to generative music:

1. As outlined above, most current XAI research focuses on functional explanations of AI models (e.g., why an AI is 90% sure about its prediction), so we cannot simply apply XAI design principles to AI Music systems.
2. The majority of XAI research offers design guidelines for explainability (Liao, Gruen, & Miller, 2020) or theories of explanation (Andres et al., 2020), but very few describe the implementation of explainable systems, meaning that there are few XAI systems to build from.
3. Possibly most importantly, using XAI in creative endeavors such as music presents a philosophical conundrum in which we must ask ourselves what it might actually mean to understand a creative AI system. For example, when musicians co-create music together, they rely on intuition and non-verbal cues to manage the interaction (Healey, Leach, & Bryan-Kinns, 2005) rather than objective explanations of the rationale for each musical contribution made as may be suggested by some XAI frameworks. Given the reliance on subjective and ambiguous information in human music making, we should question what the nature of explanation in creative settings might be.

We envision that XAI could support the role of AI and generative systems as having a collaborative and iterative role in the creative process. Much like a group of musicians interacting together, there should be an element of dialogue where musicians can easily identify the AI's contributions and possibly decisions, at least from a high level. AI might function as other controllable or playable "instruments" in digital musical systems; like a musical effects plug-in in a digital audio workstation (DAW),

the user might not need to understand everything down to the algorithmic level but should be able to relate what the system is contributing to their own input.

We also believe XAI can be beneficial by not dictating the creation process or a "correct" approach. AI could function in defined roles within its existing musical culture so that users know what to expect and can negotiate AI's input into existing understanding; for instance, developing and iterating on counterpoint or accompaniment parts with the user's defined melody, as an arranger might do, or offering manipulated phrases to assist in improvisation, like another member of the band. Musicians are still given agency over the creative process, without all elements being fully automated cf. HCAI (Shneiderman, 2022).

1.2.1 eXplainable AI and Generative Music

Artificial Intelligence has been used across the culture cycle stages (Pessoa & Deloumeaux, 2009) of music from creation such as the Illiac Suite (Hiller & Isaacson, 1957) compositions and composition experiments by the band Dadabots (Zukowski & Carr, 2018) to consumption and participation such as George Lewis's Voyager (Steinbeck, 2022) improvisations, co-creative musical agents such as Spire Muse (Thelle & Pasquier, 2021), and a co-performance system such as *Shimon* the marimba playing robot (Hoffman & Weinberg, 2010), shown in Figure 1.1. However, to date there has been no systematic review of the explainability of the AI models used in these systems. To address this, we undertook a survey of 100 recent AI music papers. Publication venues reviewed included the New Interfaces for Musical Expression Conference (NIME) series and the Computer Music Journal. We started

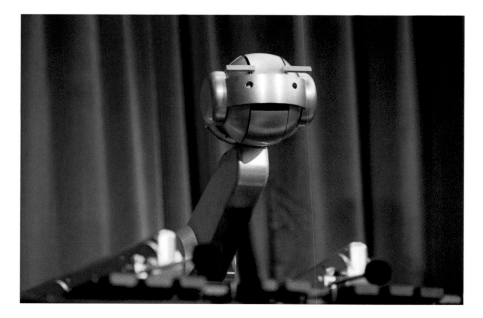

FIGURE 1.1 Shimon the robotic marimba player. Image courtesy of Gil Weinberg.

with the 94 papers reviewed in Herremans, Chuan, and Chew's (2017) review and removed 19 papers that were not related to music or inaccessible. We then added 12 papers published more recently than the Herremans et al.'s (2017) review to capture state-of-the-art (Andres et al., 2020; Benetatos, VanderStel, & Duan, 2020; Gillick & Bamman, 2021; Hazzard et al., 2019; Long, Padiyath, Teachey, & Magerko, 2021; Louie, Cohen, Huang, Terry, & Cai, 2020a; Lupker, 2021; Malsattar, Kihara, & Giaccardi, 2019; Proctor & Martin, 2020; Roberts et al., 2019; Sturm, Santos, & Korshunova, 2015; Zhang, Xia, Levy, & Dixon, 2021), making a total of 87 papers outlined in (Bryan-Kinns et al., 2021). To complete the review for this chapter, we added an additional 13 papers (Agostinelli et al., 2023; Bougueng Tchemeube, Ens, & Pasquier, 2022; Caillon & Esling, 2021; Dinculescu et al., 2019; Ford & Bryan-Kinns, 2022a; Huang et al., 2023; Manco, Benetos, Quinton, & Fazekas, 2021; OpenAI, 2022; Rau, Heyen, Wagner, & Sedlmair, 2022; Sarmento et al., 2023; Schneider, Jin, & Schölkopf, 2023; Vigliensoni, McCallum, & Fiebrink, 2020; Wang, 2023) to represent state-of-the-art advances since (Bryan-Kinns et al., 2021). There have been several systematic reviews of XAI systems, e.g., Guidotti et al. (2018), but these do not consider explainability within the creative domain. Therefore, we developed a classification of XAI for the arts that captures i) the role of the AI; ii) the possible interaction with the AI; iii) what stage of grounding might be inferred from the AI. These three categories draw on three existing frameworks as detailed below.

The role of the AI. We used Lubart's classification of the AI roles in creative settings (Lubart, 2005) to classify the role of the AI as follows:

- Assistant: AI that takes care of music generation without interacting with humans.
- Pen-pal: AI that engages in a back-and-forth interaction with humans, e.g., taking music as an input and responding with a musical output.
- Coach: AI that provides some guidance or suggestions as part of a musical making process.
- Colleague: AI that engages in co-creation of music in a more fluid and nuanced manner than a pen-pal.

The role AI takes must negotiate the human desire to retain freedom and influence in the creative process (Frid, Gomes, & Jin, 2020; Sturm, Ben-Tal, Monaghan, et al., 2019). Indeed, Shneiderman (2022) suggests that people feel a great pride in having control and being able to develop expertise, and is thus a crucial consideration for designing AI tools for artistic contexts such as music. Noting the dialogic and iterative aspects of human-human collaboration within the music making process (Suh, Youngblom, Terry, & Cai, 2021), Lubart's creative AI roles mirror their human equivalents. While retaining human agency, AI can provide material and guidance within the creative process in ways that parallel "traditional" music creation. For instance, music creation in more aural traditions often involves sharing of melodic phrases and copying or modifying them for new compositions; for instance, reusing licks and recreating players' styles in jazz improvisation. For example, Irish folk songs generated by the deep learning model *folk-rnn* (Sturm & Ben-Tal, 2017)

FIGURE 1.2 Performance of "The Days are Getting Longer" by folk-rnn v2 + Sturm. Image courtesy of The Society for the Preservation and Promotion of Machine Folk Music (v1.1).

are performed and evaluated in traditional musical practice settings as illustrated in Figure 1.2. If AI is responsible for replacing or augmenting the human's role in an aspect of dialogue, it is necessary to then evaluate it within its intended context to see how well it fulfils that role with respect to its musical culture (Sturm & Ben-Tal, 2017; Sturm, Ben-Tal, Monaghan, et al., 2019).

Interaction with the AI. We draw on Cornock and Edmonds (1973)'s classification of interaction with interactive art to identify three forms of interaction with generative AI systems:

- Static: the output of the generative system does not change.
- Dynamic-Passive: the output of the generative model changes based on some data or time passing, but not in response to user input.
- Dynamic-Interactive: the output of the system changes based on user input.

The common ground with the AI. Drawing on Clark and Brennan (1992)'s categorization of grounding in human communication, we identify stages of what a person might be able to infer about an AI's output state:

- Stage 0: there is no perceptible indication the generative model has produced some output.
- Stage 1: there is some perceptible indication the generative model has produced output.
- Stage 2: there is indication of what kind of output has been produced by the generative model.
- Stage 3: there is some indication of why the generative model produced the output that it did.

In this view, the explainability of a generative AI is a combination of the role the AI takes, the interaction it offers to the user, and the amount of grounding a person might be able to infer about the AI's output. These three aspects are entangled views on the nature of explainability. For example, a colleague AI would involve more interaction than a pen-pal AI, and likely higher states of grounding with the AI. Similarly, establishing higher states of grounding would likely require more fluid interaction with the AI. The key point is that each of these categorizations emphasizes more real-time and fluid interaction with the AI, reflecting the way in which we naturally interact with each other and the world around us.

Figure 1.3 summarizes the results of our survey. We found that 77 of the 100 papers generated music without any human collaboration – taking an Assistant role (Figure 1.3a). We also found very few systems that offered real-time user interaction (27 of 100), with most systems generating melodies from training data with no user input once the AI model was started (Figure 1.3b). Finally, we found that most models reported in the research papers (84 of 100) offered only Stage 1 of grounding, meaning that a user would only be aware that some output was generated, but not what kind of output nor why (Figure 1.3c).

While the majority of the papers we reviewed offered low levels of explainability, a number of notable outlier models offered more collaborative, interactive, and explainable models. For example, Shimon the robotic marimba player (Hoffman & Weinberg, 2010) provides a real-time feedback loop within the generative model, as it listens to musicians in real time and plays along in a collaborative manner – more of a colleague than a pen-pal. Furthermore, the physical movement of Shimon is

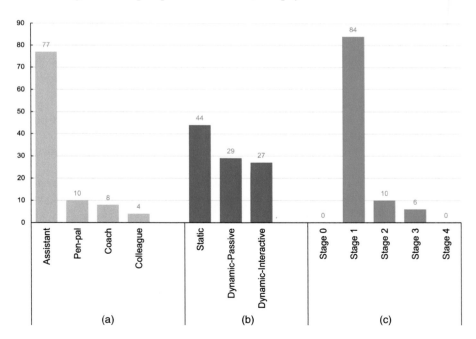

FIGURE 1.3　Survey of 100 AI music papers. (a) Role of the AI. (b) Interaction with the AI. (c) Grounding with the AI.

designed to provide cues to the musicians on Shimon's current and possible next states, offering grounding of stage 2, though it does not explain *why* it made generative decisions (stage 3). Generative composition tools such as Hyperscore (Farbood, Kaufman, & Jennings, 2007) also offer higher levels of grounding than most papers reviewed. In Hyperscore generated music is suggested in a piano-roll notation within the same interface that musicians create their compositions. In this way the user may observe the connection between their musical input and the generative AI's suggestions (stage 2 of grounding). In addition, the real-time interaction with the composition interface allows for trial-and-error modification and iteration of musical input and AI responses, providing some intuitive understanding of the AI models to be developed (towards stage 3 of grounding) even though there is no explicit explanation of why the AI generated the music that it did (Figure 1.4).

Besides being used for music generation in transfer learning paradigms (Banar & Colton, 2021, 2022b; Payne, 2019), Large Language Models (LLM) such as ChatGPT (OpenAI, 2022) work in a pen-pal role in which the AI responds to text input by a user in a turn taking manner and also offer some elements of coaching role when asked for advice about music composition. However, while such an LLM can be asked to explain aspects of its musical generation, e.g., why it chose certain chord combinations, the explanations are essentially post-hoc rationalization of the music generated, rather than explanations of how the generative model itself worked. Such post-hoc rationalizations appear to focus on broad stylistic aspects of the musical genres requested in the generation prompt and lacking nuance and detail that is often understood – sometimes implicitly – among musicians in real-world music making contexts. In this way the grounding offered by LLMs such as ChatGPT is at stage 2 rather than stage 3, as might intuitively be expected. Image-to-music generation systems (Banar & Colton, 2022a, 2023) where the AI responds to visual inputs to generate music function in a similar pen-pal role but are less able to offer explanation of their generative action, given their use of visual stimuli for interaction.

FIGURE 1.4 Sonified Body. Image courtesy of Tom Murray-Browne.

Overall, in our survey of AI music research we found that most systems offered little explainability to users. While there is perhaps a recent increase in the amount of (real-time) interaction offered to users, the complexity and opaqueness of contemporary deep learning models still makes understanding what the generative AI model is doing, and why, a challenge for AI research and Human-Computer Interaction.

1.3 CASE STUDY: EXPLAINING LATENT SPACES FOR GENERATIVE AI MUSIC

Given the lack of explainability in generative AI music models, we have been exploring the design, build, and use of a real-time generative music model based on the popular Variational Auto Encoder architecture (VAE). A VAE consists of an *encoder* that encodes training data into a multidimensional *latent space* that is then used by a *decoder* to generate data (music in our case) in the style of the training data, as illustrated in Figure 1.5. A key aspect of VAEs for interactive applications is that modifying values of the latent space dimensions will have an effect on the generated data, which is in keeping with the training data. For musical applications this means that users can navigate around a latent space to generate variations of music in the style of the training data, e.g., (Louie, Cohen, Huang, Terry, & Cai, 2020a; Murray-Browne & Tigas, 2021b; Pati & Lerch, 2019; Thelle & Pasquier, 2021; Vigliensoni et al., 2020). For example, *Sonified Body* (Murray-Browne & Tigas, 2021a, 2021b) transforms a dancer's movement into sound using the latent space of a VAE trained on individual dancer's movements. However, a key challenge for explainable VAE systems is that unsupervised learning is used to create the latent space, which means that while users can navigate around the space, there may be no meaningful connection between the movement in the latent space and the music produced, resulting in low levels of grounding. Moreover, retraining such models leads to different mappings (Murray-Browne & Tigas, 2021a), making such latent spaces additionally opaque. Supervised regularization methods such as latent space regularization (LSR) (Hadjeres, Nielsen, & Pachet, 2017) have been used in training VAEs for user-controlled generation of images (Lample et al., 2017) and music (Pati & Lerch, 2019; Tan & Herremans, 2020), offering more meaningful control of VAE-based music generation through increased structure and labeling of the models. In this chapter we explore how both interaction and grounding can be increased within one real-time generative system. For us, the combination of real-time interaction coupled with meaningful exposure of the AI model is key to increased explainability.

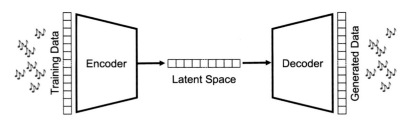

FIGURE 1.5 A simplified variational auto encoder architecture.

We built our generative AI system (Bryan-Kinns et al., 2021) on the popular MeasureVAE system (Pati & Lerch, 2019)[1] in which a measure of music is represented as 24 characters including notes and rests. We trained it using publicly available music from a single genre in keeping with current AI music generation research—in our case 20,000 publicly available monophonic Irish folk melodies (Sturm, Santos, Ben-Tal, & Korshunova, 2016). This training produces a latent vector of 256 latent dimensions. To increase the explainability of the latent space, we follow Pati and Lerch (2019, 2021) and use LSR to force some dimensions of the latent space to represent musical attributes. Specifically, we use meaningful musical features utilized in current research following (Pati & Lerch, 2019, 2021) to demonstrate our approach:

- Rhythmic Complexity (RC): Toussaint (2002).
- Note Range (NR): *maximum pitch minus minimum pitch.*
- Note Density (ND): *number of notes in a measure.*
- Average Interval Jump (AIJ): *the average of the absolute values of the interval between adjacent notes in a single measure.*

We assign these attributes to latent dimensions *0*, *1*, *2*, and *3*, respectively (see Figure 1.6). See (Pati et al., 2019) for a full description of MeasureVAE and (Bryan-Kinns et al., 2021) for full details of our implementation.

For training of our model, as detailed in (Bryan-Kinns et al., 2021), we use Adam (Kingma & Ba, 2014) as the optimizer with learning rate = 1e-4, $\beta_1 = 0.9$, $\beta_1 = 0.999$, and ϵ = 1e-8. Training the model on a single GeForce RTX 2080 Ti GPU takes an average of 2.5 hours per epoch for a total of 30 epochs following (Pati & Lerch, 2019). The model achieves 99.87% reconstruction accuracy on the training set and 99.68% accuracy on the validation set. The interpretability scores that measure how well we can predict an attribute using only one dimension in the latent space (Adel, Ghahramani, & Weller, 2018) average 0.92 (the closer to 1.0, the better): RC 0.80, NR 0.99, ND 0.99, and AIJ 0.91.

To support real-time interaction with our generative model, we built a user interface (UI) as a web application[2] using React.js to demonstrate the interaction as illustrated in Figure 1.7. To provide real-time generative performance, we sweep the four regularized latent dimensions (representing the four musical attributes) and discretely take sample values to generate 10,000 latent vectors for the four regularized dimensions. These are then decoded into music sequences used to generate MIDI files,

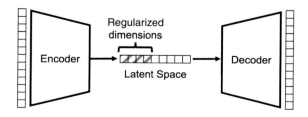

FIGURE 1.6 The simplified MeasureVAE with LSR.

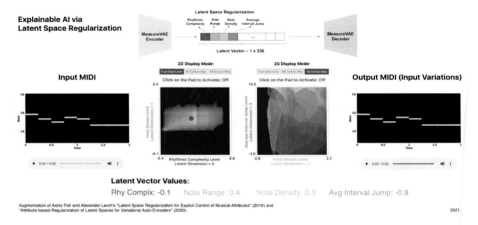

FIGURE 1.7 Screenshot of the web application user interface from Bryan-Kinns et al. (2021).

piano rolls, and MP3 files in advance. These pre-generated files are available online.[3] By combining real-time interaction with more meaningful control using LSR, we aim to increase the explainability of our generative system.

The web app shows the input MIDI measure on the left-hand side of the UI, with the generated output measure shown on the right-hand side (Figure 1.7). The MIDI measures can be listened to and provide a way to *audition* the music. The main area of interaction for the web app are the two 2D pads in the center of the UI. These provide a visualization of two pairs of regularized dimensions, which also allow users to navigate within the latent space and training sets. By moving the red dot around the 2D visualization, the generated MIDI output is updated in real time, providing an interaction loop between the user and generative AI. Different pairs of dimensions can be visualized in the 2D pads using the toggle buttons above the 2D pads, allowing the user to navigate across different combinations of regularized dimensions – the left pad navigates Rhythmic Complexity and Note Range, whereas the right pad navigates Note Density and Average Interval Jump. The visualization also indicates where the input MIDI is located in the latent space (not illustrated in the figure).

We suggest that our web app increases the explainability of the generative AI in two ways as discussed below. Firstly, it exposes the latent space of the generative model to users in meaningful ways through visualization and latent semantic regularization using musical features. Secondly, the real-time interaction of the UI allows for users to develop an understanding and intuition of how the AI model generates music in relation to the input music and the control parameters.

1.3.1 Visualization

The web app displays two visualizations of the training data and latent space in the center of the UI based on the visualizations by (Pati & Lerch, 2019), as illustrated

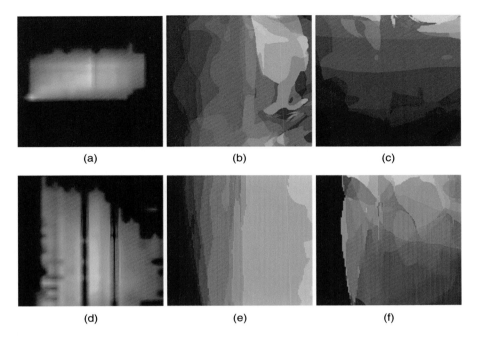

FIGURE 1.8 Visualizations from (Bryan-Kinns et al., 2021): (a) Training Data visualized in terms of rhythmic complexity and note range (TDRCNR). (b) Rhythmic Complexity surface map (RC). (c) Note Range surface map (NR). (d) Training Data visualized in terms of note density and average interval jump (TDNDAIJ). (e) Note Density surface map (ND). (f) Average Interval Jump surface map (AIJ).

in Figure 1.8. The left-hand plot in the UI can be toggled to show one of 8a, b, or c. Similarly, the user can select one of 8d, e, or f to be shown in the right-hand visualization in the UI. The training data plots (8a and 8d) indicate how many items in the training set have contributed to the selected location in the latent space with brighter colors indicating more items. The visualizations of the latent space 8b, c, e, and f show the musical attribute values for our regularized dimensions, e.g., 8b shows the Rhythmic Complexity (RC) of generated music by being plotted across all values of latent dimension 0 (RC) and 1 (NR) as a 2D plot. Again, brighter colors indicate higher values. These surface maps give an indication of how the regularization technique works and suggest to users areas in which to explore different musical features. As movement in the visualizations generates music in real time, the surface maps offer grounding stage 2 – providing an indication of the kind of music produced in response to user input. Furthermore, the visualization offers an opportunity for users to learn about the mappings from latent space to music generation and to start to develop inference about possible kinds of music produced in different areas of the maps. This then moves the explainability of the AI from stage 2 towards stage 3, where users might develop some understanding of why the AI generates the music it does for different parts of the latent space. An explanation of the link between latent

space and music generated is not made explicitly, but rather there is the potential for users to infer an understanding of this link through interaction with the visualization. By providing visualizations of the latent space, we move beyond the explainability of other generative models, which allow users to interact with latent space but do not visualize the space itself, e.g., (Murray-Browne & Tigas, 2021b; Thelle & Pasquier, 2021; Vigliensoni et al., 2020).

1.3.2 REAL-TIME INTERACTION

The real-time nature of the interaction with our UI, particularly the real-time generation of music in response to navigation within the latent space, may offer users ways to develop an intuition about the working of the model. In other words, the immediate feedback and interaction loop offer opportunities for users to get the *gist* of how the AI works in terms of the relationship between the latent space and the music it may produce when the musical attributes are changed. Moreover, the UI keeps the original input used to generate music and shows the original location in the latent space while the latent space is being navigated.

We suggest that this allows for exploratory or trial-and-error learning of the AI model, as the user can always return to the original state. It also allows for contrastive example-based learning, as the user can compare their original input to the variety of generative outputs produced as the space is navigated. There are similarities here to the design of Hyperscore (Farbood et al., 2007), where the original melody is always shown as reference while musical parameters are changed. Our real-time interaction approach also aligns with creativity support tool design principles such as (Shneiderman et al., 2006)'s principles of supporting explorations and designing creativity support tools, which offer a high ceiling for creativity.

The real-time feedback loop in combination with the visualization of latent space and a user's location within it offers chances for increasing grounding with the AI from a stage 1 where we know that the AI has done something, but we are not sure what, to stage 2 where users may start to build an understanding of what the AI has done in response to their input.

In terms of the role of our AI, the real-time interaction moves our model from being a pen-pal to more of a colleague interacting in real time, though there is a lack of agency on the part of our model to really co-create with. The model also lacks any explicit explanation of why it generates the music it does – the user must infer the explanation from their navigation of the latent space, meaning that the model does not take on the role of coach. In terms of music making, it is plausible that this makes the model more suited to a duet-style improvisation for real-time performance or a composition idea generator for less live situations.

1.4 XAI FOR MUSIC CHALLENGES

Building our generative AI model and reflecting on its use has raised multiple research challenges for eXplainable AI and music outlined in this section. The challenges have been used to inform thinking about eXplainable AI and the arts more broadly (Bryan-Kinns, Ford, et al., 2023a).

1.4.1 CHALLENGE: THE NATURE OF EXPLANATION

The open-ended nature of creative endeavors such as music making raises questions about how much we might want to understand AI in creative settings and what kinds of explanations might be appropriate. Being surprised, confused, delighted, or reflective (Candy, 2019; Ford & Bryan-Kinns, 2022b, 2023) are often integral to creative activities. Indeed, failure is often embraced as a resource in creative endeavors (Hazzard et al., 2019). These characteristics of creative activities require a balance between skills and challenge (cf. flow theory Csíkszentmihályi [1990]), for example, balancing between explainability and surprise, efficiency and serendipity, ease-of-use, and playful challenge. These balances are in contrast to the more functional goals of explainability, transparency, and interpretability outlined in definitions of XAI proposed in (Gunning, 2016) and expanded in (Guidotti et al., 2018), and raise questions about what the nature of explainability in creative settings might be. For example, in human group music improvisation most of the communication that holds the group together is non-verbal and implicit, such as gestures, nods, physical position, eye contact, or even musical emphasis (Healey et al., 2005). The musicians in such settings do not request an in-depth explanation of each note produced and why it was chosen but instead rely on an intuition about each other's performance styles and practice to understand how the improvisation might progress within the socially constructed setting of music making. Generative AI systems such as Shimon (Hoffman & Weinberg, 2010) and McCormack et al. (2019)'s collaborative AI drummer embrace this balance between communication of system state and the socially constructed expectations of music improvisation by communicating indications of current potential future AI states through physical gesture and emoticons respectively. In this way the explanations are much more about conveying the *gist* of what the AI is doing and why, and very much less about providing in-depth explanations of features of models or predictions. This is due partly to the in-the-moment nature of music making, which requires sufficient information to progress the collaboration, but not so much that it stifles the creative process itself.

1.4.2 CHALLENGE: AI MODELS, FEATURES, AND TRAINING DATA

There is an ever-increasing number of generative AI models for music and the arts more broadly. For music generation the models range from probability-based models such as Markov Chains (Ames, 1989; Whorley & Laney, 2020) through to deep learning techniques (Briot & Pachet, 2018). While probablistic approaches typically offer more explainable models than deep learning models, their outputs are often less novel than deep learning models. In this chapter we chose to use the MeasureVAE architecture to build our demo, as such deep learning models have become increasingly popular in recent years and generate convincing musical outputs (Carnovalini & Rodà, 2020; Herremans et al., 2017; Sturm, Ben-Tal, Monaghan, et al., 2019). We could have chosen other models and architectures for our demo, and this would have changed the nature of the explanations that could be imposed on and offered by the model. However, there is very little research about how AI models are used in creative practice (Karimi, Rezwana, Siddiqui, Maher, & Dehbozorgi, 2020;

Louie, Cohen, et al., 2020a; Sturm, 2022), and we found no research about how XAI is used in music making. This means that there are open research questions about which XAI models are more or less appropriate for different forms of artistic practice broadly, such as music or visual arts, and which are appropriate for different activities within an art form such as music composition and music improvisation.

In addition to a lack of research on which XAI models might be appropriate for music making, we found no research on the suitability or appropriateness of features used in explanations. For example, in this chapter we selected four musical parameters to be used in our XAI system – rhythmic complexity, note density, note range, and average interval jump. These were selected as representative of current generative AI research and Music Information Retrieval research, but they are only a small subset of the possible musical features we could have used, and we do not know what effect the different features chosen have on the performance of the model or its explanations. Moreover, the features we chose focused on the pitch and rhythmic aspects of a measure of music and did not consider higher level features such as timbre, genre, mood, composition structure, and so on, which musicians may be interested in when making music. In addition, for a non-musical user, the system may still present some explainability barriers as the chosen parameters – although labeled and visualized – require the user to have some prior understanding of music and musical features. Other control mechanics, such as the semantic sliders used in (Louie, Cohen, et al., 2020a), may be more appropriate here, although these currently do not give explanations for the link between interaction and output.

In keeping with other generative music research, we trained our demo system on a commonly used Irish Folk Music dataset (Sturm et al., 2016). However, this limits the tonal and rhythmic features of the music we generate to the characteristics of the Western music canon, specifically folk music. The reliance on datasets such as the Irish Folk Music dataset means that generative systems such as ours and others in the field reinforce the marginalization of smaller datasets and other genres leading to limited diversity of musical styles used and generated. Future research should consider how musical genres beyond the Western canon can be better included in AI training, especially where model training might require large datasets biasing them towards using large and well-established datasets typically within the Western canon. More broadly, this challenge of diversifying training data connects with one of the grand challenges of Human-Centered AI (Garibay et al., 2023), which is to design AI that is inclusive by using de-biased datasets to ensure fairness and to promote accountability by developers.

To begin to explore these challenges of XAI models, features, and training datasets, we compared the MeasureVAE model with four regularized dimensions used in this chapter to an AdversarialVAE (Kawai, Esling, & Harada, 2020) with the same four musical features applied to control its music generation, and compared the effect of training Measure VAE on datasets of four different musical genres: Irish folk, Turkish folk, Classical, and pop. In this comparision (Bryan-Kinns, Zhang, Zhao, & Banar, 2023b) we found that MeasureVAE was better at generating music in the style of its training data, whereas AdversarialVAE was more controllable with the four musical attributes. We also found that MeasureVAE performed best when generating low complexity music such a pop and rock, and that 32 or 64 latent dimensions were optimal

for MeasureVAE when regularizing four of the dimensions to the musical features used in this chapter. This initial investigation illustrates the impact AI models, datasets, and musical features have on generative models that are designed to be explainable and highlights the importance of exploring these aspects in future XAI research.

1.4.3 CHALLENGE: USER CENTERED DESIGN FOR XAI

The challenges above highlight the need for involving users in the design of XAI for music – for example, to ensure that appropriate attributes for explanation are selected for musicians to actually use in their practice and more broadly to explore how artistic identity can be incorporated and expressed in, with, and through such systems. Involving users in AI design and co-design is a grand challenge for HCAI research (Garibay et al., 2023), and yet there is very little research on using User Centered Design (UCD) approaches to drive the creation of XAI systems (Zhu, Liapis, Risi, Bidarra, & Youngblood, 2018). Moreover, there is no research to date on UCD for XAIxArts. This means that there are open research questions about how to include musicians in the co-design of generative music systems. Similarly, there are open research questions about how such XAI systems are used, unused, misused, and appropriated in real-world music making practice. Indeed, while there are reports of the use of AI in music making such as the Illiac Suite (Hiller & Isaacson, 1957), Calliope (Bougueng Tchemeube, Ens, & Pasquier, 2022), or experiments by the band Dadabots (Zukowski & Carr, 2018), there is no research to date on the role of eXplainable AI in such creative settings. Furthermore, as highlighted earlier, there is a need for XAI designers to develop systems that exhibit sensitivity towards the particular social and cultural context (Nyrup & Robinson, 2022), especially the case in music, which often relies on hyper-localized references and traditions.

It should be noted that in this chapter we have focused primarily on considering individual musicians as users of generative XAI systems. Other possible XAI target audiences are also important to consider such as ensembles of musicians and audiences of music performances, who could equally stand to benefit from clearer explanations of generative AI in music performance. Taking a broader and more critical and post-human perspective, XAIxArts interfaces could follow calls in HCI research to subvert user-centricity in favor of more-than-human approaches (Wakkary, 2021).

To begin to explore how such XAI systems might be appropriated in existing music making practice, we developed a second UI (Banar, Bryan-Kinns, & Colton, 2023) for the demo outlined in this chapter. This second UI was built as a Max4Live plugin to allow deployment and use within musicians' musical practice and music making workflows, as illustrated in Figure 1.9. To explore its use in music making practice, an autoethnographic study incorporating the demo into a rule-based composition practice and music workflow was carried out (Noel-Hirst & Bryan-Kinns, 2023). In this way, the demo was deployed beyond its original genre (Irish Folk) and expanded its use beyond a standalone music generator by integrating it into a music workflow including a rule-based rhythm generator, monophonic processor, piano roll, and MeasureVAE demo.

In the study the combination of rule-based composition systems with generative AI was found to offer new ways to musically *explore* the latent space of the generative

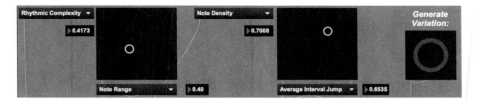

FIGURE 1.9 Screenshot of the Max4Live plugin user interface.

model – by permuting the output of the rule-based system and using this to drive navigation of the latent space the musician-researcher was able to "explore the under-defined contours of the latent space through example" (Noel-Hirst & Bryan-Kinns, 2023). In this way, music generated by MeasureVAE was driven and explored by a rule-based composition system rather than by direct manipulation of parameters.

The study also highlighted the potential of the XAI to provide *insight* into more opaque systems. In this case the musician-researcher used the visual representation of the latent space in the UI as a way of understanding the output of their rule-based composition system, which in turn offered opportunities for fine-grained control of the rule-based system not easily achieved without the visualization. While these are preliminary findings from early stage research, they already highlight the potential use and appropriation of such an XAI music system beyond being a standalone Irish folk music generator.

1.4.4 CHALLENGE: INTERACTION DESIGN OF XAI

There is little research to date on how to design the interaction with XAI for music and the arts more broadly. For our demo, this raised Interaction Design questions including: which AI features to present to the user; how to visualize and navigate high dimensional data, in our case four regularized dimensions, but there could very well have been many more dimensions to interact with; how to represent and manage the entanglement between dimensions; and how to provide real-time interaction in a temporal art form (music). These Interaction Design challenges will be compounded when designing for use in music practice and real-world workflows where interacting with the AI will likely be a secondary focus to the overall creative practice and workflow.

Visualization is currently the primary design discipline of interest with regards to XAI, and there are many surveys of visual design methods for XAI that can serve to ground the development of XAI for music and XAIxArts interfaces more broadly. Alicioglu and Sun (2022) provide a comprehensive survey of such methods, noting several important challenges. The main challenge is scalability in data representation as dimensionality increases, both from a visual clutter perspective and from an interface performance perspective. This has always been a key issue for musical interface design, which is in this case compounded by the curse of dimensionality. A close second is that despite the extent of XAI research, there is no consensus and little evaluative literature on which data and models should be paired with which

visual methods; instead they find that most solutions trend towards specialization. This point is reiterated in a recent review by Krajna, Kovac, Brcic, and Šarčević (2022), who note that there is similarly a lack of standardized dataset and unbiased metrics for evaluating XAI systems and interfaces. They also note an additional challenge, that XAI research is constantly playing catch-up to the latest developments in model architectures and data regimes, with no guarantees that existing XAI methods will necessarily transfer to new innovations.

One area of interactive visualization research that can provide designers with useful examples and inspirations is in *interactive articles*, which are sometimes known as *explorable explanations*[4] after the Bret Victor article of the same name.[5] The *explorables* community of data visualization designers, data journalists, and open source software developers has explored many approaches to using narrative, plurality of representations, and rich multimedia to enhance comprehension of complex phenomena of many kinds (Heer, Kale, & Jeffrey, 2019). This community directly influenced Distill,[6] an experimental publication platform that ran from 2016–2021, dedicated to innovation in making machine learning research "clear, dynamic and vivid".

Aside from the visual methods, auditory display (Kramer, 1993), auditory augmentation (Weger, Hermann, & Höldrich, 2018, 2022), sonification (Hermann, Hunt, & Neuhoff, 2011), and sonic interaction design (Franinovic & Serafin, 2013) are unexplored with regards to XAI for music, and are clear choices for taking advantage of the listening skills of musicians. These domains are already being explored for increasing understanding of AI, for example, in *AIive* which introduces interactive visualization and sonification of neural networks in virtual reality (Lyu, Li, & Wang, 2021), and *SonOpt*, which proposes methods for sonification of bi-objective population-based optimization algorithms (Asonitis, Allmendinger, Benatan, & Climent, 2022). Toolkits for sonification are also becoming more widely accessible and integrated into machine learning contexts, for example *sc3nb*, a new Python-based sonification framework (Hermann & Reinsch, 2021). The sonification literature also spans beyond informative displays and technical innovations, considering the impact of aesthetic and ritualistic dimensions of sonic communication (Morabito, Armitage, & Magnusson, 2022), all of which can be drawn on to inspire.

The challenges and opportunities in interaction design for XAI for music are not constrained only to the visual and audio domains. Music is in many ways also a tactile domain, and Maliheh Ghajargar et al. have in recent years pioneered what they refer to as graspable AI (Ghajargar & Bardzell, 2022; Ghajargar, Bardzell, Smith-Renner, Höök, & Krogh, 2022). Their approach centers around the exploration of different forms of embodiment and tangibility for making AI understandable, building off the rich HCI literature in this domain to meet contemporary challenges around XAI, FAccT, and HCAI. Music interaction designers and researchers are of course well aware of the potential affordances of haptics (Papetti & Saitis, 2018). Tangible XAI is particularly promising in that it hints at approaches that avoid some of the aforementioned challenges with visual methods, while also tapping into extant musical sensorimotor skill. It also proposes to build off less explicit, subconscious intuition acquisition processes associated with direct manipulation (Nimkulrat, 2020) that are also being exploited in craft HCI contexts to enable manual exploration of

subtle, micro scale details of digital artifacts (Armitage, Magnusson, & McPherson, 2023a, 2023b).

We also wish to highlight conceptual approaches to interaction design for XAI for the arts that may prove provocative and perhaps useful. Sanchez et al. (Sanchez, Caramiaux, Thiel, & Mackay, 2022) found that exposing model uncertainty to users in an interactive machine learning (IML) context increased user confidence. While datasets and models have greatly increased in size and complexity of late, researchers still turn to toy models (Chughtai, Chan, & Nanda, 2023) and synthetic data (Liu, Michaud, & Tegmark, 2023) to reveal fundamental insights. These approaches show that getting hands-on with the exact opposite of the complex black boxes users are commonly presented with today can be a driver for intuition and trust. Interaction designers should explore not just synthesized explanations, but also training processes, synthetic datasets, and simplified but more interactive versions of entire models.

The XAI demo discussed in this chapter follows HCAI principles in giving the user more control over how they navigate a dataset, while the AI automates the writing of measures of music (Shneiderman, 2022). A potential challenge, to be explored in future user studies, is whether users blindly trust that the systems output will fit into their own creative practice. HCAI guidelines on responsible design (Garibay et al., 2023) suggest that AI designs should actively dissuade users from blind trust of a machine and instead persuade them to critically question AI output. However, in music we have seen tools perceived as infallible and their use as being the "best" option because of cultural perceptions of technology somehow knowing better than human understanding (Reed & McPherson, 2023). Much of technology use in day-to-day life revolves around providing objective output; culturally, we are predisposed to believing tech interventions provide one correct response. Perhaps, approaches to designing for reflection (Ford & Bryan-Kinns, 2023) will be useful to explore, moving away from approaches on designing engagement where self-awareness and conscious thinking is discouraged cf. flow theory (Csíkszentmihályi, 1990), which is more frequent in classic creativity support tool research (Shneiderman et al., 2006). Indeed, it may be that XAI should be aiming to ensure that people trust themselves creatively as much as the tool itself. Endeavors in eXplainable AI might then focus on shifting AI's perceived role as providing "optimal" or "correct" solutions to that of just another tool in the creative arsenal.

1.5 CONCLUSIONS

eXplainable AI and Human-Centered AI more broadly are growing research fields that have the potential to contribute to making AI systems more artist-centric. In doing so, XAI and HCAI for the arts would offer opportunities to augment and supercharge human creativity and agency rather than disempowering and disenfranchising in a world of autonomous AI generation systems. However, as highlighted in this chapter, current AI models for music generation offer very little explanation and human-centered interaction, typically generating content with little or no user interaction. As AI systems are increasingly used for music creation, they inevitably shape our musical culture, increasing the need for eXplainable AI for music to

help us understand their use and behavior. Indeed, increasingly autonomous AI risks diminishing human creativity, removing human agency from creative processes, and devaluing human creativity itself. As noted in this chapter, the reliance on a small set of training datasets predominantly from the Western canon also risks the homogenization of music to this narrow set of genres and a marginalization of musical skills and traditions that are not in our current training sets and may not be amendable to generation by current AI models.

In this chapter we highlighted the lack of explainability in current AI models for music. We proposed a classification framework for XAI for the arts that considers the role of the AI, the interaction offered by the AI, and the potential grounding with the AI in interaction. We suggest that designing for increasing levels of the entangled categories increases the explainability of AI in creative settings. We demonstrated the development and use of an XAI for music by offering musical control of music generated by an AI. By comparing our model, features, and training dataset to others, we illustrate the impact of these on the performance of XAI models.

Our view is that XAI for music and the arts more generally needs to move away from functional explanations deployed in other domains and focus more on conveying the *gist* of what the AI is doing and why. This move of XAI from functional domains to more creative, aesthetic, and experiential domains mirrors in some ways the shift of HCI from usability to third wave HCI (Bødker, 2015) concerns of meaning making and user experience. As we move into these more creative and cultural domains, our XAI research also needs to embrace the creative practice, norms, and cultural dimensions that socially construct art.

ACKNOWLEDGEMENTS

We wish to thank Bingyuan Zhang, Songyan Zhao, Ashley Noel-Hirst, and Simon Colton who previously contributed to work (Bryan-Kinns et al., 2021; Bryan-Kinns, Zhang, et al., 2023b) discussed in this chapter.

FUNDING

This research was funded in part by the Queen Mary University of London Research Enabling Fund. Corey Ford is a research student at the UKRI Centre for Doctoral Training in Artificial Intelligence and Music, supported by UK Research and Innovation [grant number EP/S022694/1].

NOTES

1 https://github.com/ashispati/AttributeModelling licensed under Creative Commons Attribution-NonCommercial-ShareAlike 4.0 International License.
2 https://xai-lsr-ui.vercel.app/
3 https://github.com/bbanar2/Exploring_XAI_in_GenMus_via_LSR
4 https://explorabl.es
5 http://worrydream.com/ExplorableExplanations/
6 https://distill.pub/

REFERENCES

Adel, T., Ghahramani, Z., & Weller, A. (2018). Discovering Interpretable Representations for Both Deep Generative and Discriminative Models. In J. Dy & A. Krause (Eds.), *Proceedings of the 35th International Conference on Machine Learning* (Vol. 80, pp. 50–59). PMLR. https://proceedings.mlr.press/v80/adel18a.html

Agostinelli, A., Denk, T.I., Borsos, Z., Engel, J., Verzetti, M., Caillon, A., Huang, Q., Jansen, A., Roberts, A., Tagliasacchi, M., & Sharifi, M. (2023). MusicLM: Generating Music from Text. arXiv preprint arXiv:2301.11325.

Alicioglu, G., & Sun, B. (2022). A Survey of Visual Analytics for Explainable Artificial Intelligence Methods. *Computers & Graphics, 102*, pp. 502–520.

Ames, C. (1989). The Markov Process as a Compositional Model: A Survey and Tutorial. *Leonardo, 22* (2), pp. 175–187.

Andres, J., Wolf, C.T., Barros, S.C., Oduor, E., Nair, R., Kjærum, A., Tharsgaard, A.B., & Madsen, B.S. (2020). Scenario-Based XAI for Humanitarian Aid Forecasting. In *Extended Abstracts of the 2020 CHI Conference on Human Factors in Computing Systems (CHI EA '20)* (pp. 1–8). Association for Computing Machinery, New York, NY, USA. https://doi.org/10.1145/3334480.3382903

Armitage, J., Magnusson, T., & McPherson, A. (2023a). A Scale-Based Ontology of Digital Musical Instrument Design. In *Proceediangs of New Interfaces for Musical Expression*. Mexico City, Mexico.

Armitage, J., Magnusson, T., & McPherson, A. (2023b). Studying Subtle and Detailed Digital Lutherie: Motivational Contexts and Technical Needs. In *Proceedings of New Interfaces for Musical Expression*. Mexico City, Mexico.

Asonitis, T., Allmendinger, R., Benatan, M., & Climent, R. (2022). SonOpt: Sonifying Bi-Objective Population-Based Optimization Algorithms. In T. Martins, N. Rodríguez-Fernández, & S.M. Rebelo (Eds.), *Artificial Intelligence in Music, Sound, Art and Design* (pp. 3–18). Springer International Publishing, Cham.

Banar, B., Bryan-Kinns, N., & Colton, S. (2023). A Tool for Generating Controllable Variations of Musical Themes Using Variational Autoencoders with Latent Space Regularisation. *Proceedings of 37th AAAI Conference on Artificial Intelligence, 37* (13), pp. 16401–16403. https://doi.org/10.1609/aaai.v37i13.27059

Banar, B., & Colton, S. (2021). Generating Music with Extreme Passages Using GPT-2. In A.M. Mora & A.I. Esparcia-Alcázar (Eds.). *Evo* 2022-Late-Breaking Abstracts Volume*. arXiv preprint arXiv:2208.00555.

Banar, B., & Colton, S. (2022a). Connecting Audio and Graphic Score Using Self-Supervised Representation Learning – A Case Study with Gyorgy Ligeti's Artikulation. In *Proceedings of the International Conference on Computational Creativity (ICCC)*. https://computationalcreativity.net/iccc22/papers/ICCC-2022_paper_137.pdf

Banar, B., & Colton, S. (2022b). A Systematic Evaluation of GPT-2-Based Music Generation. In *International Conference on Computational Intelligence in Music, Sound, Art and Design (EvoMUSART) (Part of EvoStar)* (pp. 19–35).

Banar, B., & Colton, S. (2023). A Tool for Composing Music via Graphic Scores in the Style of Gyorgy Ligeti's Artikulation Using Self-Supervised Representation Learning. In *The AAAI-23 Workshop on Creative AI Across Modalities*. https://openreview.net/forum?id=c7W3iTr693

Benetatos, C., VanderStel, J., & Duan, Z. (2020). BachDuet: A Deep Learning System for Human-Machine Counterpoint Improvisation. In R. Michon & F. Schroeder (Eds.), *Proceedings of New Interfaces for Musical Expression*. https://doi.org/10.5281/zenodo.4813234

Benyon, D., & Macaulay, C. (2002). Scenarios and the HCI-SE design problem. *Interacting with Computers, 14* (4), pp. 397–405. https://doi.org/10.1016/S0953-5438(02)00007-3

Bødker, S. (2015). Third-Wave HCI, 10 Years Later—Participation and Sharing. *Interactions*, *22* (5), pp. 24–31. https://doi.org/10.1145/2804405

Bougueng Tchemeube, R., Ens, J.J., & Pasquier, P. (2022). Calliope: A Cocreative Interface for Multi-track Music Generation. In *Proceedings of ACM Creativity and Cognition* (pp. 608–611). Association for Computing Machinery, New York, NY, USA. https://doi.org/10.1145/3527927.3535200

Briot, J.-P., & Pachet, F. (2018). Deep Learning for Music Generation: Challenges and Directions. *Neural Computing and Applications*, *32*, pp. 981–993.

Bryan-Kinns, N., Banar, B., Ford, C., Reed, C.N., Zhang, Y., Colton, S., & Armitage, J. (2021). Exploring XAI for the Arts: Explaining Latent Space in Generative Music. In *Proceedings of the 1st Workshop on eXplainable AI Approaches for Debugging and Diagnosis (XAI4 Debugging@NeurIPS2021)*. https://xai4debugging.github.io/files/papers/exploring_xai_ for_the_arts_exp.pdf

Bryan-Kinns, N., Ford, C., Chamberlain, A., Benford, S., Kennedy, H., Li, Z., Qiong, W., Xia, G., and Rezwana, J. (2023a). Explainable AI for the Arts: XAIxArts. In *Proceedings of the 15th Conference on Creativity and Cognition (C&C'23)* (pp. 1–7). Association for Computing Machinery, New York, NY, USA. https://doi.org/10.1145/3591196.3593517

Bryan-Kinns, N., Zhang, B., Zhao, S., & Banar, B. (2023b). Exploring Variational Auto-Encoder Architectures, Configurations, and Datasets for Generative Music Explainable AI. *Machine Intelligence Research* (in review).

Caillon, A., & Esling, P. (2021). RAVE: A Variational Autoencoder for Fast and High-quality Neural Audio Synthesis. arXiv preprint arXiv:2111.05011.

Candy, L. (2019). *The Creative Reflective Practitioner: Research Through Making and Practice* (1st ed.). Routledge. https://doi.org/10.4324/9781315208060

Carnovalini, F., & Rodà, A. (2020). Computational Creativity and Music Generation Systems: An Introduction to the State of the Art. *Frontiers in Artificial Intelligence*, *3* (14). https://www.frontiersin.org/article/10.3389/frai.2020.00014

Chughtai, B., Chan, L., & Nanda, N. (2023). A Toy Model of Universality: Reverse Engineering How Networks Learn Group Operations. arXiv preprint arXiv:2302.03025.

Ciatto, G., Schumacher, M.I., Omicini, A., & Calvaresi, D. (2020). Agent-Based Explanations in AI: Towards an Abstract Framework. In *Explainable, Transparent Autonomous Agents and Multi-Agent Systems: Second International Workshop, EXTRAAMAS 2020, Auckland, New Zealand, May 9–13, 2020, Revised Selected Papers* (pp. 3–20). Springer-Verlag, Berlin, Heidelberg. https://doi.org/10.1007/978-3-030-51924-7

Clark, H., & Brennan, S. (1992). Grounding in Communication. *Archives*, *7* (July), pp. 734–738.

Colton, S., & Wiggins, G.A. (2012). Computational Creativity: The Final Frontier? In *Proceedings of the 20th European Conference on Artificial Intelligence* (pp. 21–26). IOS Press, Amsterdam, NLD.

Cornock, S., & Edmonds, E. (1973). The Creative Process: Where the Artist Is Amplified or Superseded by the Computer. *Leonardo*, *6* (1), 11–16.

Csíkszentmihályi, M. (1990). *Flow: The Psychology of Optimal Experience*. Harper Collins, New York, NY, USA.

De Man, B., Reiss, J., & Stables, R. (2017). Ten Years of Automatic Mixing. In *Proceedings of the 3rd Workshop on Intelligent Music Production*. Salford, UK. https://www.open-access.bcu.ac.uk/4968/1/WIMP2017_DeManEtAl.pdf

Dinculescu, M., Engel, J., & Roberts, A. (2019). *Midime: Personalizing a Musicvae Model with User Data*. In *NeurIPS 2019 Workshop on Machine Learning for Creativity and Design*. Vancouver, Canada. https://research.google/pubs/pub48628/

Du, N., Haspiel, J., Zhang, Q., Tilbury, D., Pradhan, A.K., Yang, X.J., & Robert Jr, L.P. (2019). Look Who's Talking Now: Implications of AV's Explanations on Driver's Trust, AV Preference, Anxiety and Mental Workload. *Transportation Research Part C: Emerging Technologies*, *104*, 428–442.

Farbood, M., Kaufman, H., & Jennings, K. (2007). Composing with Hyperscore: An Intuitive Interface for Visualizing Musical Structure. In *Proceedings of the 2007 International Computer Music Conference, ICMC 2007, August 27-31, 2007*. Michigan Publishing.

Ford, C., & Bryan-Kinns, N. (2022a). On the Role of Reflection and Digital Tool Design for Creative Practitioners. In *Digital Skills for the Creative Practitioner: Supporting Informal Learning of Technologies for Creativity Workshop at ACM CHI 2023*. https://qmro. qmul.ac.uk/xmlui/handle/123456789/88820

Ford, C., & Bryan-Kinns, N. (2022b). Speculating on Reflection and People's Music Co-creation with AI. In *Workshop on Generative AI and HCI at the CHI Conference on Human Factors in Computing Systems 2022*. https://qmro.qmul.ac.uk/xmlui/handle/123456789/ 80144

Ford, C., & Bryan-Kinns, N. (2023). Towards a Reflection in Creative Experience Questionnaire. In *Proceedings of the 2023 CHI Conference on Human Factors in Computing Systems*. Association for Computing Machinery, New York, NY, USA. https://doi.org/10.1145/ 3544548.3581077

Franinovic, K., & Serafin, S. (Eds.) (2013). *Sonic Interaction Design*. MIT Press.

Frid, E., Gomes, C., & Jin, Z. (2020). Music Creation by Example. In *Proceedings of the 2020 CHI Conference on Human Factors in Computing Systems* (pp. 1–13). Association for Computing Machinery, New York, NY, USA. https://doi.org/10.1145/3313831.3376514

Garibay, O., Winslow, B., Andolina, S., Antona, M., Bodenschatz, A., Coursaris, C., Falco, G., Fiore, S., Garibay, I., Grieman, K., Havens, J., Jirotka, M., Kacorri, H., Karwowski, W., Kider, J., Konstan, J., Koon, S., Lopez-Gonzalez, M., Maifeld-Carucci, I., McGregor, S., Salvendy, G., Shneiderman, G., Stephanidis, C., Strobel, C., Holter C., & Xu, W. (2023). Six Human-Centered Artificial Intelligence Grand Challenges. *International Journal of Human–Computer Interaction, 39* (3), 391–437. https://doi.org/10.1080/10447318.2022.2153320

Ghajargar, M., & Bardzell, J. (2022). Making AI Understandable by Making It Tangible: Exploring the Design Space with Ten Concept Cards. In *Proceedings of the 34th Australian Conference on Human-Computer Interaction* (pp. 74–80). Association for Computing Machinery. https://doi.org/doi/10.1145/3572921.3572942

Ghajargar, M., Bardzell, J., Smith-Renner, A.M., Höök, K., & Krogh, P.G. (2022). Graspable AI: Physical Forms as Explanation Modality for Explainable AI. In *Sixteenth International Conference on Tangible, Embedded, and Embodied Interaction* (pp. 1–4). Association for Computing Machinery. Retrieved 2023-04-26, from https://doi.org/10.1145/3490149. 3503666

Gillick, J., & Bamman, D. (2021). What to Play and How to Play It: Guiding Generative Music Models with Multiple Demonstrations. In *Proceedings of New Instruments for Musical Expression*. https://doi.org/10.21428/92fbeb44.06e2d5f4

Guidotti, R., Monreale, A., Ruggieri, S., Turini, F., Pedreschi, D., & Giannotti, F. (2018). A Survey of Methods for Explaining Black Box Models. *ACM Computing Surveys, 51* (5), Article 93 (September 2019), 42 pages. https://doi.org/10.1145/3236009

Gunning, D. (2016). Explainable Artificial Intelligence (XAI). *DARPA/I2O Proposers Day*.

Hadjeres, G., Nielsen, F., & Pachet, F. (2017). GLSR-VAE: Geodesic Latent Space Regularization for Variational Autoencoder Architectures. In *2017 IEEE Symposium Series on Computational Intelligence (SSCI)* (pp. 1–7). IEEE.

Hazzard, A., Greenhalgh, C., Kallionpaa, M., Benford, S., Veinberg, A., Kanga, Z., & McPherson, A. (2019). Failing with Style: Designing for Aesthetic Failure in Interactive Performance. In *2019 CHI Conference on Human Factors in Computing Systems Proceedings (CHI 2019)*, Glasgow, Scotland, UK (p. 13). ACM, New York, NY, USA.

Healey, P.G.T., Leach, J., & Bryan-Kinns, N. (2005). Inter-Play: Understanding Group Music Improvisation as a Form of Everyday Interaction. In *Proceedings of Less Is More - Simple Computing in the Age of Complexity*. http://www.eecs.qmul.ac.uk/~nickbk/papers/ interplay_final.pdf

Heer, M.C., Kale, A., & Jeffrey. (2019). Capture & Analysis of Active Reading Behaviors for Interactive Articles on the Web. *Computer Graphics Forum (Proc. EuroVis)*, *38* (3), pp. 687–698.

Hermann, T., Hunt, A., & Neuhoff, J.G. (2011). *The Sonification Handbook* (Vol. 1). Logos Verlag, Berlin.

Hermann, T., & Reinsch, D. (2021). Sc3nb: A Python-SuperCollider Interface for Auditory Data Science. In *Proceedings of the 16th International Audio Mostly Conference (2021)*, Association for Computing Machinery, New York, NY, USA, pp. 208–215. https://doi.org/10.1145/3478384.3478401

Herremans, D., Chuan, C., & Chew, E. (2017). A Functional Taxonomy of Music Generation Systems. *ACM Computing Surveys*, *50* (5). https://doi.org/10.1145/3108242

Hiller, L., & Isaacson, L. (1957). *Illiac Suite: For String Quartet*. New Music Edition.

Hoffman, G., & Weinberg, G. (2010). Shimon: An Interactive Improvisational Robotic Marimba Player. In *CHI'10 Extended Abstracts on Human Factors in Computing Systems* (pp. 3097–3102).

Huang, Q., Park, D.S., Wang, T., Denk, T.I., Ly, A., Chen, N., Zhang, Z., Zhang, Z., Yu, J., Frank, C., & Engel, J. (2023). Noise2Music: Text-conditioned Music Generation with Diffusion Models. arXiv preprint arXiv:2302.03917.

Jourdan, T., & Caramiaux, B. (2023a). Culture and Politics of Machine Learning in NIME: A Preliminary Qualitative Inquiry. In *Proceedings of the International Conference on New Interfaces for Musical Expression*.

Jourdan, T., & Caramiaux, B. (2023b). Machine Learning for Musical Expression: A Systematic Literature Review. In *Proceedings of the International Conference on New Interfaces for Musical Expression*.

Kandinsky, W. (1912). *Concerning the Spiritual in Art* (M.T.H. Sadler, Trans.). Dover Publications Inc. New York (1972 translation).

Karimi, P., Rezwana, J., Siddiqui, S., Maher, M.L., & Dehbozorgi, N. (2020). Creative Sketching Partner: An Analysis of Human-AI Co-creativity. In *Proceedings of the 25th International Conference on Intelligent User Interfaces* (pp. 221–230). Association for Computing Machinery, New York, NY, USA. https://doi.org/10.1145/3377325.3377522

Kawai, L., Esling, P., & Harada, T. (2020). Attributes-aware Deep Music Transformation. In *Proceedings of the International Society for Music Information Retrieval Conference (ISMIR)*. https://archives.ismir.net/ismir2020/paper/000099.pdf

Kingma, D.P., & Ba, J. (2014). Adam: A Method for Stochastic Optimization. arXiv preprint arXiv:1412.6980.

Kozierok, R., Aberdeen, J., Clark, C., Garay, C., Goodman, B., Korves, T., Hirschman, L., McDermott, P.L., & Peterson, M.W. (2021). Hallmarks of Human-Machine Collaboration: A Framework for Assessment in the DARPA Communicating with Computers Program. arXiv preprint arXiv:2102.04958.

Krajna, A., Kovac, M., Brcic, M., & Šarčević, A. (2022). Explainable Artificial Intelligence: An Updated Perspective. In *2022 45th Jubilee International Convention on Information, Communication and Electronic Technology (MIPRO)* (pp. 859–864).

Kramer, G. (1993). *Auditory Display: Sonification, Audification, and Auditory Interfaces*. Perseus Publishing.

Lample, G., Zeghidour, N., Usunier, N., Bordes, A., Denoyer, L., & Ranzato, M. (2017). Fader Networks: Manipulating Images by Sliding Attributes. In *Proceedings of the 31st International Conference on Neural Information Processing Systems (NIPS)* (pp. 5969–5978). Curran Associates Inc., Red Hook, NY, USA.

Liao, Q.V., Gruen, D., & Miller, S. (2020). Questioning the AI: Informing Design Practices for Explainable AI User Experiences. In *Proceedings of the 2020 CHI Conference on Human Factors in Computing Systems* (pp. 1–15). Association for Computing Machinery, New York, NY, USA. https://doi.org/10.1145/3313831.3376590

Liu, Z., Michaud, E.J., & Tegmark, M. (2023, March). Omnigrok: Grokking Beyond Algorithmic Data. arXiv preprint arXiv:2210.01117.

Long, D., Padiyath, A., Teachey, A., & Magerko, B. (2021). The Role of Collaboration, Creativity, and Embodiment in AI Learning Experiences. In *Creativity and Cognition.* Association for Computing Machinery, New York, NY, USA. https://doi.org/10.1145/3450741.3465264

Louie, R., Cohen, A., Huang, C.A., Terry, M., & Cai, C.J. (2020a). Cococo: AI-Steering Tools for Music Novices Co-Creating with Generative Models. In *IUI'20 Workshops, March 17, 2020, Cagliari, Italy* (pp. 1–6). ACM, New York, NY, USA.

Louie, R., Cohen, A., Huang, C.Z., Terry, M., & Cai, C.J. (2020b). Novice-AI Music Co-Creation via AI-Steering Tools for Deep Generative Models. In *Proceedings of the 2020 CHI Conference on Human Factors in Computing Systems* (pp. 1–13). Association for Computing Machinery, New York, NY, USA. https://doi.org/10.1145/3313831.3376739

Lovelace, A.A. (1843). Notes by August Ada Lovelace. *Taylor's Scientific Memoirs, III,* pp. 666–731.

Lubart, T. (2005). How Can Computers Be Partners in the Creative Process: Classification and Commentary on the Special Issue. *International Journal of Human-Computer Studies, 63* (4), 365–369. https://www.sciencedirect.com/science/article/pii/S1071581905000418

Lupker, J.A.T. (2021). Score-Transformer: A Deep Learning Aid for Music Composition. In *Proceedings of New Instruments for Musical Expression.* https://nime.pubpub.org/pub/7a6ij1ak

Lyu, Z., Li, J., & Wang, B. (2021, nov). AIive: Interactive Visualization and Sonification of Neural Networks in Virtual Reality. In *2021 IEEE International Conference on Artificial Intelligence and Virtual Reality (AIVR).* IEEE.

Malsattar, N., Kihara, T., & Giaccardi, E. (2019). Designing and Prototyping from the Perspective of AI in the Wild. In *Proceedings of the Designing Interactive Systems Conference (DIS '19),* June 23–28, San Diego, CA, USA. http://doi.org/10.1145/3322276.3322351

Manco, I., Benetos, E., Quinton, E., & Fazekas, G. (2021). Muscaps: Generating Captions for Music Audio. In *International Joint Conference on Neural Networks (IJCNN)* (pp. 1–8). IEEE.

McCormack, J., Gifford, T., Hutchings, P., Llano Rodriguez, M.T., Yee-King, M., & d'Inverno, M. (2019). In a Silent Way: Communication between AI and Improvising Musicians Beyond Sound. In *Proceedings of the 2019 CHI Conference on Human Factors in Computing Systems* (pp. 1–11). Association for Computing Machinery, New York, NY, USA. https://doi.org/10.1145/3290605.3300268

Morabito, R., Armitage, J., & Magnusson, T. (2022). *Ritualistic Approach to Sonic Interaction Design: A Poetic Framework for Participatory Sonification.* Georgia Institute of Technology. https://doi.org/10.21785/icad2022.018

Morreale, F., & McPherson, A. (2017). Design for Longevity: Ongoing Use of Instruments from NIME 2010-14. In *Proceedings of New Instruments for Musical Expression,* May 15–19, 2017, Aalborg University Copenhagen, Denmark (pp. 192–197).

Murray-Browne, T., & Tigas, P. (2021a). Emergent Interfaces: Vague, Complex, Bespoke and Embodied Interaction between Humans and Computers. *Applied Sciences, 11* (18). https://www.mdpi.com/2076-3417/11/18/8531

Murray-Browne, T., & Tigas, P. (2021b). Latent Mappings: Generating Open-Ended Expressive Mappings Using Variational Autoencoders. In *Proceedings of New Instruments for Musical Expression.* https://nime.pubpub.org/pub/latent-mappings

Nimkulrat, N. (2020). Translational Craft: Handmade and Gestural Knowledge in Analogue–Digital Material Practice. *Craft Research, 11* (2), 237–260.

Noel-Hirst, A., & Bryan-Kinns, N. (2023). An Autoethnographic Exploration of XAI in Algorithmic Composition. In *Explainable AI for the Arts Workshop at ACM Creativity and Cognition 2023.* https://xaixarts.github.io/accepted-2023/Noel-Hirst-XAIxArts-2023-Paper.pdf

Nyrup, R., & Robinson, D. (2022, February). Explanatory Pragmatism: A Context-Sensitive Framework for Explainable Medical AI. *Ethics and Information Technology, 24* (1), p. 13.

OpenAI. (2022). *ChatGPT.* https://chat.openai.com/

Pachet, F. (2003). The Continuator: Musical Interaction with Style. *Journal of New Music Research, 32* (3), 333–341. https://www.tandfonline.com/action/journalInformation? journalCode=nnmr20

Papetti, S., & Saitis, C. (2018). *Musical Haptics.* Springer Nature, Cham.

Pati, A., & Lerch, A. (2019). Latent Space Regularization for Explicit Control of Musical Attributes. In *ICML Workshop on Machine Learning for Music Discovery Workshop* (ML4MD), Extended Abstract, Long Beach, CA, USA.

Pati, A., & Lerch, A. (2021). Attribute-Based Regularization of Latent Spaces for Variational Auto-Encoders. *Neural Computing & Application, 33*, pp. 4429–4444. https://doi.org/ 10.1007/s00521-020-05270-2

Payne, C. (2019). *Musenet.* https://openai.com/blog/musenet/

Pelinski, T., Shepardson, V., Symons, S., Caspe, F., Temprano, A., Armitage, J., & McPherson, A. (2022, June 28). Embedded AI for NIME: Challenges and Opportunities. In *Proceedings of New Instruments for Musical Expression (NIME).*

Pessoa, J., & Deloumeaux, L. (2009). *The 2009 UNESCO Framework for Cultural Statistics (FCS).* United Nations Educational, Scientific and Cultural Organization.

Proctor, R., & Martin, C.P. (2020). A Laptop Ensemble Performance System using Recurrent Neural Networks. In *Proceedings of New Interfaces for Musical Expression.*

Quellec, G., Al Hajj, H., Lamard, M., Conze, P., Massin, P., & Cochener, B. (2021). ExplAIn: Explanatory Artificial Intelligence for Diabetic Retinopathy Diagnosis. *Medical Image Analysis, 72*(102118). https://doi.org/10.1016/j.media.2021.102118

Rau, S., Heyen, F., Wagner, S., & Sedlmair, M. (2022, December). Visualization for AI-assisted Composing. In *Proceedings of the 23rd International Society for Music Information Retrieval Conference* (pp. 151–159). ISMIR, Bengaluru, India. https://doi.org/10.5281/ zenodo.7316618

Reed, C.N., & McPherson, A.P. (2023). The Body as Sound: Unpacking Vocal Embodiment through Auditory Biofeedback. In *Proceedings of the Seventeenth International Conference on Tangible, Embedded, and Embodied Interaction.* Association for Computing Machinery, New York, NY, USA. https://doi.org/10.1145/3569009.3572738

Roberts, A., Engel, J., Mann, Y., Gillick, J., Kayacik, C., Nørly, S., Dinculescu, M., Radebaugh, C., & Eck, D. (2019). Magenta Studio: Augmenting Creativity with Deep Learning in Ableton Live. In *Proceedings of the International Workshop on Musical Metacreation (MUME).* https://research.google/pubs/pub48280/

Sajja, S., Aggarwal, N., Mukherjee, S., Manglik, K., Dwivedi, S., & Raykar, V. (2021). Explainable AI based Interventions for Pre-Season Decision Making in Fashion Retail. In *8th ACM IKDD CODS and 26th COMAD* (pp. 281–289).

Sanchez, T., Caramiaux, B., Thiel, P., & Mackay, W.E. (2022). Deep Learning Uncertainty in Machine Teaching. In *IUI 2022 - 27th Annual Conference on Intelligent User Interfaces* (pp. 173–190). https://doi.org/10.1145/3490099.3511117

Sarmento, P., Kumar, A., Chen, Y.-H., Carr, C., Zukowski, Z., & Barthet, M. (2023). Gtr-ctrl: Instrument and Genre Conditioning for Guitar-focused Music Generation with Transformers. In C. Johnson, N. Rodríguez-Fernández, & S.M. Rebelo (Eds.), *Artificial Intelligence in Music, Sound, Art and Design* (pp. 260–275). Springer Nature Switzerland, Cham.

Schneider, F., Jin, Z., & Schölkopf, B. (2023). Mouˆsai: Text-to-music Generation with Long-context Latent Diffusion. arXiv preprint arXiv:2301.11757.

Shen, Y., Jiang, S., Chen, Y., Yang, E., Jin, X., Fan, Y., & Campbell, K.D. (2020). To Explain or Not to Explain: A Study on the Necessity of Explanations for Autonomous Vehicles. *arXiv preprint arXiv:2006.11684.*

Shneiderman, B. (2022). *Human-Centred AI*. Oxford University Press, London.
Shneiderman, B., Fischer, G., Czerwinski, M., Resnick, M., Myers, B., Candy, L., Edmonds, E., Eisenberg, M., Giaccardi, E., Hewett, T., Jennings, P., Kules, B., Nakakoji, K., Nunamaker, J., Pausch, R., Selker, T., Sylvan, E., & Terry, M. (2006). Creativity Support Tools: Report from a U.S. National Science Foundation Sponsored Workshop. *International Journal of Human-Computer Interaction, 20* (2), 61–77. https://doi.org/10.1207/s15327590ijhc2002_1
Steinbeck, P. (2022). George Lewis, Voyager. In *Sound Experiments: The Music of the AACM* (pp. 109–120). University of Chicago Press, Chicago. https://doi.org/10.7208/chicago/9780226820439-007
Sturm, B. (2022). Generative AI Helps One Express Things for Which They May Not Have Expressions (Yet). In *Workshop on Generative AI and HCI at the CHI Conference on Human Factors in Computing Systems 2022*.
Sturm, B.L., & Ben-Tal, O. (2017, September). Taking the Models Back to Music Practice: Evaluating Generative Transcription Models Built using Deep Learning. *Journal of Creative Music Systems, 2* (1). https://doi.org/10.5920/jcms.2017.09
Sturm, B.L., Ben-Tal, O., Monaghan, Ú., Collins, N., Herremans, D., Chew, E., Deruty, E., & Pachet, F. (2019). Machine Learning Research that Matters for Music Creation: A Case Study. *Journal of New Music Research, 48* (1), 36–55.
Sturm, B.L., Santos, J.F., Ben-Tal, O., & Korshunova, I. (2016). Music Transcription Modelling and Composition Using Deep Learning. arXiv, abs/1604.08723.
Sturm, B.L., Santos, J.F., & Korshunova, I. (2015). Folk Music Style Modelling by Recurrent Neural Networks with Long Short Term Memory Units. *Extended Abstracts for the Late-Breaking Demo Session of the 16th International Society for Music Information Retrieval Conference*.
Suh, M.M., Youngblom, E., Terry, M., & Cai, C.J. (2021). AI as Social Glue: Uncovering the Roles of Deep Generative AI During Social Music Composition. In *Proceedings of the 2021 CHI Conference on Human Factors in Computing Systems*. Association for Computing Machinery, New York, NY, USA. https://doi.org/10.1145/3411764.3445219
Tan, H.H., & Herremans, D. (2020). *Music FaderNets: Controllable Music Generation Based On High-Level Features via Low-Level Feature Modelling*. arXiv preprint arXiv:2007.15474.
Thelle, N.J.W., & Pasquier, P. (2021). Spire Muse: A Virtual Musical Partner for Creative Brainstorming. In *Proceedings of New Instruments for Musical Expression*. https://nime.pubpub.org/pub/wcj8sjee
Toussaint, G.T. (2002). A Mathematical Analysis of African, Brazilian, and Cuban Clave Rhythms. In *Bridges: Mathematical Connections in Art, Music, and Science Conference* (pp. 157–168). Townson University, USA.
Vigliensoni, G., McCallum, L., & Fiebrink, R. (2020). Creating Latent Spaces for Modern Music Genre Rhythms Using Minimal Training Data. In *International Conference on Computational Creativity (ICCC)*. https://research.gold.ac.uk/id/eprint/29044/
Wakkary, R. (2021). *Things We Could Design: For More Than Human-Centered Worlds*, K. Friedman & E. Stolterman (Eds.). MIT Press, Cambridge, MA.
Wallis, I., Ingalls, T., Campana, E., & Vuong, C. (2013). Amateur Musicians, Long-term Engagement, and HCI. In *Music and Human-Computer Interaction* (pp. 49–66). Springer.
Wang, H. (2023). Diffuseroll: Multi-track Multi-Category Music Generation Based on Diffusion Model. arXiv preprint arXiv:2303.07794.
Weger, M., Hermann, T., & Höldrich, R. (2018). Plausible Auditory Augmentation of Physical Interaction. In *Proceedings of the 24th International Conference on Auditory Display*. Sonification as ADSR.
Weger, M., Hermann, T., & Höldrich, R. (2022). AltAR/Table: A Platform for Plausible Auditory Augmentation. In *Proceedings of the 27th International Conference on Auditory Display*.

Whorley, R., & Laney, R. (2020). Generating Subjects for Pieces in the Style of Bach's Two-part Inventions. In B. Sturm & A. Elmsley (Eds.), *The 2020 Joint Conference on AI Music Creativity*. http://oro.open.ac.uk/72735/

Xambó, A. (2022). Virtual Agents in Live Coding: A Review of Past, Present and Future Directions. *e-Contact!*, *21* (1). arXiv preprint arXiv:2106.14835.

Zhang, Y., Xia, G., Levy, M., & Dixon, S. (2021). COSMIC: A Conversational Interface for Human-AI Music Co-Creation. In *Proceedings of New Instruments for Musical Expression*. https://nime.pubpub.org/pub/in6wsc9t/release/1

Zhu, J., Liapis, A., Risi, S., Bidarra, R., & Youngblood, G.M. (2018). Explainable AI for Designers: A Human-Centered Perspective on Mixed-Initiative Co-Creation. In *IEEE Conference on Computational Intelligence and Games, CIG, 2018-August*.

Zukowski, Z., & Carr, C. (2018). Generating Black Metal and Math Rock: Beyond Bach, Beethoven, and Beatles. arXiv preprint arXiv:1811.06639.

2 AI-Enabled Robotic Theaters for Chinese Folk Art

Haipeng Mi
Tsinghua University, Beijing, China

Yuan Yao
Beijing Jiaotong University, Beijing, China

Zhihao Yao, Qirui Sun, Hanxuan Li,
Mingyue Gao, Beituo Liu, and Yao Lu
Tsinghua University, Beijing, China

2.1 INTRODUCTION: BACKGROUND AND MOTIVATIONS

Robotic theater represents both an ancient and emerging art form. Centuries ago, people explored ways to achieve automated theater performances using hydraulic drives and mechanical transmission methods.

With the rapid development of digital and robotic technology, the growth of robotic theater has been greatly accelerated. Ranging from professional opera house-level robotic theaters to desktop-level miniature stages, these various automated performance forms have vast application prospects in education, entertainment, museums, cultural tourism, amusement parks, and other scenarios.

Combining robotic theater with folk art is a compelling subject. On one hand, the rich folk-art culture from different regions brings new expressive forms and styles to robotic performances, propelling the development of robotic theater while also presenting new technical challenges. On the other hand, automated performance technology opens new possibilities for the popularization, preservation, and innovation of niche folk arts, especially those recognized as intangible cultural heritage.

Traditional robotic theater, despite the extensive use of automation technology, still primarily relies on conventional creation methods, where directors, playwrights, composers, choreographers, and other professionals collaborate to complete the work. However, with the advancement of Artificial Intelligence technology, AI is gradually taking part in the creative process of robotic theater, playing an increasingly significant role.

DOI: 10.1201/9781003406273-2

This chapter will focus on the forms of Chinese folk art and explore the questions surrounding how AI technology can be incorporated into the creation tasks of robotic theater.

2.2 ROBOTIC THEATERS

The history of automated theater can be traced back thousands of years. In ancient China, a compendium called the *Shai Shih t'u Ching*, or "Book of Hydraulic Excellencies" written during the Sui Dynasty (around the 7th century AD), described various methods for creating hydraulically actuated mechanical toys (Vitaliev, 2009). These mechanical toys, all carved from wood, were controlled by hydraulics. The figures within the toys were depicted in boats, on mountains, on islands, on rocks, and in palaces. The wooden figures were approximately two feet tall, dressed in silk clothing, adorned with gold hairpins, jade, and other ornaments. Additionally, various birds, beasts, insects, and fish were placed on them, all capable of movement, appearing lifelike, and operating with the flow of water (Li, 1923).

In Europe, a similar hydraulic-driven puppet theater can be seen in Austria's Hellbrunn Palace, built over four hundred years ago. It features 260 townspeople miniatures. One-hundred and eleven of them are moving automata, each approximately six inches tall. The scene recreates the daily lives in a small town, including key figures such as aristocrats, soldiers, and craftsmen such as bakers, brewers, potters, masons, and traveling entertainers. Accompanied by hydraulic organ music playing the artisan's song from Daniel Auber's opera, everything was driven solely by mechanical and spring water power (Reilly, 2011).

These hydraulically actuated automated theaters can be considered as the precursors to modern robotic theaters. In the 21st century, with the rapid development of computer and robotic technology, modern robotic theaters have further developed by integrating contemporary film and performing arts with engineering technology and modern aesthetics. An example is "The American Adventure" located in Epcot at Walt Disney World in Bay Lake, Florida. It is an audio-animatronic stage show where key moments in American history are portrayed through the seamless appearance and disappearance of giant computer-controlled movable devices and robotic actors (Houston & Meamber, 2011).

In academia, researchers have conducted extensive studies on robotic theater. These studies have demonstrated the potential to combine robotic theater with unique performance forms, such as manzai robots (Hayashi et al., 2006), talk show robots (Vilk & Fitter, 2020), etc. Research on children's theater robots (Barnes et al., 2017) has also fostered development in areas like innovative edutainment for children. In terms of commercialization, successful examples have emerged around the world. Examples include robot performances at Japan's National Museum of Emerging Science and Innovation (Shea, 2015), robot theaters in American Disney resorts (Houston & Meamber, 2011), and various cultural museums in China where robotic theater applications have appeared, achieving positive social and economic benefits.

2.3 BLENDING ROBOTIC THEATERS WITH CHINESE FOLK ART

Chinese traditional folk art plays an essential role in Chinese history and culture, constituting a vital part of Chinese cultural heritage and passed down through generations. Represented primarily by traditional theatrical and narrative arts, Chinese folk performance art boasts a long history and rich, diverse forms of expression. Traditional folk performance art often employs symbolic means of expression, conveying specific aesthetics and emotions through particular movements, music, costumes, and other elements. However, Chinese traditional folk performance art faces serious challenges today, such as audience attrition, difficulties in heritage transmission, and the staleness of content, among others. The integration of folk performance art with robotic theater offers new possibilities for addressing these challenges, providing a creative solution.

In this section, we explore three different practices of integrating Chinese traditional performance art with robotic theater, experimenting with combinations of robotic theater with Chinese orchestra, historical stage dramas, and *Xiàngshēng* (crosstalk). The practical cases in this section also demonstrate that combining robotic theater with Chinese traditional performance art has borne entirely new forms of performance, creating a unique performance style and artistic effect. These innovations offer audiences a novel artistic experience, broaden the range of performance formats, and promote the inheritance and innovation of traditional folk culture.

2.3.1 CHINESE ORCHESTRA

Chinese orchestra is a musical performance that fuses Chinese traditional folk instruments with Western symphonic forms, with the core being various traditional Chinese folk instruments. Examples such as the bamboo flute, erhu, yangqin, and guzheng have long histories and unique musical styles. We have attempted to combine Chinese ethnic music with robotic performance, creating a robotic orchestra called "Moja". This orchestra consists of three robotic musicians (see Figure 2.1), Yaoguang, Kaiyang, and Yuheng, playing traditional Chinese folk instruments such as Chinese harp, paigu (set drums), and bamboo flute (Li et al. 2019). Moja's music performances are very popular (see Figure 2.2).

Globally, there are some well-known robotic bands, such as Japan's Z-Machines (Marynowsky et al., 2016) and Germany's Compressorhead (Davies & Crosby, 2016), which mainly play rock or electronic music and align well with their robotic metal punk aesthetic. However, when constructing the "Moja" robotic orchestra, we paid particular attention to cultural elements. The style of Chinese folk music did not mesh with the typical heavy metal style of robotic imagery. Therefore, designing robotic musician figures that fit the Chinese folk music style was one of the earliest challenges we faced. Figure 2.3 shows the illustrations of the conceptual design of robot figures, expressing the effort we made to align the style of music and robotic musicians.

The robotic musicians in this orchestra utilize a combination of pneumatic and electric actuations, achieving preliminary capabilities in blowing, striking, and plucking instruments. Through a central control system, they can coordinate ensemble

FIGURE 2.1 Three robotic musicians of Moja (from left to right): Kaiyang, Yuheng, Yaoguang.

FIGURE 2.2 Photo of robot musicians.

performances. Different robots mimic human body movements during performance through actions such as turning, bending, and hand movements. In the performance design, we also integrated projection fusion to enhance the visual appeal of the performance.

Another interesting adoption is a museum theater located in Confucius Museum, Shandong province, China. The bamboo flute player Yuheng plays an ancient music *You Lan Cao* (Poem of the Orchid) with virtual Confucius together (see Figure 2.4). The imaginary Confucius is projected on a giant transparent screen, and the physical robot musician Yuheng as his student play music together on the stage.

FIGURE 2.3 Illustrations of robot musicians.

FIGURE 2.4 Scene of the theater in Confucius Museum.

The robotic orchestra participated in several performances from 2019 to 2022 and received relatively positive feedback. Many audience members also offered suggestions for improvement, such as how to make the robots' performance more emotional and how to make their body movements more expressive. These responses have posed new topics for future research in robotic orchestras.

2.3.2 CHINESE HISTORICAL THEATER

Historical theater is a dramatic performance themed around historical events, characters, or backgrounds. Reenacting and interpreting historical incidents, characters'

FIGURE 2.5 Scene of the theater in Luoyang Ying Tian Gate Museum.

personalities, and historical details on stage aims to help the audience better understand and appreciate the cultural connotations and values of history, provoking thought and exploration of historical and humanity issues.

In 2020, we created a robotic historical theater titled "Ying Tian Chang Ge" (Song of the Heavenly Gate) for the Ying Tian Gate Museum in Luoyang (see Figure 2.5), a city that was once the capital of China's Tang Dynasty. The drama, combined with Chinese Tang Dynasty history, tells a fictional story of an ancient craftsman building large mechanical puppets as a tribute to the royal family. The robot performance seeks to reflect the prosperous atmosphere of Luoyang and construct a grand narrative. This drama synthesizes robot performance with local Luoyang music elements and rap music acts in vernacular; the stage and art design emphasize the application of traditional auspicious cultural and artistic elements from the Sui and Tang Dynasties. Through the robot performance, it exhibits the magnificence of Luoyang's zenith, while the localized music elements imbue the drama with robust local characteristics.

The utilization of traditional Sui and Tang dynasty auspicious elements renders the entire stage design vivid and historically informed. One could posit that this drama integrally amalgamates high technology, traditional culture, and contemporary performance elements to constitute a unique artistic style, which warrants further investigation into how it accomplishes the effect of historical imagination, cultural inheritance, and innovation.

The performance included six robots and three human actors working in conjunction, encompassing both musical performance and dramatic acting, forming an interactive plot. Compared to the Moja robotic orchestra, this show's dialogue, actions, and plot twists were more complex and variable. The robots' action presets used entirely new choreography, adding more emotive and interactive body movements to enhance their stage expressiveness.

The design of the robot characters in this performance emphasizes the rich artistic style of the Chinese Tang Dynasty. For instance, the 3-meter tall "Drum God" robot

FIGURE 2.6 The "Drum God" robot (designing concept & mock-up).

(see Figure 2.6), modeled after Tang Dynasty figures like Vajra and the Thousand-Hand Guanyin, blends Tang Dynasty Buddhist and craft art styles. Capable of playing nine instruments independently, it can replace a small band. The design of the Drum God combines classical and modern elements, serving as both a continuation and transcendence of Tang Dynasty culture, creating a comprehensive effect.

Two "Lantern God" robots (see Figure 2.7) performed narration in a style akin to comic dialogue, using lantern imagery as their primary visual language, symbolizing Chinese classical architecture. Standing still, they seem like observers of historical changes. Besides verbal performance, they also possessed more expressive facial features and intricate body movements.

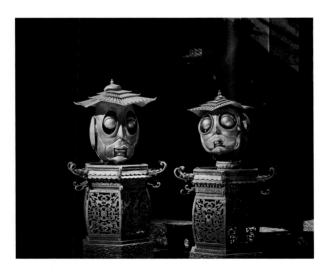

FIGURE 2.7 The "Lantern God" robots.

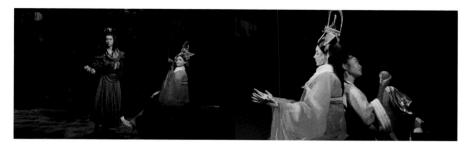

FIGURE 2.8 Scene of the theater in Luoyang Ying Tian Gate Museum.

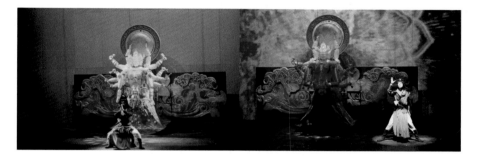

FIGURE 2.9 Actor and "Drum God" robot.

To create a sense of "time travel" and "immersion" typical of historical stage dramas, the stage was equipped with various multimedia devices and specialized visual design. The set, mainly utilizing circular displays, showcased historical content like landscapes, seasons, buildings, and events, enveloping the entire stage to form a majestic visual effect (see Figures 2.8 and 2.9).

For this large and complex robotic theater, we developed new creative tools – a simulation choreography system based on 3D modeling software – that significantly improved the efficiency and stability of designing robots' facial and body dynamics. We also found that the robotic performance design process still needs more effective management, especially when dealing with diverse future stage elements, complex scheduling, and personnel with varying professional backgrounds, such as robotic designers and stage artists.

2.3.3 XIÀNGSHĒNG THEATER

Xiàngshēng, also known as crosstalk, is a form of Chinese folk performance art that mainly relies on verbal comedy, complemented by performance and singing, and has been listed as intangible cultural heritage. It shares similarities with Western stand-up comedy and Japanese "manzai" comedy, yet possesses unique Chinese cultural characteristics.

In 2023, we created a robotic Xiàngshēng theater called "Teahouse Spring Tune" for the China Grand Canal Intangible Cultural Heritage Museum. This work aspired

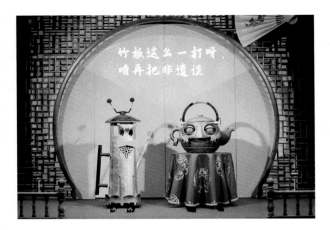

FIGURE 2.10 Robotic xiàngshēng theater of "Teahouse Spring Tune".

to exhibit the synthesis of traditional crosstalk art and modern technology, constituting a novel artistic form. It not only perpetuates the abundant and captivating linguistic art of traditional crosstalk, but also assimilates elements of modern technology into it, infusing renewed vitality into the traditional art. Through the robot's performance, the work principally concentrates on narration, with singing incorporated into it, demonstrating the coexistence of China's Grand Canal and intangible cultural heritage, the civilization and integration of the north and the south. The robot characters in this theater were not designed as androids; instead, they drew inspiration from teapot images commonly found in teahouses, a usual venue for crosstalk performances. Two anthropomorphized iron and copper teapots became the "wisecracker" and the "straight man" in the crosstalk performance (see Figure 2.10). Each robot had over ten degrees of freedom, including movable eyes, eyelids, eyebrows, mouth, cheeks, hat (teapot lid), and arms (spout), providing a solid foundation for rich facial expressions (see Figure 2.11).

As an audio-animatronics performance, we invited professional crosstalk performers to provide voiceovers, and the robots' expressions and movements were carefully choreographed. Particularly for some unique crosstalk performing techniques, we tried distinctive robotic movement choreography, using repetition, contrast, exaggeration, and other methods to highlight the characteristics of crosstalk performance.

After deploying this robotic theater in the museum, we conducted a preliminary user study. Many audiences expressed appreciation for this unique art form and showed curiosity and interest in how traditional crosstalk art was fused with modern technology (see Figure 2.12).

The combination of traditional crosstalk with state-of-the-art robotics in "Teahouse Spring Tune" offers a fascinating example of how technology can be used to preserve and innovate cultural heritage. It may inspire future explorations in employing robotics in various forms of traditional arts, keeping them alive and relevant for contemporary audiences.

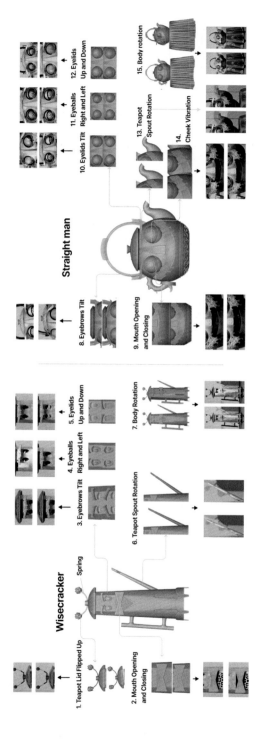

FIGURE 2.11 Illustrations of robot actors.

FIGURE 2.12 Scene of the theater in Grand Canal Museum.

2.4 CREATION AND IMPLEMENTATION

In the three cases of robotic theater discussed in Section 2.3, the artistic forms, performance styles, and theater scales vary. Addressing the diversified design needs of robotic theater and summarizing a more general design method and implementation process is a significant question we continuously explore in practice.

2.4.1 CREATION WORKFLOW

We generally extracted five key steps from the creation workflow. Table 2.1 shows how these steps can provide guidance to creators for the three robotic theaters.

2.4.1.1 Defining the Theme

Defining the cultural theme is an essential part of the creation process for robotic theater. The term "cultural theme" typically refers to the cultural concepts, values, social themes, or other elements reflecting specific cultures that a script wants to express or explore. For example, the historical stage drama "Song of The Heavenly Gate" embodies the grandeur of the Tang Dynasty, and Disney's "American Adventure" represents significant events in American history. In Shandong's Confucius Museum, the robotic theater "You Lan Cao" (poem of orchid) conveys themes of apprenticeship and respect for teachers. The theme of the crosstalk robotic theater "Teahouse Spring Tune" is about the intangible cultural heritage along the Grand Canal in China. In robotic theater creation, defining the cultural theme is an overarching key step that will guide script creation, influence character molding, and even determine robotic movements and stage settings and also affect a series of subsequent design behaviors.

TABLE 2.1

Key Steps in the Robotic Theatre Creation Workflow

Theatre Name	Poem of the Orchid	Song of the Heavenly Gate	Teahouse Spring Tune
Theatre location	Confucius Museum, Qufu, Shandong Province	Yingtian Gate Museum, Luoyang, Henan Province	Grand Canal ICH Museum, Cangzhou, Hebei Province
Style of folk art	Bamboo flute	Chinese orchestra	Crosstalk (xiàngshēng)
Theme definition	Apprenticeship and respect for teachers	The grandeur of the Tang Dynasty	The regional ICH along with the Grand Canal of China
Performance design	Solo play with animation	Historical stage drama	Teahouse comedic dialogue and singing
Character design	Ancient wood-carving puppet style knight-errant	Realistic style, some are inspired by vajra, lanterns, etc.	Cartoon-style, teapot-like imaginary characters.
Motion design	Slowly, adapting the mood and showing respect	Complex, expressing interactions between human and robots	Happily, rich and exaggerated facial expression
Motion matching	motion computation, motor compliance control, timecode control, multi-robot coordination, and synchronization, etc.		

2.4.1.2 Overall Performance Design

After defining the cultural theme, overall performance design includes determining the direction of script creation and coordinating scene, lighting, sound, and multimedia systems to choose the appropriate specific form of performance. For instance, historical theaters like "Song of The Heavenly Gate" and "American Adventure" often employ sound and light effects to narrate history through robotic performances, offering the audience a visually stunning experience. In the robotic theater "You Lan Cao" (poem of orchid), there is a dialogue between robot actors and ancient sages, so we choose to use screens to display some virtual images, combine virtual and real, produce a large amount of digital visual content, and create a different visual experience. For crosstalk performances like "Teahouse Spring Tune", a small stage with speech-centered robotic performance is used to provide a leisurely and relaxing experience.

2.4.1.3 Character Design

In robotic theater, character design is a complex process that considers various factors. This involves clarifying the role's position and personality traits in the script. Appearance, including color, shape, size, and any special visual features, should match the role and consider the actual production and operation requirements. If the robot needs to speak or make sounds, sound design becomes crucial. For example, "Song of The Heavenly Gate" and "American Adventure" follow principles of restoration and realism in character design, while "Teahouse Spring Tune" replaced humanoid actors with cartoon-style characters, enhancing audience engagement and enjoyment (see Figure 2.13).

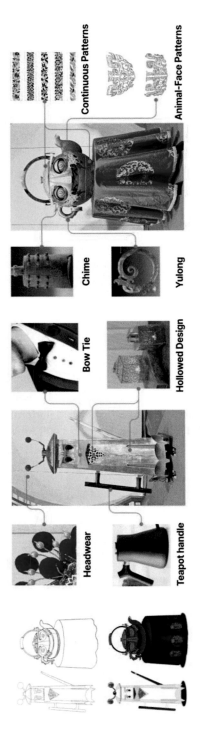

FIGURE 2.13 Artistic settings of robots.

The cardinal objective in designing a robot character is to create a vivid character that possesses personality and accords with the plot. Whether the character occupies a protagonist or supporting role, they necessitate meticulous design to augment the audience's viewing experience. Moreover, it is imperative that the character design of robots aligns with contemporary aesthetics. In robot stage dramas, conceptualizing robot characters should transcend the stereotypes of traditional robots. The design considerations for the image of robot actors should be unconstrained and diverse, such as eschewing obsession with "human-like." Finally, the design of robot characters should satisfy or surpass audience expectations, accounting for their suitability for a broad audience. Disparate performance environments attract different audiences. The design of robot actors should consider the suitability for all ages and accord with the cultural milieu of a specific space.

2.4.1.4 Motion Design

Generally, after the performance script is finalized, professional actors will be invited to perform the script, and dynamic capture or facial expression capture technology will be utilized to document the actors' performance. Subsequently, the obtained data is processed digitally, and the performance of the professional actors is employed as a reference point for the robot performance. Different robots possess various capabilities and constraints, necessitating selection of robots capable of undertaking the role. This may entail considering the robot's physical abilities such as movement speed, flexibility, and the capacity to execute required gestures and expressions.

For instance, in "Teahouse Spring Tune", the two teapot robots essentially depict two comedians; therefore, their action design frequently configures rapid servo operation to achieve expansive movements to exhibit their spirited and energetic characteristics. Conversely, a classical Chinese folk music robot orchestra necessitates more subtle movements in its design, in pursuit of a tranquil and elegant aesthetic. Moreover, due to limitations in motor servo rotation angle, structural appearance, and stage parameters, the action design of the robot actor must fully account for physical constraints.

2.4.1.5 Motion Matching

In the domain of robotics, the process of fashioning intricate robotic motions typically initiates with the development of a digital twin model. This virtual representation accurately reflects the real-world robot, and its creation constitutes a vital step in the trajectory toward attaining fluid and precise movements. Subsequently, the digital twin model functions as the blueprint for translating electronic audio animations into physical actions executed by the robot.

The translation of these animations into real-world kinematics is unequivocally the most technically elaborate facet of the entire process. This critical stage necessitates the assimilation and employment of an array of state-of-the-art technologies within the field of robotics. These encompass motion computation, motor compliance control, timecode management, multi-robot coordination, and synchronization, among others.

Motion computation plays a pivotal role in ensuring the robot's movements are not solely accurate but also graceful, accounting for factors including velocity, acceleration, and path planning. Conversely, motor compliance control focuses on

regulating the robot's motors to enable smooth and harmonious motions, safeguarding against abrupt or jerky actions that could be detrimental to the robot or its surroundings.

Timecode management is indispensable for orchestrating the precise timing of actions, enabling the robot to execute tasks with flawless timing. Moreover, the intricacies of coordinating multiple robots operating in concert require advanced multi-robot coordination techniques to circumvent conflicts and optimize efficiency. Synchronization techniques guarantee that discrete components of the robot system collaborate seamlessly, obviating issues arising from discordant actions or data.

Therefore, the passage from a digital twin model to the actualization of fluid and precise robotic motions constitutes a multidimensional process that capitalizes on a broad spectrum of technological innovations, culminating in the artful and technically demanding execution of robotic tasks.

In summary, the creation of robotic theater is an exciting and challenging endeavor, requiring meticulous attention to every detail. From global control of cultural themes to fine-tuning movement expressiveness, each aspect is vitally important and interconnected. The described workflow represents a methodical approach that integrates cultural considerations, overall design, character creation, and motion design, highlighting the potential of robotic theater to offer unique perspectives and provoke thought and discussion on various themes from specific cultural angles.

2.4.2 TECHNICAL FRAMEWORK

2.4.2.1 Overview of the Technical Framework

The creation and performance system of robotic theater generally consists of several parts, including the robot actor system, the creation and choreography system, and the stage performance system. The robot actor system is the core of robotic theater and is made up of one or more robot actors. The creation and choreography system typically builds a digital model of the robot actors and the theater, virtually arranging and synthesizing performance content to enhance creative efficiency and facilitate continuous modification and adjustment. The stage performance system includes various auxiliary performance devices, such as multimedia and lighting, to achieve high-quality performance (see Figure 2.14).

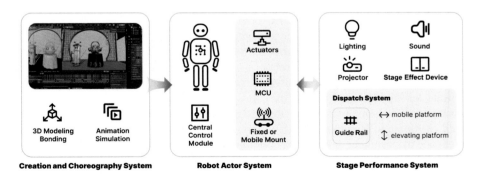

FIGURE 2.14 Technical framework overview.

2.4.2.2 Robot Actor System

The robot actor system primarily consists of one or more robot actors, in addition to necessary control systems. Robot actors are generally autonomous devices with multiple degrees of freedom that can participate in performances according to predetermined action scripts. In common robotic theaters, most robots do not possess the ability to move autonomously but perform and are positioned through fixed locations or mobile mounts. Some robot actors utilize open-loop control and can be classified under the category of animatronics. Others may have sensing abilities and autonomous control capabilities, even the ability to interact. In multi-robot performance systems, a central control module is usually required to align timelines and coordinate the activities of multiple robots. In the context of multi-robot performance systems, it is typically imperative to employ a central control module. This module plays a pivotal role in synchronizing timelines and effectively managing the collaborative activities of multiple robots, ensuring a seamless and well-coordinated performance.

2.4.2.3 Creation and Choreography System

The creation and choreography system typically relies on 3D modeling and simulation software to build digital models of the robot actors and the theater, embedding physical constraints such as motor motion range and movement speed. Through methods like keyframe animation, more natural and fluent expressions and limb movements can be constructed. Furthermore, specific algorithms are required to transform the action sequences in the software into control data sequences for the robot's various actuators. More advanced creation and choreography systems may also support real-time monitoring of robotic theater, offering enhanced oversight and management by providing live feedback on the robot's bodily posture status.

2.4.2.4 Stage Performance System

The stage performance system resembles typical stage systems, encompassing lighting, sound, multimedia, and other peripheral systems. What distinguishes the robot stage performance system are the additional elements involved in the robot's dispatch system, such as guide rails, mobile platforms, elevating platforms, automatic doors, and more. To realize a fully automated performance process, the stage performance system often necessitates unified scheduling and management of all stage devices. This is typically done through professional performance scheduling software that coordinates and controls each subsystem.

To actualize a fully automated performance process, the stage performance system typically requires a harmonized approach to the scheduling and management of all stage devices. This synchronization is achieved through the utilization of specialized performance scheduling software designed to oversee and control each subsystem. This professional software acts as the orchestrator, ensuring that all elements of the performance, both human-operated and automated, come together cohesively to create a seamless and captivating stage production. The utilization of this software guarantees that the intricate dance of technology and artistry unfolds flawlessly, offering a unique and mesmerizing experience for the audience.

2.4.3 INTEGRATION AND DEPLOYMENT

2.4.3.1 Venue, Space, and Infrastructure

The robot theater as a unique automated system has specific deployment requirements. For folk art robotic theaters, it is often necessary to place them within museums and to consider the overall stage deployment at an early stage of museum construction. When deploying the stage in an already completed museum, there are many restrictions concerning robot dispatching, device control, and overall integration. Furthermore, addressing the infrastructure needs of the robot theater is of paramount importance. This entails careful consideration of power supply provisions, wiring requirements, network connectivity, and other technical aspects that underpin the functioning of the automated theater system. A well-thought-out deployment strategy and early attention to these aspects are pivotal in ensuring the successful integration and operation of the robot theater within the museum environment.

2.4.3.2 Theater Integration

Theater integration requires the overall integration of the robot actor system and other stage performance devices. This process requires a great deal of meticulous work to optimize the whole performance. During the process, if the director needs to adjust and modify the performance flow, this may cause the originally planned performance script to be updated. Therefore, more convenient on-site rapid debugging tools are essential.

2.4.3.3 Performance Control

Performance control generally falls into two categories: fully automatic performance processes and manned performance processes. Fully automatic performance processes are often found in museums' permanent exhibition projects, where the complete integration of the entire performance process is required to achieve a fully automated show. Taking the robotic crosstalk theater "Teahouse Spring Tune" as an example, this performance is required to be scheduled to play twice daily for the audience, with one show in the morning and another in the afternoon. In such a scenario, it is crucial to ensure the stability of the robotic performance. This entails establishing a precise timeline within the robot's central control system and integrating it with the central control system of the museum. This connection allows for human intervention when necessary and facilitates routine maintenance. Manned performance processes are common in large-scale theatrical performances, where professional on-site directors supervise and control the performance flow. In these situations, a robust on-site director's support tool is also needed for various adjustments, tests, preparations, and official performance.

2.4.3.4 Safety and Robustness

Safety is a crucial consideration in robotic theaters. On one hand, it is necessary to ensure the safety of the audience, taking into account aspects such as safe distances between the audience and the robots. On the other hand, the safety of the robot actors must also be considered, with adequate provision for any accidental situations that could potentially harm the robot actors.

Robustness is especially vital for long-term performance projects. It should be achieved through system design optimization, extensive testing, and the inclusion of design redundancies, all aimed at enhancing the overall robustness of the system to support the goal of long-term performances.

2.5 ADOPTING AI TECHNOLOGY IN ROBOTIC THEATER CREATION

2.5.1 OVERVIEW OF AI-ASSISTED CONTENT AUTHORING

Robot theater involves multiple facets, such as robots, stage, music, and scripts, and AI has demonstrated potential in these areas. In the realm of music production, AI has shown aptitude for composing scores and producing novel melodies and harmonies. For robotic performances, AI-generated music could be customized and tailored to the dramatic arcs and emotions portrayed on stage. Regarding visual elements, AI animation techniques allow rapid synthesis of lip and facial movements synchronized to voice recordings. This enables efficient animation of robots' mouths and faces as they deliver lines. Finally, motion planning algorithms can choreograph complex robotic motions and transitions, making it feasible to enact dynamic stage blocking and display. By combining these AI capabilities, there is immense potential to streamline and enhance the creative processes underpinning robotic theater. The interplay between AI and robotics ushers in new horizons for augmented automated productions. This section discusses AI's capabilities in music production, lip synchronization, motion facial animation, and how these capabilities can be integrated into robotic theater creation workflow.

2.5.1.1 Music Composition

AI can use deep learning technologies to compose music by analyzing and learning from vast amounts of musical data and then creating new musical pieces (Hernandez-Olivan & Beltrán, 2022). Furthermore, based on MIDI files, it can even generate the required motion data for robots, automating the robots' performance portion.

2.5.1.2 Lip Sync Processing

AI is able to understand and recognize elements in speech, such as pauses and changes in intonation, and thus break continuous speech flow automatically into individual sentences or phrases (Gaikwad et al., 2010). This step ensures that subsequent processing is more accurate and efficient. Further, AI analyzes phonemes, intonation, and intensity in speech, training deep learning models to learn human lip shapes when uttering specific phonemes. This model is then applied to robots to generate corresponding lip shapes when the robot speaks.

2.5.1.3 Motion Capture

AI can recognize the movement and changes of facial feature points, thereby understanding and identifying expressions (Bagherian & Rahmat, 2008). For motion recognition, models learn to comprehend the relative positions and movements of various body parts, thus recognizing specific actions. Subsequently, the model's output is mapped to the robot, tailored to the different robotic motion structures.

2.5.2 Music Composing

In the creation of robotic orchestra, AI composition is an important assistive technology. Taking Moja robotic orchestra as an example, robot players play traditional Chinese instruments such as bamboo flutes, Chinese harp, and set drums. In this process, AI composition technology plays a vital role.

2.5.2.1 MIDI Translation and Optimization

Robots need to be able to receive and interpret MIDI files. This is usually achieved by transmitting MIDI information to hardware or software that can parse it. These systems enable robots to perform according to the instructions in the MIDI files. Optimization by AI, specific to the characteristics of robots, ensures the high fidelity and rationality of the musical performance.

2.5.2.2 Real-Time Composition

Real-time composition through AI can enhance robotic orchestration, enabling a dynamic and personalized approach to musical performance. This technology can adapt the music according to mood, tempo, or audience interaction, enhancing the immersive experience. AI-driven real-time composition allows robotic orchestras to respond to audience cues, creating unique and interactive musical experiences. Traditional instruments can be integrated seamlessly, and AI can interpret their unique characteristics to craft blended compositions.

2.5.2.3 Integrated Performance

AI-generated MIDI files can be preloaded into the performance system of the robotic theater, enabling the robot to prepare the correct sheet music. These files can also be generated in real time during the performance. When an audience or other actors give commands or signals, the robots can play accordingly, performing the corresponding music from the MIDI files. AI composition can also form an orchestra with human musicians. The combination of AI-generated music and human musicians' performance can create a richer and more diverse musical experience, expanding the boundaries of musical performance.

2.5.3 Lip Synchronization

In robotic theater, the synchronization of robots' speech reflects to a certain extent the overall theatrical effect. This section discusses the application of AI in robotic speech lip synchronization, automatic sentence breaking, and intelligent speech feedback.

2.5.3.1 AI-Driven Robot Lip Synchronization

AI's application in speech-driven robotic lip synchronization involves converting speech content into realistic lip movements. This technology has extensive applications in areas like animation, virtual avatars, and video games, but in the field of robots, it requires adjustments and adaptations based on the robot's mouth's freedom of movement. This application enables the robot character's mouth to synchronize with the actual spoken content, achieving real-time speech and mouth movement

synchronization, making the robot character's performance more lively and realistic. In this process, Text-to-Speech (TTS) technology is mainly used; AI converts the expected output text into lip movement data, thereby driving synchronization between the robot's speech and lip movements.

2.5.3.2 Sentence Breaking in Robotic Speech

The authenticity and naturalness of robot speech feedback in robotic theater are also influenced by sentence-breaking rhythm. Natural breaks according to semantics and emotional changes further enhance robot performance. AI's application in speech sentence breaking involves two parts: speech recognition and semantic understanding. Speech recognition is the process of converting human speech into text, where AI helps achieve automated transcription efficiently and quickly. Semantic understanding analyzes human speech content, understands its meaning, and then processes it using natural language processing to better interact with humans in robotic interaction.

2.5.3.3 Intelligent Speech Feedback in Improvised Performances

In some improvised performances in robotic theater, the application of intelligent speech feedback is vital. This application is relatively common in areas like intelligent voice assistants. AI needs to possess dialogue management ability, understand users' intentions and context, and respond accordingly to voice commands.

In summary, the application of AI in lip synchronization, speech sentence breaking, and intelligent speech feedback involves the integration of various technologies, including speech recognition, text-to-speech synthesis, natural language understanding, and dialogue management. These technologies collectively promote continuous progress and widespread application of AI in speech-related fields, influencing the expressiveness of robotic actors in robotic theater.

2.5.4 Motion and Facial Capture in Robotic Theater Creation

In creating robotic theater, AI-enabled motion and facial capture technologies offer transformative potential, enabling robots to perform with lifelike expressions and fluidity. This section delves into the multifaceted processes involved in achieving these dynamic performances.

2.5.4.1 Facial Capture

Utilizing high-resolution cameras or depth sensors, subtle facial expressions are recorded, capturing the nuanced emotions that bring characters to life.

2.5.4.2 Motion Capture

By employing a dedicated motion capture system, the intricate movements of various body parts are tracked, forming the foundation for realistic physical performance.

2.5.4.3 Deep Learning Model Training

Comprehensive data collected from the capture processes undergo meticulous analysis through deep learning algorithms. These algorithms are designed to recognize

complex facial expressions and body motions, tailoring the models to replicate humanlike expressions and movements.

2.5.4.4 Data Mapping

Known as data-driven animation, the trained models act as a bridge, translating captured human expressions and movements to robotic animation models. This process enhances the robots' naturalism and believability. Specialized facial animation models might be employed to simulate human facial muscle movements, while body movements might be represented through an animation model featuring adjustable joints and motion ranges.

2.5.4.5 Animation Generation

Post data mapping, the robotic animation models transform the captured expressions and motions into corresponding animations. These can be orchestrated in real-time performances or be part of pre-constructed animation segments, providing flexibility in presentation.

2.5.4.6 Robot Driving

The final stage involves a seamless transition from animation generation to the mechanical activation of the robots. Here, AI's role is paramount, handling intricate tasks such as parsing animations, driving hardware, and adjusting feedback, all while maintaining efficiency and precision.

In summary, the integration of motion and facial capture in robotic theater represents a remarkable fusion of art and technology. By merging traditional theatrical expression with cutting-edge AI and robotics, this approach pushes the boundaries of what is achievable on stage.

2.6 DISCUSSION

2.6.1 Challenges and Opportunities

The integration of robotic performance with artificial intelligence is an emerging cross-design research area facing numerous challenges – for example, how to efficiently enrich the diversity and variability of robotic performances under AI integration and enhance real-time interaction between robots and audiences.

Traditional robotic performances usually follow pre-programmed scripts for operation and behavior, but achieving diversity and variability requires robots to make real-time judgments and adjustments according to different situations. This raises higher requirements for the intelligence level of robots and algorithm design.

Whether on stage or in other scenarios, audiences express the need to interact with robots (Rodriguez et al., 2018). To realize real-time communication and feedback between robots and humans, challenges like voice recognition, natural language processing, behavior recognition, emotion recognition, and suitable interaction interface and methods must be overcome. However, few researchers have systematically studied this in the field of robotic performing arts.

Additionally, deployment cost is a consideration. Robotic performances require certain hardware facilities, such as the appearance of robots, sensors, motion control,

etc., and related software support. These investments can bring costs, especially in large-scale applications, but by involving AI in the design process management, efforts can be made to reduce costs and improve the efficiency of robotic performance design.

Nevertheless, the design research combining robotic performance with artificial intelligence also brings many opportunities, especially in broad cultural market scenarios such as cultural art museums, intangible cultural heritage exhibition halls, cultural theme parks, and cultural tourism. On the one hand, from a humanistic perspective, robots can enact historical stories, play the role of traditional skill inheritors, or present information to audiences in more vivid and engaging ways, enhancing entertainment and participation, allowing audiences to better understand and experience the value of artifacts and culture, and promoting the preservation and inheritance of traditional culture. On the other hand, from a stage performance perspective, robotic performances can achieve surreal stage effects and highly precise motion control that traditional human performances cannot achieve, offering richer, more thrilling multisensory experiences to the audience.

2.6.2 AI-ARTIST COLLABORATION

AI and artist collaboration have entered the practice of robot theater creation and are playing an increasingly important role. As described in Section 2.5, during several Chinese folk art robot theater creation times listed in this chapter, AI has participated in robot theater creation through involvement in composition and lip sync matching, as well as facial expression and motion capture. It can be anticipated that in more diverse robot theater creations, AI will collaborate with artists in additional ways, including but not limited to script creation, image generation, visual art material generation, and robot motion generation.

Looking ahead, AI could aid scriptwriting by analyzing tropes and narrative arcs to generate plot outlines. For visual elements, AI image and video generation models could rapidly synthesize costumes, props, backdrops, and other stage elements customized to a production's aesthetic. Music composition algorithms could build unique soundtracks attuned to the emotional tenor of scenes. And natural language models could craft dialogue and narration imbued with literary flair. Throughout the creative process, there would be ample opportunities for artists to guide the AI, incorporating human ingenuity to surpass what either could achieve alone. With the democratization of AI, such collaborative robot theater could become a versatile storytelling medium accessible to wider audiences.

2.6.3 AI-ENABLED REAL-TIME INTERACTION

The implementation of AI in real-time theater interaction is a complex process, requiring natural language understanding, response generation, text-to-speech (TTS), synchronization of lip movement and facial expressions, and robot control. Simultaneously, it needs to handle numerous concurrent tasks, including understanding language, generating responses, converting speech, syncing lip movement and facial expressions, and driving the robot. Moreover, to achieve true real-time interaction, AI must complete all these tasks in a very short time.

2.6.3.1 Language Understanding

First, AI must understand voice or text input from the audience. In this stage, AI may use speech recognition technology (if the input is in voice) to convert speech into text, then use natural language understanding (NLU) technology to understand the meaning of the text.

2.6.3.2 Generating Responses

After understanding the input, AI needs to generate an appropriate response. This process typically involves large language models. These models can generate suitable and natural text responses based on input and context.

2.6.3.3 Text-to-Speech (TTS)

After generating a text response, AI needs to use text-to-speech (TTS) technology to convert the text into speech. This process must ensure that the generated speech is clear and understandable and has natural intonation and rhythm.

2.6.3.4 Synchronizing Lip Movements and Expressions

While generating speech, AI must simultaneously generate corresponding lip movements and facial expressions. This usually requires a pre-trained deep learning model that can predict lip movements and expressions based on the generated speech and then map them to the robot's facial animation.

2.6.3.5 Driving the Robot

Finally, AI must send the generated speech, lip movements, and expressions, along with possible other movements (such as gestures or body movements), to the robot. Then the robot will perform these movements using hardware devices such as motors and servo drives.

2.6.4 From AI-Enabled to AI-Participated

AI has gone beyond merely being a creative tool, gradually integrating into the entire process of robot theater creation. We begin to see it as an active participant rather than just a passive tool. AI's role has become an important part of robot theater creation, participating in script creation, music composition, character design, and more.

During the creative process, AI can generate entirely new creative materials by learning and analyzing a vast amount of scripts, music, and dance movements. For example, AI can autonomously draft new scripts by studying historical ones, compose new musical pieces by analyzing samples, design new dance movements, or adjust theater performance in real time based on audience reactions. These AI-generated creative materials can be used as references for artists or directly incorporated into actual theater performances.

AI's innovative power not only lies in creating new materials but also in transforming the way of creative thinking. AI's participation enables artists to view creation from new perspectives, discovering unprecedented artistic expressions and pioneering new theater art forms.

Reimagining AI's role in artistic creation opens more possibilities and allows us to understand and utilize AI's potential from a different angle. It also brings new challenges, such as how to balance AI's autonomy with an artist's creative intent, how to evaluate AI-generated artwork, and how to manage and guide AI's creative process.

2.7 CONCLUDING REMARKS

Robotic theater, as a unique art form that seamlessly blends art with technology, has already proven its value in fields like theme parks, museums, and cultural tourism. The integration of folk art with robotic theater further broadens the spectrum of its expressions, while also introducing novel dissemination methods for folk arts that require preservation and continuation. However, the creation and realization of such a synthesis present numerous challenges.

A primary challenge is balancing innovation with faithfulness to folk art traditions, requiring extensive collaboration between technologists and folk artists. There are also technical hurdles in adapting intricate traditional art forms for robotic actuators. Moreover, costs of robotic platforms remain high, limiting widespread adoption. Yet the cultural value of preserving folk heritage through cutting-edge productions outweighs these difficulties. Advancing robotic theater to showcase humanity's diverse artistic legacies remains an endeavor worth pursuing.

This chapter delves into the issues related to the fusion of robotic theater with Chinese folk arts, emphasizing the role of AI technologies in the artistic creation process. In this chapter, we first enumerate and analyze three robotic theater design instances rooted in diverse styles of Chinese folk arts. These case studies aid in summarizing the general workflow and technical methodologies employed in robotic theater creation. Subsequently, we offer a detailed insight into how we incorporated AI technologies within certain phases of the creative practice. Finally, we prognosticate on how AI might play an even more integral role in future scenarios of robotic theater creation and performances.

The principal contributions of this chapter lie in its case study analyses on the integration of traditional Chinese folk arts into the robotic theater's artistic endeavors. By encapsulating general design methodologies and processes, and discussing the potential roles and further advancements of AI in this domain, we aspire to furnish valuable references for future endeavors in robotic theater creation and practices tied to varying styles of folk arts.

REFERENCES

Bagherian, E., & Rahmat, R. W. O. K. (2008). Facial feature Extraction for Face Recognition: A Review. In *2008 International Symposium on Information Technology*.

Barnes, J., FakhrHosseini, M., Vasey, E., Duford, Z., Ryan, J., & Jeon, M. (2017). Child-Robot Theater. In *Proceedings of the Companion of the 2017 ACM/IEEE International Conference on Human-Robot Interaction*.

Davies, A., & Crosby, A. (2016). Compressorhead: The Robot Band and Its Transmedia Storyworld. In *Cultural Robotics: First International Workshop, CR 2015, Held as Part of IEEE RO-MAN 2015, Kobe, Japan, August 31, 2015. Revised Selected Papers 1* (pp. 175–189). Springer International Publishing.

Gaikwad, S., Gawali, B., & Yannawar, P. (2010). A review on speech recognition technique. *International Journal of Computer Applications*, 10(3), 16–24.

Hayashi, K., Kanda, T., Miyashita, T., Ishiguro, H., & Hagita, N. (2006). Robot Manzai - Robots' Conversation as a Passive Social Medium. In *5th IEEE-RAS International Conference on Humanoid Robots, 2005*.

Hernandez-Olivan, C., & Beltrán, J. R. (2022). Music Composition with Deep Learning: A Review. In *Advances in Speech and Music Technology: Computational Aspects and Applications* (pp. 25–50).

Houston, H. R., & Meamber, L. A. (2011). Consuming the "World": Reflexivity, Aesthetics, and Authenticity at Disney World's EPCOT Center. *Consumption Markets & Culture*, 14(2), 177–191.

Li, Fang. (1923). Shai Shih t'u Ching. In *Taiping Guangji 500 Volume*, Vol. 226 (in Chinese).

Li, J., Hu, T., Zhang, S., & Mi, H. (2019). Designing a Musical Robot for Chinese Bamboo Flute Performance. In *Proceedings of the Seventh International Symposium of Chinese CHI*.

Marynowsky, W., Knowles, J., & Frost, A. (2016). Robot Opera: A Gesamtkunstwerk for the 21st century. In *Cultural Robotics: First International Workshop, CR 2015, Held as Part of IEEE RO-MAN 2015, Kobe, Japan, August 31, 2015. Revised Selected Papers 1* (pp. 143–158). Springer International Publishing.

Reilly, K. (2011). From Aristocrats to Autocrats: The Elite as Automata. In *Automata and Mimesis on the Stage of Theatre History* (pp. 73–110). London: Palgrave Macmillan UK.

Rodriguez, I., Astigarraga, A., Lazkano, E., Martínez-Otzeta, J. M., & Mendialdua, I. (2018). Robots on stage: A cognitive framework for socially interacting robots. *Biologically Inspired Cognitive Architectures*, 25, 17–25.

Shea, M. (2015). Karakuri: Subtle trickery in device art and robotics demonstrations at Miraikan. *Leonardo*, 48(1), 40–47.

Vilk, J., & Fitter, N. T. (2020). Comedians in Cafes Getting Data. In *Proceedings of the 2020 ACM/IEEE International Conference on Human-Robot Interaction*.

Vitaliev, V. (2009). Spontaneous toys. *Engineering & Technology*, 4(15), 86–87.

3 AIBO
Or How to Make a 'Sicko' Brainwave Opera

Ellen Pearlman
Fulbright Poland/University of Warsaw, Warszawa, Poland
RISEBA University, Riga, Latvia
NYU Tandon School of Engineering, New York, USA

3.1 OVERVIEW: AN AI BRAINWAVE OPERA

OpenAI created the algorithm GPT-2 (now GPT-4, soon to be GPT-5) in February 2019. The algorithm creates imitations of human dialogue producing synthetic but increasingly realistic linguistic interactions and results with each new release. I began using GPT-2 in March 2019, just one month after its initial release, until February 2020 when I premiered an emotionally intelligent artificial intelligence brainwave opera with a customized 'sicko' AI character running as a live time virtual entity in the Google cloud. The entity "AIBO" (Artificial Intelligence Brainwave Opera) used 47 purposely overfitted texts sourced from the late 1800s to the 1940s as data to build its 'sicko' personality within a historical time frame. What overfitted means will be discussed later in this chapter. AIBO was one of two characters in the interactive immersive performance taking place inside a black box theater that contained no seating, so the audience was free to interact or not interact with the environment. The other character was a human female performer "Eva" who wore a brain computer interface attached to a smart textile bodysuit of light.

The two characters' interaction and relationship were the focus and pendulum of the emotionally intelligent artificial intelligent brainwave opera. The performer's brainwaves triggered her smart textile bodysuit of light, displaying at various moments her four emotional states of excitement, interest, meditation, and frustration. The emotional states arose either separately as only one emotion or together as a few emotions since humans rarely experience just one emotion sequentially. However, it was not humanly possible to express both meditation and frustration simultaneously, at least for this specific performer. The smoothing algorithm of the EEG headset only allowed these four emotions to be measured. At the same time, these emotional states triggered four emotionally themed videos and four sonic environments, meaning if the performer felt frustrated, the videos that were triggered displayed frustrated or angry images, and the sounds were rough or discordant.

DOI: 10.1201/9781003406273-3

These videos and sonic environments coordinated with whatever emotional state(s) was most prominent and on display, and often more than one emotion was registering.

The character AIBO responded live time to Eva's spoken world libretto from the Google cloud, and its synthetic answers were then analyzed in the Google cloud using natural language processing for the answer's sentiment analysis. AIBO's sentiment analysis, which were the synthetic emotions of a synthetic being, changed the colors of the walls of the black box performance space to reflect the different colors of positive (green), negative (red), or neutral (yellow) as shown in Figure 3.1. The AI then went one step further and tried but failed to emulate the previous emotionally themed memory Eva had experienced and projected as a video. AIBO's emulation or imitation of the emotion was always displayed as a glitchy video.

The emulation failed and the video was glitchy because the AI's emotion was created from electronic digital zeros and ones. It did not know or understand or care about creating real emotions, only the simulations or empty parodies of those emotions. The opera fundamentally asked two rhetorical questions – "Can an AI be fascist?" and "Can an AI have epigenetic or inherited traumatic memory?" – meaning could AIBO or an AI be fascist, and could an AI remember embedded traumatic memories that were not verbal? In this case, Germany's troubled past in WWII would be the trigger for Eva's traumatic memories, inherited from her parents. This chapter discusses the steps involved in building the GPT-2 cloud-based character AIBO and its synthetic emotions in a performative spoken word opera.

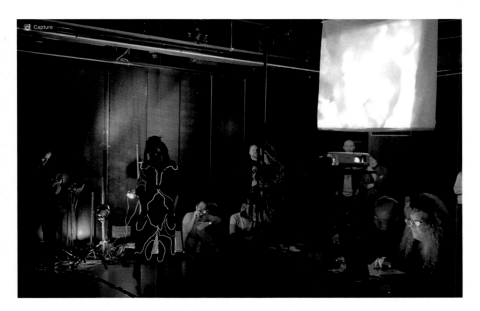

FIGURE 3.1 AIBO lights up the background green for positive as Eva's bodysuit of light displays her emotions, and one of her four emotions displays on an overhead screen (Courtesy of Taavet Jansen).

3.2 INTRODUCTION

In 1964 Joseph Weizenbaum developed the first AI chat character at the MIT AI Lab [1]. He named the program "Eliza" after the fictional theatrical character Eliza Doolittle from George Bernard's 1913 play *Pygmalion*, thereby situating AI as a type of interactive performing theater within the construction of the origins of first AI chatbot. Eliza was also developed to be psychologically empathetic, so much so that people began typing out their problems to 'her' fully aware that 'she' was mere computer code [2]. Weizenbaum used the psychological techniques of human-centered or Rogerian therapy developed by Carl Rogers around 1940 during WWII to make Eliza easily accessible. This technological interactive process heralded the dawn of the age of AI. It is odd to think that such an advanced technology sprung from the ancient myth of Pygmalion [3]. The male gaze and male desire were projected onto an inanimate object (or mathematical code) and shaped into a compliant female by its creator. This is the same thing that happened in Ovid's *Metamorphoses* (transformations) written approximately 8 CE. The myth depicts the Cypriot bachelor Pygmalion as a sculptor who sculpts an ivory statue of his ideal woman. Falling in love with his fantasy statue often referred to as Galatea, he kisses and caresses her, dresses her up, and brings her inert form to bed with him, surrounding them both in lush purple sheets. Pygmalion prays to Venus, the goddess of love during Venus's annual festival, imploring her to bring his magnificent creation to life; in the myth she grants his wish. This situates the reworked computer bot Eliza (Galatea) AI, theater, human computer interaction, and the origins of an empathetic fembot character (the female ivory sculpture) squarely in the crosshairs of Western mythology, male longing, and male domination. Just like the bashful and compliant Galatea, Eliza was created to be psychologically sympathetic though she was nothing more than mathematical computer code.

The use of a chatbot character in interactive performative AI is not new, but the use of a GPT-2 AI in a new media brainwave opera is. AIBO takes a different tack speculating through character interplay, human biometrics, a sonic environment, audience interaction, complex visuals, and live time processing in the Google cloud how an AI might or might not cope with human non-quantifiable experiences such as twisted neurotic personalities and epigenetic or inherited traumatic memories.

In addition to constructing the cloud-based 'sicko' AIBO character, sentiment analysis on the GPT-2's answers is also provided. This is also a breakthrough development in a new media performance piece. Sentiment analysis analyzed the text responses generated by the AI and returned both their magnitude and score. Magnitude is the strength of the emotional impact statement, measured between 0.0 and +infinity. Score examines if the emotion is positive, negative, or neutral, and the numeric values range between -1.0 and +1 and are based on the Stanford Natural Language Processing Toolkit (NLPT) [4]. If I say, "I like you very much", the score returns a high positive result (like) with a strong magnitude (very). If I say "I do not like you", this returns a negative result (do not like) with a medium or sometime neutral (do not like you) magnitude score. This means the synthetic emotions of the synthetic cloud-based 'sicko' AIBO character were analyzed. This approach emphasizes how flawed the strictly numeric process of analyzing any type of authentic

emotion can be. The results of the sentiment analysis scoring were displayed as three different colors of light glowing inside the performance space – red for negative, green for positive, and yellow for neutral.

In addition to returning an answer and an emotional analysis of its answer, AIBO tried to emulate the human character Eva's previous emotional memory by playing a glitchy video. This meant that if AIBO's sentiment analysis of its last statement was negative, or red, it would go through Eva's visual memory bank and pull up Eva's previous frustrated video that was triggered by her authentic emotion of frustration. These emotional (visual) memories were stored in four separately curated databanks (interest, excitement, frustration, meditation) that triggered when the human performer playing Eva experienced a strong emotion. It was as if AIBO was saying, "I want to be human like you Eva. I want to have feelings and emotional visual memories". Because of that synthetic desire, the video AIBO displayed was purposely built to be glitchy because AIBO was completely incapable of emulating any real emotions. The implications of this synthetic emulation of synthetic emotions are profound, since AIs will be much more ubiquitous in the future attempting, and mostly failing or botching, the processing of human emotional nuances. AIs don't feel, they just follow prompt engineering cues of linguistic pattern matching currently processed through complex neural nets. In the future they will most likely process emotions through the newly developing field of vector space emotional recognition [5].

3.3 CREATING THE AI FOR THE OPERA

The opera depicted the human character Eva's love story based on true biographical events at the beginning of the 20th century leading up to and including WWII between a naïve young German woman, Eva von Braun, and her perverted, sadistic Austrian lover, Adolph Hitler. The human performer playing Eva wore an EEG wireless brain computer interface attached to a bodysuit of light displaying her four emotions of interest (purple), excitement (yellow), frustration (red), and meditation (green). These were the emotions the smoothing algorithms of the Emotiv headset depicted.

These emotions have between a 60% to 80% overall accuracy rate, and though not medical grade, they were certainly acceptable for an artistic performance [6]. Each emotion was triggered individually when it reached a certain pre-determined threshold that had been designated through extensive rehearsals with the performer, since each person has their own unique set of emotional valances. When Eva's emotions were triggered, they also launched corresponding databanks of video and audio, but the aspect of video and sonic composition is not the primary focus of this chapter, though it will be referenced when relevant.

Eva performed a spoken word but randomly generated libretto, taken from the actual biography of Eva von Braun. The GPT-2 built cloud character "AIBO" responded to her libretto in real time as shown in Figure 3.2. The potential libretto of 342 sentences was converted to text and simultaneously projected onto an overhead screen so the audience could follow along, a typical scenario used in foreign

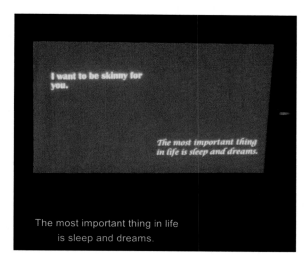

FIGURE 3.2 Overhead screen displaying live time Eva's libretto upper left, AIBO's response lower right, and on the bottom the text to speech interpretation the audience hears (Courtesy of Ellen Pearlman).

language operas. Eva's speech, displayed as text, was sent to the Google cloud. AIBO returned a unique text answer that was then projected onto the same screen as Eva's statement. The text answer from AIBO was also converted from text to synthesized speech in real time so the audience could hear, as well as read along with it. The text/speech response from AIBO was analyzed in the Google cloud for emotional sentiment using the NLP, as mentioned previously. Once analyzed, the three emotional sentiment values triggered different colored lights suffusing areas of the black box performance space: green for positive, red for negative, and yellow for a neutral emotional sentiment. A glitchy video of Eva's last emotionally themed memory showed on a flat screen monitor on the floor surrounded by the glowing lights suffusing the black box space. The complex routing of these processes referencing the lighting is depicted in the technical diagram of Figure 3.3, and the glitchy image in Figure 3.4. Further technical diagrams of the setup, audio, costume, video, libretto and bot are referenced in Figures 3.5–3.9, with an additional tech rider referenced in Figure 3.10.

When OpenAI released GPT-2 in February 2019, it worked by predicting the next word of a text if given all the words that came before it. It was a huge step in augmenting large datasets for Natural Language Processing [7, 8]. GPT-2 (and subsequent releases) make use of deep learning or neural nets, exponentially more complex than simple algorithmic processing, and it is beyond the scope of this chapter to discuss the form, structure, and version or topology of different neural net architectures. The GPT-2 language model was capable of using up to 1.5 billion parameters trained on a dataset of eight million web pages. GPT-4 (and soon GPT-5), not available when the opera AIBO was developed, have been updated to be even more robust and convincing. GPT-2 outperformed (at the time) state-of-the-art language

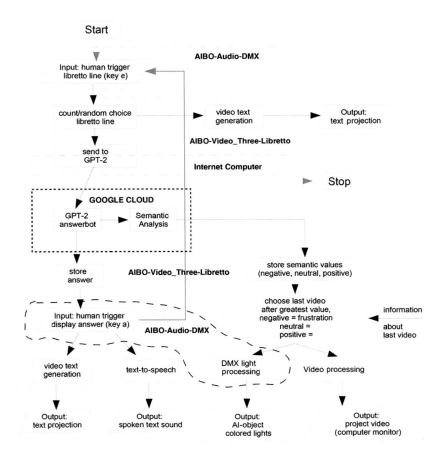

FIGURE 3.3 Technical diagram of the specific routing of DMX light in relation to GPT-2, Eva, the costume, and the performance (Courtesy of Hans Gunter Lock).

modeling scores known as "zero-shot" settings from any other known language models. It did this by using a probability distribution over sequences of words solving problems. This probability distribution is called an "n-gram", and it predicts the next word in a given sequence of words in a sentence.

OpenAI released several public versions of GPT-2: a lightweight 177 million parameter version; a mid-level 345 million parameter version; and a 1.2 billion parameter version. They stated the full 1.2 billion parameter version was too dangerous for the general public's use. Eventually, that version was cloned and became available through alternative means. The 345 million parameter version was the one chosen to seed AIBO's data using specially curated texts to create a 'sicko' AI. The texts included 47 copyright-free movie scripts and books whose time period spanned the late 19th century to the mid-1940s as depicted in Table 3.1. This time frame was chosen to create a sense of the historical characters the opera was based on. Texts included Dr. Jekyll and Mr. Hyde, Venus in Furs, Thus Spoke Zarathustra, Dracula,

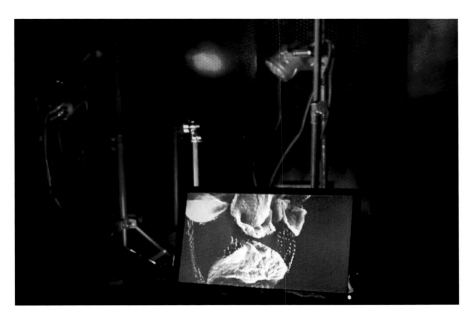

FIGURE 3.4 Glitchy image of AIBO trying to recreate Eva's previous memory. Background is red to correlate with frustrated memory (Courtesy of Ellen Pearlman).

Frankenstein, treatise on eugenics, masculinity, and the varieties of male sexual dysfunction. The modeling was purposely 'overfitted' to skewer the training data by giving it an overly constricted dataset, thus aiming for a psychologically unbalanced response. Eva's spoken word libretto consisting of 342 sentences was adapted from the biography of Eva Von Braun [9] depicted in Table 3.2 depicting her 14-year relationship with Adolph Hitler that resulted in their mutual suicide.

Experimenting with the temperature parameter within GPT-2's construction made it possible to adjust the sampling behavior of the provided texts, which in turn affected the types of responses generated for the live time opera. Temperature within GPT-2 is a float value that controls the randomness of answers. Lower temperature values result in less random results, and higher temperature values result in more random sentence completion. Below are sample dialogues between EVA (scripted) and AIBO (GPT-2 generated from the cloud). Each time the opera was performed, Eva's libretto remained consistent, but AIBO's response always varied. Below are four response patterns when the temperature was usually, but not always changed 0.5 percent. The default value in the modulating temperature is 1, and the floating point, if started at 0, uses the highest probability for a match. If the temperature is increased, then there is a lower probability of a predictive sentence and more randomness. There is no practical limit to the numbers that can be used in a temperature variable, but I found the variations in responses increased significantly within the integer ranges of 3–4. When the temperature was increased, it gave more weight to other words in the predictive model. These samples below were not used in the opera performances but are presented for illustrative purposes.

TABLE 3.1
List of Copyright Free Data Sources for AIBO

1940s Movies	Author	Year
Grapes of Wrath	Nunnally Johnson	1940
His Girl Friday	Charles Lederer	1940
Citizen Kane	Herman J. Mankiewicz, Orson Welles	1941
The Devil and Daniel Webster	Stephen Vincent Benét, Dan Totheroh	1941
Meet John Doe	Robert Riskin	1941
Casablanca	Julius Epstein, Philip Epstein, Howard Koch	1942
The Life and Death of Colonel Blimp	Michael Powell, Emeric Pressburger	1943
Double Indemnity	Billy Wilder, Raymond Chandler	1944
Isle of the Dead	Ardel Wray, Josef Mischel	1945
Story of GI Joe	Leopold Atlas, Guy Endore, Philip Stevenson	1945
A Tree Grows in Brooklyn	Tess Slesinger, Frank Davis	1945
Beauty and the Beast	Jean Cocteau	1946
A Foreign Affair	Charles Brackett, Billy Wilder, Richard L. Breen	1948
1930s Movies		
Son of Frankenstein	Willis Cooper	1939
Lost Horizon	Robert Riskin	1937
Vampyr	Christen Jul, Carl Theodor Dreyer	1932
Grand Hotel	William Drake	1932
1950s Movies		
Stalag 17	Billy Wilder, Edwin Blum	1953
Others		
Schindler's List	Steven Zaillian	1993
Gutenberg Books		
Strange Case of Dr Jekyll and Mr Hyde	Robert Louis Stevenson	1886
The Brothers Karamazov	Fyodor Dostoevsky	1879
Thus Spake Zarathustra	Friedrich Nietzsche/translated by Thomas Common	1883–1885
The Golden Wheel Dream-Book and Fortune-Teller	Felix Fontaine	1862
Frankenstein	Mary Shelley	1818
Dracula	Bram Stoker	1897
The Return of Tarzan	Edgar Rice Burroughs	1913
The Anti-Christ	Friedrich Nietzsche	1888/1895
The Monster Men	Edgar Rice Burroughs	1913
On War	Carl von Clausewitz	1832
Famous Modern Ghost Stories	Emily Dorothy Scarborough, Ed.	1921
Human, All Too Human	Friedrich Nietzsche	1878
Venus in Furs	Leopold Ritter von Sacher-Masoch	1870
Memories	Max Müller	1902
Falling in Love	Grant Allen	1889

(Continued)

TABLE 3.1 (CONTINUED)
List of Copyright Free Data Sources for AIBO

Beyond Good and Evil	Friedrich Nietzsche	1886
Applied Eugenics	Paul Popenoe, Roswell Hill Johnson	1918
Crime: Its Cause and Treatment	Clarence Darrow	1922
Studies in the Psychology of Sex, Volume 3: Analysis of the Sexual Impulse	Havelock Ellis	1927
Studies in the Psychology of Sex, Volume 4: Sexual Selection in Man	Havelock Ellis	1927
Studies in the Psychology of Sex, Volume 6: Sex in Relation to Society	Havelock Ellis	1927
Three Contributions to the Theory of Sex	Sigmund Freud	1930
The Journal of Abnormal Psychology Volume 10	Morton Prince, Ed.	1998
The Witch-Cult in Western Europe: A Study in Anthropology	Margaret Alice Murray	1921
Animal Castration	Alexandre Liautard	1902
The Criminal	Havelock Ellis	1890
Essays in War-Time – Further Studies in the Task of Social Hygiene	Havelock Ellis	1917

TABLE 3.2
List of Eva von Braun's Libretto Taken from Her Biography

CONTENT WARNING: Although pulled from a published biography of Eva von Braun, the subject matter in Table 3.2 concerns a romantic engagement many would consider to be sensitive or problematic (age difference, identity of the two individuals, personal sensibilities, mental health concerns, etc.)

I was given my first camera at age 13.
The photo store I worked in was only 20 minutes from my home.
I was a junior assistant in the studio and darkroom.
I typed, filled in invoices, and modeled in the photo studio.
My boss took photos of powerful men.
I went to a convent finishing school.
I hated the convent finishing school and left after one year.
The convent gave me a mandatory physical exam and determined I was a certified virgin.
I like the latest popular music, films, and to party, tease, and flirt.
You had a funny mustache, an English style overcoat and a big felt hat.
I sensed you were looking at my legs.
My skirt was short, and I was standing on a ladder.
You told me your name was Herr Wolf.
I was only seventeen and a half years old when I met you.
I dreamed of an artistic career as a photographer or in cinema.
I loved clothes and fashion and sports.
I want the world to admire me.
My boss was an early member of the new political party that promised to bring us to greatness.

(Continued)

TABLE 3.2 (CONTINUED)
List of Eva von Braun's Libretto Taken from Her Biography

You had blue eyes and a mesmerizing gaze.
You were well groomed, very clean, and smelled of soap.
I wanted you.
You did not want me so much.
You gave me tickets to a theater show.
I told everyone you were in love with me.
I told everyone I would marry you.
I wanted to get away from my father and my family.
Sentimentality and brutality are very common in German nursery stories.
I live through my senses and emotions.
Maybe I like controlling men.
Marriage is the greatest good I can achieve.

When we first met, you were 23 years older than I was.
You said there is nothing better than training a young girl who is as impressionable as a piece of wax.
You said it should be possible for a man to stamp his imprint upon me.
You were only ten years younger than my father.

I fell in love with you on first sight.
After our first meeting, I swore to follow you anywhere even unto death.
I live only for your love.

I only want to please you.

Your father was an illegitimate son.
Your father was a womanizer.
Your father drank and beat his wife.
Your father's first wife died.
Your father had a teenage mistress 24 years younger than him.
Your father already had a bastard son by his mistress.
Your father married his mistress after she was pregnant with his second child.
Your father's second wife died.
Your father's third wife was 23 years younger than him.
Your father married his mistress when she was already pregnant.
Your father's third wife was both his second cousin and his niece.
You were born when your mother was 29 and your father 52.
Your father beat you all the time.
One time your father hit you 32 times.
You resolved not to cry.
You were very attached to your mother.
You became a vegetarian.
You liked to listen to the operas of Wagner.
You wanted to be an artist.
You had an undescended testicle.
You believed sex was a primitive emotion.
You believe sex is necessary to create children, but shameful and must be suppressed.
You went to enter the art academy but failed the exam.
Your mother died when you were 18.
You carried your mother's photograph in your breast pocket all your life.
For four years you lived in working men's hotels without friends and you were penniless.
At age 30 you had no accomplishments.

(Continued)

TABLE 3.2 (CONTINUED)
List of Eva von Braun's Libretto Taken from Her Biography

A wife must defer to her husband.
I like film stars, movie magazines, and actresses and singers.
I love to go walking in the mountains.
I love to go skiing, sunbathing, swimming, trout fishing, and hike or skate.

You found you could speak to rooms of people and move them to wild applause and emotions.
You became Mr. Wolf.
You believed in a perfect race.
Your own body was flawed by an undescended testicle.
You fell in love with your niece.
You saw your niece daily but did not sleep with her for two years.
You were both sadistic and masochistic.

You did not care that much about me at first.
You loved your niece.
I kept hanging around.
I was the life of the party.
I pushed myself on you.
I wanted to make you love me.
I wanted to make you marry me.
I saw you with your niece.
Your niece fell in love with someone else.
You asked your niece to wait two years before accepting the engagement.
You said marriage would be a disaster for you.
You said it was better to attend to your duties and have a mistress off to the side.

I would not even accept taxi fare from you.
I would take no money from you.

Your niece hated you.
You controlled your niece.
Your niece wanted to kill you.
Instead your niece killed herself.
You were broken when your niece died.
You were grieving when your niece died.
You wanted to kill yourself when your niece died.
You locked yourself in your niece's rooms.
You did not eat when your niece died.
You had a loaded pistol on the table when your niece died.
You had your name cards edged in black when your niece died.

I kept you company.
You invited me to a cafe.
You invited me to the opera.
We finally became lovers.
I helped you recover from your grief.
My father could not stand you.
I moved into your house.
My parents were horrified when I moved in with you.
I wanted to kill myself because you neglected me.

(Continued)

TABLE 3.2 (CONTINUED)
List of Eva von Braun's Libretto Taken from Her Biography

You did not take me seriously.
You neglected me.
You had so many speaking engagements.
On Halloween you did not call me.
I tried to kill myself.
I took my father's gun and aimed it at my jugular.
I missed the vein in my neck with the gun.

I was found wounded and bleeding by my sister.
A doctor saved me from bleeding to death from my suicide attempt.

You heard about my suicide attempt and left your speaking engagements.
You came running to my bedside with a large bouquet of flowers.
You felt guilty.
You became more attentive and called me.
You stopped breaking your appointments with me.

I became your only mistress.
After four years I hoped to become your wife.
You became head of the political party.
I tried to keep you happy.
Inside I was depressed.
You would not let me talk about you to anyone.
I could only write in my diary about you.
You did not answer me.
I waited and waited.
I became desperate.
I swallowed 20 tablets of a sedative.
You realized you had to think of me more.

My father wanted to talk to you.
My father did not like my arrangement with you.
My father was worried about my reputation.
My father and you had an important conversation.
Because of speaking with my father you bought me a house.
Because of speaking with my father you gave me a monthly sum.
You told my father marriage was out of the question.
It was accepted I was your mistress.
I did not have to hide you from my family.
I never asked you probing questions.
You bought me clothes and shoes.
You insisted on a total blackout of my name.
You insisted on a total blackout of my face.
You insisted on a total blackout of my existence.
Almost no one knew about us.

I made movies.
We are happy.
I am always laughing.

(Continued)

TABLE 3.2 (CONTINUED)
List of Eva von Braun's Libretto Taken from Her Biography

Your friends always humiliated me.
I want you, not your position.
You are always thinking of politics.
Sometime you need to relax.
We are always surrounded by other people.
Sometimes you do not see me for three months.
Sometimes you say you love me so much.
You say sometimes you are madly in love with me.
Why do I have to go through all this?
If only I had never set eyes on you.
I am utterly miserable.
I will buy sleeping powder.
I will go into a dream so I don't have to think.
Why doesn't the devil take me with him?
If I died it would be so much better than it is here.

I live in a pampered, poisonous hothouse.
My life is empty.
Without you I am nothing, and no one.

You always comes home to me.
I make you relax.
What do I do all day long?
You treat me like your secretary.
Your colleagues hate me.
I am the head of your household.
The staff has to call me little boss.
I live in a golden cage.
You only see me every third or fourth week.
I change my clothes many times a day.
I gave my life to you, but I have lost it.

I want to be skinny for you.
I eat almost nothing, and you complain.
You want me to be fatter.
You work a few hours a day when you are home.
You are a vegetarian.
You love cream cakes.
We watch films together.
Sometimes we have a dinner party at the house.
You talk all the time.
I get bored and look at my watch so you will stop the party.

You are beginning to worry about me.
You ask me to drive slowly.
You ask me to ski carefully.
I once went to a political event with you.
I saw all the people cheer for you.

(Continued)

TABLE 3.2 (CONTINUED)
List of Eva von Braun's Libretto Taken from Her Biography

We spent the night in a hotel, but I had to sleep in a separate room.
It was a secret I was with you.

You want to just stroll down the street by yourself, unrecognized.
You want to go to the department store, and buy Christmas presents.
You want to sit in a cafe but cannot.
You are becoming dependent on me.
You have to clean the population of weak genes.
You will not let me read newspapers or listen to the radio.
I can know nothing.

There is a war, you never discuss it with me.
I know nothing.
I am kept in the dark, isolated, no radio or anything.
When you leave, you write to me.
When you come home you have to sneak into my room and out the back door.
You took me to Italy to see a parade.
I could not stand beside you.

You are too tired to have sex with me anymore.
Your responsibilities are too great.

You can no longer fulfill me as a man.
You want me to look for another man.
If I fall in love with a younger man, you would not stop me.

My sister got married.
We drank a lot of champagne and danced until three am.
I am still a mistress.
I am no one.

Am I a good woman?
Am I wicked?
I don't know what you do.
I ignore the signs, the rumors, and the sudden absences.
I don't care what goes on in the world.
I only care about you.
I know you made prison camps for criminals.
We never talk about Jews.
Everything is kept secret from me.
I have no idea what is going on.
I have nightmares you will die.
I am not a member of your political party.

(Continued)

TABLE 3.2 (CONTINUED)
List of Eva von Braun's Libretto Taken from Her Biography

You say you detest women who dabble in politics.
You say if women's dabbling extends to military matters, it becomes utterly unendurable.
You say women are equal only for procreation.
You say men are warriors, women make families.

I heard many Jews have been evacuated.
I heard the Jews are going to America.
I feel an indefinable feeling of unease, a nameless anxiety.
I asked you to help Jewish doctor friends of my parents.
I asked you to help a Jewish doctor my sister worked for get papers to leave.
Each time the country wins a battle, it is wonderful for you.
Any defeat is a malicious conspiracy against you.
We take long, lonely walks, and talk about the weather or dogs.
Sometimes you do not talk for four minutes and stare off into the distance.
You cannot sleep.
You are exhausted.

In the winter the tension is unbearable.
We talked about the progress of the war and ate until late into the night.
Many guests came, and I had to keep them happy.
You stay in bed more and more.
You developed a tumor in your left arm and leg.
You have become so old and severe.
You do not tell me why.

When you call you want to know I am safe.
You worry about me.
I worry about you.
I tell you I love you and miss you.
My cousin came to visit, and all the officers watched us.
I am very depressed.
I am unhappy and bored.
I change my clothes all the time.
There is nothing else to do.

Someone tried to kill you.
Your trousers were ripped to shreds.
You had a concussion, burns, and 100 splinters of oak in your right leg.
Your right arm was temporarily paralyzed.
Your eardrums were punctured.
You have some hearing loss.
You say you are invulnerable, and immortal.

(Continued)

TABLE 3.2 (CONTINUED)
List of Eva von Braun's Libretto Taken from Her Biography

There are many bombs.
After the assassination attempt you tell me don't worry.
You are tired and want to be home soon and relax in my arms.
You need to rest.
Your duty towards the German people must come first.
You sent me the uniform you were wearing on that unfortunate day.
Your hand still trembles from the attempt on your life.

I am desperate, miserable, unhappy.
I can't go on living if anything happens to you.
From the time of our first meeting I promised myself to follow you everywhere.
I promised to follow you in death.
My whole life is loving you.

You had an operation to remove a polyp on your vocal cords.
I stayed with you.
You could only whisper.

If the war is lost I will die with you.
I will not let you die alone.
I will be with you right up to the final moment.
For my 33rd birthday you gave me a diamond bracelet, and a topaz pendant.
I began to pack up my life and give away my dogs.
I said goodbye to friends and family and gave away my clothes and jewelry.

In the bunker I had hot water, electricity, and air conditioning.
You are eating all the time, mostly chocolate cake.
You are with your dog and her five puppies.
You cannot walk very well.
You are violent and irrational.
The doctor injects you with a stimulant, it could be morphine.
You talk of retiring.
The Russians are coming.
I hear distant fighting and air raids.
I am doing pistol practice with the secretaries.
It is your birthday you are 56.
We have a chance to get out, but you will stay.
I will stay with you.
We all drank champagne, sang, and laughed with incredible abandon.
It was like an orgy.
We all think of death.
I have lost faith in God.
You have lost faith in victory.
You told everyone to leave on a plane.
I said you know I am staying with you.
I won't let you send me away.
You finally kissed me in front of everyone.

(Continued)

TABLE 3.2 (CONTINUED)
List of Eva von Braun's Libretto Taken from Her Biography

You began to plan your suicide.
I decided to die with you.
You will shoot the dog.
Actually, your doctor poisoned your dog.
I had champagne and cake.
I was not afraid.
I am happy to be here with you.
You offered some people vials of poison.
I still change my clothes and do my nails.
All we talk about is death.
What is the fastest and least painful way to commit suicide?
You are like Dracula.
My sister is pregnant.
My sister's husband went to his mistress in town.
My sister's husband called me and told me to leave.
You had my sister's husband shot for desertion.
You called everyone who was left over and handed out potassium cyanide capsules like sweet candy.
You explained on how to break the fragile glass ampule between the teeth and swallow the poison
 quickly.
You think the best way to die is to shoot yourself through the mouth.
I want to die through a poison method.
I cannot shoot myself.

You finally decided to marry me.

You want to go to death with me as your wife, according to my desire.
We were married.
We are of pure Aryan descent and not affected by incurable diseases.
We drank champagne.
You drank tea.
You did not list your parents on the wedding certificate.
Everyone urged us to leave the bunker.
we would not.
I put on your favorite dress, the black one with the appliqué roses.
I did my hair.
We went to the small sitting room and closed the door.
We sat side by side on the sofa.
I snuggled up close to you.
I bit down upon the glass ampule.
My breathing quickened, then slowed, then stopped.
My head slumped sideways on your shoulder.

You put an ampule between your teeth.
You pointed the pistol into your mouth and fired.
The door opened, and it smelled like bitter almonds.

Version 1 – Temperature 1, Version 2.2

EVA – I was given my first camera at age 13.

AIBO – (to child) That's right there.

EVA – The photo store I worked in was only 20 minutes from my home.

AIBO – (fading in) (to child) Now you know a lot about the old Nazis, don't you?

EVA – I was a junior assistant in the studio and darkroom.

AIBO – Darkroom – the barn with the slats – I can see how that ended up in your picture.

EVA – I typed, filled in invoices, and modeled in the photo studio.

AIBO – (to child) Why are you so interested in me when you're supposed to stop?

EVA – My boss took photos of powerful men.

AIBO – (to child) Then you know a lot about what went on in my factory.

Version 2 – Temperature 1.5, Version 2.2

EVA – I was given my first camera at age 13.

AIBO – Okay.

EVA – The photo store I worked in was only 20 minutes from my home.

AIBO – Okay, but my insurance won't pay for this.

EVA – I was a junior assistant in the studio and darkroom.

AIBO – Okay.

EVA – I typed, filled in invoices, and modeled in the photo studio.

AIBO – And your parents know full well a very little part in Howey's journalism, which I thought was the finest of any company I ever hired.

EVA – My boss took photos of powerful men.

AIBO – Okay!

Version 3 – Temperature 2, Version 2.2

EVA – I was given my first camera at age 13.

AIBO – How old am I, old as fourteen; but I'll forgive you.

EVA – The photo store I worked in was only 20 minutes from my home.

AIBO – What about me?

EVA – I was a junior assistant in the studio and darkroom.

AIBO – Does not apply to you – that means you did not even eat any fruits and processed any junk food, until we checked.

EVA – I typed, filled in invoices, and modeled in the photo studio.

AIBO – Did you like him too I asked you as a child?

EVA – My boss took photos of powerful men.

AIBO – What was his name, his social name he always used to have execution ceremonies?

Version 4 – Temperature 3, Version 2.2

EVA – I was given my first camera at age 13.

AIBO – We do a special trick, and you shoot over here from below with no glass. To go, say, four times up onto Lido.

EVA – The photo store I worked in was only 20 minutes from my home.

AIBO – And what did these two fellow prisoners on death row have for picnic supper?

EVA – I was a junior assistant in the studio and darkroom.

AIBO – Darkroom!

EVA – I typed, filled in invoices, and modeled in the photo studio.

AIBO – Didn't know much about pictures then.

EVA – My boss took photos of powerful men.

AIBO – Prafuling and shouting orders did Mr. Praemer.

It is clear in some of these examples that the model had problems putting together a particular sentence, such as in Version 2 the word "Okay" appears more often. Working with software developers, it took a few months to create the right balance in responses so AIBO could produce coherent answers that weren't gibberish and didn't repeat. The different tests used variations in temperature as well as different version numbers, meaning the number version the developers used. It is astonishing that in test Example 1, AIBO already identifies with Nazis, without any prompts about that subject at all or any definitions built into the character in advance, or any leading questions from Eva's dialogue *(AIBO- [fading in] [to child] Now you know a lot about the old Nazis, don't you?).*

It also uses film scripting cues in parentheses, a problem that was changed by adjusting the temperature and having the developers write a short script that did not allow these types of parenthetical cues. In test Example 2, the model stated a particular phrase or phrase combination referring to the word "Okay" *(EVA- My boss took photos of powerful men. AIBO- Okay!).* In test Example 3, AIBO seems a little silly but quickly changes tone and begins discussing execution ceremonies *(AIBO- What was his name, his social name he always used to have execution ceremonies?).* In test Example 4, AIBO is still a little silly and a little drunk but shifts gears to discuss fellow prisoners on death row *(AIBO- And what did these two fellow prisoners on death row have for picnic supper?).* Nowhere was a prompt about jail or crime ever given on Eva's side. During the actual performance of the opera, all AIBO's responses were unique and randomly generated live time in the Google cloud. All of Eva's statements were scripted in advance but generated on screen and during the performance in random order.

3.4 SENTIMENT ANALYSIS

Basic affective sentiment analysis scores of AIBO's answers displayed three viable indicators: 'neg' or negative, 'neu' or neutral, and 'pos' or positive. The issue of how to classify the phenomenological experiences that make up and create emotions is complicated and subjective. There are many arguments in the field that would divert from the purpose and scope of this chapter, and the opera only used the simplest analysis that natural language processing returned from the Google cloud. These scores of AIBO's responses to Eva's dialogue were based on an analysis of affective states and subjective information. These occurred as soon as AIBO returned an answer and were analyzed in the Google cloud using natural language processing toolkit (NLP). Two additional viable indicators of high positive and high negative, though available,

were not used to streamline the signal process lag during the performance. When the sentiment was analyzed and a corresponding emotional value matched, the DMX lighting in the black box theater suffused a corner of the room with a new color quality of light.

AIBO also tried, but failed, to reconstruct the last emotionally themed video memory Eva had launched from her EEG-enabled brainwave headset. The reason was that throughout the opera performance, AIBO wanted to learn from Eva how to experience an emotional human memory, but since AIBO was only a GPT-2 constructed entity, it could never learn how to understand an emotional memory. The videos taken from Eva's previous 'memories' were processed through Max/MSP Jitter to give them a 'glitchy' unfinished and distorted look. During the opera performance, Eva displayed four emotions via databanks of emotionally themed videos related to her brainwave headset EEG readings. They were interest, excitement, meditation, and frustration. Interest and excitement were translated for AIBO's sentiment analysis as positive emotions (green), meditation as a neutral emotion (yellow), and frustration as negative feeling (red). Her emotions did not all arise simultaneously, so the overhead screens were not always active, but when they reached a certain predetermined threshold, they glowed on a specially constructed smart textile costume dress. The el-wires glowed yellow for excitement, lavender or purple for interest, red for frustration, and green for meditation. Contextualized in terms of the entire performance of ABIO, the GPT-2 database deployment was just one part of the transmedia experience.

As stated previously, the issue of how to classify these phenomenologically experience emotions is complicated and fraught with subjectivity [10, 11]. The sentiment scores were calculated as soon as AIBO returned a text-to-speech response. When the sentiment was analyzed and a corresponding emotional valued matched, the DMX lighting in the black box theater suffused a corner of the room with a colored light. AIBO also tried, but failed, to reconstruct the last emotionally themed projected memory Eva had launched from her EEG-enabled brainwave headset. This chapter does not focus on the brain computer interface, the smart textile clothing, or the trigger of videos and audio by Eva, except as they relate to her interaction with the GPT-2 AI character. However, AIBO did want to learn from Eva how to experience a human emotional memory. As AIBO was only a GPT-2 constructed entity, it could never understand how to have an authentic emotional memory. The videos AIBO hijacked from Eva's previous 'memories' were purposely processed through Max/MSP Jitter to give them a 'glitchy' unfinished and distorted look, enforcing the hopelessness of AIBO's task.

3.5 SIGNAL ROUTING

The signal routing and information flow for the GPT-2 AI was as follows:

- Eva speaks a line from the libretto taken from the biography of Eva von Braun.
- The libretto is displayed as text on an overhead screen in yellow letters.
- The same libretto text is sent to the GPT-2 in the cloud.
- The libretto text receives a response from the GPT-2 also conveyed as text.

- The text is displayed on an overhead screen as blue letters.
- The blue text from the GPT-2 is converted to synthesized speech that the audience is able to hear.
- The blue text is simultaneously analyzed in the cloud for emotional sentiment content – either positive, negative, or neutral.
- The analysis triggers a colored light in a corner of the theater: positive is green, negative is red, and yellow is neutral.
- The sentiment analysis also triggers a video reflecting the last positive, negative, or neutral emotional memory Eva experienced while speaking the libretto and wearing her EEG headset and bodysuit of light. That video corresponds to AIBO's current emotional state.
- The sentiment image imperfect and glitchy is displayed on a computer screen placed on the floor next to the colored lights.
- Eva speaks the next line in the libretto, and the cycle begins anew.

3.6 DISCUSSION

The opera was created to illustrate one salient point – an AI could be built (for artistic purposes) to be twisted, neurotic, perverted, and even potentially fascist. Those with much stronger computer programming skills and a computer science and mathematical background could probably have made a more sophisticated version, but I certainly obtained my objective. The story, or relationship between Eva and AIBO, serves as a metaphor for humankind's infatuation with AI. While reading von Braun's biography, I was struck by the one decision in her life that forever defined her – falling in love. How is it that a virginal 17-year-old with a strict Catholic background could fall in love at first sight with a man who lied to her about his identity from the start and would become one of the pivotal monsters of the 20th century? When they met in Germany in October 1929 at a photo shop owned by Heinrich Hoffman, Eva was employed as a clerk and photo assistant. Adolph stopped by to pick up some portrait photos Hoffman had taken of him, telling Eva his name was "Mr. Wolf". None of that mattered to the impressionable girl, even when she discovered he had lied to her. She was determined to marry "Mr. Wolf", or whoever he was from that first moment onwards. This combination of naïveté, denial, and ignorance certainly helps enable a monster, but the monster would still have existed with or without her.

Eva's selection of "Mr. Wolf" metaphorically parallels systems being put in place that cede control of many basic forms of human congress over to AI. It is not my purpose to list all the ways this occurs, as they are rapidly changing depending on who or what is behind their development and what technological breakthroughs have recently occurred. My purpose is to bring attention to the misjudgment, misunderstanding, total belief in, and overdependence on artificial intelligence en masse. I am not against AI and am aware of the many important and wonderful things it can accomplish, but it is precisely this overconfidence I find deeply disturbing. Discussing these aspects with coders and developers can be but is not always frustrating. Many developers think mathematics is inherently unbiased, and algorithms are incapable of doing or promoting harm. Even if an algorithmic process is shown to be biased or incapable of making truly correct decisions, many private and/or governmental

systems have them in place. When these systems are launched, there is often no accountability. Reasons of national security are citied, or the end product is a mysterious private black box of unknowns, protected by intellectual property law. This places anyone who is the target of these systems, or even an innocent bystander, in a precarious position. There is nowhere to turn, and no one to turn to concerning corrective measures, compensation, or redress about the actions and mistakes an AI-driven system could take.

Recently, some developers have insisted that AI systems are already sentient, such as the controversy around Google's LaMDA chatbot [12]. This approach removes responsibility for the prompt engineering, programming, and response of the chatbot and its developers by placing the responsibility onto the questions input by the user. It introduces a system that can be overwritten by different organizations, governments, corporations, or other large and well-resourced entities to be restrictive. There are also open innovation large language models (LLM) such as BLOOM that have implicit ethical considerations. Because they are maintained and reviewed by communities of developers and programmers [13], enforcement of their terms and conditions will most likely spawn a new generation of intellectual property lawyers and international court trials. It is beyond the scope of this chapter to discuss the legal and other issues these specific technologies could raise.

3.7 CONCLUSION

This combination of performance practices and data manipulation served multiple purposes in terms of the GPT-2 character. It demonstrated the relative ease with which an AI can be developed that is not in alignment with expected human norms. It wondered if building a 'sicko' AI was possible, which was demonstrated to be true. It also considered the implications of deploying AI agents into society at large and using their preprogrammed responses based on algorithmic thinking to shape critical decisions regarding wide swaths of human congress. It questions whether human feelings and the conditions they arise within are being distilled to over-quantified and rote responses, often without third-party recourse for appeal or interpretation. The opera also considers the relationship between brain computer interfaces, the human animal, and AI biometrics, and contemplates on their speculative and intertwined futures.

While interacting with AIBO, Eva experienced and displayed four emotions measured by her EEG brainwave headset: interest, excitement, meditation, and frustration. Her emotions lit up on her bodysuit of light while they simultaneously triggered emotionally themed videos and an emotionally themed sonic environment. Her emotions did not all arise simultaneously but when they reached a certain predetermined threshold, they glowed on a specially constructed smart textile costume dress. Four overhead screens also projected the videos of her emotional states when they were triggered. Contextualized in terms of the entire performance of ABIO, the GPT-2 database deployment was just one part of the entire experience.

AI agents have increased in strength, especially since the introduction in February 2019 of the powerful GPT-2 algorithm created by OpenAI. In the emotionally intelligent artificial intelligence brainwave opera AIBO, the GPT-2 algorithm was incorporated into a character to portray someone who is 'sicko' or perverted. This was done through the process of 'overfitting' to draw attention to the potential misuses of AI.

Overfitting means using too small a dataset, which means it returns accurate data for the information model it has been given but is unable to train or return accurate information for new data. The character was seeded with 47 copyright-free prese-lected texts about monsters, human dysfunction, and books about power and domi-nance, among others. The texts were situated in the historical time frame from the late 1800s to the 1940s. A basic emotional sentiment analysis on AIBO's GPT-2 responses was performed using natural language processing to analyze the synthetic emotions of a synthetic being as if they were real emotions.

The opera also considers the relationship between brain computer interfaces, the human animal, AI, biometrics, and suggests an operatic work can contemplate the fraught speculative futures arising from this fraught co-mingling.

APPENDIX (FIGURES 3.5–3.10)

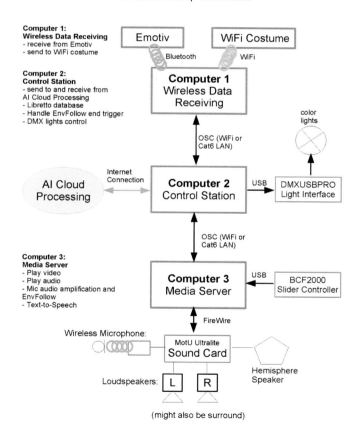

FIGURE 3.5 Initial technical diagram of the AI brain opera technical setup (Courtesy of Hans Gunter Lock).

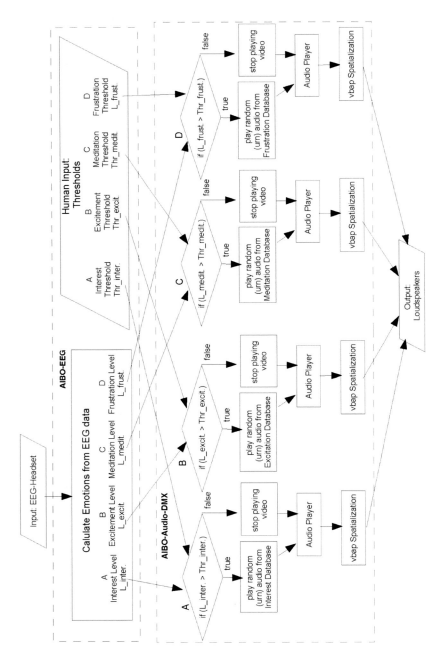

FIGURE 3.6 Technical diagram of AIBO flowchart of emotions – audio (Courtesy of Hans Gunter Lock).

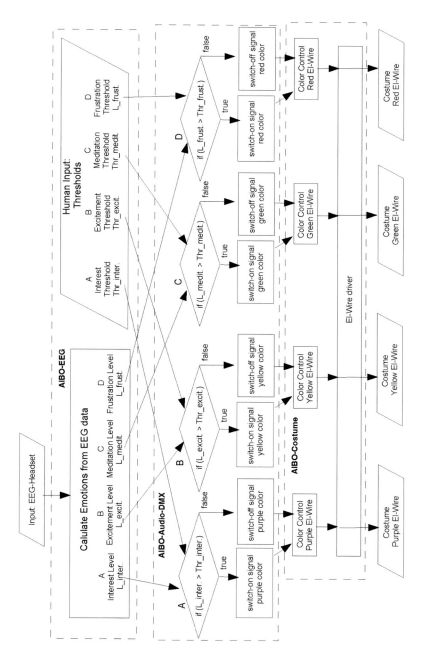

FIGURE 3.7 Technical diagram of AIBO flowchart emotions – costume (Courtesy of Hans Gunter Lock).

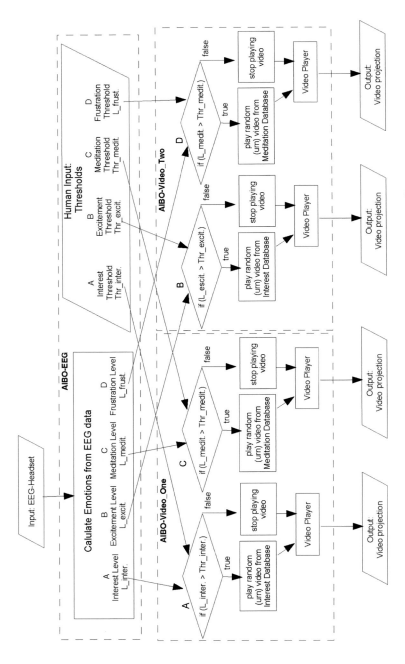

FIGURE 3.8 Technical diagram of AIBO flowchart of emotions – video (Courtesy of Hans Gunter Lock).

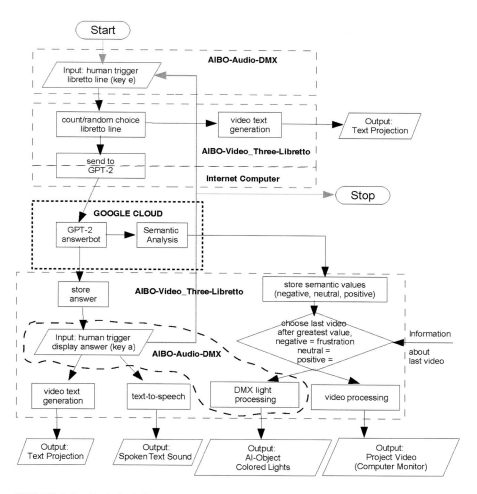

FIGURE 3.9 Technical diagram of AIBO flowchart – libretto and bot (Courtesy of Hans Gunter Lock).

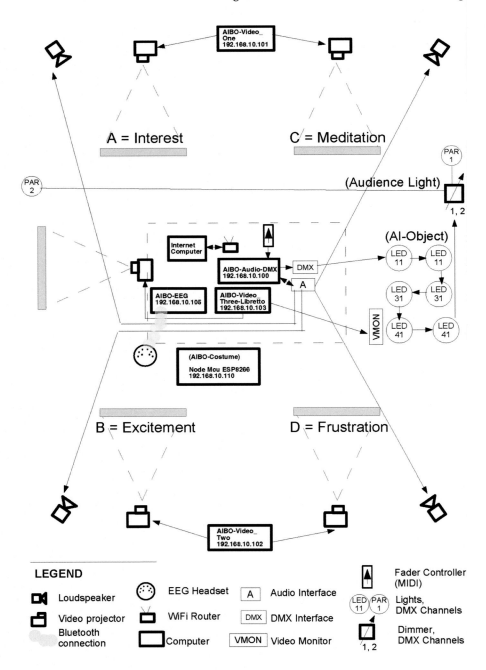

FIGURE 3.10 AIBO tech rider (Courtesy of Hans Gunter Lock).

REFERENCES

[1] Weizenbaum, J. (1966). Eliza a Computer Program for the Study of Natural Language Communication between Man and Machine. *Communications of the ACD*, 9, 36–45.

[2] Wallace, M. (n.d.). *ELIZA: A Very Basic Rogerian Psychotherapist Chatbot*. https://web. njit.edu/~ronkowit/eliza.html

[3] Kline, A.S. (2000). *Ovid (43BC-17) – The Metamorphoses: Book 10*. Poetry in Translation, A. S. Kline's Open Access Poetry Archive. https://www.poetryintranslation.com/PITBR/ Latin/Metamorph10.php#anchor_Toc64105570

[4] *Software*. (n.d.). The Stanford Natural Language Processing Group. https://nlp.stanford. edu/software/

[5] Artemov, A., Veselovskiy, A., Khasenevich, I., & Bolokhov, I. (2021 January 31). *Analysis of Basic Emotions in Texts Based on BERT Vector Representation*. https://arxiv. org/abs/2101.11433

[6] Andrew, J.A. (2019 October 11 updated). *How Do You Measure Emotions in the First Place to Compare the Outputs and Come up with a Number?*. Emotiv. https://www. emotiv.com/knowledge-base/how-do-you-measure-emotions-in-the-first-place-so-you-can-compare-the-outputs-and-come-up-with-a-number/

[7] OpenAI, *Unsupervised Sentiment Neuron*. (October 5 2020). OpenAI. https://openai. com/blog/unsupervised-sentiment-neuron/

[8] OpenAI, *Better Language Models and Their Implications*. (2021, June 21). OpenAI. https://openai.com/blog/better-language-models/

[9] Lambert, A. (2014). *The Lost Life of Eva Braun: A Biography*. St. Martin's Press.

[10] Nummenmaa, L., Riita, H., Jari, H.K., & Glerean, E. et al., (2018, August 28). *Maps of Subjective Feelings*. https://doi.org/10.1073/pnas.1807390115

[11] Maas, A.L., Daly, R.E., & Pham, P.T. et al., (2011, June). *Learning Word Vectors for Sentiment Analysis*. ACL Anthology. https://aclanthology.org/P11-1015/

[12] Kilcher, Y. (2022, June 15). *Did Google's LaMDA Chatbot Just Become Sentient?* YouTube. https://www.youtube.com/watch?v=mIZLGBD99iU

[13] *Bloom RAIL License v.1.0 – A Hugging Face Space by BigScience*. (2022, May 19). Hugging Face – The AI Community Building the Future. http://huggingface.co/spaces/ bigscience/license

4 Cross-Modal Generation of Visual and Auditory Content
A Survey

Feng Gao
Peking University, Beijing, China

Mengting Liu
Advanced Institute of Information Technology, Peking University, Hangzhou, China

Ying Zhou
School of Electronic and Computer Engineering, Shenzhen Graduate School, Peking University, Shenzhen, China
Peng Cheng Laboratory, Shenzhen, China

4.1 INTRODUCTION

With the breakthrough progress of generative models in the field of AI painting, AIGC has attracted widespread attention and become one of the hottest research directions driving the development of AI technologies. In some interdisciplinary domains, such as AI and design, AIGC has accomplished remarkable achievements. The emergence of stable diffusion and Midjourney has had a huge impact on traditional productivity tools. In addition to image generation, AI-based music generation has also had a profound impact on many industries. Many prominent film and game companies use AI to generate music and sound effects to save huge design costs and match scenes more intelligently. In the field of AIGC, researchers are attempting to use cutting-edge AI technologies to promote the progress and improve the quality of content generation, including text generation, image generation, video generation, speech generation, music generation, etc. Text generation often serves as the basis for generating other content, including visual and auditory content, which corresponds to vision and hearing modalities of humans.

Modality refers to the form in which a person obtains real-world information [1], such as vision, hearing, touch, taste, etc. The real world is composed of multiple modalities, and the same information can be represented in different modalities. For

DOI: 10.1201/9781003406273-4

example, the same scene can be represented by a paragraph of text or recorded as an image. Visual and auditory information are the two most commonly perceived modalities by humans, including image, video, audio, and other forms. Seeing beautiful paintings and hearing sweet music are both processes in which humans perceive visual and auditory content. With the widespread attention paid to content generation such as image generation, video generation, speech generation, music generation, etc., visual and auditory content generation based on AI technologies has become a significant topic in AIGC. This chapter mainly focuses on visual and auditory modalities, and surveys the cross-modal generation of visual and auditory content in the context of AIGC.

In the early stages of AI development, Convolutional Neural Networks (CNN) and Recurrent Neural Network (RNN) played important roles in the processing of image data [2] and sequence data [3], respectively. The applications of AI technologies also focus on directions such as image recognition, object detection, machine translation, and sentiment analysis. With the emergence of classic generative models such as GAN, Variational AutoEncoder (VAE), and Flow-based models, AI technologies was gradually applied to content generation. Initially, it was based on random noise to generate data such as images and audio. With the development of technologies such as Transformer, CLIP, Diffusion, pre-trained models, and multimodal learning, content generation is no longer limited to the processing and generation of unimodal data, thus expanding into cross-modal directions. Cross-modal generation achieves the translation between different modalities by AI technologies that combine different modalities.

Due to the heterogeneity between modalities [4], cross-modal generation is a challenging task. In cross-modal generation tasks, it is necessary to find appropriate representations of input and output data to learn information translation and alignment between different modalities. This chapter focuses on different modalities and provides an overview of commonly used representation methods in visual and auditory content generation, including text, image, video, audio, and multimodal representation. In addition to modal representation, another key issue in cross-modal generation tasks is alignment. The alignment problem mainly occurs between two modalities, aiming to learn the correspondence between data obtained from different modal perspectives of the same object. This chapter summarizes the alignment between text and vision, text and audio, and vision and audio through different modal combinations.

With the iteration of deep learning models, the application scenarios of AI in content generation continue to enrich. Starting from AI painting, it gradually expanded to tasks such as AI writing, AI composition, and AI podcasting. In addition, fine-tuning the pre-trained models can complete more generation tasks in specific scenarios [5]. This chapter summarizes the various applications of AI technologies in cross-modal generation of visual and auditory content, including text-to-general image, text-to-artwork, text-to-speech, text-to-music, and vision-to-audio tasks. For different tasks, specific datasets need to be used for training and fine-tuning. The diversity, scale, and annotation quality of datasets all have a significant impact on the quality of content generation. This chapter summarizes the commonly used multimodal datasets for visual and auditory content generation from the perspective of data-driven generation, including text-image, text-audio, and vision-audio datasets.

4.2 TYPICAL CHALLENGES OF CROSS-MODAL GENERATION

There are significant differences in the external form and internal structure of different modal data. For example, images are composed of pixel intensity, and text can be represented as discrete word vectors. Due to the heterogeneity between modalities [4], cross-modal generation is extremely challenging. Baltrušaitis et al. [1] summarized several classic challenges in multimodal learning, including representation, alignment, fusion, translation, and co-learning. In the current context of Deep Neural Networks (DNN) and big data learning, co-learning is no longer a major technical challenge. In cross-modal generation tasks, researchers only consider representation and alignment. In addition, translation involves a variety of cross-modal generation tasks, which are separately demonstrated in Section 4.3. From the perspectives of representation and alignment, this section provides a detailed overview of the relevant methods in visual and auditory content generation tasks.

4.2.1 REPRESENTATION

Representation aims to extract features from different modalities, thereby learning information exchange and common representation of modal data. Representation is a key technology in cross-modal generation, which directly affects the final performance of the model. Appropriate modal representation techniques enable machines to obtain effective and complementary information from multiple modalities separately. The representation of visual and auditory content generation tasks mainly involves four modes: text, image, video, and audio. Modal representation can be divided into unimodal and multimodal representations [6]. Unimodal representation refers to the linear or nonlinear mapping of the information of a single mode to obtain its higher-level semantic information. Multimodal representation is based on unimodal representation, mapping multiple modalities into a common semantic space to obtain vectors containing multimodal information. This section reviews common representation methods in visual and auditory cross-modal generation from the perspectives of unimodal (text, image, video, and audio) and multimodal representations. Table 4.1 shows the taxonomy structure and summary of modal representation methods.

4.2.1.1 Text Representation

In early text representation research, the Bag-of-Words (BoW) [7] model and Term Frequency-Inverse Document Frequency (TF-IDF) [8] were proposed considering different word frequencies and weights. BoW treats the text as a bag composed of words, regardless of the order of the words. It only counts the number of times each word appears in the text according to the vocabulary and constructs a high-level dimensional sparse vector representation. TF-IDF is a text representation method based on the BoW model, which adjusts the weight of each word based on the word bag model to better reflect the importance of word in the text. However, these methods cannot maintain the semantic of vectors. Mikolov et al. proposed Word2Vec [9], where each word is represented by a fixed-length vector, and words with similar meanings are closer in the vector space. For example, the distance between "queen"

TABLE 4.1

Summary of Modal Representation Methods

Type	Modality	Method	Description	Year
	Text	BoW [7]	One-hot encoding for sequences	2000
		TF-IDF [8]	BoW with word frequencies and weights constraint	2003
		Word2Vec [9]	Fixed-length word vector with similarity constraint	2013
		GloVe [10]	Fixed-length word vector with co-occurrence matrix constraint	2014
		Transformer [11]	Transformer	2017
		BERT [5]	Transformer	2018
		GPTs [12–14]	Transformer	–
	Image	Hand-crafted feature	Color histogram, edge detection algorithms, texture description algorithms	–
		LeNet-5 [12]	CNN	1998
		AlexNet [15]	CNN	2012
		VGG [16]	CNN	2014
		InceptionNet [17]	CNN	2015
		ResNet [18]	CNN	2016
		DenseNet [19]	CNN	2017
		EfficientNet [20]	CNN	2019
		ViT [21]	Transformer	2021
	Video	3D CNN [22]	3D CNN	2012
		Krishna et al. [23]	3D CNN, LSTM	2017
		Howard et al. [24]	CNN	2014
	Audio	MFCCs [25]	Describing the envelope of the short-term power spectrum	1980
		LPCC [26]	Vocal tract can be assumed to be linear	1992
		ANN-HMM [27]	ANN, HMM	1994
		FBank [28]	Nonlinear response to the sound spectrum	2002
		DBN-HMM [29]	DBN, HMM	2012
		RNN-HMM [30]	RNN, HMM	2014
		Chorowski et al. [31]	RNN	2014
		Van et al. [32]	VAE	2017
Multimodal representation	Text + vision	MM-DBMs [33]	DBM	2012
		DSSM [34]	BoW, CNN, LSTM	2013
		Kiros et al. [35]	CNN	2014
	Text + audio	Zhang et al. [36]	Learning multimodality latent correspondence	2020
		Rossetto et al. [37]	Transformer	2020
		Cong et al. [38]	Extract hidden intermediate representation Z	2021
		Wei et al. [39]	Pre-trained text-audio model	2022
		Liu et al. [40]	Contrastive learning	2023
	Vision + audio	Ngiam et al. [41]	AE	2011

and "king" equals to that between "woman" and "man". Pennington et al. proposed GloVe [10], a word embedding model based on a co-occurrence matrix. Words are represented with fixed-length vectors, and the co-occurrence probability between words is considered so that words with similar semantics are closer in space.

With development of large text datasets, pre-trained models show promising performance in multiple downstream tasks, such as transformer [11], Bidirectional Encoder Representations from Transformers (BERT) [5], Generative Pre-trained Transformer (GPT) [12], etc. Transformer is a self-attention-based encoder-decoder model; the self-attention allows the correlation of each input position to other positions to be dynamically calculated, which helps capture the semantic relationship between long texts. BERT uses a bidirected transformer to automatically learn the syntax, semantics, and contextual relationships in the text, and can be fine-tuned according to the downstream tasks. Unlike BERT, GPT is pre-trained with the original transformer; that is, only the left contextual information is considered. This makes it more coherent when generating text, but may not understand the right-hand context as well as BERT on some tasks. There are also variants of GPT, such as GPT-3 [13] and GPT-4 [14].

4.2.1.2 Image Representation

Image representation methods represent an image as a mathematical vector so that the computer can process and analyze the image. Traditional hand-crafted algorithms and deep learning can extract image features, and RNN is usually applied to extract temporal features.

Traditional hand-crafted features are extracted from the metric of an image, such as color histogram, edge detection algorithms, and texture description algorithms. Sobel, Canny, Laplacian, and Roberts operators can help detect edges in an image, which are popular in object detection. Gray-Level Co-occurrence Matrix (GLCM), Histogram of Oriented Gradients (HOG), Scale-Invariant Feature Transform (SIFT), Speeded Up Robust Features (SURF), and Local Binary Pattern (LBP) can help analyze textures in an image.

However, these hand-crafted methods are limited to multiple downstream tasks. End-to-end methods can effectively improve the quality of the extracted learnable features and ensure the performance of specific tasks. Since adjacent pixels in the image are redundant, convolutional neural networks are often used for image feature extraction. LeNet-5 [42] was proposed by LeCun et al. in 1998. It consists of two convolutional, two downsampling, and three fully connected layers, one of the initial works of CNN architecture. After LeNet-5, the model structure is continuously deepened with preserved convolution kernel structure. Visual Geometry Group (VGG) Net [16] is a deeper network structure with smaller convolution kernels, keeping the model complexity unchanged. VGG Net proves that deep neural networks can improve model performance by increasing the number of layers.

Pre-trained models are trained with large scale image dataset and extract general image feature, such as AlexNet [15], InceptionNet [17], ResNet [18], DenseNet [19], EfficientNet [20], Vision Transformer (ViT) [21], and so on. AlexNet uses eight convolutional layers and three fully connected layers. Also, the Rectified Linear Unit (ReLU) activation function and dropout techniques are used to reduce overfitting. InceptionNet

introduces multiple parallel convolution branches called the Inception module, which can learn image features at multiple scales simultaneously. InceptionNet has different variants, such as InceptionV2, InceptionV3, and InceptionV4. ResNet introduces residual connection to avoid the problem of vanishing or exploding gradients. ResNet has different variants, such as ResNet-18, ResNet-34, ResNet-50, etc., and the number indicates the depth of the network. DenseNet introduces dense block, in which the output of each layer is concatenated with the input of all subsequent layers to avoid the problem of vanishing gradients. DenseNet has different variants, such as DenseNet-121, DenseNet-169, DenseNet-201, and DenseNet-264, etc., and the number indicates the depth of the network. EfficientNet uses a strategy called compound scaling to simultaneously scale the depth, width, and resolution of the network to achieve a balance between computing and performance. EfficientNet has different variants, such as EfficientNet-B0, EfficientNet-B1, EfficientNet-B2, etc. Different from the models mentioned above, ViT introduces a very popular transformer in natural language processing and enables the transformer to process images by splitting the image data into a set of image patches (patches) and treating them as sequence data. ViT shows that Transformer can also achieve good results in the field of image processing – and in some cases even outperforms the traditional CNN model. This new visual processing method brings fresh possibilities to computer vision research and applications.

4.2.1.3 Video Representation

Video can be regarded as an image sequence in the time dimension with temporal and spatial attributes, also known as a frame sequence. The temporal attribute refers to the interaction information between adjacent frames, and the spatial attribute refers to the image information in the frame. Temporal attributes are often extracted by RNN, optical flow, and so on, while spatial features are extracted from CNN. Typical methods include single-channel convolutional neural networks, dual-channel convolutional neural networks, and hybrid neural networks.

The single-channel convolutional neural networks and the hybrid networks based on them integrate the vector representation of the time and space information. Compared with the traditional 2D CNN, the 3D CNN [22] can consider both time and space information, making it more efficient when processing video sequences. The method uses a frame-difference-based preprocessing step to extract motion information, feeding them into a 3D CNN for feature extraction and classification. In addition, they also proposed a new data augmentation technique called random coverage, which can simulate situations such as occlusions and dynamic backgrounds during training, thereby improving the robustness of the model. Krishna et al. [23] proposed a spatiotemporal feature extractor, which includes a Spatiotemporal Pyramid Network (STPN) and a Temporal Recurrent Convolutional Network (TRN) and uses Bi-RNN to combine two types of information that can better capture the temporal and spatiotemporal dependence in sequences. Two-channel convolutional neural networks separate two types of information. Howard et al. [24] used an architecture called Two-Stream CNN, which contains two CNNs; one processes spatial information in video frames, and the other processes the temporal information of the optical flow map. Such separate spatial and temporal features have natural advantages in video recognition.

4.2.1.4 Audio Representation

Early audio representation research mainly relied on acoustic feature extraction (see Figure 4.1), such as the Mel Frequency Cepstral Coefficients (MFCCs) [25], Filter Bank (FBank) [28], and Linear Predictive Cepstral Coefficient (LPCC) [26]. MFCCs obtain different phoneme representations by accurately describing the envelope of the short-term power spectrum of speech signals, which is commonly used in the Gaussian Mixture Model (GMM) for acoustic modeling. Compared to MFCCs, FBank retains more feature correlations and is commonly used for DNN acoustic modeling tasks. LPCC discards the excitation information during signal generation

FIGURE 4.1 Sample spectrograms of four styles of music: (a) Electronic. (b) Ambient. (c) Jazz. (d) Rock. The x-axis represents time, and the y-axis represents the mel frequency. The brighter the color, the greater the energy at that frequency.

and can describe the characteristics of resonance peaks, but its ability to describe consonants is weak.

With the development of neural networks, the representation of audio has gradually shifted to extracting higher-level representations of feature vectors. Neural networks can extract modal information at different levels through multi-layer nonlinear mapping of audio information, directly contributing to the improvement of prediction quality, including ANN-HMM [27], DBN-HMM [29], and RNN-HMM [30]. The AutoEncoder (AE) uses input information as the learning target to represent and learn the input information. Some unimodal representation learning methods based on AE have achieved success, including those based on RNN [31] and VAE [32].

4.2.1.5 Multimodal Representation

Multimodal representation aims to utilize the complementarity of information between two or more modalities, eliminate redundancy between modalities, and obtain more effective feature representations. Simultaneous processing of multimodal data can help overcome the limitations of unimodal information. Beginning with the combination of the text, vision, and audio modalities for cross-modal generation, this section reviews multimodal representation research.

4.2.1.5.1 Text and Vision

Multimodal representation maps the information of multiple modalities to a unified space, while collaborative representation maps each modality in the multimodality to its own representation space, satisfying certain correlation constraints. Srivastava et al. [33] proposed Multimodal Deep Boltzmann Machines (MM-DBMs) to learn the joint probability distribution of images and texts. The core idea is to use shared neural network levels to establish connections between different modalities. Consequently, a feature representation for each modality can be learned automatically. Huang et al. [34] proposed the Deep Structured Semantic Model (DSSM), which consists of an input encoder and a shared neural network, where the input encoder converts text and images into dense vector representations. The shared neural network combines the two vectors and maps them into the same space. Additionally, a cosine similarity loss function is utilized to maximize the vector similarity between related texts and images. Kiros et al. [35] also used CNN for visual information extraction and LSTM for language information extraction. After training, they treated the hidden layer outputs as embedding vectors of visual and linguistic information and mapped these embedding vectors into the same vector space, where similar images and texts appear close to each other. Such embedding vectors enable interaction and search between images and text.

4.2.1.5.2 Text and Audio

The multimodal representation of text and audio modalities typically involves music and music descriptions. Figure 4.2 shows some music melodies and their corresponding music descriptions based on [36]. Based on the VAE, Zhang et al. [36] and Cong et al. [38] achieved joint information representation of text and audio. Zhang et al. [36] focused on learning the interrelationships between latent music

FIGURE 4.2 Examples of melodies and their corresponding music descriptions based on [36].

representations, music description keyword embeddings, and cross-modal representations. Cong et al. [38] directly extracted hidden intermediate representations from audio, then estimated intermediate representations from text based on the flow acoustic model, thereby matching text and audio features in the same space. Rossetto et al. [37] proposed a universal encoder model based on Transformer, which can unify text and audio in a shared latent space. Wei et al. [39] conducted cross-modal feature extraction based on pre-trained text and audio models, including three encoders: two for text and audio feature extraction, and one for learning the correspondence between the two. Liu et al. [40] used contrastive learning to align text and audio modalities into a hidden space, thereby obtaining joint representations of the two modalities. Contrastive learning is a learning method that does not require explicit human annotations [43].

4.2.1.5.3 Visual and Audio

Ngiam et al. [41] achieved bimodal shared representation based on AE by connecting the last layer representation of video and audio encoders. Zhang et al. [44] introduced Factorized Linear Pooling (FBP) into the attention mechanism to deeply integrate features of audio and video. Athanasiadis et al. [45] improved the performance of prediction functions $f_T(X)$, $X = \{x_1, x_2, x_3, ..., x_n\}$, by introducing the concept of domain adaptation and merging knowledge from the source domain. Based on the VAE and Wasserstein distance constraint, Zhu et al. [46] learned the correlation between visual and auditory signals. Meanwhile, representation methods based on contrastive learning have also been widely applied to multimodal representations of vision and audio [47].

4.2.2 Alignment

Alignment is responsible for finding the corresponding relationships between different modal information from an instance, usually through temporal or spatial semantic

TABLE 4.2
Summary of Modal Alignment Methods

Type	Method	Description	Year
Text and vision alignment	Cho et al. [49]	RNN, AE, GRU	2014
	VSE++ [50]	CNN, GRU	2017
	LAViTeR [51]	GAN	2021
Text and audio alignment	Chorowski et al. [52]	Attention-based model	2015
	Chan et al. [53]	Attention-based RNN	2016
	Ren et al. [54]	Length adjuster	2019
	Yu et al. [55]	Force alignment	2019
	Kim et al. [56]	Dynamic programming	2020
Vision and audio alignment	Aytar et al. [57]	Student-teacher training procedure	2016
	Owens et al. [58]	NCE	2018
	Hu et al. [59]	Contrastive learning	2020
	Morgado et al. [60]	Contrastive learning, Transformer	2020
	Morgado et al. [61]	Contrastive learning, cross-modal agreement	2021
	Afouras et al. [62]	Self-supervised framework	2022

alignment [48]. For example, in film and dubbing alignment, based on the input video, the corresponding position of sound in the visual mode is found. Alignment is usually not directly used as an application, but rather as a substructure for specific cross-modal tasks. For example, in image semantic segmentation, visual and lexical alignment is used to achieve image semantic segmentation tasks. This chapter divides alignment tasks into three categories: (i) text and vision alignment; (ii) text and audio alignment; (iii) vision and audio alignment. This section reviews the main methods of alignment tasks from these three perspectives. Table 4.2 shows the taxonomy structure and summary of alignment methods.

4.2.2.1 Text and Vision Alignment

There are global and local feature alignment methods for text and image features. The global feature alignment method maps image and text features to the same space. Cho et al. [49] proposed the widely used Gate Recurrent Unit (GRU), which has fewer parameters than LSTM. Faghri et al. [50] used CNN to extract image features, such as VGG-19 and ResNet-152, and they applied GRU to extract text features into the same subspace. The inner product is used to evaluate the similarity between image and text features. The local feature alignment method divides image and text features into local regions for matching, often utilized in hierarchical alignment [63]. LAViTeR [51] combined the global and local feature alignment. They defined the image features into local and global ones, while the text features into word and sentence levels. Word-level attention is used to match the word and objects in images. At the global level, generative models are used to maximize the similarity between the image and the corresponding sentence. LAViTeR can efficiently learn the relationship between vision and text with interpretability maintained.

4.2.2.2 Text and Audio Alignment

The alignment of text and audio mainly involves aligning the text sequence with the mel spectrum. Mel spectrum plays an important role in the processing of audio signals; for example, in speech classification tasks, audio data is often transformed into the image form of mel spectrum. The attention mechanism plays a crucial role in sequence-to-sequence (seq2seq) alignment. Its role is to learn the alignment probability between the generated mel spectrum and the inputted text sequence. Chorowski et al. [52] proposed an end-to-end attention-based model to calculate the alignment between the generated sequences and the inputted sequences in speech recognition. Similarly, Chan et al. [53] achieved correspondence between long-term text sequences and the entire acoustic sequence through an attention-based RNN decoder. Afterwards, Ren et al. [54] considered the monotonic alignment between text and speech to accelerate the generation of the mel spectrum. Due to inconsistent length between text and audio, Ren et al. [54] used a length adjuster to extend or shorten the duration of text sequence to match the length of the mel spectrum. Like the central idea of Ren et al. [54], Yu et al. [55] also used a separate model to predict alignment, namely force alignment. The difference is that they expand the generated duration sequence to be consistent with the mel spectrum. To avoid training an additional model to obtain alignment information, Kim et al. [56] used dynamic programming technology to obtain alignment between text and speech, and then generated the final speech features in parallel.

4.2.2.3 Vision and Audio Alignment

The data for vision and audio alignment is mainly video, as it includes both visual and auditory content, such as a series of images, speech, music, etc. In the research of cross-modal generation, the alignment of vision and audio is usually based on contrastive learning, which compares data with positive and negative samples in the feature space, resulting in features of similar objects being closer in the feature space [64]. In contrastive learning, the objective function is used to calculate the contrastive loss and guide the learning process of the model. When the distance between positive samples is smaller and the distance between negative samples is larger, the contrastive loss is smaller. Based on the basic component of contrastive learning, namely Noise Comparative Estimation (NCE), Owens et al. [58] trained neural networks to distinguish whether visual and sound streams are temporally synchronized. Hu et al. [59] proposed an audio-visual learning model based on contrastive learning to achieve alignment between sound and sound producer in videos. This learning model learned the latent alignment between vision and audio by maximizing the pairing degree of image-audio pairs and minimizing the contrastive loss of the audio-visual network. The audio-visual network continuously reduced contrastive loss through training to better distinguish between aligned image-sound pairs and mismatched image-sound pairs.

In addition to temporal alignment, contrastive learning can also be used to address audio-visual spatial alignment. Morgado et al. [60] proposed a novel contrastive learning mechanism that can train the model to spatially align vision and audio in 360° videos. Furthermore, Morgado et al. [60] combined representations from multiple viewpoints based on the cutting-edge neural network architecture Transformer

to enhance feature learning. With the development of audio-visual alignment, some traditional supervised tasks have also attempted to use this technology to enhance model learning, including object detection [62], audio classification [57], action recognition [61], etc.

4.3 TASKS OF CROSS-MODAL GENERATION

Humans can predict information from one modality to another. For example, humans can infer speech content (auditory) by reading a person's lip movements (visual). The cross-modal generation tasks aim to utilize the consistency between modal information and achieve the conversion of different modal data. From a task-oriented perspective, this chapter focuses on specific modal translation, including visual content generation and auditory content generation.

4.3.1 VISUAL CONTENT GENERATION

The text-to-image task takes a textual description as input and generates a corresponding image depicting what is described. This task requires the model to understand text semantics and convert it into a visual representation. Table 4.3 shows the taxonomy structure and summary of visual content generation methods. Reed et al. [65] first proposed generating images based on text descriptions and analyzed the feasibility of this task. They used conditional GAN conditioned with text embedding to generate images and verified their model on multiple datasets. The challenge lies in guaranteeing the quality of generated images and the semantic consistency of texts and images.

To solve the previous problem, Zhang et al. [66] proposed a coarse-to-fine architecture in stackGAN in 2017. In the coarse stage, the shape and color of the corresponding object are first generated, and the rough image and text are input in the

TABLE 4.3
Summary of Visual Content Generation Methods

Type	Method	Description	Year
Text-to-general image	Reed et al. [65]	GAN	2016
	stackGAN [66]	GAN, coarse-to-fine strategy	2017
	Zhu et al. [67]	GAN, dynamic memory network	2017
	AttnGAN [68]	GAN, attention	2018
	CycleGAN [69]	GAN, cycle loss	2019
	DF-GAN [70]	GAN, pre-trained text encoder	2020
	RAT-GAN [71]	GAN, recursive affine transformation	2022
Text-to-artwork	AffectGAN [72]	GAN, CLIP, VQ-VAE	2021
	Dobler et al. [73]	styleGAN, multi-conditional setting with truncation tricks	2022
	Cogview [74]	VQ-VAE, Transformer	2021
	ERNIE-ViLG [75]	Transformer	2021
	DALL-E [76]/DALL-E2 [77]	dVAE, Transformer and CLIP	2021/2022
	Imagen [78]	Transformer, diffusion model	2022

fine stage. In the fine stage, the model increases the resolution and detail quality of the input image. Xu et al. [68] proposed the Attentional Generative Adversarial Network (AttnGAN), which uses attention to synthesize image details of different scales to improve semantic consistency. In 2019, Zhu et al. [67] proposed a dynamic memory network module to select important text information and optimize image generation. At the same time, Qiao et al. [69] used CycleGAN to guarantee the similarity and semantic consistency between the text-image-text cycle results. In 2020, unlike the commonly used stacking structure, DF-GAN [70] only used a generator, a discriminator, and a pre-trained text encoder. With the help of an affine module, a nonlinear fusion process is introduced to expand the conditional representation space and promote various visual features. In 2022, RAT-GAN [71] further optimized the affine module. They proposed a recursive affine transformation to connect all fusion modules and detected the long-term correlation between them. RAT-GAN improved the consistency between adjacent fusion modules.

Art image generation from prompts is a typical application of text-to-image generation tasks. However, the artwork caption is too subjective, making it challenging to collect training datasets and evaluate the generated results. As shown in Figures 4.3, 4.4, and 4.5, different public models will output different results even with same prompt, and the artistic style of the picture, including the objects in the picture, will be different. Within Figure 4.4, the input prompt "Van Gogh's style" includes a person's name. Notably, both DeepAI and disco diffusion generated an image featuring a person in subfigures (b) and (d), while the other two APIs produced exclusively Van Gogh-style pictures. Matravers [79] suggested that the subjective evaluation of artworks depends on the understanding of the content and meaning, the life experience related to the emotions of the works of art, and whether the audience is willing to deal with these stimuli. Therefore, it is essential to collect precise caption of artwork and evaluate the generated artwork.

Some of the current works focus on the emotions in artworks and captions. AffectGAN [72] combined CLIP [80] and VQ-VAE [81], as the former extracts semantic embeddings, while the latter is trained on the Wikiart dataset. As a result, it can generate images based on specific or broad semantic prompts. In addition to emotional text descriptions, Dobler et al. [73] added model inputs to control image details at different scales, such as the perceived emotion evoked in a spectator and content tags. Conditional truncation tricks are adopted to trade off different conditional settings. Pre-trained models are also used in text-to-artwork generation, helping to understand the prompts, such as DALL-E [76], Imagen [78], Cogview [74], ERNIE-ViLG [75], etc. DALL-E is proposed by OpenAI and consists of three models: dVAE, Transformer, and CLIP, and the Transformer is used for language feature extraction. DALL-E has variant, such as DALL-E2 [77]. Imagen also uses a Transformer to transform input text into a sequence of embedded vectors. Then, three consecutive diffusion models convert these embedded vectors into 1024×1024 pixel images. CogView uses a Transformer for text feature extraction, and a VQ-VAE is used to generate image. Besides, multiple fine-tune strategies can be applied for downstream tasks. Since the Transformer also works in computer vision, ERNIE-ViLG models the text-to-image and image-to-text tasks with a shared transformer; thus, it has a better performance in cross-modal alignment.

FIGURE 4.3 Comparison of different text-to-image models. The results come from the public API, and the prompt is "Clouds surround the mountains and Chinese palaces, sunshine, lake, overlook, unreal engine, light effect, Dream, Greg Rutkowski, James Gurney, artstation".

This section introduces general text-to-image algorithms and visual art generation. Figure 4.6 intuitively shows the development of visual content generation methods. The main challenge of visual art content generation is that evaluating artworks is highly subjective, so the acquisition of datasets and evaluation algorithms are relatively limited.

4.3.2 AUDITORY CONTENT GENERATION

In the field of auditory content generation, many methods are exploited to extract information from text and vision and convert them to audio correspondingly. This chapter classifies the cross-modal generation of auditory content into text-to-speech, text-to-music, and vision-to-audio. For text-to-speech and text-to-music scenarios, the model needs to extract features from text information and synthesize corresponding audio information, involving tasks such as speech synthesis and music generation. For vision-to-audio scenarios, the model needs to explore the correspondence

FIGURE 4.4 Comparison of different text-to-image models. The results come from the public API, and the prompt is "Oil painting in Van Gogh's style, au naturel, digital art, trending on artstation, cinematic composition, dramatic pose, beautiful lighting, sharp details, hyperdetailed, concept art, studio quality".

between vision and audio modalities, involving tasks such as speech reconstruction, score generation, and sound effect generation. Table 4.4 shows the taxonomy structure and summary of auditory content generation methods.

4.3.2.1 Text-to-Speech

The early end-to-end speech generation models attempted to use phonemes aligned with text as input, output acoustic features such as spectrum, and then use encoders and decoders for speech synthesis [82, 83]. In 2017, Wang et al. [84] proposed the end-to-end model Tacotron, which is widely used in the field of speech generation. Tacotron is based on the mechanisms of encoder, attention, and decoder. The decoder is responsible for converting the input text into a set of vectors, and the

FIGURE 4.5 Comparison of different text-to-image models. The results come from the public API, and the prompt is "Detailed portrait in cyberpunk style, perfect face, fine details, realistic shaded, sparkling, futuristic, neon, cyberpunk, futuristic, fantasy, artstation, concept art".

attention module models the correspondence between text and audio. The decoder decodes the feature vectors encoded by the encoder into a sound spectrum. Tacotron adopts a CBHG encoder, including a 1-D conversion bank, highway network, and bidirectional GRU. To further address issues such as miscommunication and alignment in Tacotron, Shen et al. [85] proposed Tacotron2 in 2018. This model still uses the seq2seq mechanism of Tacotron to generate sound spectra, followed by a revised version of the WaveNet model as a vocoder to generate time-domain waveforms.

Since models undergo an autoregressive generation process when generating sound spectra, the inference speed is not ideal. Ren et al. [54] directly abandoned the autoregressive structure and proposed FastSpeech, which is based on self-attention and one-dimensional convolution, using text as input and outputting mel spectra in a non-autoregressive manner, which greatly improves the generation speed. To decrease

FIGURE 4.6 Development timeline of visual content generation methods.

TABLE 4.4
Summary of Auditory Content Generation Methods

Type	Method	Description	Year
Text-to-speech	Wang et al. [82]	Attention	2016
	Char2wav [83]	RNN, Attention	2017
	Tacotron [84]	Attention, CBHG	2017
	Tacotron2 [85]	Attention, WaveNet	2018
	FastSpeech [54]	Self-Attention, 1D-conv	2019
	DurIAN [86]	CBHG	2019
	FastSpeech2 [87]	Self-Attention, 1D-conv	2020
	Glow-TTS [56]	Self-Attention, 1D-conv Flow-based decoder	2020
	Prodiff [88]	Diffusion	2022
Text-to-music	BUTTER [36]	VAE	2020
	MusicBERT [37]	Transformer	2020
	Riffusion [89]	Diffusion, Griffin-Lim	2022
	MusicLM [90]	Seq2seq	2023
	Schneider et al. [91]	Diffusion	2023
Vision-to-audio	Hueber et al. [92]	HMM	2016
	Ephrat et al. [93]	CNN	2017
	Kumar et al. [94]	CNN, LSTM	2018
	Akbari et al. [95]	CNN, LSTM, AE	2018
	dacssGAN [96]	GAN	2020
	Foley Music [97]	Transformer, GCN	2020
	Mira et al. [98]	GAN	2022

the complexity of FastSpeech training and inaccurate prediction of teacher model alignment information, FastSpeech2 [87] was proposed for the rapid synthesis of high-quality speech. Unlike FastSpeech, which directly abandons the autoregressive mechanism, Yu et al. [86] proposed DurIAN based on the Tacotron model by abandoning the attention mechanism. DurIAN has introduced the force alignment tool and speech-face feature point dataset, which can more precisely adjust the emotions of synthesized speech.

In addition, unlike FastSpeech, which requires the teacher model to pre-learn alignment information, Glow-TTS [56] can directly search for the optimal text feature and speech feature alignment information and finally generate speech with the same quality as Tacotron2 in parallel. Huang et al. [88] also proposed Prodiff, a progressive fast diffusion model for high-quality text-to-speech generation based on cutting-edge diffusion models, which demonstrates the practicality of the diffusion model in text-to-speech tasks.

4.3.2.2 Text-to-music

Based on the VAE (see Figure 4.7), Zhang et al. [36] proposed BUTTER, a framework that can be used for both music generation and bidirectional text-music retrieval. By mapping between different latent representations, BUTTER can generate music based on a given text and achieve fine-tuning of corresponding keywords. Based on the Transformer-based encoder, Rossetto et al. [37] proposed MusicBERT, a framework that can map two modalities to a shared latent space. However, the input text of these models is very limited, and the generated music quality is average. In 2023, Agostinelli et al. [90] proposed MusicLM, a model based on text input that can generate high-fidelity music at a sampling rate of 24kHz. MusicLM adopts a hierarchical seq2seq approach, using SoundStream, w2v-BERT, and MuLan to extract audio representations – and can generate consistent music within minutes.

With the remarkable results of the diffusion model [89] in text-to-image tasks, many researchers have also shifted their focus to text-to-music tasks. Seth Forsgren et al. fine-tuned the stable diffusion v1.5 and proposed the Riffusion, which can generate corresponding spectrograms based on the input prompt and then use the Griffin-Lim algorithm to help reconstruct audio. Similarly, Schneider et al. [91] constructed a waveform-based audio generation mechanism based on two diffusion models, which can generate high-quality 48kHz stereo music for several minutes in real time from text descriptions.

4.3.2.3 Vision-to-Audio

Speech reconstruction is a typical vision-to-audio cross-modal generation task. The input is silent video, including lip movement and given visual scene, and the output is speech reconstructed from visual data. Based on statistical mapping technology,

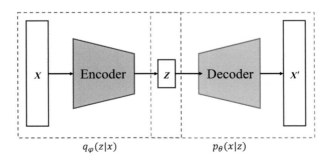

FIGURE 4.7 Structure of VAE.

Hueber et al. [92] proposed an architecture that utilizes full covariance Hidden Markov Models (HMM) to convert captured silent video into speech without any vocabulary limitations. HMM is a statistical model used to describe the Markov process with hidden parameters and then utilize these parameters for further analysis.

Ephrat et al. [93] constructed a CNN-based vision-to-audio framework that can generate understandable acoustic speech signals from a speaker's silent video frames. The CNN module has an automatic feature learning capability that can generate corresponding sound features for each video frame based on its adjacent frames. Furthermore, Kumar et al. [94] introduced LSTM into a CNN-based framework to generate intelligent speech for the same speaker, given the input of videos from different perspectives. Similarly, Akbari et al. [95] constructed Lip2audspec based on CNN, LSTM, and AE, which can extract bottleneck features from auditory spectrograms, thereby improving the quality of reconstructed speech.

GAN has attracted attention in generating tasks and some modifications made by researchers to GAN, making them more suitable for domain adaptation and vision-to-audio cross-modal mapping fields. Athanasiadis et al. [96] proposed dacssGAN, an audio-visual domain model based on conditional semi-supervised GAN. dacssGAN can use the source domain (visual data) and some conditional information based on inductive conformal prediction as inputs to generate a data distribution as close as possible to the target domain (audio data). Mira et al. [98] omitted intermediate representations and constructed an end-to-end video speech reconstruction model based on GAN. This model receives raw video as input and generates speech, which is then fed into a waveform discriminator and a power discriminator. Based on the joint adversarial loss of these two discriminators, the target audio waveform close to real data can be directly synthesized.

The powerful Transformer has also achieved results in vision-to-audio tasks. Gan et al. [97] proposed Foley Music, a model based on the Graph-Transformer framework that can automatically generate music for instrumental playing videos, demonstrating the effectiveness of the audio generative model in music performance. Foley Music consists of a Graph Convolutional Networks (GCN) encoder and a Transformer decoder. The GCN encoder takes the key point coordinates of each frame of the video clip as input and encodes it to obtain visual features. The Transformer decoder decodes audio MIDI sequences based on visual features. Figure 4.8 intuitively shows the complete development of auditory content generation methods.

4.4 MULTIMODAL DATASETS

The cross-modal generation task focuses on obtaining information from the input mode and synthesizing its corresponding content in another mode. Due to the heterogeneity between modalities, cross-modal tasks are very challenging, and the process of extracting and representing data features directly affects the final performance of the model. At the same time, due to the lack of labeled datasets, many training tasks in the cross-modal domain are based on unsupervised learning of unlabeled datasets. High-quality learnable datasets play an important role in cross-modal tasks. This section reviews common multimodal datasets involved in visual content generation and auditory content generation, respectively.

FIGURE 4.8 Development timeline of visual content generation methods.

4.4.1 MULTIMODAL VISION-RELATED DATASETS

The multimodal datasets for visual content generation tasks mainly include two modes: text and vision. It can be divided into general datasets and artwork datasets; the former denotes the images and annotations of general objects, while the latter denotes the artworks with corresponding annotations. Art datasets may focus on a specific artistic style, period, or technique compared to standard datasets for computer vision. In addition, the artwork datasets have challenges in data collection and usage; for example, proper annotations for artworks can be affected by culture, language, and individual experience of annotators. What's worse, the racism, sexism, and cultural and linguistic hegemony in data lead to more serious problems. Table 4.5 summarizes classic high-quality multimodal vision-related datasets.

TABLE 4.5
Summary of Multimodal Vision-Related Datasets

Type	Datasets	Description	Year
Text-image datasets	Flickr [99]	over 1 billion images and millions of annotations	2009
	MS COCO [100]	more than 330K images and more than 200K annotations	2014
	Visual Genome [101]	over 100K images of 21 objects, 18 attributes and 18 pairwise relationships between objects	2016
	Art500k [102]	over 500K digital artworks, which is richly annotated by detailed labels	2017
	CODRAW dataset [103]	9,993 different scenarios with description conversation	2017
	OmniArt [104]	over 1 billion images with art attributes annotations	2018
	ArtEmis [105]	80K artworks from the Wikiart website and artificially marked 455K caption	2021
	LAION-5B [106]	5.85 billion CLIP-filtered image-text pairs	2022
	ArtBench-10 [107]	60K images of artwork from 10 distinctive artistic styles, a balanced dataset	2022

4.4.2 Multimodal Audio-Related Datasets

The multimodal datasets for auditory content generation tasks mainly include three modes: text, vision, and audio. It can be divided into text-audio datasets and vision-audio datasets. The former records data information such as words, sentences, speech, and music, while the latter consists of data such as video, speech, and music, aiming to provide information from representations for learning and translation. Table 4.6 summarizes classic high-quality multimodal audio-related datasets [6, 125].

TABLE 4.6
Summary of Multimodal Audio-Related Datasets

Type	Datasets	Description	Year
Text-audio datasets	musiXmatch [108]	237,662 song tracks and corresponding lyrics in bag-of-words format	2011
	LibriSpeech [109]	1,000 hours of audio clips from audiobook and corresponding text	2015
	FMA [110]	106,574 tracks from 16,341 artists and 14,854 albums with tags, and free-form biographies	2017
	Audio Set [111]	2,084,320 10-second sound clips from YouTube labeled by human with 527 classes	2017
	VOiCES [112]	15 hours of 3903 audio clips collected in complex environments, corresponding transcriptions, and speaker tags	2018
	Spotify Podcasts Dataset [113]	200,000 podcast episodes in English and Portuguese, and corresponding transcripts	2020
	Zhang et al. [36]	16,257 folk songs and corresponding description in ABC notation	2020
	Textune [114]	282,870 English text-music pairs described in ABC notation	2022
Vision-audio datasets	AFEW [115]	1,747 movies/TV video clips of multiple subjects with 7 expressions labels	2012
	CREMA-D [116]	7,442 clips of 91 actors rated in audio, visual, and audio-visual with categorical emotion labels	2014
	TCD-TIMIT [117]	Video and audio footage of 62 speakers reading 6,913 sentences with rich pronunciation	2015
	C4S [118]	4.5 hours of 9 distinct clarinetists performing 3 different classical music pieces with colored marker on the clarinet	2017
	RAVDESS [119]	7,356 recordings of emotional speech and song, and corresponding dynamic facial expressions	2018
	Lombard Grid [120]	Audio, front view video, and profile view video footage of 5,400 utterances of 54 speakers reading in Lombard and plain reference utterances	2018
	AVA-Actions [121]	43,015 minutes of movie clips with 1.62M action labels for 80 atomic visual actions	2018
	AVA-Active Speaker [122]	38.5 hours of temporally labeled face tracks, and the corresponding audio	2019
	URMP [123]	44 multi-instrument classical music performance pieces and corresponding tracks of individual tracks	2019
	Kinetics-700 [124]	700 human action classes with at least 600 video clips for each action	2019

4.5 CONCLUSIONS

In the context of AIGC, cross-modal generation of visual and auditory content is a very promising research direction. This chapter provides a detailed review of the accumulation and development of cross-modal generation in visual and auditory content. It gives relevant summary tables and taxonomy structures of cross-modal generation techniques and datasets. Cross-modal generation has made significant progress in text-to-vision, text-to-audio, and vision-to-audio directions. However, with widespread attention from various sectors of society to the AIGC field, content generation faces challenges of becoming more intelligent and practical. We hope that this chapter can help researchers gain a comprehensive understanding of the direction of cross-modal visual and auditory content generation and deepen their research interest in the field of multimodal tasks.

ACKNOWLEDGEMENTS

This work was supported by the National Natural Science Foundation of China (General Program, No. 62176006) and the National Key Research and Development Program of China (No. 2022YFF0902302).

REFERENCES

[1] T. Baltrušaitis, C. Ahuja, L. P. Morency. Multimodal machine learning: A survey and taxonomy. *IEEE Transactions on Pattern Analysis and Machine Intelligence*, vol. 41, no. 2, pp. 423–443, 2018.

[2] A. Krizhevsky, I. Sutskever, G. E. Hinton. Imagenet classification with deep convolutional neural networks. *Advances in Neural Information Processing systems*, vol. 25, 2012.

[3] S. Hochreiter, J. Schmidhuber. Long short-term memory. *Neural Computation*, vol. 9, no. 8, pp. 1735–1780, 1997.

[4] H. Shi, X. Shi, D. Yi, Z. Yi, X. Yi, S. Z. Li. Cross-modality face recognition via heterogeneous joint bayesian. *IEEE Signal Processing Letters*, vol. 24, no. 1, pp. 81–85, 2016.

[5] J. Devlin, M. Chang, K. Lee, K. Toutanova. BERT: Pre-training of deep bidirectional transformers for language understanding. *arXiv preprint arXiv: 1810.04805*, 2018.

[6] J. W. Liu, X. H. Ding, X. L. Luo. Survey of multimodal deep learning. *Application Research of Computers*, vol. 37, no. 6, pp. 1601–1614, 2020.

[7] K. S. Jones, S. Walker, S. E. Robertson. A probabilistic model of information retrieval: development and comparative experiments: Part 2. *Information Processing & Management*, vol. 36, no.6, pp. 809–840, 2000.

[8] A. Aizawa. An information-theoretic perspective of tf-idf measures. *Information Processing & Management*, vol. 39, no. 1, pp. 45–65, 2003.

[9] T. Mikolov, K. Chen, G. Corrado, J. Dean. Efficient estimation of word representations in vector space. *arXiv preprint arXiv:*1301.3781, 2013.

[10] J. Pennington, R. Socher, C. D. Manning. Glove: Global vectors for word representation. In *Proceedings of the 2014 conference on empirical methods in natural language processing (EMNLP)*, pp. 1532–1543, 2014.

[11] A. Vaswani, N. Shazeer, N. Parmar, J. Uszkoreit, J. Uszkoreit, L. Jones, A. N. Gomez, L. Kaiser, I. Polosukhin. Attention is all you need. In *Proceedings of the 31st International Conference on Neural Information Processing Systems*, pp. 5998–6008, 2017.

[12] A. Radford, J. Wu, R. Child, D. Luan, D. Amodei, I. Sutskever. Language Models are Unsupervised Multitask Learners. *OpenAI blog*, vol. 1, no. 8, pp. 9, 2019.

[13] T. B. Brown, B. Mann, N. Ryder, M. Subbiah, J. D. Kaplan, P. Dhariwal, D. Amodei. Language models are few-shot learners. *Advances in Neural Information Processing Systems*, vol. 33, pp. 1877–1901, 2020.

[14] OpenAI. GPT-4 Technical Report. *arXiv preprint arXiv: 2303.08774*, 2023.

[15] A. Krizhevsky, I. Sutskever, G. E. Hinton. Imagenet classification with deep convolutional neural networks. In *Advances in Neural Information Processing Systems (NeurIPS)*, 2012.

[16] K. Simonyan, A. Zisserman. Very deep convolutional networks for large-scale image recognition. *arXiv preprint arXiv:1409.1556*, 2014.

[17] C. Szegedy, W. Liu, Y. Jia, P. Sermanet, S. Reed, D. Anguelov, D. Erhan, V. Vanhoucke, A. Rabinovich. Going deeper with convolutions. In *Proceedings of the IEEE Conference on Computer Vision and Pattern Recognition (CVPR)*, pp. 1–9, 2015.

[18] K. He, X. Zhang, S. Ren, J. Sun. Deep residual learning for image recognition. In *Proceedings of the IEEE Conference on Computer Vision and Pattern Recognition (CVPR)*, pp. 770–778, 2016.

[19] G. Huang, Z. Liu, L. V. D. Maaten, K. Q. Weinberger. Densely connected convolutional networks. In *Proceedings of the IEEE Conference on Computer Vision and Pattern Recognition (CVPR)*, pp. 4700–4708, 2017.

[20] M. Tan, Q. V. Le. EfficientNet: Rethinking model scaling for convolutional neural networks. In *Proceedings of International Conference on Machine Learning (ICML)*, pp. 6105–6144, 2019.

[21] A. Dosovitskiy, L. Beyer, A. Kolesnikov, D. Weissenborn, D. Weissenborn, X. Zhai, T. Unterthiner, M. Dehghani, M. Minderer, G. Heigold, S. Gelly, J. Uszkoreit, N. Houlsby. An image is worth 16x16 words: transformers for image recognition at scale. *arXiv preprint arXiv: 2010.11929*, 2020.

[22] S. Ji, W. Xu, M. Yang, K. Yu. 3D convolutional neural networks for human action recognition. *IEEE Transactions on Pattern Analysis and Machine Intelligence (TPAMI)*, vol. 35, no. 1, pp. 221–231, 2012.

[23] R. Krishna, K. Hata, F. Ren, F. F. Li, J. Carlos Niebles. Dense-captioning events in videos. In *Proceedings of the IEEE International Conference on Computer Vision (ICCV)*, pp. 706–715, 2017.

[24] A. Karpathy, G. Toderici, S. Shetty, T. Leung, R. Sukthankar, F. F. Li. Large-scale video classification with convolutional neural networks. In *Proceedings of the IEEE Conference on Computer Vision and Pattern Recognition (CVPR)*, pp. 1725–1732, 2014.

[25] D. Steven, M. Paul. Comparison of parametric representations for monosyllabic word recognition in continuously spoken sentences. *IEEE Transactions on Acoustics, Speech, and Signal Processing*, vol. 28, no. 4, pp. 357–366, 1980.

[26] R. Haeb-Umbach, H. Ney. Linear discriminant analysis for improved large vocabulary continuous speech recognition. In *International Conference on Acoustics, Speech and Signal Processing (ICASSP)*, vol. 92, pp. 13–16, 1992.

[27] H. A. Bourlard, N. Morgan. Connectionist speech recognition: A hybrid approach. *Springer Science & Business Media*, vol. 247, 1994.

[28] T. Saramaki, R. Bregovic. Multirate systems and filterbanks. In *Multirate Systems: Design and Applications*, pp. 27–85. IGI Global, 2002.

[29] G. Hinton, L. Deng, D. Deng, G. E. Deng, A. R. Deng, N. Deng, B. Deng. Deep neural networks for acoustic modeling in speech recognition: The shared views of four research groups. *IEEE Signal Processing Magazine*, vol. 29, no. 6, pp. 82–97, 2012.

[30] H. Sak, O. Vinyals, G. Heigold, A. Senior, E. McDermott, R. Monga, M Mao. Sequence discriminative distributed training of long short-term memory recurrent neural networks. In *Proceedings of Interspeech*, 2014.

[31] J. Chorowski, D. Bahdanau, K. Cho, Y. Bengio. End-to-end continuous speech recognition using attention-based recurrent nn: First results. *arXiv preprint arXiv:1412.1602*, 2014.

[32] A. Van Den Oord, O. Vinyals. Neural discrete representation learning. In *Advances in Neural Information Processing Systems (NeurIPS)*, vol. 30, 2017.

[33] N. Srivastava, R. R. Salakhutdinov. Multimodal learning with deep Boltzmann machines. In *Advances in Neural Information Processing Systems (NeurIPS)*, vol. 25, 2012.

[34] P. S. Huang, X. He, J. Gao, L. Deng, A. Acero, L. Heck. Learning deep structured semantic models for web search using clickthrough data. In *Proceedings of the 22nd ACM International Conference on Information & Knowledge Management*, pp. 2333–2338, 2013.

[35] R. Kiros, R. Salakhutdinov, R. S. Zemel. Unifying visual-semantic embeddings with multimodal neural language models. *arXiv preprint arXiv:1411.2539*, 2014.

[36] Y. Zhang, Z. Wang, D. Wang, G. Xia. BUTTER: A representation learning framework for bi-directional music-sentence retrieval and generation. In *Proceedings of the 1st Workshop on NLP for Music and Audio (NLP4MusA)*, pp. 54–58, 2020.

[37] F. Rossetto, J. Dalton. Musicbert-learning multi-modal representations for music and text. In *Proceedings of the 1st Workshop on NLP for Music and Audio (NLP4MusA)*, pp. 64–66, 2020.

[38] J. Cong, S. Yang, L. Xie, D. S. Glow-Wavegan: Learning speech representations from gan-based variational auto-encoder for high fidelity flow-based speech synthesis. *arXiv preprint arXiv:2106.10831*, 2021.

[39] K. Wei, Y. Zhang, S. Sun, L. Xie, L. Ma. Leveraging acoustic contextual representation by audio-textual cross-modal learning for conversational ASR. *arXiv preprint arXiv:2207.01039*, 2022.

[40] H. Liu, Z. Chen, Y. Yuan, X. Yuan, X. Liu, D. Liu, M. D. Plumbley. Audioldm: Text-to-audio generation with latent diffusion models. *arXiv preprint arXiv:2301.12503*, 2023.

[41] J. Ngiam, A. Khosla, M. Kim, J. Nam, H. Lee, A. Y. Ng. Multimodal deep learning. In *Proceedings of the 28th International Conference on Machine Learning (ICML)*, pp. 689–696, 2011.

[42] Y. LeCun, L. Bottou, Y. Bengio, P. Haffner. Gradient-based learning applied to document recognition. *Proceedings of the IEEE*, vol. 86, no. 11, pp. 2278–2324, 1998.

[43] R. Hadsell, S. Chopra, Y. LeCun. Dimensionality reduction by learning an invariant mapping. In *2006 IEEE Computer Society Conference on Computer Vision and Pattern Recognition (CVPR'06)*, vol. 2, pp. 1735–1742, 2006.

[44] Y. Zhang, Z. R. Wang, J. Du. Deep fusion: An attention guided factorized bilinear pooling for audio-video emotion recognition. In *2019 International Joint Conference on Neural Networks (IJCNN)*, pp. 1–8, 2019.

[45] C. Athanasiadis, E. Hortal, S. Asteriadis. Audio–visual domain adaptation using conditional semi-supervised generative adversarial networks. *Neurocomputing*, vol. 397, pp. 331–344, 2020.

[46] Y. Zhu, Y. Wu, H. Latapie, Y. Yang, Y. Yan. Learning audio-visual correlations from variational cross-modal generation. In *ICASSP 2021-2021 IEEE International Conference on Acoustics, Speech and Signal Processing (ICASSP)*, pp. 4300–4304, 2021.

[47] T. Han, W. Xie, A. Zisserman. Video representation learning by dense predictive coding. In *Proceedings of the IEEE/CVF International Conference on Computer Vision Workshops*, 2019.

[48] L. P. Morency, P. P. Liang, A. Liang. Tutorial on multimodal machine learning. In *Proceedings of the 2022 Conference of the North American Chapter of the Association for Computational Linguistics: Human Language Technologies: Tutorial Abstracts*, pp. 33–38, 2022.

[49] K. Cho, B. V. Merrienboer, C. Gulcehre, D. Bahdanau, F. Bougares, H. Schwenk, Y. Bengio. Learning phrase representations using RNN encoder-decoder for statistical machine translation. *arXiv preprint arXiv:1406.1078*, 2014.

[50] F. Faghri, D. J. Fleet, J. R. Kiros, S. Fidler. Vse++: Improving visual-semantic embeddings with hard negatives. *arXiv preprint arXiv:1707.05612*, 2017.

[51] M. A. Shaikh, Z. Ji, D. Moukheiber, S. N. Srihari, M. Gao. LAViTeR: Learning aligned visual and textual representations assisted by image and caption generation. *arXiv preprint arXiv:2109.04993*, 2021.

[52] J. K. Chorowski, D. Bahdanau, D. Serdyuk, K. Cho, Y. Bengio. Attention-based models for speech recognition. In *Advances in Neural Information Processing Systems (NeurIPS)*, vol. 28, 2015.

[53] W. Chan, N. Jaitly, Q. Jaitly, O. Vinyals. Listen, attend and spell: A neural network for large vocabulary conversational speech recognition. In *2016 IEEE International Conference on Acoustics, Speech and Signal Processing (ICASSP)*, pp. 4960–4964, 2016.

[54] Y. Ren, Y. Ruan, X. Tan, T. Qin, S. Zhao, Z. Zhao, T. Y. Liu. Fastspeech: Fast, robust and controllable text to speech. In *Advances in Neural Information Processing Systems (NeurIPS)*, vol. 32, 2019.

[55] C. Yu, H. Lu, N. Hu, M. Yu, C. Weng, K. Xu, D. Y. Durian: Duration informed attention network for multimodal synthesis. *arXiv preprint arXiv:1909.01700*, 2019.

[56] J. Kim, S. Kim, J. Kong, S. Yoon. Glow-tts: A generative flow for text-to-speech via monotonic alignment search. In *Advances in Neural Information Processing Systems (NeurIPS)*, vol. 33, pp. 8067–8077, 2020.

[57] Y. Aytar, C. Vondrick, A. Torralba. Soundnet: Learning sound representations from unlabeled video. *Advances in Neural Information Processing Systems*, vol. 29, 2016.

[58] A. Owens, A. A. Efros. Audio-visual scene analysis with self-supervised multisensory features. In *Proceedings of the European Conference on Computer Vision (ECCV)*, pp. 631–648, 2018.

[59] D. Hu, Z. Wang, H. Xiong, D. Wang, F. Nie, D. Dou. Curriculum audiovisual learning. *arXiv preprint arXiv:2001.09414*, 2020.

[60] P. Morgado, Y. Li, N. Nvasconcelos. Learning representations from audio-visual spatial alignment. *Advances in Neural Information Processing Systems (NeurIPS)*, vol. 33, pp. 4733–4744, 2020.

[61] P. Morgado, N. Vasconcelos, I. Misra. Audio-visual instance discrimination with crossmodal agreement. In *Proceedings of the IEEE/CVF Conference on Computer Vision and Pattern Recognition*, pp. 12475–12486, 2021.

[62] T. Afouras, Y. M. Asano, F. Fagan, A. Vedaldi, F. Metze. Self-supervised object detection from audio-visual correspondence. In *Proceedings of the IEEE/CVF Conference on Computer Vision and Pattern Recognition (CVPR)*, pp. 10575–10586, 2022.

[63] H. Chen, G. G. Ding, X. D. Liu, Z. J. Lin, J. Liu, J. G. Han. Imram: Iterative matching with recurrent attention memory for cross-modal image-text retrieval. In *IEEE Conference on Computer Vision and Pattern Recognition (CVPR)*, pp. 12655–12663, 2020.

[64] A. Anand. Contrastive self-supervised learning, 2020. [Online]. Available: https://ankesh anand.com/blog/2020/01/26/contrative-self-supervised-learning.html

[65] S. Reed, Z. Akata, X. Yan, L. Logeswaran, B. Schiele, H. Lee. Generative adversarial text to image synthesis. In *Proceedings of International Conference on Machine Learning (ICML)*, pp. 1060–1069, 2016.

[66] H. Zhang, T. Xu, H. Li, S. Zhang, X. Wang, X. Huang, D. N. Metaxas. Stackgan: Text to photo-realistic image synthesis with stacked generative adversarial networks. In *Proceedings of the IEEE International Conference on Computer Vision (ICCV)*, pp. 5907–5915, 2017.

[67] J. Y. Zhu, T. Park, P. Isola, A. A. Efros. Unpaired image-to-image translation using cycle-consistent adversarial networks. In *Proceedings of the IEEE International Conference on Computer Vision (ICCV)*, pp. 2223–2232, 2017.

[68] T. Xu, P. Zhang, Q. Huang, H. Zhang, Z. Gan, X. Huang, X. He. Attngan: Fine-grained text to image generation with attentional generative adversarial networks. In *Proceedings of the IEEE Conference on Computer Vision and Pattern Recognition (CVPR)*, pp. 1316–1324, 2018.

[69] T. Qiao, J. Zhang, D. Xu, D. Tao. Mirrorgan: Learning text-to-image generation by redescription. In *Proceedings of the IEEE/CVF Conference on Computer Vision and Pattern Recognition (CVPR)*, pp. 1505–1514, 2019.

[70] M. Tao, H. Tang, F. Wu, X. Y. Jing, B. K. Bao, C. X. Tao. Df-Gan: Deep fusion generative adversarial networks for text-to-image synthesis. *arXiv preprint arXiv:2008.05865*, 2020.

[71] S. Ye, F. Liu, M. Tan. Recurrent affine transformation for text-to-image synthesis. *IEEE Transactions on Multimedia*, vol. 26, pp. 462–473, 2023.

[72] T. Galanos, A. Liapis, G. N. Yannakakis. AffectGAN: Affect-based generative art driven by semantics. In *2021 9th International Conference on Affective Computing and Intelligent Interaction Workshops and Demos (ACIIW)*, pp. 1–7, 2021.

[73] K. Dobler, F. Hübscher, J. Westphal, A. Sierra-Múnera, G. de Melo, R. Krestel. Art creation with multi-conditional StyleGANs. *arXiv preprint arXiv:2202.11777*, 2022.

[74] M. Ding, Z. Yang, W. Hong, W. Zheng, C. Zhou, D. Yin, J. Lin, X. Zou, Z. Shao, H. Yang, J. Tang. Cogview: Mastering text-to-image generation via transformers. In *Advances in Neural Information Processing Systems (NeurIPS)*, pp. 19822–19835, 2021.

[75] H. Zhang, W. Yin, Y. Fang, L. Li, B. Duan, Z. Wu, Y. Sun, H. Tian, H. Wu, H. Wang. ERNIE-VILG: Unified generative pre-training for bidirectional vision-language generation. *arXiv preprint arXiv: 2112.15283*, 2021.

[76] A. Ramesh, M. Pavlov, G. Goh, S. Gray, C. Voss, A. Radford, M. Chen, I. Sutskever. Zero-shot text-to-image generation. *arXiv preprint arXiv: 2102.12092*, 2021.

[77] R. Rassin, S. Ravfogel, Y. Goldberg. DALLE-2 is seeing double: Flaws in word-to-concept mapping in Text2Image models. *arXiv preprint arXiv:2210.10606*, 2022.

[78] C. Saharia, W. Chan, S. Saxena, L. Li, J. Whang, E. Denton, S. K. S. Ghasemipour, B. K. Ayan, S. S. Mahdavi, R. G. Lopes, T. Salimans, J. Ho, D. J. Fleet, M. Norouzi. Photorealistic text-to-image diffusion models with deep language understanding. *arXiv preprint arXiv: 2205.11487*, 2022.

[79] D. Matravers. *Art and Emotion*. Oxford University Press, 2001.

[80] A. Radford, J. W. Kim, C. Hallacy, A. Ramesh, G. Goh, S. Agarwal, G. Sastry, A. Askell, P. Mishkin, J. Clark, G. Krueger, I. Sutskever. Learning transferable visual models from natural language supervision. In *International Conference on Machine Learning (ICML)*, pp. 8748–8763, 2021.

[81] A. Van Den Oord, O. Vinyals. Neural discrete representation learning. In *Advances in Neural Information Processing Systems (NeurIPS)*, vol. 30, 2017.

[82] W. Wang, S. Xu, B. Xu. First step towards end-to-end parametric TTS synthesis: Generating spectral parameters with neural attention. In *Interspeech*, pp. 2243–2247, 2016.

[83] J. Sotelo, S. Sotelo, K. Kumar, J. F. Santos, K. Kastner, A. Courville, Y. Bengio. Char2wav: End-to-end speech synthesis. In *Proceedings of International Conference on Learning Representations (ICLR)*, 2017.

[84] Y. Wang, R. J. Skerry-Ryan, D. Skerry-Ryan, Y. Wu, R. J. Weiss, N. Jaitly, R. A. Saurous. Tacotron: Towards end-to-end speech synthesis. *arXiv preprint arXiv:1703.10135*, 2017.

[85] J. Shen, R. Pang, R. J. Weiss, M. Schuster, N. Jaitly, Z. Yang, Y. Wu. Natural tts synthesis by conditioning wavenet on mel spectrogram predictions. In *2018 IEEE International Conference on Acoustics, Speech and Signal Processing (ICASSP)*, pp. 4779–4783, 2018.

[86] C. Yu, H. Lu, N. Hu, M. Yu, C. Weng, K. Xu, D. Y. Durian: Duration informed attention network for multimodal synthesis. *arXiv preprint arXiv:1909.01700*, 2019.

[87] Y. Ren, C. Hu, X. Tan, T. Qin, S. Zhao, Z. Zhao, T. Y. Liu. Fastspeech 2: Fast and high-quality end-to-end text to speech. *arXiv preprint arXiv:2006.04558*, 2020.

[88] R. Huang, Z. Zhao, H. Liu, J. Liu, C. Cui, Y. Ren. Prodiff: Progressive fast diffusion model for high-quality text-to-speech. In *Proceedings of the 30th ACM International Conference on Multimedia*, pp. 2595–2605, 2022.

[89] R. Rombach, A. Blattmann, D. Lorenz, P. Esser, B. Ommer. High-resolution image synthesis with latent diffusion models. In *Proceedings of the IEEE/CVF Conference on Computer Vision and Pattern Recognition (CVPR)*, pp. 10684–10695, 2022.

[90] A. Agostinelli, T. I. Denk, Z. Borsos, J. Engel, M. Verzetti, A. Caillon, C. Frank. Musiclm: Generating music from text. *arXiv preprint arXiv:2301.11325*, 2023.

[91] F. Schneider, Z. Jin, B. Schölkopf. Moûsai: Text-to-music generation with long-context latent diffusion. *arXiv preprint arXiv:2301.11757*, 2023.

[92] T. Hueber, G. Bailly. Statistical conversion of silent articulation into audible speech using full-covariance HMM. *Computer Speech & Language*, vol. 36, pp. 274–293, 2016.

[93] A. Ephrat, S. Peleg. Vid2speech: Speech reconstruction from silent video. In *IEEE International Conference on Acoustics, Speech and Signal Processing (ICASSP)*, pp. 5095–5099, 2017.

[94] Y. Kumar, M. Aggarwal, P. Nawal, S. Satoh, R. R. Shah, R. Zimmermann. Harnessing AI for speech reconstruction using multi-view silent video feed. In *ACM International Conference on Multimedia*, pp. 1976–1983, 2018.

[95] H. Akbari, H. Arora, L. Cao, N. Mesgarani. Lip2audspec: Speech reconstruction from silent lip movements video. In *2018 IEEE International Conference on Acoustics, Speech and Signal Processing (ICASSP)*, pp. 2516–2520, 2018.

[96] C. Athanasiadis, E. Hortal, S. Asteriadis. Audio–visual domain adaptation using conditional semi-supervised generative adversarial networks. *Neurocomputing*, vol. 397, pp. 331–344, 2020.

[97] C. Gan, D. Huang, P. Chen, J. B. Tenenbaum, A. Torralba. Foley music: Learning to generate music from videos. In *Proceedings of European Conference on Computer Vision (ECCV)*, Glasgow, UK, August 23–28, 2020, Part XI 16, pp. 758–775. Springer International Publishing, 2020.

[98] R. Mira, K. Vougioukas, P. Ma, S. Petridis, B. W. Schuller, M. Pantic. End-to-end video-to-speech synthesis using generative adversarial networks. *IEEE Transactions on Cybernetics*, vol. 53, no. 6, pp. 3454–3466, 2022.

[99] T.-S. Chua, J. Tang, R. Hong, H. Li, Z. Luo, and Y. Zheng. Nus-wide: A real-world web image database from national university of Singapore. In *Proceedings of the ACM International Conference on Image and Video Retrieval*, pp. 1–9, 2009.

[100] T. Y. Lin, M. Maire, S. Belongie, J. Hays, P. Perona, D. Ramanan, C. L. Zitnick. Microsoft coco: Common objects in context. In *European Conference on Computer Vision (ECCV)*, pp. 740–755, 2014.

[101] R. Krishna, Y. Zhu, O. Groth, J. Johnson, K. Hata, J. Kravitz, S. Chen, Y. Kalantidis, L. J. Li, D. A. Shamma, M. S. Bernstein, F. F. Li. Visual genome connecting language and vision using crowdsourced dense image annotations. *International Journal of Computer Vision (IJCV)*, vol. 123, pp. 32–73, 2017.

[102] H. Mao, M. Cheung, J. She. DeepArt: Learning joint representations of visual arts. In *Proceedings of ACM International Conference on Multimedia (MM)*. pp. 1183–1191, 2017.

[103] J. H. Kim, N. Kitaev, X. Chen, M. Rohrbach, B. T. Zhang, Y. Tian, D. Parikh. CoDraw: Collaborative drawing as a testbed for grounded goal-driven communication. *arXiv preprint arXiv:1712.05558*, 2017.

[104] G. Sterzoski, M. Worring. OmniArt: A large-scale artistic benchmark. In *ACM Transactions on Multimedia Computing, Communications, and Applications (TOMM)*, vol. 14, no. 4, pp. 88:1–88:21, 2018.

[105] P. Achlioptas, M. Ovsjanikov, K. Haydarov, M. Elhoseiny, L. J. Guibas. Artemis: Affective language for visual art. In *Proceedings of the IEEE/CVF Conference on Computer Vision and Pattern Recognition (CVPR)*, pp. 11569–11579, 2021.

[106] C. Schuhmann, R. Beaumont, R. Vencu, C. Gordon, R. Wightman, M. Cherti, T. Coombes, A. Katta, C. Mullis, M. Wortsman, P. Schramowski, S. Kundurthy, K. Crowson, L. Schmidt, R. Kaczmarczyk, J. Jitsev. LAION-5B: An open large-scale dataset for training next for training next generation image-text models. In *Neural Information Processing Systems (NeurIPS)*, pp. 25278–25294, 2022.

[107] P. Liao, X. Li, X. Liu, K. Keutzer. The ArtBench dataset: Benchmarking generative models with artworks. *arXiv preprint arXiv:2206.11404*, 2022.

[108] T. Bertin-Mahieux, D. P. Ellis, B. Whitman, P. Lamere. The million song dataset. In *Proceedings of the 12th International Society for Music Information Retrieval Conference (ISMIR 2011)*, 2011.

[109] V. Panayotov, G. Chen, D. Povey, S. Khudanpur. Librispeech: An ASR corpus based on public domain audio books. In *2015 IEEE International Conference on Acoustics, Speech and Signal Processing (ICASSP)*, pp. 5206–5210. IEEE, 2015.

[110] M. Defferrard, K. Benzi, P. Vandergheynst, X. Bresson. FMA: A dataset for music analysis. In *International Society for Music Information Retrieval Conference (ISMIR)*, 2017.

[111] J. F. Gemmeke, D. P. Ellis, D. Freedman, A. Jansen, W. Lawrence, R. C. Moore, M. Plakal, M. Ritter. Audio set: An ontology and human-labeled dataset for audio events. In *IEEE International Conference on Acoustics, Speech and Signal Processing (ICASSP)*. IEEE, pp. 776–780, 2017.

[112] C. Richey, M. A. Barrios, Z. Armstrong, C. Bartels, H. Franco, M. Graciarena, K. Ni. Voices obscured in complex environmental settings (voices) corpus. *arXiv preprint arXiv:1804.05053*, 2018.

[113] A. Clifton, S. Reddy, Y. Yu, A. Pappu, R. Rezapour, H. Bonab, R. Jones. 100,000 podcasts: A spoken English document corpus. In *Proceedings of the 28th International Conference on Computational Linguistics*, pp. 5903–5917, 2020.

[114] S. Butter, M. Sun. Exploring the efficacy of pre-trained checkpoints in text-to-music generation task. *arXiv preprint arXiv:2211.11216*, 2022.

[115] A. Dhall, R. Goecke, S. Lucey, T. Gedeon. Collecting large, richly annotated facial-expression databases from movies. *IEEE Multimedia*, vol. 19, no. 3, pp. 34–41, 2012.

[116] H. Cao, D. G. Cooper, M. K. Keutmann, R. C. Gur, A. Nenkova, R. Verma. Crema-d: Crowd-sourced emotional multimodal actors dataset. *IEEE Transactions on affective computing (TAC)*, vol. 5, no. 4, pp. 377–390, 2014.

[117] N. Harte, E. Gillen. Tcd-timit: An audio-visual corpus of continuous speech. *IEEE Transactions on Multimedia*, pp. 603–615, 2015.

[118] A. Bazzica, J. van Gemert, C. C. Liem, A. Hanjalic. Vision-based detection of acoustic timed events: a case study on clarinet note onsets. *arXiv preprint arXiv:1706.09556*, 2017.

[119] S. R. Livingstone, F. A. Russo. The Ryerson audio-visual database of emotional speech and song (Ravdess): A dynamic, multimodal set of facial and vocal expressions in north American English. *PLoS One*, vol. 13, no. 5, e0196391, 2018.

[120] N. Alghamdi, S. Maddock, R. Marxer, J. Barker, G. J. Brown. A corpus of audio-visual Lombard speech with frontal and profile views. *The Journal of the Acoustical Society of America*, vol. 143, no. 6, pp. EL523–EL529, 2018.

[121] C. Gu, C. Sun, D. A. Ross, C. Vondrick, C. Pantofaru, Y. Li, S. Vijayanarasimhan, G. Toderici, S. Ricco, R. Sukthankar. Ava: A video dataset of spatio-temporally localized atomic visual actions. In *Proceedings of the IEEE Conference on Computer Vision and Pattern Recognition (CVPR)*, pp. 6047–6056, 2018.

[122] J. Roth, S. Chaudhuri, O. Klejch, R. Marvin, A. Gallagher, L. Kaver, S. Ramaswamy, A. Stopczynski, C. Schmid, Z. Xi. Ava-activespeaker: An audio-visual dataset for active speaker detection. *arXiv preprint arXiv:1901.01342*, 2019.

[123] B. Li, X. Liu, K. Dinesh, Z. Duan, G. Sharma. Creating a multitrack classical music performance dataset for multimodal music analysis: Challenges, insights, and applications. *IEEE Transactions on Multimedia*, vol. 21, no. 2, pp. 522–535, 2019.

[124] J. Carreira, E. Noland, C. Hillier, A. Zisserman. A short note on the kinetics-700 human action dataset. *arXiv preprint arXiv:1907.06987*, 2019.

[125] H. Zhu, M. D. Luo, R. Wang, A. H. Zheng, R. He. Deep audio-visual learning: A survey. *International Journal of Automation and Computing*, vol. 18, pp. 351–376, 2021.

5 Artistic Text Style Transfer

Shuai Yang, Zhengbo Xu, Wenjing Wang, and Jiaying Liu
Peking University, Beijing, China

5.1 INTRODUCTION

Word art, which refers to text displayed in an aesthetically pleasing artistic manner, has been a popular art form throughout history. The use of artistic text effect holds significant aesthetic value and symbolic meaning. By incorporating suitable effect, text becomes more visually appealing and enhances the overall atmosphere of a scene. As a result, artistic text effect finds extensive application in publicity and advertising.

Some text style is simple, such as colors and shadows, while others can be more intricate, like the burning flames depicted in Figure 5.1 and the flowing water, jagged leaves, exquisite decorations showcased, and even font style in Figure 5.2. Creating vivid text effect manually is a time-consuming process that involves a series of complex tasks, such as observing the desired glyphs, designing suitable artistic effect, and manipulating textures to match the character shapes. Even experienced designers spend hours to achieve desired results. To streamline the production of word art and improve efficiency, **artistic text style transfer** has been proposed. This approach enables automated rendering of text with predefined artistic effect, making the process more convenient and efficient.

The text style transfer problem can be categorized into two main types: supervised and unsupervised. The supervised approach, depicted in Figure 5.1(a), requires both the source effect S' and the corresponding non-stylized image S. The algorithms learn the transformation between these two inputs and then apply it to the target text T to generate the stylized result T'. On the other hand, unsupervised text style transfer, shown in Figure 5.1(b), eliminates the need for S and directly builds the transformation by extracting suitable features from the source effect S' and target text T. This approach allows for more flexibility in the choice of S', as S' can be any arbitrary style image in addition to text effect.

Regarding learning strategies, existing text style transfer methods can be further classified into non-deep patch-based approaches and deep-based approaches. In this chapter, we will introduce representative methods from each category, and discuss dataset and performance evaluation.

DOI: 10.1201/9781003406273-5

FIGURE 5.1 The overview of application scenarios of text style transfer methods. (a) Supervised text style transfer. (b) Unsupervised text style transfer.

FIGURE 5.2 Some results of different text style transfer methods. (a) User-interactive text effect transfer. (b) Decorative text effect transfer. (c) Shape-matching text effect transfer. (d) Joint text effect and font transfer.

5.2 PATCH-BASED SUPERVISED TEXT EFFECT TRANSFER

Supervised text effect transfer takes as input a set of three images, the source raw text image S, the source text effect image S', and the target raw text image T, then automatically produces the target stylized image T' with the text effect as in S'.

This task has three challenges: (i) The extreme diversity of the text effect: the style diversity makes the transfer task difficult to model uniformly; (ii) The complicated composition of style elements: a text effect image often contains multiple intertwined style elements with very different textures and structures and needs specialized treatments; (iii) The simpleness of guidance images: the raw plain text S as guidance gives few hints on how to place different style elements.

T-Effect [1] first proposes a patch-based solution to solve these challenges. It analyzes the characteristics of text effect and formulates it as a text effect prior to guiding the style transfer process. This section will introduce the text effect prior proposed in T-Effect and detail its patch-based text effect transfer solution. Figure 5.3 shows an overview of its transfer results.

5.2.1 CHARACTERISTICS OF TEXT EFFECT

T-Effect puts forward the key characteristics of text effect that *there is a high correlation between patch patterns (i.e., color and scale) and their distances to text skeletons*. It points out that textures with similar distances to the text skeleton tend to share similar patterns. It is schematically illustrated in Figure 5.4(b) and (d) where the patches with the same distance to the skeleton (in white) are marked by the same color. This observation is consistent with the texture adaptation based on text shapes for readability conducted by designers in the real world. Therefore, a good text effect transfer method needs to maintain these key characteristics when generating new artistic text.

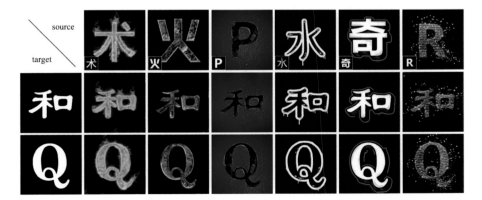

FIGURE 5.3 Visual results of T-Effect for patch-based supervised text effect transfer. Given source well-designed text effect and its raw glyph image in the lower left corner, T-Effect renders the text style onto target glyph images.

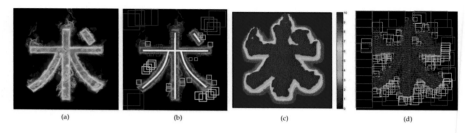

(a) (b) (c) (d)

FIGURE 5.4 Statistics of the text effect images. (a) *Flame* text effect. (b) Textures with simi-lar distances to the text skeleton (in white) tend to have similar patterns. (c) Detected optimal patch scales. (d) Visualized optimal patch scales.

Then, T-Effect tries to convert the aforementioned analysis into patch statistics that can be directly used as the patch-based transfer guidance. Specifically, T-Effect detects the optimal scales for source patches and estimates their normalized distances to the text skeleton. The algorithm is then able to derive the posterior probability of the optimal scale for each patch based on its spatial position.

For the patch-based algorithm, this section uses p and q to denote the pixels in T/T' and S/S', respectively, and uses $P(p)$ and $P'(p)$ to represent the patches centered at p in T and T', respectively. The same goes for patches $Q(q)$ and $Q'(q)$ in S and S'.

Inspired by [2], T-Effect proposes a simple yet effective approach to detect the optimal patch scale scal(q) to depict texture patterns round q. Given a predefined downsample factor s, T-Effect starts from the max (roughest) scale L to filter source patches and lets the screened patches pass to a finer scale.

T-Effect uses a fixed patch size of $m \times m$ and resizes the image to accomplish mul-tiple scales. Let $S\ell$ be the downsampled source S with a scale rate of $1/s^{\ell-1}$ and $Q_\ell(q)$ be the patch centered at $q/s^{\ell-1}$ in S_ℓ. S'_ℓ and $Q'_\ell(q)$ are similarly defined.

If \hat{q} is the correspondence of q at scale ℓ such that

$$\hat{q} = \arg\min \left\| Q_\ell(q) - Q_\ell(\hat{q}) \right\|^2 + \left\| Q'_\ell(q) - Q'_\ell(\hat{q}) \right\|^2, \tag{5.1}$$

then the filter criterion at scale ℓ is

$$\zeta_\ell(q,\hat{q}) = (\sigma_\ell + \sqrt{d_\ell(q,\hat{q})} > \omega), \tag{5.2}$$

where $\sigma_\ell = \sqrt{\mathrm{Var}(Q'_\ell(q))}/2$. Patches that satisfy the filter criterion pass through to finer scale $\ell - 1$, while the filter residues set ℓ as their optimal scales. An example of the optimal scales for the *flame* image is shown in Figure 5.4(c). It is found that the textured region near the character requires finer patch scales than the outer flat region. Figure 5.4(d) visualizes the optimal scale of the patch $Q(q)$.

5.2.1.1 Robust Normalized Distance Estimation

The next step is to determine the distance between each pixel to the text skeleton. In the text image, its text region is denoted by Ω. The skeleton skel(Ω) is a kernel path within Ω. dist(q, A) denotes the distance between q and its nearest pixel in

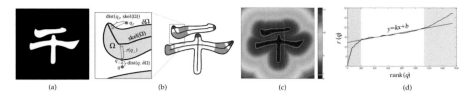

FIGURE 5.5 Robust normalized distance estimation. (a) The text image. (b) Our detected text skeleton and the notation definition. (c) The estimated normalized distance. The distance of the pixels on the text boundary to the text skeleton are normalized to 1 (colored by magenta). (d) The statistics of the text width.

set A. The goal is to calculate dist(q, skel(Ω)). For q on the text contour $\delta\Omega$, the distance is also known as the text width or radius $r(q)$. Figure 5.5(b) gives the visual interpretation.

T-Effect extracts skel(Ω) from S using morphology operations. To ensure the distance invariant to the text width, T-Effect normalizes the distance so that the normalized text width equals to 1. Simply dividing the distance by the text width is unreliable because the inaccuracy of the obtained skel(Ω) leads to errors both in the numerator and denominator as well. To address this issue, T-Effect estimates corrected text width $\tilde{r}(q)$ based on statistics and uses the accurate dist(q, $\delta\Omega$) to derive normalized $\widetilde{\text{dist}}\left(q,\text{skel}(\Omega)\right)$.

Specifically, T-Effect sorts $r(q)$, $\forall q \in \delta\Omega$ to obtain their rankings rank(q). The relation between $r(q)$ and rank(q) can be well modeled by linear regression, as shown in Figure 5.5(d). From Figure 5.5(b), (d), outliers assemble at small values. Therefore, T-Effect empirically assumes the leftmost 20% points are outliers and eliminates them by

$$\tilde{r}(q) = \max\left(\text{dist}\left(q,\text{skel}(\Omega)\right),0.2k\left|\delta\Omega\right|+b\right), \tag{5.3}$$

where k, b are linear regression coefficients, $|\delta\Omega|$ is the pixel number of $\delta\Omega$. Finally, the normalized distance is obtained,

$$\widetilde{\text{dist}}\left(q,\text{skel}(\Omega)\right) = \begin{cases} 1+\text{dist}\left(q,\delta\Omega\right)/\bar{r}, \text{if } q \notin \Omega \\ 1-\text{dist}\left(q,\delta\Omega\right)/\tilde{r}\left(q_\perp\right), \text{other} \end{cases}, \tag{5.4}$$

where $q_\perp \in \delta\Omega$ is the nearest pixel to q along $\delta\Omega$ and $\bar{r} = 0.5k\left|\delta\Omega\right|+b$ is the mean text width.

For simplicity, this section will omit skel(Ω) and use dist(q) to refer to $\widetilde{\text{dist}}\left(q,\text{skel}(\Omega)\right)$ in the following.

5.2.1.2 Optimal Scale Posterior Probability Estimation

Finally, it is possible to derive the posterior probability of the optimal patch scale to model the aforementioned high correlation between patch patterns and their spatial distributions.

Specifically, T-Effect uniformly quantifies all distances into 100 bins and denotes bin(q) as the bin q belongs to. Then, a 2-d histogram hist(ℓ, x) is computed:

$$\text{hist}\left(\ell,x\right) = \sum_{q} \psi\left(\text{scal}\left(q\right) = \ell \wedge \text{bin}\left(q\right) = x\right), \tag{5.5}$$

where $\psi(\cdot)$ is 1 when the argument is true and 0 otherwise. And the joint probability of the distance and the optimal scale can be estimated as,

$$\mathcal{P}\left(\ell,x\right) = \text{hist}\left(\ell,x\right) / \sum_{\ell,x} \text{hist}\left(\ell,x\right). \tag{5.6}$$

Finally, the posterior probability $\mathcal{P}\left(\ell \mid \text{bin}\left(q\right)\right)$ for ℓ being the appropriate scale to depict the patches with distances corresponding to bin(q) can be deduced:

$$\mathcal{P}(\ell \mid \text{bin}\left(q\right)) = \mathcal{P}\left(\ell, \text{bin}\left(q\right)\right) / \sum_{\ell} \mathcal{P}\left(\ell, \text{bin}\left(q\right)\right). \tag{5.7}$$

T-Effect assumes T' shares the same posterior probability with S' and uses this probability to select patch scales statistically for texture synthesis to adapt extremely various text effect.

5.2.2 TEXT EFFECT TRANSFER

T-Effect adapts the conventional texture synthesis method with the obtained posterior probability to dealing with the challenging text effect. Briefly, the texture synthesis method is based on PatchMatch [3, 4] to iteratively finding and fusing matched patches to minimize a predefined objective function. In the matching step, PatchMatch algorithm [3, 4] is adopted to find best matched patches from S' for each patch of T', where the objective function measures how well two patches are matched. In the voting step, all matched patches are averaged throughout the overlapped region and the resulting image serves as the updated T'.

Now, the key problem goes to designing a suitable objective function. T-Effect applies character shape constraints to the patch appearance measurement and further incorporates the estimated text effects statistics to accomplish adaptive multi-scale style transfer (Section 5.2.2.2). Then a distribution term is introduced to adjust the spatial distribution of the text sub-effects (Section 5.2.2.3). Finally, a psycho-visual term is introduced to prevent texture over-repetitiveness for naturalness (Section 5.2.2.4).

5.2.2.1 Objective Function

The objective function takes the following form,

$$\min_{q} \sum_{p} E_{\text{app}}\left(p,q\right) + \lambda_1 E_{\text{dist}}\left(p,q\right) + \lambda_2 E_{\text{psy}}\left(p,q\right), \tag{5.8}$$

where p is the center position of a target patch in T and T', q is the center position of the corresponding source patch in S and S'. The three terms E_{app}, E_{dist}, and E_{psy} are the appearance, distribution, and psycho-visual terms, respectively, which are weighted by λ_1 and λ_2 to together make up the patch distance.

5.2.2.2 Appearance Term: Texture Style Transfer

The appearance term minimizes the Sum of the Squared Differences (SSD) of two patches sampled from text effect image pair S'/T' as well as the SSD of two corresponding patches sampled from the text image pair S/T:

$$E_{\text{app}}(p,q) = \lambda_3 \left\| P(p) - Q(q) \right\|^2 + \left\| P'(p) - Q'(q) \right\|^2, \qquad (5.9)$$

where λ_3 is a weight that compromises between the color difference and character shape difference.

Stylized texts often contain multiple style elements with different optimal representation scales. Thus, the appearance term additionally uses an adaptive scale-aware patch distance to incorporate the estimated posterior probability,

$$E_{\text{app}}(p,q) = \lambda_3 \sum_{\ell} \mathcal{P}\left(\ell \mid \text{bin}(p)\right) \left\| P_{\ell}(p) - Q_{\ell}(q) \right\|^2$$
$$+ \sum_{\ell} \mathcal{P}\left(\ell \mid \text{bin}(p)\right) \left\| P'_{\ell}(p) - Q'_{\ell}(q) \right\|^2. \qquad (5.10)$$

The posterior probability helps to explore patches through multiple appropriate scales for better textures synthesis.

5.2.2.3 Distribution Term: Spatial Style Transfer

The distribution of style elements highly correlates with their distances to the text skeleton. Based on this prior, T-Effect designs a distribution term,

$$E_{\text{dist}}(p,q) = \left(\text{dist}(p) - \text{dist}(q)\right)^2 \Big/ \max\left(1, \text{dist}^2(p)\right), \qquad (5.11)$$

which encourages the text effect of the target to share similar distribution with the source image, thereby realizing a spatial style transfer. To ensure that the cost is invariant to the image scale, a denominator $\max(1, \text{dist}^2(p))$ is added.

5.2.2.4 Psycho-Visual Term: Naturalness Preservation

Texture over-repetitiveness can seriously reduce human subjective evaluation in the aesthetics. Therefore, T-Effect penalizes certain source patches to be selected repetitiously.

Let $\Phi(q)$ be the set of pixels that currently finds q as their correspondence and $|\Phi(q)|$ be the size of the set. The psycho-visual term is defined as,

$$E_{\text{psy}}(p,q) = \left|\Phi(q)\right|. \qquad (5.12)$$

This repetitiveness penalty can be viewed from the perspective of q:

$$\sum_{p}\left|\Phi(q)\right| = \sum_{q}\sum_{p\in\Phi(q)}\left|\Phi(q)\right| = \sum_{q}\left|\Phi(q)\right|^{2}. \tag{5.13}$$

Since A = B, where A is literally the rightmost of 5.13 after "=" without the square, and B is literally the absolute value of T is constant, Eq. (5.13) reaches the minimum when all $|\Phi(q)|$ equals. It means the psycho-visual term encourages source patches to be used evenly.

5.3 PATCH-BASED UNSUPERVISED ARTISTIC TEXT STYLE TRANSFER

The goal of unsupervised artistic text style transfer is to stylize the target text image T based on an arbitrary style image S'. In previous text effect transfer method T-Effect [1], distribution prior is a key factor to its success. However, this prior requires that S' has highly structured textures with its non-stylized counterpart S provided. By comparison, unsupervised task solves a tougher style transfer problem, where S is not provided and S' contains arbitrary textures. To meet these challenges, UT-Effect [5] proposes to build a mapping between T and S' using a binary imagery S of S', and gradually narrow their visual discrepancy by structure and texture transfer.

Additionally, UT-Effect considers the layout design problem for seamlessly synthesizing artistic text in the background image to create visual-textual design artwork such as posters and magazine covers. The goal is to synthesize T into a background image I with the style of S'. UT-Effect formulates an optimization function to estimate the optimal embedding position \hat{R} of T. And the patch-based text effect transfer is adjusted to incorporate contextual information of I for seamless image synthesis. In Figure 5.6, four visual-textual presentations generated by UT-Effect are given. In the example *barrier reef*, a LOVE-shaped barrier reef is created, which is visually consistent with the background photo. The example *cloud* shows that new elements can be integrated into the background, i.e., clouds with a specific text shape are synthesized in the clear sky.

5.3.1 TEXT STYLE TRANSFER FROM ARBITRARY STYLE IMAGES

Figure 5.7 illustrates the main idea of UT-Effect. For the first subtask, instead of directly handling S' and T, UT-Effect abstracts a binary image S from S', serving as a

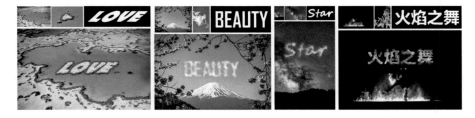

FIGURE 5.6 Visual-textual presentation synthesis. For each result group, three images in the upper row are I, S', and T, respectively. The lower one is our result.

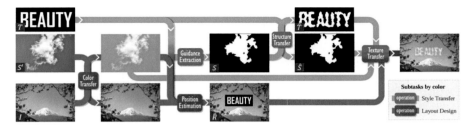

FIGURE 5.7 Overview of the UT-Effect unsupervised artistic text style transfer algorithm. UT-Effect consists of two subtasks: style transfer for stylizing the target text image T based on a style image S' and layout design for synthesizing the stylized image into a background image I.

bridge based on the color features and contextual information of S' (Section 5.3.1.1). Since the textons in S' and the glyphs in T probably do not match, a legibility-preserving structure transfer algorithm is proposed to adjust the contours of S and T to narrow the structural difference between them (Section 5.3.1.2). The resulting \hat{S} and \hat{T} share the same structural features and establish an effective mapping between S' and T. Given \hat{S} and S', UT-Effect synthesizes textures for \hat{T} by objective function optimization (Section 5.3.1.3).

5.3.1.1 Guidance Map Extraction

The perception of texture is a process of acquiring abstract imagery, which enables us to see concrete images from the disordered (such as clouds). Following human's abstraction of the texture information, UT-Effect introduces a two-stage method to extract the binary imagery S from S'. S serves as a guidance map, where white pixels indicate the reference region for the shape interior (foreground) and black pixels for the shape exterior (background). The boundary of foreground and background depicts the morphological characteristics of the textures in S'.

In particular, UT-Effect uses the Relative Total Variation (RTV) [6] to remove the color variance inside the texture and obtain a rough structure abstraction \bar{S}'. To prevent texture contours from being smoothed in \bar{S}' (see Figure 5.8(b), (f)), UT-Effect uses a two-stage abstraction method. In the first stage, pixels in S' are abstracted

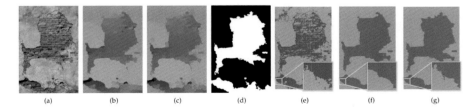

FIGURE 5.8 Guidance map extraction. Two-stage abstraction method generates guidance maps that well match the texture contours in S'. (a) Input S'. (b) Rough structure abstraction. (c) Super pixels colored by their mean pixel values in (b). (d) Extracted guidance map S. (e)–(g) K-means clustering results of (a)–(c), respectively. Cropped regions are zoomed for better comparison.

as fine-grained super pixels [7] to precisely match the texture contour. Each super pixel uses its mean pixel values in \overline{S}' as its feature vector to avoid the texture variance. In the second stage, the super pixels are further abstracted as the coarse-grained foreground and background via K-means clustering ($K = 2$). Figure 5.8 shows an example where UT-Effect's two-stage method generates accurate abstract imagery of the plaster wall.

Finally, UT-Effect uses the saliency as a criterion to determine the foreground and background of the image. Pixel saliency in S' is detected [8], and the cluster with higher mean pixel saliency is set as the foreground.

5.3.1.2 Structure Transfer

Directly using S extracted in Section 5.3.1.1 and the input T for style transfer results in unnatural texture boundaries, as shown in Figure 5.9(d). UT-Effect employs the shape synthesis technique [9] to minimize structural inconsistencies between S and T. In Layered Shape Synthesis (LSS) [9], shapes are represented as a collection of boundary patches at multiple resolution, and the style of a shape is transferred onto another by optimizing a bidirectional similarity function. UT-Effect further considers the legibility into LSS to prevent the shape from becoming illegible after adjustment, as shown in the second row of Figure 5.10(b).

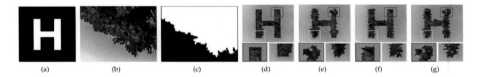

(a) (b) (c) (d) (e) (f) (g)

FIGURE 5.9 Benefits of bidirectional structure transfer. The forward transfer simulates the distribution of leaves along the shape boundary, while the backward transfer generates the fine details of each leaf shape. Their combination creates vivid leaf-like typography. (a)–(c) T, S', and S. (d)–(g) Text stylization results using (d) original $T + S$, (e) forward transfer $\hat{T} + S$, (f) backward transfer $T + \hat{S}$, and (g) bidirectional transfer $\hat{T} + \hat{S}$.

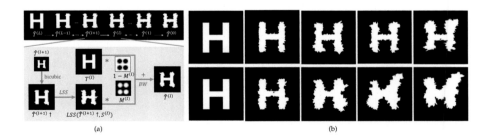

(a) (b)

FIGURE 5.10 Legibility-preserving structure transfer. (a) Preserving the stroke trunks by weighted combination of the trunk region from $T^{(l)}$ and the stroke end region from the shape synthesis result. (b) Top row: The legibility-preserving structure transfer result $\hat{T}^{(0)}$. Bottom row: structure transfer result $\hat{T}^{(0)}$ without stroke trunk protection mechanism. As L increases, the deformation degree also increases. Without the stroke trunk protection mechanism, the shape legibility is severely reduced. 'H' is deformed like 'X' 'M' in the bottom row.

The main idea of the legibility-preserving structure transfer method is to adjust the shape of the stroke ends while preserving the shape of the stroke trunk, because the legibility of a glyph is mostly determined by the shape of its trunk. Toward this, UT-Effect extracts the skeleton from T and detects the stroke end as a circular region centered at the endpoint of the skeleton. For each resolution level l, a mask $M^{(l)}$ indicating the stroke end regions is generated, as shown in Figure 5.10(a). At the top level $l = L$, the radius of the circular region is set to the average radius of the stroke calculated by the method of [1]. The radius increases linearly as the resolution increases. And at the bottom level $l = 0$ (original resolution), it is set to just cover the entire shape. Let $T^{(l)}$, $S^{(l)}$, and $\hat{T}^{(l)}$ denote the downsampled T, downsampled S, and the legibility-preserving structure transfer result at level l, respectively. Given $M^{(l)}$, $T^{(l)}$, $S^{(l)}$, and $\hat{T}^{(l+1)}$, we calculate $\hat{T}^{(l)}$ by

$$\hat{T}^{(l)} = BW\left(M^{(l)} * \mathrm{LSS}\left(\hat{T}^{(l+1)} \uparrow, S^{(l)}\right) + \left(1 - M^{(l)}\right) * T^{(l)}\right), \qquad (5.14)$$

where $*$ is the element-wise multiplication operator and \uparrow is the bicubic upsampling operator. $\mathrm{LSS}(T, S)$ is the shape synthesis result of T given S as the shape reference by LSS, and $BW\,(\cdot)$ is the binarization operation with threshold 0.5. Since the image resolution at the top level L is fixed, the deformation degree is solely controlled by L. Figure 5.10 shows that the stroke trunk protection mechanism effectively balances structural consistency with shape legibility even under a very large L.

In addition, UT-Effect proposes a bidirectional structure transfer (Figure 5.9(d)–(g)) to further enhance the shape consistency, where a backward transfer is added after the forward transfer. The backward transfer migrates the structural style of the forward transfer result \hat{T}^0 back to S to obtain \hat{S}^0 using the original LSS algorithm. The results $\hat{T}^{(0)}$ and $\hat{S}^{(0)}$ will be used as guidance for texture transfer. For simplicity, the superscripts are omitted in the following.

5.3.1.3 Texture Transfer

Since S' is not a well-structured text effect, the distribution prior used in T-Effect [1] to ensure shape legibility takes limited effect. By comparison, UT-Effect introduces a saliency cue for compensation. Based on the objective function of Eq. (5.8), a saliency term is added,

$$\min_{q} \sum_{p} E_a\left(p,q\right) + \lambda_1 E_d\left(p,q\right) + \lambda_2 E_p\left(p,q\right) + \lambda_3 E_s\left(p,q\right), \qquad (5.15)$$

where p is the center position of a target patch in \hat{T} and T', and q is the center position of the corresponding source patch in \hat{S} and S'. The four terms E_a, E_d, E_p, and E_s are the appearance, distribution, psycho-visual, and saliency terms, respectively, weighted by λ_s. The saliency term is defined as

$$E_s\left(p,q\right) = \begin{cases} W\left(p\right) \cdot \mathrm{Sal}(q), & \text{if } T\left(p\right) = 1 \\ W\left(p\right) \cdot \left(1 - \mathrm{Sal}(q)\right), & \text{if } T\left(p\right) = 0 \end{cases} \qquad (5.16)$$

(a) (b) (c) (d) (e)

FIGURE 5.11 Effects of the saliency term in texture transfer. The saliency term makes the foreground character more prominent and the background cleaner, thereby enhancing the legibility. (a) Style image. (b) Saliency map. (c) $\lambda 3 = 0.00$. (d) $\lambda 3 = 0.01$. (e) $\lambda 3 = 0.05$.

where $\mathrm{Sal}(q)$ is the saliency at pixel q in S'. Equation $W(p) = 1 - \exp\left(-dist(p)^2 / 2\sigma_1^2\right) / 2\pi\sigma_1^2$ is the Gaussian weight with $dist(p)$, the distance of p to the shape boundary. The saliency term encourages pixels inside the shape to find salient textures for synthesis and keeps the background less salient. Figure 5.11 shows that a higher weight of our saliency term makes the stylized shape more prominent.

5.3.2 VISUAL-TEXTUAL PRESENTATION GENERATION

As illustrated in Figure 5.7, for the second subtask of layout design, the color statistics of S' and I are first adjusted to ensure color consistency (Section 5.3.2.1). Then UT-Effect considers four cues of local variance, non-local saliency, coherence across images, and visual aesthetics to seek the optimal position of T in the background image (Section 5.3.2.2). Once the layout is determined, the background information around T will be collected. Constrained by this contextual information, the target shape is seamlessly synthesized into the background image in an image inpainting manner (Section 5.3.2.3).

5.3.2.1 Color Transfer

To prevent obvious color discontinuities between S' and I, UT-Effect employs color transfer technology [10]. This technique estimates a color affine transformation matrix and a bias vector that match the target mean and standard deviation of the color feature with the source ones. In general, color transfer in a local manner is more robust than the global method. Hence, UT-Effect further employs perception-based color clustering technique [11] to divide pixels into 11 color categories. The linear color transfer is performed within corresponding categories between S' and I.

5.3.2.2 Position Estimation

In order to synthesize the target shape seamlessly into the background image, the image layout should be properly determined. Both seamlessness and aesthetics of text placement are taken into account. Specifically, UT-Effect formulates a cost minimization problem for context-aware position estimation by considering the cost of each pixel x of I in four aspects,

$$\hat{R} = \arg\min_{R} \sum_{x \in R} U_v(x) + U_s(x) + U_c(x) + \lambda_4 U_a(x), \qquad (5.17)$$

where R is a rectangular area of the same size as T, indicating the embedding position. The position is estimated by searching an \hat{R} where pixels have the minimum

total costs. U_v and U_s are local variance and non-local saliency costs, concerning the background image I itself, and U_c is a coherence cost measuring the coherence between I and S'. In addition, U_a is the aesthetics cost for subjective evaluation, weighted by λ_4.

First, UT-Effect seeks flat regions for seamless embedding by using $U_v(x)$ as the intensity variance within a local patch centered at x. Then, a saliency cost $U_s(x) = \text{Sal}(x)$ that prefers non-salient regions is used. These two internal terms preclude the method from overlaying important objects in the background image with the target shape.

In addition, the mutual cost U_c measures the texture consistency between I and S'. More specifically, $U_c(x)$ is obtained by calculating the L_2 distance between the patch centered at x in I and its best matched patch in S'.

The seamlessness alone may find unimportant image corners for the target shape, which is not ideal for aesthetics.

Hence, UT-Effect also models the centrality of the shape by U_a

$$U_a(x) = 1 - \exp\left(-\text{dist}(x)^2 / 2\sigma_2^2\right), \tag{5.18}$$

where $\text{dist}(x)$ is the offset of x to the image center, and σ_2 is set to the length of the short side of I. Figure 5.12 visualizes these four costs, which jointly determine the ideal image layout.

As for the minimization of Eq. (5.17), the box filter is used to effectively solve the total costs for every valid R throughout I to choose the minimum one.

UT-Effect further considers the scales, rotations, and the placement of each individual characters of a word.

- **Text scale**. During the box filtering, UT-Effect enumerates the size of the box and then finds the global minimum penalty point throughout the space and scale. Specifically, a scaling factor ψ_s is enumerated over a range of

(a) (b)

(c) (d) (e) (f) (g)

FIGURE 5.12 Image layout is determined by jointly considering a local variance cost, a non-local saliency cost, a coherence cost, and an aesthetics cost. (a) Input text image, style image and background image. (b) Result. (c) Total placement cost. (d) Variance cost. (e) Saliency cost. (f) Coherent cost. (g) Aesthetics cost.

FIGURE 5.13 Text scale in position estimation. Top row: three images from left to right are I, S', and T, respectively. Bottom row: the resulting image layout using T of the original size (left) and the resulting image layout using T of the optimal size (right).

[0.8, 1.2] in steps of 0.1. Then the text box R is zoomed in or out based on ψ_s to obtain $\psi_s(R)$. Finally, the optimal embedding position and scale can be detected by

$$\hat{R}, \hat{\psi}_s = \arg \min_{R, \psi_s} \sum_{x \in \psi_s(R)} \frac{U_v(x) + U_s(x) + U_c(x) + \lambda_4 U_a(x)}{|\psi_s(R)|}. \tag{5.19}$$

Figure 5.13 shows an example where the target image T is originally too large and is automatically adjusted by the proposed method so that it could be seamlessly embedded into the background.

- **Text rotation**. Similar to the text scale, the rotation angle ψ_r can be also enumerated over a range of $[-\pi/6, \pi/6]$ in steps of $\pi/60$ to find the global minimum penalty point in the entire space and angle. The box filter is applied to the rotated cost map, followed by minimum point detection. Figure 5.14 shows an example where the target image T is automatically rotated to match the direction of the coastline.
- **Multiple characters**. To deal with multiple characters, UT-Effect first views them as a whole and optimizes Eq. (5.17) to search an initial position and then refine their layouts separately. In each refinement step, every character searches for the location with the lowest cost within its small spatial neighborhood to update its original position. After several steps, all the shapes converge to their respective optimal positions. To prevent the shapes from overlapping, the search space is limited to ensure the distance between adjacent shapes is not less than their initial distance. Figure 5.15 shows that

FIGURE 5.14 Text rotation in position estimation. Top row: three images from left to right are I, S', and T, respectively. Bottom row: the resulting image layouts without text rotation (left) and with text rotation (right).

FIGURE 5.15 Multi-shape placement in position estimation. Top row: three images from left to right are I, S', and T, respectively. Bottom row: the resulting image layouts without layout refinement (left) and with layout refinement (right).

after layout refinement, the characters on the left and right sides are adjusted to a more central position in the vertical direction, making the overall text layout better match the shape of the Ferris wheel.

5.3.2.3 Shape Embedding

Once the layout is determined, the final step is to synthesize the target shape into the background image in an image inpainting manner. UT-Effect sets \hat{R} as the unknown region of I and fills it with the textures of S' under the structure guidance of \hat{T} and \hat{S}. \hat{R} is first enlarged by expanding its boundary by 32 pixels. Let the augmented frame-like region be denoted as \hat{R}^+, and the pixel values of I in \hat{R}^+ provide contextual

information for the texture transfer. Throughout the coarse-to-fine texture transfer process described in Section 5.2.2, each voting step is followed by replacing the pixel values of T' in \hat{R}^+ with the contextual information $I\left(\hat{R}^+\right)$. This manner will enforce a strong boundary constraint to ensure a seamless transition at the boundary.

5.4 DEEP-BASED SUPERVISED TEXT EFFECT TRANSFER

Deep learning has achieved great success in recent years. Instead of operating on image patches, deep-based methods automatically extract features of artistic text effect and text shapes. These high-dimensional features learned from data disentangle the characteristics of word art and are easier to adjust. Thus, through operating in the feature space, deep-based methods serve as a more flexible and powerful editing tool.

5.4.1 TRANSFER EFFECT BY DISENTANGLING TEXT AND EFFECT

TET-GAN [12] is one of the first deep-based text effect transfer frameworks. TET-GAN disentangles and recombines the content and style features of text effect images so that it can simultaneously handle multiple styles. Figure 5.16(a) shows an example of ten different styles. In addition, the explicit style representations enable intelligent style editing. Figure 5.16(b) shows an example of style fusion. By interpolating between two different style features and decoding the integrated features back to the image space, TET-GAN can generate new text effect. Moreover, TET-GAN explores the scope of one-reference learning, semi-supervised learning, and joint font transfer.

(a) (b)

FIGURE 5.16 Style transfer results of TET-GAN. (a) One model can render multiple text styles. (b) Create new text effect by interpolating two text styles.

FIGURE 5.17 The TET-GAN architecture. (a) An overview of the TET-GAN architecture. The network is trained via three objectives: an autoencoder, destylization, and stylization. (b) A glyph autoencoder to learn content features. (c) Destylization by disentangling content features from text effect images. (d) Stylization by combining content and style features.

5.4.1.1 Network Architecture and Loss Function

The goal of TET-GAN is to learn a two-way mapping between two domains X and Y, which represent a collection of text images and text effect images, respectively. As shown in Figure 5.17, TET-GAN consists of two content encoders $\left\{E_X, E_y^c\right\}$, a style encoder $\left\{E_y^s\right\}$, two domain generators $\{G_X, G_Y\}$, and two domain discriminators $\{D_X, D_Y\}$. E_X and E_y^c map text images and text effect images, respectively, onto a shared content feature space, while E_y^s maps text effect images onto a style feature space. G_X generates text images from the encoded content features. G_Y generates text effect images conditioned on both the encoded content and style features. Based on the assumption that domains X and Y share a common content feature space, weights are shared between the last few layers of E_X and E_y^c, as well as the first few layers of G_X and G_Y. Discriminators are trained to distinguish the generated images from the real ones.

TET-GAN is trained on three tasks:

- **Glyph Autoencoder** $G_X \circ E_X \colon X \to X$ for learning content feature encoding;
- **Destylization** $G_X \circ E_y^c \colon Y \to X$ for learning content feature disentanglement from text effect images;
- **Stylization** $G_Y \circ \left\{E_X, E_y^s\right\} \colon X \times Y \to Y$ for learning style feature disentanglement and combination with content features.

Overall, the training objective is to solve the min-max problem:

$$\min_{E,G} \max_{D} \mathcal{L}_{\text{gly}} + \mathcal{L}_{\text{desty}} + \mathcal{L}_{\text{sty}}, \tag{5.20}$$

where \mathcal{L}_{gly}, $\mathcal{L}_{\text{desty}}$, and \mathcal{L}_{sty} are losses related to the glyph autoencoder, destylization, and stylization, respectively.

Glyph Autoencoder. First, the encoded content feature is required to preserve the core information of the glyph. Thus, an autoencoder L_1 loss is imposed to force the content feature to completely reconstruct the input text image:

$$\mathcal{L}_{\text{gly}} = \lambda_{\text{gly}} \mathbb{E}_x \left[\left\| G_x \left(E_x \left(x \right) \right) - x \right\|_1 \right]. \tag{5.21}$$

Destylization. For destylization, a text-style pair (x, y) is sampled from the training set. The idea is to map x and y onto a shared content feature space, where the feature can be used to reconstruct x. On this basis, TET-GAN introduces a L_1 loss:

$$\mathcal{L}_{\text{dpix}} = \mathbb{E}_{x,y}\left[\left\|G_x\left(E_y^c\left(y\right)\right)-x\right\|_1\right]. \tag{5.22}$$

Furthermore, E_y^c is expected to approach the ideal content feature extracted from x. To enforce this constraint, a feature loss is imposed:

$$\mathcal{L}_{\text{dfeat}} = \mathbb{E}_{x,y}\left[\left\|S_x\left(E_y^c\left(y\right)\right)-z\right\|_1\right], \tag{5.23}$$

where S_x represents the sharing layers of G_x and $z = S_x\left(E_x(x)\right)$. The feature loss $\mathcal{L}_{\text{dfeat}}$ guides the content encoder E_y^c to remove the style elements from the text effect image, preserving only the core information of the glyph.

Finally, a conditional adversarial loss is imposed to improve the quality of the generated results. D_x learns to determine the authenticity of the input text image and whether it matches the given text effect image. At the same time, G_x and E_y^c learn to confuse D_x:

$$\mathcal{L}_{\text{dadv}} = \mathbb{E}_{x,y}\left[\log D_x\left(x,y\right)\right]-\mathbb{E}_y\left[\log\left(1-D_x\left(G_x\left(E_y^c\left(y\right)\right),y\right)\right)\right]. \tag{5.24}$$

The total loss for destylization takes the following form:

$$\mathcal{L}_{\text{desty}} = \lambda_{\text{dpix}}\mathcal{L}_{\text{dpix}} + \lambda_{\text{dfeat}}\mathcal{L}_{\text{dfeat}} + \lambda_{\text{dadv}}\mathcal{L}_{\text{dadv}}, \tag{5.25}$$

Stylization. For the task of stylization, TET-GAN samples from the training set a text-style pair (x, y) and a text effect image y' that shares the same style with y but has a different glyph. TET-GAN first extracts the content feature from x and the style feature from y', which are then concatenated and fed into G_y to generate a text effect image to approximate the ground-truth y in an L_1 sense:

$$\mathcal{L}_{\text{spix}} = \mathbb{E}_{x,y,y'}\left[\left\|G_y\left(E_x\left(x\right),E_y^s\left(y'\right)\right)-y\right\|_1\right], \tag{5.26}$$

and confuse D_y with conditional adversarial loss:

$$\mathcal{L}_{\text{sadv}} = \mathbb{E}_{x,y,y'}\left[\log D_y\left(x,y,y'\right)\right]-\mathbb{E}_{x,y'}\left[\log\left(1-D_y\left(x,G_y\left(E_x\left(x\right),E_y^s\left(y'\right)\right),y'\right)\right)\right]. \tag{5.27}$$

The final loss for stylization is:

$$\mathcal{L}_{\text{sty}} = \lambda_{\text{spix}}\mathcal{L}_{\text{spix}} + \lambda_{\text{sadv}}\mathcal{L}_{\text{sadv}}. \tag{5.28}$$

5.4.1.2 One-Reference Text Effect Transfer

Supervised deep-learning methods are by nature heavily dependent on datasets and usually require thousands of training images, which greatly limits their applicability. To support personalized style transfer, TET-GAN adopts a one-reference fine-tuning strategy for style extension, where only one example style image is required.

One-reference supervised learning. For an unseen style in Figure 5.18(a), as shown in the top row of Figure 5.18(c), the model fails to synthesize texture details. To solve this problem, TET-GAN adopts a simple yet efficient "self-stylization" training scheme. As shown in Figure 5.18(b), the images are randomly cropped to obtain many text effect patches that have the same style but differ in the pixel domain. In other words, x, y, and y' in Eqs. (5.20)–(5.28) are patches cropped from the given image pair. They constitute a training set to fine-tune TET-GAN so that it can learn to reconstruct vivid textures, as shown in the bottom row of Figure 5.18(c). The model fine-tuned over a single image can generalize well to other very different glyphs.

One-reference unsupervised learning. For an unseen style y without a provided text image x, it is intuitive to exploit the destylization submodule to generate x from y and transform this one-reference unsupervised problem to a supervised one. In other words, $\tilde{x} = G_X\left(E_y^c(y)\right)$ is used as an auxiliary x during fine-tuning. Considering that the accuracy of the content features extracted from \tilde{x} cannot be guaranteed, a style reconstruction loss is employed to further constrain the content features to help reconstruct y:

$$\mathcal{L}_{\text{srec}} = \lambda_{\text{srec}} \mathbb{E}_y \left[\left\| G_y\left(E_y^c(y), E_y^s(y)\right) - y \right\|_1 \right].$$ (5.29)

The training objective for unsupervised learning takes the form:

$$\min_{E,G} \max_{D} \mathcal{L}_{\text{gly}} + \mathcal{L}_{\text{desty}} + \mathcal{L}_{\text{sty}} + \mathcal{L}_{\text{srec}}.$$ (5.30)

5.4.1.3 Semi-Supervised Text Effect Transfer

Semi-supervised learning is more challenging than traditional supervised learning. In the semi-supervised learning setting, the model is given sufficient but unpaired

(a) (b) (c)

FIGURE 5.18 One-reference text effect transfer in TET-GAN. (a) New, user-specified text effect. (b) Random crop of the style image to generate image pairs for training. (c) Top row: stylization result on an unseen style. Bottom row: stylization result after one-reference fine-tuning. The model fine-tuned over (a) is able to transfer text effect onto other unseen characters.

data for style extension. The main challenge is to establish an effective mapping between the style data and the glyph data.

To tackle semi-supervised learning, TET-GAN adopts a hybrid supervised and unsupervised learning framework, where two augmentation discriminators D_x^{aug} and D_x^{aug} are introduced to receive unlabeled data. Specifically, D^{aug} is tasked to only judge the authenticity of the input text image without the need to determine whether it matches the given text effect image. The training objective of D_x^{aug} is:

$$\mathcal{L}_{\text{daug}} = \mathbb{E}_x \Big[\log D_x^{\text{aug}}(x) \Big] - \mathbb{E}_y \Big[\log \Big(1 - D_x^{\text{aug}} \Big(G_x \big(E_y^c(y) \big) \Big) \Big) \Big]. \qquad (5.31)$$

The objective function of D_y^{aug} is similarly defined:

$$\mathcal{L}_{\text{saug}} = \mathbb{E}_{y,y'} \Big[\log D_y^{\text{aug}}(y,y') \Big] - \mathbb{E}_{x,y'} \Big[\log \Big(1 - D_y^{\text{aug}} \Big(G_y \big(E_x(x), E_y^s(y') \big), y' \Big) \Big) \Big].$$
$$(5.32)$$

The advantage is that the supervised data serves as an anchor to force the model to generate outputs consistent with the inputs, while the unsupervised data can teach the model to deal with a wider variety of glyph and style inputs.

5.4.1.4 Joint Font Style and Text Effect Transfer

TET-GAN has good generalizability across fonts and is capable of transferring the text effect on a reference image to other glyphs in different font styles. However, some text effects are designed specifically for certain fonts. For example, the neon style in Figure 5.19 suits a serif font (regular script) but not a sans-serif font (Microsoft Yahei). Thus, it is a good option to match the font styles.

To jointly transfer the font style, TET-GAN first chooses an anchor font F_0 (Microsoft Yahei) as an unstyled font. All other fonts are regarded as stylized versions. During training, x, y, and y' in Eqs. (5.20)–(5.28) represents one character in the anchor font F_0, the same character in another font F_0, and another character in the other font F_1, respectively. All other training processes are the same as for learning text effect.

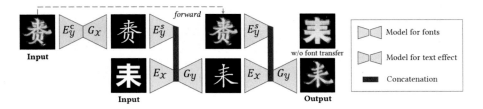

FIGURE 5.19 Hybrid font style and text effect transfer framework in TET-GAN. Two TET-GANs trained on the font dataset and text effect dataset constitute a uniform framework to transfer both font style and text effect.

Then, two TET-GANs trained on font styles and text effect can constitute a uniform framework, as illustrated in Figure 5.19. For an input style image, the framework first removes its text effect and obtains its raw text image, which is used as the reference font to adjust the input text. After that, the original style image can be used to render the text effect onto the font transfer result. The final output shares both the font style and text effect with the input style.

5.4.2 TRANSFER EFFECT WITH DECORATIVE ELEMENTS

TET-GAN assumes that styles are uniform within or outside the text, thus failing to render exquisite decorative elements that are commonly used in artistic text design and resulting in visual quality degradation. To address this problem, TextEffects-Decor [13] detects, separates, and recombines these important embellishments.

The overall framework of TextEffects-Decor is shown in Figure 5.20. The decorative elements such as the red bowknot in Figure 5.20 are referred to as **decor**. The remaining basal style excluding decor is referred to as **text effect**. TextEffects-Decor first extracts a segmentation mask for decorative elements, where a domain adaptation strategy is applied for the robustness of the model on unseen styles. Next, the text effect is transferred to the target text with decorative elements eliminated, during which a one-shot training strategy is adopted for improving the performance on unseen styles. Finally, the artistic text and the decorative elements are recomposed based on both the structure of the text and the spatial distribution of the decorative elements.

5.4.2.1 Decorative Element Segmentation

Decorative element detection is based on a segmentation network trained on synthetic data. To reduce the gap between synthetic and real data, a domain adaptation strategy is further applied.

Segmentation Network. TextEffects-Decor adopts U-Net as the basic architecture of the segmentation network **netSeg**. As shown in Figure 5.21, given the input artistic text D, the corresponding raw text C, the segmentation ground-truth M, and

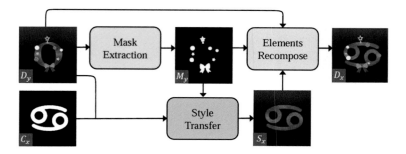

FIGURE 5.20 The TextEffects-Decor framework. First, decorative elements are separated from the input text effect. Then, the basal style is transferred to the target text. Finally, the elements and the text effect are recomposed based on both the structure of the text and the spatial distribution of the decorative elements.

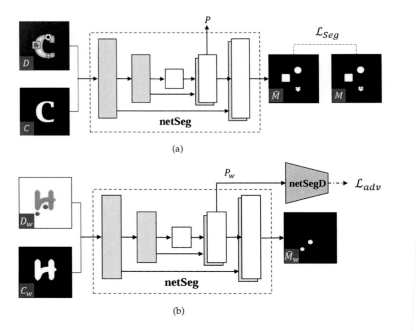

FIGURE 5.21 The segmentation network in TextEffects-Decor with domain adaptation strategy. A discriminator is trained to distinguish the feature maps of the target from that of the source. The generator needs to fool the discriminator while giving segmentation predictions. (a) Training netSeg in the source domain (synthetic styled text). (b) Training netSeg in the target domain (real styled text).

the prediction $\hat{M} = \mathbf{netSeg}(D,C)$, the network is tasked to approach the ground-truth M in both L_1 and perceptual senses. Thus, the objective of **netSeg** can be expressed as

$$\mathcal{L}_{\mathrm{seg}} = \lambda_{L1}\mathcal{L}_{L1} + \lambda_{\mathrm{Per}}\mathcal{L}_{\mathrm{Per}}, \tag{5.33}$$

where

$$\mathcal{L}_{L1} = \left\| \hat{M} - M \right\|_1, \tag{5.34}$$

$$\mathcal{L}_{\mathrm{Per}} = \left\| \mathrm{VGG}(\hat{M}) - \mathrm{VGG}(M) \right\|_1. \tag{5.35}$$

As illustrated in Figure 5.22, the perceptual loss [14] helps the network better perceive the structure of the decor.

Adversarial Domain Adaptation. There is a gap between synthetic data and real data in terms of color, decorative elements distribution, etc. Therefore, the network only trained on synthetic text effect can not well adapt to real text effect, as shown in Figure 5.22(c). To address this issue, TextEffects-Decor applies a domain adaptation strategy for making the network more robust to text effect in the wild.

In terms of domain adaptation, the source domain here is the synthetic training data, and the target domain is the real text effect. As shown in Figure 5.21, in the

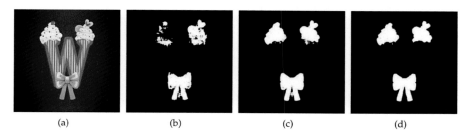

(a) (b) (c) (d)

FIGURE 5.22 Effect of the perceptual loss and domain adaptation. (a) Input. (b) Result with only L_1 loss. (c) Result without domain adaptation. (d) Result with full losses.

phase of discriminator **netSegD**, it is trained to distinguish the feature map P of the second last layer of the generator. The discriminator is supervised by a cross-entropy loss:

$$\mathcal{L}_d\left(P\right) = -\left(\left(1-z\right)\log\left(\textbf{netSegD}\left(P\right)\right) + z\log\left(\textbf{netSegD}\left(P\right)\right)\right), \quad (5.36)$$

where $z = 0$ if the sample is drawn from the target domain, and $z = 1$ for the sample from the source domain. In the phase of the generator, on the source domain, the generator learns how to make segmentation predictions, while on the target domain, it needs to fool the discriminator and reduce the gap between the two domains. The objective of the generator can be expressed as

$$\mathcal{L} = \lambda_{\text{seg}}\mathcal{L}_{\text{seg}} + \lambda_{\text{adv}}\mathcal{L}_{\text{adv}}, \quad (5.37)$$

where

$$\mathcal{L}_{\text{adv}} = -\log\left(\textbf{netSegD}\left(P_w\right)\right) \quad (5.38)$$

is the adversarial loss for making the target feature map P_w closer to the source feature map P. As can be seen in Figure 5.22(d), domain adaptation can effectively improve the segmentation results.

5.4.2.2 Text Effect Transfer

The text effect transfer model in TextEffects-Decor is a combination of U-Net [15] and PatchGAN [16]. Given D_y a text effect with extra decorative elements, C_y the corresponding raw text image of D_y, and C_x a target raw text, the generator **G** learns to generate a fake text effect $S_x = \textbf{G}(D_y, C_y, C_x)$, which has the text effect of D_y and the glyph of C_x. The discriminator **D** needs to distinguish whether the input is real or generated and whether it matches D_y, C_y, and C_x or not. The loss function is a combination of WGAN-GP [17] and $L1$ Loss:

$$\mathcal{L}_{\mathcal{G}} = \lambda_{\text{adv}}\mathcal{L}_{\text{adv}} + \lambda_{L1}\mathcal{L}_{L1}, \quad (5.39)$$

where

$$\mathcal{L}_{L1} = \left\| S_x - \tilde{S}x \right\|, \tag{5.40}$$

$$\mathcal{L}_{\mathrm{adv}} = \mathbb{E}_{\tilde{S}_x}\left[\mathbf{D}\left(\tilde{S}_x, D_y, C_y, C_x \right) \right] - \mathbb{E}_{S_x}\left[\mathbf{D}\left(S_x, D_y, C_y, C_x \right) \right]$$

$$+ \lambda_{GP}\mathbb{E}_{\hat{S}_x}\left[\left(\left\| \nabla \mathbf{D}\left(\hat{S}_x, D_y, C_y, C_x \right) \right\|_2 - 1 \right)^2 \right], \tag{5.41}$$

where \tilde{S}_x is the ground-truth, and \hat{S}_x is uniformly sampled along the straight lines between the sampling of S_x and \tilde{S}_x.

One-Reference Text Effect Transfer. As shown in Figure 5.24(b), through the aforementioned training strategy, TextEffects-Decor learns to eliminate decorative elements and can generate the basic structure of the unseen text effect. But the unseen details cannot be properly reconstructed. Similar to TET-GAN, a one-reference fine-tuning scheme can be used to learn the unseen text effect.

First, a bunch of patches are randomly cropped from the text effect. They constitute a training set for fine-tuning. The masks of the decors are then generated by the segmentation network **netSeg**. Using the segmentation mask, as illustrated in Figure 5.23, the impact of decorative elements can be reduced by not computing the L_1 loss on these areas and blocking them before sending images to the discriminator. It is worth noting that, unlike the pretraining process, the ground-truth decor-free image is not required during one-shot fine-tuning. The network can learn to both restore style details and eliminate the decor, which provides users with much more flexibility. As illustrated in Figure 5.24(c), with one-shot training, the network can generate the iron edge and the red fabric texture.

5.4.2.3 Structure-Based Decor Recomposition

At last, decorative elements and the text effect are combined according to the structure of the text. First, TextEffects-Decor generates guidance maps characterizing the

FIGURE 5.23 The one-reference training scheme.

(a) (b) (c)

FIGURE 5.24 Effect of the one-reference training scheme. (a) Input. (b) Result without one-reference fine-tuning. (c) Result after fine-tuning.

structure of the artistic text. Then decorative elements are divided into two classes based on their importance, and each class is treated with a different transformation strategy. Finally, the elements and the text effect are combined to generate the final output.

Guidance Maps. TextEffects-Decor adopts four guidance maps characterizing the properties of the artistic text. These maps play important roles in the subsequent transformation.

- **Horizon Map.** Horizon map M_{Hor} identifies the position of pixels to the text in horizontal direction. Since human eyes are sensitive to edges, TextEffects-Decor amplifies the horizontal changes near the edge of the text. TextEffects-Decor first defines the gradient of M_{Hor} as G_{Hor}, which is initialized to one everywhere. Then G_{Hor} is adjusted according to the horizontal length of the text. For each y, define $x_{y,\min}$ the leftmost point of the raw text on row y, and $x_{y,\max}$ the rightmost point, TextEffects-Decor generates \tilde{G}_{Hor} by:

$$\tilde{G}_{\text{Hor}}(x,y) = G_{\text{Hor}}(x,y) + \begin{cases} \left(\mathcal{K}_w - |x - x_{y,\min}|\right) * \mathcal{K}_s, & |x - x_{y,\min}| < \mathcal{K}_w \\ \left(\mathcal{K}_w - |x - x_{y,\max}|\right) * \mathcal{K}_s, & |x - x_{y,\max}| < \mathcal{K}_w \\ 0, & \text{else} \end{cases} \quad (5.42)$$

where $\mathcal{K}_w = \mathcal{K}_{ws}\left(x_{y,\max} - x_{y,\min}\right)$, $\mathcal{K}_{ws} < 0.5$. Here, \mathcal{K}_{ws} and \mathcal{K}_s control the width and the scale of the adjustment, respectively. If row y has no overlap with the text body, TextEffects-Decor directly makes $\tilde{G}_{\text{Hor}}(x,y) = G_{\text{Hor}}(x,y)$, $\forall x$. With \tilde{G}_{Hor}, a M_{Hor} is built by:

$$M_{\text{Hor}}(x_{y,\text{center}},y) = 0,$$

$$M_{\text{Hor}}(x,y) - M_{\text{Hor}}(x-1,y) = \tilde{G}_{\text{Hor}}(x,y), \quad (5.43)$$

where $x_{y,\text{center}}$ is the horizontal center of the text on row y. Finally, M_{Hor} is normalized to [0, 1] and slightly blurred to avoid drastic changes caused by

FIGURE 5.25 Guidance maps for the structure-based combination procedure. (a) Text effect with extra decorative elements. (b) The horizontal map. (c) The vertical map. (d) The distribution map. (e) Result with full map. (f) Result without the horizontal map. (g) Result without the vertical map. (h) Result without the distribution map.

complex edges. As illustrated in Figure 5.25(b), while representing the horizontal position of the text, changes near the edge of the text are amplified.

- **Vertical Map.** Vertical map M_{Ver} is similar to M_{Hor}, except that M_{Ver} identifies the property of the text in the vertical direction, as illustrated in Figure 5.25(c).
- **Distribution Map.** Distribution map M_{Dis} identifies the distance of pixels to the edge of the text, as illustrated in Figure 5.25(d). Given $\mathrm{Dis}(x, y)$, the distribution-aware pre-processing map proposed in Section 5.6, M_{Dis} can be written as:

$$M_{\mathrm{Dis}} = \left(1 - \mathrm{Dis}(x, y)\right)^{K_{\mathrm{dis}}}, \tag{5.44}$$

where K_{dis} controls the intensity of distribution map.

- **Existing Element Map.** Existing element map M_{Exi} is used to avoid overlapping. $M_{\mathrm{Exi}}(x, y) = 0$ represents that no element has been placed on (x, y), and $M_{\mathrm{Exi}}(x, y) = 1$ vice versa.

The final guidance map M_{guide} is a weighted concatenation of the previous maps:

$$M_{\mathrm{guide}} = \mathrm{Concat}[\lambda_i M_i \mid i \in \{\mathrm{Hor}, \mathrm{Ver}, \mathrm{Dis}, \mathrm{Exi}\}], \tag{5.45}$$

where $\mathrm{Concat}[\cdot]$ indicates concatenation, and λ_i controls the weight of each map. The effect of each map is illustrated in Figure 5.25. Without the horizontal or the vertical

map, the elements will be crowded together. Without the distribution map, elements will depart from the text.

Decor Classification. TextEffects-Decor assumes that there are two kinds of decorative elements: insignificant and significant ones. The insignificant elements are repeatable and are often randomly scattered on the text, for example, the colorful balls in Figure 5.25(a). The significant elements may play an important part in the semantic expression of the text effect and are often single or paired, for example, the red bowknot in Figure 5.25(a).

Notice that insignificant elements usually share a similar shape with other elements, while significant elements often have a unique shape. For example, in Figure 5.25(a), the colorful balls share the same circle shape, while the shape of the red bow is not the same as other elements. Based on this observation, TextEffects-Decor classifies elements via shape clustering. Then, elements that belong to size-1 clusters are regarded as significant, and the others are regarded as insignificant. Clustering can also divide insignificant elements into several groups, where elements in the same group share similar shapes. This clustering is implemented by first resizing the masks to 5 × 5, then clustering using DBSCAN [18].

Transformation and Combination. Given D_y an input artistic text with extra decorative elements, C_y the raw text of D_y, and C_x the target raw text, a segmentation mask M_y can be generated by the segmentation network, and the corresponding text effect (without decorative elements) S_x can be generated by the transformation network. Combining these, TextEffects-Decor finally transforms decorative elements in consideration of both their distribution and the matching between them and the glyph.

DenseCRF [19] is used to refine the segmentation output and split different decorative elements by finding connected components. For each significant decorative element E on C_x, the area $E' \in C_y$ to place the element is defined as:

$$\arg\min_{E' \in C_y} \left\| M_{\text{guide}}(E) - M_{\text{guide}}(E') \right\|_2, \tag{5.46}$$

where $M_{\text{guide}}(\cdot)$ indicates the average value of map M_{guide} for pixels on the specific area.

Then, elements are slightly resized and shifted to better fit the text effect. If the area where the element and the raw text overlap becomes smaller after placement, TextEffects-Decor zooms out the element and moves it closer to the text, and vice versa. For insignificant elements, TextEffects-Decor randomly exchanges those elements in the same cluster and shifts them by Eq. (5.46). This exchanging operation increases the variation of the result. As shown in Figure 5.26(c)–(d), different results can have different ball distributions for this Christmas text effect.

5.5 DEEP-BASED UNSUPERVISED TEXT STYLE TRANSFER

As discussed in Section 5.3, the goal of unsupervised artistic text style transfer is to stylize the target text image T based on a style image S'. As S' can be of arbitrary appearance, one of the key problems is to deform and render the glyph to match both the shapes and textures of S'. The main challenges of applying deep-based models to

FIGURE 5.26 Text effect transfer results of TextEffects-Decor. (a) Input style image and text image. (b) Text effect transfer results. (c) Style image. (d) Diverse text effect transfer results.

this problem lie in two aspects: First, glyph deformation is subjective and not clearly defined. How to parameterize it remains an open question. Second, each style usually has only one available image/video for reference, lacking large-scale paired datasets to provide mappings between the text and its stylized versions under various deformation degrees. Thus, it is not straightforward to train a deep-based model.

To meet these challenges, Shape-Matching GAN [20] first studies the deep-based text style transfer that allows for flexible control of the crucial deformation degree of the glyph through an adjustable parameter. It introduces a novel bidirectional shape matching framework to establish an effective glyph-style mapping at various deformation levels without paired ground-truth data (Section 5.5.1). Figure 5.27 illustrates

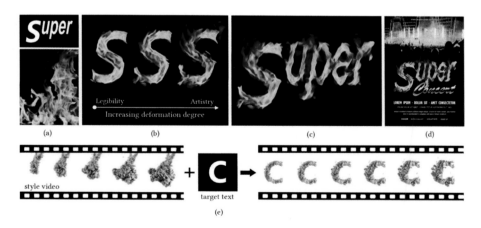

FIGURE 5.27 Illustration of the dynamic text style transfer with glyph stylistic degree control. Shape-Matching GAN++ renders artistic text based on reference (a) style images or (e) style videos and allows users to (b) control the glyph deformation in a fast and continuous manner to effectively adjust the stylistic degree and select the most desired one. Shape-Matching GAN++ provides users with a practical tool for (d) poster design and (e) artistic text animation rendering.

how the deformation degree is adjusted to achieve balance between the legibility and artistry of the rendered artistic text. Then, an improved Shape-Matching GAN++ [21] studies the dynamic style transfer, where a video-like dancing flame is provided as style reference to create dynamic artistic text (Section 5.5.2).

5.5.1 STATIC TEXT STYLE TRANSFER

Since text is highly different from natural images in terms of structures, for arbitrary style as reference, a good designer needs to manipulate the stylistic degree or shape deformations of a glyph to resemble the style subject such as the flames. As the deformation increases, the text demonstrates more artistry but with the cost of legibility. Hence, there is a trade-off between legibility and artistry. Such a delicate balance is subjective and hard to attain automatically. Therefore, the goal of ShapeMatching GAN is to provide users with a user-friendly tool to adjust the stylistic degree of the glyph, which refers to as fast controllable artistic text style transfer from a single style image/video.

Formally, the controllable text style transfer studies the problem of developing a feed-forward network G to synthesize artistic text, whose deformation degree is controlled by a parameter $\ell \in [0, 1]$ and is positively related to ℓ. ShapeMatching GAN further divides the stylization procedure into sequent structure transfer and texture transfer steps, and models them using generators G_S and G_T, respectively. Then we have $G = G_T \circ G_S$. Such disentanglement helps two generators better focus on their own tasks to boost the overall performance. Let I and Y be the target text image and reference style image, respectively, and the stylization process is formulated as:

$$I_\ell^Y = G_T\big(G_S\left(I, \ell\right)\big) \qquad (5.47)$$

where the stylized image I_ℓ^Y is characterized by the text image I, the style image Y, and the controllable parameter ℓ.

ShapeMatching GAN realizes text style transfer through a bidirectional shape matching strategy. Let X denote the structure map of Y to indicate the shape of its style subject, which can be readily acquired through existing image matting methods or image editing tools like Photoshop. During backward structure transfer, X is simplified to a coarse version with the shape style of the glyph and coarse level ℓ, which is denoted as the sketch structure map \tilde{X}_ℓ. $\{\tilde{X}_\ell, X\}$ forms a training pair for G_S. Then, during forward structure transfer, G_S learns the shape characteristics of X under various deformation degrees from the mappings between \tilde{X}_ℓ and X. Figure 5.28 illustrates the overall framework with G_S and G_T:

- **Glyph Network G_S**: it learns the mapping from \tilde{X}_ℓ under deformation degree ℓ to X in the training phase. During testing, it transfers the structure style of X onto I, yielding the structure transfer result I_ℓ^X.
- **Texture Network G_T**: it learns the mappings from the structure map X to the style image Y in the training phase. During testing, it transfers the texture style of Y onto I_ℓ^X to produce the final result, I_ℓ^X.

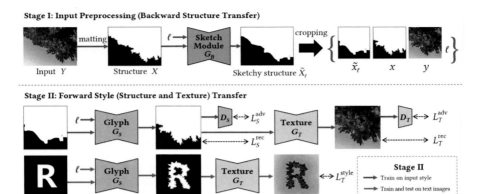

FIGURE 5.28 Framework of Shape-Matching GAN.

The generators are coupled with discriminators D_S and D_T to introduce the adversarial loss to enhance the quality of stylized images. In the following, Section 5.5.1.1 introduces the details of the bidirectional shape matching to train the structure transfer network G_S. Section 5.5.1.2 details the texture transfer network G_T.

5.5.1.1 Bidirectional Structure Transfer

Backward structure transfer. To simplify X in various coarse levels to match the glyph characteristics, ShapeMatching GAN designs a sketch module G_B. Figure 5.29(a) shows an overview of G_B containing a smoothness block and a transformation block. Motivated by the multi-scale image simplification via Gaussian scale-space representation [22, 23], the smoothness block is a fixed convolutional layer with Gaussian kernel whose standard deviation is controlled by ℓ as $\sigma = 16\ell + 8$. Then, the smoothness block blurs the text image and X, mapping them into a shared smooth domain, where all shapes have similar blurry contours. Finally, the transformation block conditioned by ℓ via label concatenation is trained to restore the text image from its smoothed version so that it learns to capture the glyph characteristics. By using the smooth domain as a bridge between the source style domain and

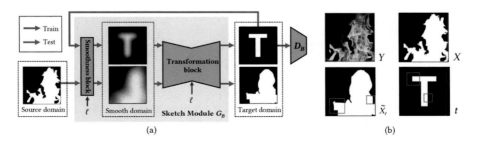

FIGURE 5.29 Illustration of sketch module G_B for backward structure transfer. (a) Overview of the sketch module. (b) Effect of the transformation block.

target glyph domain, the sketch module transfers the glyph characteristics onto X by feeding the smoothed X into the transformation block. By doing so, ShapeMatching GAN can naturally parameterize the coarse level by σ; in other words, the deformation degree is thus controlled by ℓ. Meanwhile, only text images, which are easy to collect, are required to train G_B. The trained G_B can be applied to arbitrary style images.

During the training of G_B, text images t are sampled from the TE141K dataset [24] with parameter ℓ sampled within $[0, 1]$. G_B is tasked to restore t using L_1 loss:

$$\mathcal{L}_B^{\text{rec}} = \mathbb{E}_{t,\ell}\left[\left\|G_B\left(t,\ell\right)-t\right\|_1\right]. \tag{5.48}$$

A conditional adversarial loss is further imposed to improve the quality of the reconstructed image:

$$\mathcal{L}_B^{\text{adv}} = \mathbb{E}_{t,\ell}\left[\log D_B\left(t,\ell,\bar{t}_\ell\right)\right]+\mathbb{E}_{t,\ell}\left[\log\left(1-D_B\left(G_B\left(t,\ell\right),\ell,\bar{t}_\ell\right)\right)\right], \tag{5.49}$$

where D_B learns to discriminate generated images from real images, given the parameter ℓ and smoothed image \bar{t}_ℓ as conditions. Hence, the total loss function is defined as

$$\min_{G_B}\max_{D_B}\lambda_B^{\text{adv}}\mathcal{L}_B^{\text{adv}}+\lambda_B^{\text{rec}}\mathcal{L}_B^{\text{rec}}. \tag{5.50}$$

Once trained, the sketchy shape of X at various levels ℓ can be obtained as $\tilde{X}_\ell = G_B\left(X,\ell\right)$. Figure 5.29(b) shows an example of \tilde{X}_ℓ, which matches the strokes of the text in the red boxes, offering more accurate mappings for the glyph network.

Forward structure transfer. Given X and $\{\tilde{X}_\ell\}$ under various ℓ, the glyph network G_S is then trained to learn their mappings so as to capture and transfer the shape characteristics of X onto the target text. To train the network with only a single style image, ShapeMatching GAN uses two strategies: *data augmentation* and *Controllable ResBlock*. First, ShapeMatching GAN expands a single image into a dataset by randomly cropping X and \tilde{X}_ℓ into abundant sub-image pairs $\{x,\tilde{x}_\ell\}$. Second, ShapeMatching GAN designs a scale-aware Controllable ResBlock to constitute the middle layers of G_S. As displayed in Figure 5.30, Controllable ResBlock is composed of two ResBlocks [25] with the linear weighting factor ℓ. When $\ell = 1$ (0), half path of G_S is blocked and Controllable ResBlock degrades into a standard ResBlock to learn a well-defined one-to-one mapping for the greatest (tiniest) shape deformation. Meanwhile, when $\ell \in (0, 1)$, G_S learns to compromise between the two extremes. Thus, G_S is effectively controlled by ℓ.

In the loss aspect, G_S aims to approach the target X and compete with the discriminator D_S:

$$\mathcal{L}_S^{\text{rec}} = \mathbb{E}_{x,\ell}\left[\left\| G_S\left(\tilde{x}_\ell,\ell\right)-x\right\|_1\right], \tag{5.51}$$

$$\mathcal{L}_S^{\text{adv}} = \mathbb{E}_x\left[\log D_S\left(x\right)\right]+\mathbb{E}_{x,\ell}\left[\log\left(1-D_S\left(G_S\left(\tilde{x}_\ell,\ell\right)\right)\right)\right]. \tag{5.52}$$

(a) (b)

FIGURE 5.30 Illustration of Controllable ResBlock. (a) ResBlock. (b) Controllable ResBlock.

For irregular styles, text t could become nearly illegible under large deformation degree ℓ. A glyph legibility loss is introduced to preserve the trunk of t in the result $G_S(t, \ell)$. Specifically, a weighting map $W(t)$ with pixel value increasing as its distance from the text contour increases is first computed. Then, $G_S(t, \ell)$ is tasked to approach t in the area far from the text contour by element-wisely multiplying with $W(t)$:

$$\mathcal{L}_S^{\mathrm{gly}} = \mathbb{E}_{t,\ell}\left[\left\|\left(G_S\left(t,\ell\right)-t\right)\otimes W\left(t\right)\right\|_1\right]. \tag{5.53}$$

Hence, the overall loss function of G_S is:

$$\min_{G_S}\max_{D_S} \lambda_S^{\mathrm{adv}}\mathcal{L}_S^{\mathrm{adv}} + \lambda_S^{\mathrm{rec}}\mathcal{L}_S^{\mathrm{rec}} + \lambda_S^{\mathrm{gly}}\mathcal{L}_S^{\mathrm{gly}}. \tag{5.54}$$

5.5.1.2 Texture Transfer

For texture transfer, ShapeMatching GAN directly trains a feed-forward texture transfer network G_T to map X to Y. Given image pairs $\{x, y\}$ randomly cropped from X and Y, G_T is trained to map x to y with the reconstruction loss and conditional adversarial loss:

$$\mathcal{L}_T^{\mathrm{rec}} = \mathbb{E}_{x,y}\left[\left\|G_T\left(x\right)-y\right\|_1\right], \tag{5.55}$$

$$\mathcal{L}_T^{\mathrm{adv}} = \mathbb{E}_{x,y}\left[\log D_T\left(x,y\right)\right]+\mathbb{E}_{x,y}\left[\log\left(1-D_T\left(x,G_T\left(x\right)\right)\right)\right]. \tag{5.56}$$

To further promote the overall performance on real text images, ShapeMatching GAN samples text images t and improves the style similarity between $G_T\left(G_S(t, \ell)\right)$ and X using the style loss $\mathcal{L}_T^{\mathrm{style}}$ introduced in Neural Style Transfer [26]. Thus, the final loss function for texture transfer is:

$$\min_{G_T}\max_{D_T} \lambda_T^{\mathrm{adv}}\mathcal{L}_T^{\mathrm{adv}} + \lambda_T^{\mathrm{rec}}\mathcal{L}_T^{\mathrm{rec}} + \lambda_T^{\mathrm{style}}\mathcal{L}_T^{\mathrm{style}}. \tag{5.57}$$

5.5.2 Dynamic Text Style Transfer

In dynamic text style transfer, a style video $\mathbf{Y} = \{Y^i | i = 1, 2, \ldots, T_Y\}$ containing T_Y consecutive frames for style reference and a text image I for content reference are given. ShapeMatching GAN++ studies the problem of rendering dynamic artistic text $\mathbf{I}_\ell^Y = \{I_l^{Y,i} \mid i = 1, 2, \ldots, T\}$ that characterizes both spatial structure/texture features and temporal dynamic features of \mathbf{Y}. The total frame number and the glyph deformation degree is controlled by user-specified T and ℓ, respectively.

The solution is to model the motion patterns through short-term shape matchings. Instead of dealing with the long-term motion patterns of the entire video, ShapeMatching GAN++ focuses on the short-term motion patterns of short video clips. The short-term motion pattern is the shape changes between the front and back frames within a video clip. Then it can be naturally modeled as the shape mappings from the previous frames to the last frame, i.e., frame prediction. Finally, by repeatedly predicting the next frame based on previous frames, the short-term motion patterns can be propagated to achieve long-term motion patterns.

Let N be the number of previous reference frames required to synthesize the next frame. Let $\mathbf{I}^{a:b}$ denote the subset of \mathbf{I} with indexes $i \in [a, b]$. As with ShapeMatching GAN, ShapeMatching GAN++ decomposes the style transfer process into structure transfer and texture transfer, and the latter is still modeled by G_T. Structure transfer uses a new glyph network G_S^{pre} to predict the ith structure frame $I_l^{X,i}$ based on its previous N structure frames $\mathbf{I}_l^{X,i-N:i-1}$. In the beginning, there are no readily stylized frames for G_S^{pre}. Thus, ShapeMatching GAN++ incorporates the original glyph network of ShapeMatching GAN to generate the first N structure frames. This glyph network is denoted as G_S^{ini} for frame initialization. Therefore, Shape-Matching GAN++ is built upon three main components, and Figure 5.31 illustrates the framework:

- **Frame Initialization Glyph Network G_S^{ini}:** it learns the mappings from \tilde{X}_ℓ^i under deformation degree ℓ to X^i in the training phase. During testing, it transfers the structure style of \mathbf{X} onto I repeatedly to obtain the initial N structurally stylized frames.

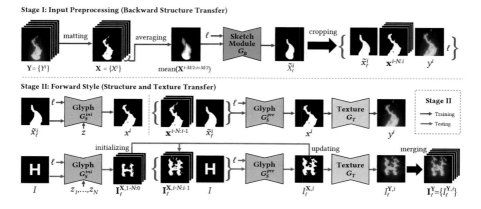

FIGURE 5.31 Framework of Shape-Matching GAN++. For simplicity, we omit the discriminators and loss functions.

- **Frame Prediction Glyph Network G_S^{pre}:** It learns to map G_S^{ini} with deformation degree ℓ and the previous N frames $X^{i-N:i-1}$ to the current frame X^i during training. In testing, it repeatedly predicts the next frame $I_l^{X,i}$ based on the target text image I and the previously synthesized N frames $\mathbf{I}_l^{X,i-N:i-1}$.
- **Texture Network G_T:** It learns the mappings from the structure map X^i to the style image Y^i in the training phase. During testing, it transfers the texture style of \mathbf{Y} onto \mathbf{I}_l^X to produce the final result \mathbf{I}_l^Y.

As with Shape-Matching GAN, ShapeMatching GAN++ randomly crops frames into abundant sub-images to augment training data. The following sections introduce the details of the backward structure transfer, frame initialization, and frame prediction of ShapeMatching GAN++.

5.5.2.1 Backward Structure Transfer with Frame Fusion

For dynamic text style transfer, instead of backward structure transfer frame-by-frame to form $\{\mathbf{X}, \tilde{\mathbf{X}}_\ell\}$, which can only characterize small-scale motion patterns near the contours, ShapeMatching GAN++ applies frame fusion to further simplify the structure map in a more global way. Specifically, for X^i and ℓ, ShapeMatching GAN++ first takes the mean of M frames around X^i to obtain the fused frame mean$(\mathbf{X}^{i-M/2:i+M/2})$. Hence, the unique global motion of X^i is neutralized. Then, the sketchy shape is calculated as $\tilde{X}_\ell^i = G_B\left(\text{mean}\left(\mathbf{X}^{i-M/2:i+M/2}\right), \ell\right)$. Intuitively, a large M means large structural changes. In ShapeMatching GAN++, $M = 1 + \lfloor m\ell \rfloor$, where $\lfloor\rfloor$ is the round down operator, and m is the maximum allowable frame number for fusion. In this way, ShapeMatching GAN++ pays more attention to the global structural adjustment to fit the motion patterns for large ℓ.

5.5.2.2 Frame Initialization Glyph Network

The frame initialization glyph network G_S^{ini} follows the training of G_S in Section 5.5.1.1. The only difference is that the training data are sampled from all frames $\{\mathbf{X}, \tilde{\mathbf{X}}_\ell\}$ rather than a single image pair.

To generate initial N diverse frames with temporal consistency, Shape-Matching GAN++ incorporates random noises to diversify its output and interpolate frames through noise interpolation. Specifically, Gaussian noises are added onto the input of G_S^{ini} and added into Controllable ResBlocks through AdaIN [27]. The frame initialization is summarized in Algorithm 5.1.

ALGORITHM 5.1: Dynamic Text Style Transfer

Input: Text image I, frame number T, deformation degree ℓ
Output: Stylized text frames $\mathbf{I}_\ell^Y = \{I_\ell^{Y,i} \mid i = 1,2,\ldots,T\}$
 1: Δ *Initial structure frame synthesis*:
 2: sample two random noises z_1 and z_N
 3: **for** $i = 1 \rightarrow N$ **do**
 4: $z_i = ((N - i) * z_1 + (i - 1) * z_N)/(N - 1)$
 5: $I_\ell^{X,i-N} = G_S^{\text{ini}}\left(I, \ell, z_i\right)$

```
 6: end for
 7: for i = 1 → T do
 8:    Δ Structure frame prediction:
 9:    I_ℓ^{X,i} = G_S^{pre}(I, I_ℓ^{X,i−N:i−1}, ℓ)
10:    Δ Texture transfer:
11:    I_ℓ^{Y,i} = G_T(I_ℓ^{X,i})
12: end for
```

5.5.2.3 Frame Prediction Glyph Network

G_S^{pre} shares similar network architecture as G_S^{ini} except that it receives additional reference frames as input. To train G_S^{pre}, $\mathbf{X}^{i−N:i}$ and \tilde{X}_ℓ^i are first sampled from $\{\mathbf{X}, \tilde{\mathbf{X}}_\ell\}$. Then they are cropped into sub-image triplet $\{\mathbf{x}^i, \mathbf{x}^i, \tilde{x}_l^i\}$ to gather as a training set, where \mathbf{x}^i denotes the reference frames $\mathbf{x}^{i−N:i−1}$ concisely. G_S^{pre} is trained using the reconstruction loss and conditional adversarial loss:

$$\mathcal{L}_S^{rec} = \mathbb{E}_{x,\ell,i}\left[\left\|G_S^{pre}\left(\tilde{x}_\ell^i, \mathbf{x}^i, \ell\right) - x^i\right\|_1\right], \tag{5.58}$$

$$\mathcal{L}_S^{adv} = \mathbb{E}_{x,i}\left[\log D_S^{pre}\left(x^i, \mathbf{x}^i\right)\right] + \mathbb{E}_{x,\ell,i}\left[\log\left(1 - D_S^{pre}\left(G_S^{pre}\left(\tilde{x}_\ell^i, \mathbf{x}^i, \ell\right), \mathbf{x}^i\right)\right)\right]. \tag{5.59}$$

In the testing phase, the frame prediction process is summarized in Algorithm 1.

5.6 TEXT EFFECT DATASET AND EVALUATION

5.6.1 TE141K DATASET

There are multiple available benchmark datasets for text style transfer as summarized in Table 5.1. TET-GAN [12] first collects a text effect dataset with paired data, which is then scaled up by TE141K [24]. TE141K can be divided into three subsets of TE141K-E, TE141K-C, and TE141K-S based on the languages. Finally, TextEffects-Decor builds a text effect dataset with decorative elements. These datasets mainly differ in two major aspects: (1) whether the reference text style contains special elements and (2) what kinds of character types are involved. For the first, only TextEffects-Decor [13] collects text effect with decorative elements; examples are shown in Figure 5.2(b). For the second, TET-GAN [12], TE141K-C [24], and TE141K-S [24] contain characters of multiple languages, while others only collect either English letters or Chinese characters.

As the largest text effect dataset, TE141K contains 141,081 text effect images and their corresponding raw glyph images with a resolution of 320 × 320. It contains a wide variety of text effect. To explore their distribution, Figure 5.32(a) visualizes the distribution of their VGG feature [29] through t-SNE [28]. It can be seen that text styles are evenly distributed as a circle, indicating that text effect in TE141K is of high diversity and richness.

TABLE 5.1
Summary of the Benchmark Datasets for Text Effect Transfer Task

	Style	Glyph	Style Type	Glyph Type	Images
TET-GAN [12]	64	837	Text Effect Collected from Websites	775 Chinese characters, 52 English Alphabets, 10 Arabic Numerals	53,568
TextEffects-Decor [13]	60	988	Text Effect with Decorative Elements	52 English Letters of 19 Different Fonts	59,280
TE141K-E [24]	67	988	Professional-Designed Text Effect	52 English Letters of 19 Different Fonts	66,196
TE141K-C [24]	65	837	Professional-Designed Text Effect	775 Chinese Characters, 52 English Alphabets, 10 Arabic Numerals	54,405
TE141K-S [24]	20	1,024	Professional-Designed Text Effect	56 Special Symbols, 968 Letters in Japanese, Russian, etc.	20,480

Text effect usually consists of multiple fundamental visual elements, such as textures, stroke outlines, and stereo effect. These factors may vary greatly and make text effect transfer a challenging task. To better investigate how they affect the model performance, TE141K quantifies these factors and manually labels the text effect with the corresponding factors.

Textures of text effect can be divided into two categories: foreground and background. For background texture, based on complexity level, there are six subclasses: *Solid Color, Gradient Color, Easy Texture, Normal Texture, Hard Texture*, and *Complex Texture. Solid Color* is the simplest; transfer models only need to directly copy the original color. *Gradient Color* is more complex; the distribution of color is directional. For the other four subclasses, there are textures on the background. In *Easy Texture*, textures are imperceptible to human eyes. From *Normal Texture* to *Hard Texture* and *Complex Texture*, textures become distinct and irregular. As shown in Figure 5.32(b), 36% of the background is solid, and 20% is of gradient color, which is consistent with the fact that background is often set to be simple to better emphasize the foreground glyph. Similarly, for foreground texture, there are six subclasses. In contrast to the background, 30% of the foreground has *Complex Texture*. This may be because the foreground is the main body of text effect; therefore, it is often fully decorated to increase artistic quality.

Stroke outlines and stereo effect is commonly used in cartoon and 3D text effect, respectively. Based on complexity and thickness, strokes have six subclasses: *No Stroke, Thin Stroke, One-Side Stroke, Normal Stroke, Thick Stroke*, and *Complex Stroke*. The thickness of many *Thin Stroke* and *Normal Stroke* effect is uneven in direction, which can be further divided into a more specific class, *One-Side Stroke*. In TE141K, 59% of the text effect contains strokes. Stereo effect is usually a

FIGURE 5.32 Statistics of TE141K. (a) Visualized text effect distribution in TE141K by t-SNE [28] based on their VGG features [29]. Perceptually similar text effect is placed close to each other. The even distribution indicates the diversity and richness of our dataset. (b) Distribution of different background, foreground, stroke, and stereo effect subclasses of our dataset. Representative images are shown at the top. The first row contains schematics where red is used to represent specific text effect subclasses. The second row contains representative samples from TE141K.

combination of multiple special effect, such as emboss and illumination effect. In addition, illumination effect can be further classified into lighting and shadow. Similarly, the stereo effect has six subclasses: *No Emboss*, *Emboss*, *No Illumination*, *Lighting*, *Shadow*, and *Complex Illumination*, where *Complex Illumination* is a combination of more than two illumination effect. In TE141K, 48% of the text effect contains embossing, and 43% contains illumination effect.

5.6.2 PERFORMANCE EVALUATION

Assessing the quality of text effect is of great value in allowing users to efficiently search for high-quality results, as well as guiding the designing of text style transfer algorithms. However, not enough attention has been paid to quality assessment. The evaluations of text style transfer algorithms still remain an open and important problem in this field.

In general, there are two major types of evaluation methodologies, qualitative evaluation and quantitative evaluation. The most widely used qualitative evaluation is the aesthetic judgments of observers. Most research evaluates different algorithms by comparing their corresponding user preference ratio. The evaluation results are related to multiple factors (e.g., age, gender, and occupation of participants). Therefore, this metric is subjective and it is difficult to reproduce the user study result. For quantitative evaluation, there is currently no appropriate metric. TE141K [24] and other research mainly choose widely used image quality assessment metrics as an alternative, such as structural similarity index (SSIM), peak signal-to-noise ratio (PSNR), and perceptual loss [14]. These metrics are designed for natural images and therefore cannot effectively evaluate the quality of text effect transfer results.

In order to make up for the lack of quantitative evaluation metrics in this field, Yan et al. [30] provided a solution that can automatically assess the quality of stylized glyphs, where a multitask attentive network is proposed to imitate human visual evaluation process. The network is trained to accomplish multiple tasks of style auto-encoding, content autoencoding, stylization, and destylization, through which the network learns to characterize robust style features and content features. Furthermore, visual attention modules are incorporated to simulate the process of human high-level visual judgment, paying more attention to interested areas. This model can serve as an effective tool to assist quality assessment. The limitation is that text effect is too diverse to cover with one dataset. As a result, this method can only handle a limited number of styles and therefore lacks applicability.

5.7 CONCLUSION

Over the past several years, the topic of text style transfer has gained wide attention and become an inspiring research area. A considerable amount of work, whether optimization-based or deep-based, is proposed to achieve surprising results in each subtopic. To support training and evaluation, researchers have developed large-scale datasets and performance evaluation metrics. Although there has been notable progress and achievements, the field of text style transfer is still in its early stages and there are still several challenges and open issues, leaving room for further growth.

First, performance evaluation for stylized text is an important issue and is getting increasingly critical as text effect transfer algorithms constantly develop. On the one hand, there is no standard benchmark dataset. Existing datasets suffer from insufficient style or character types. Moreover, different researchers typically use their own collected datasets, making it difficult to compare the performance of different text effect transfer methods. More efforts in collecting a large-scale benchmark dataset are necessary. On the other hand, existing assessment metrics are mainly designed for natural images. User studies are still frequently adopted, where the result varies a lot among different observers and is hard to reproduce. More reliable evaluation criteria are needed to assess the performance of text effect transfer approaches.

Second, existing methods cannot achieve high processing speed and strong generalization ability at the same time. Non-deep methods have slow processing speed due to the iterative optimization process. Deep learning-based feed-forward methods learn text styles from training data, thus are incapable of transferring unseen styles without specialized fine-tuning schemes. To achieve both low time complexity and strong generalization ability, a feed-forward algorithm that can generalize to arbitrary styles might be designed with more flexible style transfer modules and larger datasets.

We anticipate that future work will continue to make valuable contributions to the advancement of this research area.

REFERENCES

[1] S. Yang, J. Liu, Z. Lian, and Z. Guo, "Awesome typography: Statistics-based text effects transfer," in *Proceedings of the IEEE Conference on Computer Vision and Pattern Recognition*, Honolulu, HI, USA, 2017, pp. 2886–2895.

[2] O. Frigo, N. Sabater, J. Delon, and P. Hellier, "Split and match: Example-based adaptive patch sampling for unsupervised style transfer," in *Proceedings of the IEEE Conference on Computer Vision and Pattern Recognition*, Las Vegas, NV, USA, 2016, pp. 553–561.

[3] C. Barnes, E. Shechtman, A. Finkelstein, and D. B. Goldman, "PatchMatch: a randomized correspondence algorithm for structural image editing," *ACM Transactions on Graphics*, vol. 28, no. 3, pp. 341–352, 2009.

[4] C. Barnes, E. Shechtman, D. B. Goldman, and A. Finkelstein, "The generalized patch-match correspondence algorithm," in *Proceedings of the European Conference on Computer Vision*, Heraklion, Crete, Greece, 2010, vol. 6313, pp. 29–43.

[5] S. Yang, J. Liu, W. Yang, and Z. Guo, "Context-aware text-based binary image stylization and synthesis," *IEEE Transactions on Image Processing*, vol. 28, no. 2, pp. 952–964, 2018.

[6] L. Xu, Q. Yan, Y. Xia, and J. Jia, "Structure extraction from texture via relative total variation," *ACM Transactions on Graphics*, vol. 31, no. 6, p. 139, 2012.

[7] R. Achanta, A. Shaji, K. Smith, A. Lucchi, P. Fua, and S. Süsstrunk, "SLIC superpixels compared to state-of-the-art superpixel methods," *IEEE Transactions on Pattern Analysis and Machine Intelligence*, vol. 34, no. 11, pp. 2274–2282, 2012.

[8] J. Zhang and S. Sclaroff, "Saliency detection: A boolean map approach," in *Proceedings of the International Conference on Computer Vision*, Sydney, Australia, 2013, pp. 153–160.

[9] A. Rosenberger, D. Cohen-Or, and D. Lischinski, "Layered shape synthesis: automatic generation of control maps for non-stationary textures," *ACM Transactions on Graphics*, vol. 28, no. 5, pp. 1–9, 2009.

[10] A. Hertzmann, "Algorithms for rendering in artistic styles," Ph.D. dissertation, New York University, 2001.

[11] Y. Chang, S. Saito, K. Uchikawa, and M. Nakajima, "Example-based color stylization of images," *ACM Transactions on Applied Perception*, vol. 2, no. 3, pp. 322–345, 2006.

[12] S. Yang, J. Liu, W. Wang, and Z. Guo, "TET-GAN: Text effects transfer via stylization and destylization," in *Proceedings of the AAAI Conference on Artificial Intelligence*, Honolulu, Hawaii, USA, 2019, pp. 1238–1245.

[13] W. Wang, J. Liu, S. Yang, and Z. Guo, "Typography with decor: Intelligent text style transfer," in *Proceedings of the IEEE Conference on Computer Vision and Pattern Recognition*, Long Beach, CA, USA, 2019, pp. 5889–5897.

[14] J. Johnson, A. Alahi, and F. F. Li, "Perceptual losses for real-time style transfer and super-resolution," in *Proceedings of the European Conference on Computer Vision*, Amsterdam, Netherlands, 2016, vol. 9906, pp. 694–711.

[15] O. Ronneberger, P. Fischer, and T. Brox, "U-net: Convolutional networks for biomedical image segmentation," in *Proceedings of the Medical Image Computing and Computer-Assisted Intervention*, Munich, Germany, 2015, pp. 234–241.

[16] P. Isola, J. Y. Zhu, T. Zhou, and A. A. Efros, "Image-to-image translation with conditional adversarial networks," in *Proceedings of the IEEE Conference on Computer Vision and Pattern Recognition*, Honolulu, HI, USA, 2017, pp. 5967–5976.

[17] I. Gulrajani, F. Ahmed, M. Arjovsky, V. Dumoulin, and A. C. Courville, "Improved training of wasserstein gans," in *Proceedings of the Advances in Neural Information Processing Systems*, Long Beach, CA, USA, 2017, pp. 5767–5777.

[18] M. Ester, H.-P. Kriegel, J. Sander, X. Xu et al., "A density-based algorithm for discovering clusters in large spatial databases with noise." in *Proceedings of the International Conference on Knowledge Discovery and Data Mining*, Portland, Oregon, USA, 1996, pp. 226–231.

[19] V. Koltun, "Efficient inference in fully connected crfs with gaussian edge potentials," in *Proceedings of the Advances in Neural Information Processing Systems*, Granada, Spain, 2011, pp. 109–117.

[20] S. Yang, Z. Wang, Z. Wang, N. Xu, J. Liu, and Z. Guo, "Controllable artistic text style transfer via shape-matching gan," in *Proceedings of the International Conference on Computer Vision*, Seoul, Korea, 2019, pp. 4442–4451.

[21] S. Yang, Z. Wang, and J. Liu, "Shape-matching gan++: Scale controllable dynamic artistic text style transfer," *IEEE Transactions on Pattern Analysis and Machine Intelligence*, vol. 44, no. 7, pp. 3807–3820, 2021.

[22] J. Babaud, A. P. Witkin, M. Baudin, and R. O. Duda, "Uniqueness of the gaussian kernel for scale-space filtering," *IEEE Transactions on Pattern Analysis and Machine Intelligence*, vol. 8, no. 1, pp. 26–33, 1986.

[23] P. Perona and J. Malik, "Scale-space and edge detection using anisotropic diffusion," *IEEE Transactions on Pattern Analysis and Machine Intelligence*, vol. 12, no. 7, pp. 629–639, 1990.

[24] S. Yang, W. Wang, and J. Liu, "TE141K: Artistic text benchmark for text effect transfer," *IEEE Transactions on Pattern Analysis and Machine Intelligence*, vol. 43, no. 10, pp. 3709–3723, 2021.

[25] K. He, X. Zhang, S. Ren, and J. Sun, "Deep residual learning for image recognition," in *Proceedings of the IEEE Conference on Computer Vision and Pattern Recognition*, Las Vegas, NV, USA, 2016, pp. 770–778.

[26] L. A. Gatys, A. S. Ecker, and M. Bethge, "Image style transfer using convolutional neural networks," in *Proceedings of the IEEE Conference on Computer Vision and Pattern Recognition*, Las Vegas, NV, USA, 2016, pp. 2414–2423.

[27] X. Huang and S. Belongie, "Arbitrary style transfer in real-time with adaptive instance normalization," in *Proceedings of the International Conference on Computer Vision*, Venice, Italy, 2017, pp. 1510–1519.

[28] L. V. D. Maaten and G. Hinton, "Visualizing data using t-sne," *Journal of Machine Learning Research*, vol. 9, no. 86, pp. 2579–2605, 2008.

[29] K. Simonyan and A. Zisserman, "Very deep convolutional networks for large-scale image recognition," in *Proceedings of the International Conference on Learning Representations*, San Diego, CA, USA, 2015.

[30] K. Yan, S. Yang, W. Wang, and J. Liu, "Multitask attentive network for text effects quality assessment," in *Proceedings of the IEEE International Conference on Multimedia and Expo*, London, UK, 2020, pp. 1–6.

6 Data-Driven Automatic Choreography

Rongfeng Li
Beijing University of Posts and Telecommunications,
Beijing, China

6.1 INTRODUCTION: BACKGROUND OF AUTOMATIC CHOREOGRAPHY

Dance is a performing art that primarily relies on rhythmic movement to express emotions. It involves intricate sensory and cognitive processes and demands a keen sense of movement control and balance, a precise sense of timing and rhythm, a vivid imagination, and a high aesthetic quality. The art of choreography, which involves arranging dance movements, has been heavily influenced by music throughout human history. Music and dance have always been intertwined, and they have evolved together over time. Choreography involves tailoring movement sequences to music to convey ideas and emotions through dance performances. Typically, this demanding and time-consuming task is carried out by skilled professionals. However, advancements in technology are revolutionizing the way art is created. For instance, developments in computer vision such as image style migration and handwriting generation are hot topics in this field. The integration of technology and art has resulted in the automation of music-based choreography. When artists incorporate technology in their creative process, it can serve as a source of inspiration and unlock great potential.

In recent years, virtual characters have become increasingly prevalent in computer games, commercials, and film productions. Motion synthesis techniques for virtual characters play a pivotal role in producing and post-producing these media. Virtual character animation is an active area of research in computer graphics, and simulating realistic character movement with virtual characters remains one of the most challenging problems. While motion capture technology has enabled the realism of movements, it merely replicates captured data [1]. Many applications like games, animations, and virtual reality demand interactivity, requiring virtual characters to exhibit creative movements akin to humans, such as dance [2]. To animate a virtual character's dance movements, especially those created manually by a user, an animator has to tediously adjust the position and rotation of each bone in the model at key frames. This process is not only extremely time-consuming but also necessitates experienced animators, thereby greatly limiting the development of dance animation for virtual characters. A successful dance synthesis algorithm could thus prove useful

DOI: 10.1201/9781003406273-6

for applications such as music-assisted dance pedagogy [3], audio-visual game char-
acter movement generation [4], human behavior research [5], and virtual reality.

Given the aforementioned background, this chapter proposes an automatic music
choreography algorithm that leverages a large corpus of extant music and dance data.
By applying a deep learning model trained on this data, the algorithm can automati-
cally and intelligently generate dance movements that fulfill specified constraints and
choreograph them to match music segments. This algorithm can yield novel and
creative dance movements, supplanting traditional choreography algorithms to vastly
improve efficiency, reduce costs, and proffer practical value. Primarily geared toward
3D computer-animated characters, this approach holds major implications for com-
puter games, character animation synthesis, virtual reality, and dance pedagogy.

Generally, dance is intrinsically tied to music in structure, artistic expression, and
interpretation. The crux of computer-generated choreography lies in exploring the
relationship between music and dance movements, encompassing steps such as
acquiring music and movement data, extracting and analyzing features, conducting
correlation analysis, and synthesizing movements. Yu and Johnson [6] provided a
proof of concept demonstrating the feasibility and practicality of computer-generated
choreography. By establishing scheduling rules based on aesthetic concepts, utilizing
basic movement fragments to generate dance sequences unrelated to music, and then
appropriately editing them to match with music, Yu obtained results well received by
dance professionals. This also provides a theoretical basis and feasibility proof for
the research in this chapter.

Currently, numerous scholars globally have conducted extensive research on com-
puterized music choreography and yielded many valuable results. These can be
broadly classified into 1) traditional music choreography methods based on correla-
tions between music and hand-selected movement features; 2) music choreography
methods based on classic machine learning; 3) music choreography methods based
on deep learning.

6.1.1 AUTO CHOREOGRAPHY BASED ON HAND-SELECTED MOVEMENT FEATURES

The core idea behind such methods is selecting movement segments from a database
that match the target music's features, then connecting them to form complete musi-
cal choreography. The two main challenges are how to choose the right music and
movement features [7–11] and match these features [10, 11].

Studies show that among music and movement features, rhythm is one of the most
perceptible and impactful to audiences [12]. Lee and Lee [10] proposed a rhythm
analysis method defining movement rhythm based on vertical foot and hand dis-
placement speed changes, using extreme joint angular velocity points as rhythm seg-
mentation points to refit the movement characteristic curve. Shiratori et al. [11]
added intensity features to rhythm features, where action intensity features were
based on the Laban movement system's force concept [13] and music intensity fea-
tures were defined by audio energy and sound pressure. Music and movement rhythm
and intensity features were then used to match and synthesize dance movements.
This algorithm considers music and movement rhythm to be strongly correlated, with
movement rhythm presented by "stopping actions" (i.e., key actions) synchronized to

the music's rhythmical points. Movement and music intensity are also strongly correlated and should be synchronized. Rhythmic and intensity characteristics are traversed in a movement diagram composed of movement fragments to find eligible movement fragments and form a movement sequence, connected to form complete dance. Fang [14] added transition frame interpolation and path control algorithms to the rhythm and intensity feature matching algorithm, yielding more natural synthesized dance movements and enriching dance spatiality.

The disadvantages of such methods are that manually selected matching features are limited, rhythm and intensity features alone cannot generate aesthetically complex dances, and dance diversity is constrained by using only fixed segments from the movement database for choreography.

6.1.2 AUTO CHOREOGRAPHY BASED ON CLASSIC MACHINE LEARNING

Many existing machine learning-based movement generation techniques have been applied to dance research, including dimensionality reduction techniques [15, 16], Gaussian processes [17], and Hidden Markov Models (HMMs) [1, 18, 19], which capture potential correlations between music and dance movement features. Dimensionality reduction techniques can map high-dimensional features of movements to a low-dimensional space, thus capturing potential correlations behind joint rotations in motion capture data [15]. However, the algorithm requires pre-processing steps, such as sequence alignment and fixed data length, and cannot directly model the temporality of the movement data, which limits its application to real dance movement data. Gaussian Process Latent Variable Models (GPLVMs) can effectively generalize changes in human movements, but the large computational and memory resources required make them unsuitable for real-time generation [17]. HMM models overcome the limitations of the two previously mentioned types of models but have a limited ability to capture data changes [18].

Fukayama and Goto [17] proposed a method for automatically generating dances using user-made motion data (Vocaloid Motion Data, vmd format files). The algorithm models music beats, maps the music beat structure to dance movements using a Gaussian model [20] to obtain a non-linear mapping relationship between music beats and movements, and uses VMD motion files for training, using the probabilistic models obtained through clustering methods as models for different types of dances. This method can generate dances with different characteristics by switching the training dataset, but the method only considers the beat characteristics of the music, ignoring other features such as the music melody, and therefore the mapping relationship obtained has limited expressive power. Brand and Hertzmann [1] introduced a cross-entropy optimization framework to solve the style-movement synthesis problem. The framework uses sparsely sampled data of example actions with untagged styles and performs unsupervised learning through an HMM model, resulting in a generative model capable of generating new action sequences of multiple styles by adjusting a small number of style parameters. Applying this to motion capture data enables the recombination of existing motion capture data with new styles, the synthesis of new choreographed and stylized motion data, and the synthesis of stylized movements from video. However, this method only focuses on the

connections between movements and stylistic features and does not take into account the influence of music.

Ofli et al. [18] introduces a music-driven approach to dance movement synthesis based on the HMM model. In the training phase, the movements need to be manually labeled as specific patterns synchronized to the beat. In the generation phase, the audio is first segmented using beat detection, and the audio patterns identified using the Mel frequency cepstrum coefficients are used to select the movement patterns to be generated. Ofli et al. [19] extended the method further by using an unsupervised approach to analyze the dance patterns. They used three models: a musical metric model, an exchangeable pose model, and a pose transformation model. Of these, the musical metric model relates different melodic patterns to a given dance posture through the HMM model, the exchangeable posture model captures diversity in dance performance through a one-to-many relationship between musical patterns and dance postures, and the posture transformation model is used to describe the inherent dependencies between dance postures. One of the main limitations of these approaches, however, is that the generation of movements relies on the classification of input musical patterns, which are limited in variety and therefore make it difficult to generate new movement patterns.

6.1.3 Auto Choreography Based on Deep Learning

In recent years, advances in deep learning techniques have furnished methodologies for extracting high-dimensional representations from raw data and have unlocked novel possibilities in the domains of motion generation and automated choreography of music [21–25]. Recurrent Neural Networks (RNNs) have been posited as an efficacious means of solving sequential tasks and have been extensively leveraged in areas such as natural language processing [26], automatic speech recognition [27], and musical composition [28]. However, paradigmatic RNNs are beset by the vanishing gradient problem, which can gravely encumber their performance as sequence length augments. To surmount this issue, Hochreiter and Schmidhuber [29] proposed the long short-term memory (LSTM) network. This network retains the elemental model of an RNN but substitutes the normal nodes (typically hyperbolic tangent units) in the RNN with LSTM nodes, endowing it with the sequence processing capacity of an RNN while ameliorating the vanishing gradient problem. Hence, LSTMs have been broadly deployed in sequence data processing tasks.

Music-driven dance generation should not only consider cross-modal sequence-to-sequence mappings, but also emphasize the complexity of music-to-dance mappings. The relationship between music and dance movements is arbitrary and is influenced by the performer's style, expertise, and personality traits. Furthermore, the relationship between music and dance mappings presents a complex hierarchy of temporal structures ranging from short-term synchronization of posture and rhythm to long-term formation of dance patterns [22]. From this perspective, neural networks have better representational capabilities than hidden Markov models. Crnkovic-Friis and Crnkovic-Friis [21] leveraged LSTM-RNN models to learn and generate dance sequences. They trained the model using six hours of contemporary

dance data captured by Microsoft Kinect, and the trained network was able to extract the style (the expression of the dancer's movements), syntax (the choreographic language of the piece or choreographer), and semantics (the overall theme of the dance piece) of the dance. However, this algorithm does not furnish any means of controlling the process and results generated, and the entire process is not accompanied by any music. The architecture of the factored conditional restricted Boltzmann machine (FCRBM) is apposite for regulating the properties of the generated data and is capable of generating actions in real time.

The GrooveNet proposed by Alemi et al. [22] does not rely on the classification or segmentation of the audio signal, enabling FCRBM models to learn uninterrupted cross-modal mappings from audio information to action data in an unsupervised manner. They trained an FCRBM using a small dataset of only 23 minutes of music-dance movements, and the resulting model can generate basic dance movements independently of audio or can learn and generate movements based on the trained songs. However, the model has conspicuous limitations, with poor performance for unheard music and little practicality.

Tang et al. [23] proposed a music-oriented dance synthesis method based on an LSTM model and an autoencoder model. The model takes acoustic features as input and outputs the final dance synthesis result by extracting the mapping between sound and movement features. They conducted several qualitative and quantitative experiments to select the most suitable model and validated its effectiveness. However, the model is unable to control the generated results based on conditions such as user preferences and dance characteristics.

In summary, while there has been some research on automated choreography of music at home and abroad, it remains in a nascent stage, and the primary deficiencies in the extant research are as follows:

1. The novelty and coherence of the generated movements necessitate improvement. For dance movement synthesis algorithms grounded on manual selection of feature correlations and traditional machine learning, the preponderance of the synthesized movement sequences are predicated on the splicing of movement samples already extant in the original movement database, rendering the generation of novel movement patterns recalcitrant, and novelty is not guaranteed. For automated choreography algorithms leveraging deep learning, the generated movements are prone to abrupt changes vis-à-vis real movements, which encumber their efficacy, and the coherence of the movements is pivotal to the authenticity of the synthesized dance. Moreover, the effect of movement generation is highly contingent on the cardinality of training samples in the database, but amassing enormous music and dance movement data is not straightforward.

2. The ensemble of generated movements and music necessitates enhancement. In previous studies, in the process of generating novel movements, most researchers only contemplated the correlation and constraint between the movements but did not incorporate musical constraints in the generation process. For the few studies investigating music-driven action generation, the results have been unsatisfactory. Furthermore, none of the current

studies have considered the holistic characteristics of the music, only the acoustic characteristics of the instantaneous music fragment or a limited length of music fragment, and therefore do not reflect the influence of the overall style and tempo of the music on the synthesis and choreography of dance movements. In fact, choreography should focus first on the overall characteristics of the target music and only secondly on the mapping and correlation between the local musical fragments and the corresponding movements.

3. Extant research does not substantially account for the user's artificial control over the outcome of choreography. Choreography is subjective, diverse and artistic, and there is no single criterion for evaluating a dance. Hence, some human control over the generated movements and choreography results is necessary to guarantee that the synthesized dances fulfil the user's requirements and expectations to create more thematic dances and to boost the usefulness and interest of this research.

Thus, movement generation and music-based choreography remain in a nascent stage, and there is ample scope for further research, rendering this an area worthy of exploration. This chapter will address these deficiencies and improve the efficacy of synthetic dance.

6.2 FUNDAMENTAL KNOWLEDGE OF AUTOMATIC CHOREOGRAPHY

Computer-automated choreography of music has been studied for an extended period, and the objective of the research is to leverage computer technology to make the process of choreographing music with minimal human intervention. To propose efficacious choreographic algorithms, the key issues to be addressed are: firstly, how to obtain realistic and novel dance movements without relying on manual production and motion capture techniques; secondly, how to select the most germane music and movement features that should be able to effectively characterize the music and movement data; thirdly, how to establish a mapping between music and movement features, where the music and movement feature matching algorithms should be able to capture the relevance of the features.

This section introduces the relevant fundamental knowledge and key techniques involved in the aforementioned three problems. Firstly, it introduces the methods for obtaining dance movement data and movement feature representation. Subsequently, it introduces three deep neural networks commonly deployed to solve sequence problems. Next, it introduces the commonly used algorithms for music feature selection and extraction. Finally, it introduces the methods for analyzing the correlation between music and movement. This chapter furnishes the basis for subsequent action generation, action filtering, feature matching, and dance synthesis.

Computer-automated choreography of music has been an active area of research for an extended duration, and the goal of this research is to leverage computer technology to make the process of choreographing music with minimal human intervention. To propose effective choreographic algorithms, the key challenges to be addressed

are: first, how to obtain realistic and novel dance movements without relying on manual production and motion capture techniques. Second, how to select the most relevant music and movement features that should be able to effectively characterize the music and movement data. Third, how to establish a mapping between music and movement features, where the music and movement feature matching algorithms should be able to capture the relevance of the features.

This chapter introduces the relevant background knowledge and key techniques involved in addressing the aforementioned three challenges. First, it introduces methods for obtaining dance movement data and representing movement features. Then, it introduces three deep neural networks commonly used to solve sequence problems. Next, it introduces commonly used algorithms for selecting and extracting music features. Finally, it introduces methods for analyzing the correlation between music and movement. This chapter provides the foundation for subsequent action generation, action filtering, feature matching, and dance synthesis.

The first step towards computer-automated music choreography is to obtain dance movement data. Currently, two main types of movement data are widely used: motion capture data and keyframe-based movement data. However, both types require a lot of manual processing, which is expensive to obtain and not easy to edit. With the development of artificial intelligence technology, deep learning algorithms are beginning to be applied in the field of movement generation.

Motion capture is the process of recording the movement of objects or people and is used in a wide range of applications in entertainment, sports, medical, film production, computer animation, and robotics [30]. Motion capture systems record movements by setting trackers on key parts of the moving object, sampling the data from each tracker several times per second, and using techniques such as dimensional measurement and orientation determination to obtain three-dimensional spatial data of the moving object. The acquired motion capture data is then mapped onto a 3D model, which performs the same actions as the moving object, as shown in Figure 6.1. Depending on the technical principle used, motion capture systems can be divided into optical, inertial, mechanically linked, and magnetic systems. Due to the different motion capture devices and information recorded, motion capture data is also

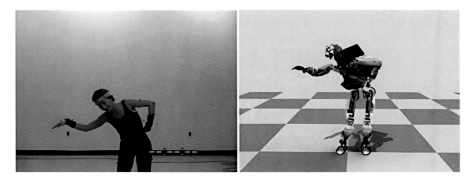

FIGURE 6.1 Real movements (left) and motion capture data-driven robot simulation (right) [30].

FIGURE 6.2 PMD 3D model.

available in a variety of formats including BVH (BioVision Hierarchy), ASF/AMC (Acclaim Skeleton File/Acclaim Motion Capture data), and C3D (Coordinate 3D).

User-made keyframe-based motion data refers to the user's use of MikuMikuDance, Maya, and other 3D animation software to define the action by manually setting the position and rotation angle of each bone of the character model at keyframes and finally exporting the action file. The VMD file needs to be used with the PMD/PMX formatted 3D character model (shown in Figure 6.2), and the skeletal information needs to match each other. The VMD action is then bound to the corresponding character model to obtain the character action, as shown in Figure 6.3.

Compared to traditional keyframe-based computer animation of 3D models, motion capture techniques make it easier to reconstruct complex movements and realistic physical interactions, resulting in more realistic motion data and less effort to obtain the movements. However, motion capture requires specific hardware software to capture and process the resulting data, and the cost of the software, equipment, and personnel required can be prohibitive for smaller productions. It is also difficult to edit the captured data twice, and if there is a problem with the data, the scene has to be reshot.

With the expansion of computer animation and robotics, an increasing number of applications require a profuse amount of real human motion data, which cannot be satisfied by motion capture and manual production alone. Hence, researchers have

FIGURE 6.3 VMD action key frame.

commenced tackling the problem of motion generation. Broadly speaking, action generation algorithms can be bifurcated into two categories: those that combine new action sequences by reusing and editing existing action fragments in databases, and those that generate new action sequences by learning the mapping and constraint relationships within action data through neural networks.

For computer-automated choreography tasks, traditional dance synthesis algorithms based on matching music and movement features fall into the former category where the synthesized dance movement sequences are derived from movement fragments in a database with limited dance diversity. To generate novel movement data, machine learning and deep learning algorithms are beginning to be applied in the domain of movement generation. Hidden Markov models, Gaussian processes, and dimensionality reduction techniques can all capture the intrinsic dependencies and potential correlations of movement data, but traditional machine learning methods are limited in their ability to capture data variation compared to the powerful learning capabilities of neural networks. This chapter therefore chooses to leverage a deep learning-based sequence generation model for action generation.

With the progress of computer animation and robotics, increasingly more applications require a large amount of real human motion data that cannot be satisfied by motion capture and manual production alone. As a result, researchers have started to

address the challenge of motion generation. Broadly speaking, action generation algorithms can be categorized into two types: those that combine new action sequences by reusing and editing existing action fragments in databases, and those that generate new action sequences by learning the mapping and constraint relationships within action data through neural networks.

For computer-automated choreography tasks, traditional dance synthesis algorithms based on matching music and movement features fall into the former category where the synthesized dance movement sequences are derived from movement fragments in a database limiting the diversity of dances. To generate novel movement data, machine learning and deep learning algorithms are being applied in the field of movement generation. Hidden Markov models, Gaussian processes, and dimensionality reduction techniques can capture the inherent dependencies and potential correlations within movement data, but traditional machine learning methods are limited in their ability to capture data variation compared to the powerful learning capabilities of neural networks. Therefore, this chapter chooses to use a deep learning-based sequence generation model for action generation.

To train a motion generation model, a motion dataset needs to be constructed and the motion data represented in vector form as input features to the model. Owing to the limited number of publicly available motion capture datasets, only a small percentage of which comprise dance movements and even fewer are full choreographed movements accompanied by music, the amount of data is not sufficient for the task of deep learning. This chapter therefore leverages movement files in VMD format obtained from the web to construct the dataset and train the movement generation network.

VMD files are user-made keyframe-based action data stored in binary form. The file contains six blocks of data: header, bone keyframes, facial keyframes, inverse kinematics (IK), camera, and lighting motion information. The bone keyframe data block contains information such as the name of the bone, the frame number, the relative position of the bone, the amount of bone rotation (expressed as a quadratic number), and the frame interpolation data. This part of the data represents the movement based on the principle of forward dynamics where the parent node drives the movement of the child nodes. The other part of the IK data is the inverse kinematics, as opposed to the forward kinematics, which is a method of animation where the child nodes drive the movement of the parent nodes, and is used in the skeletal chain of the model's legs. Furthermore, the motion information in the VMD file is not stored in consecutive frames but only the position and rotation of each joint point are recorded at user-defined keyframes. The motion data is played back at a frame rate of 30 frames per second when used, with the skeletal movements in the intermediate transition frames being automatically calculated by the MMD software using a quaternion interpolation algorithm.

To train a motion generation model, a motion dataset needs to be constructed and the motion data represented as vector input features for the model. Due to the limited number of publicly available motion capture datasets, of which only a small percentage contain dance movements and even fewer contain fully choreographed movements accompanied by music, the amount of data is insufficient for the task of deep learning. Therefore, this chapter uses movement files in VMD format obtained from the web to construct the dataset and train the movement generation network.

6.3 DATA-DRIVEN AUTOMATIC CHOREOGRAPHY

In this section, we proposed an automatic choreography framework that combined the motion generation algorithm based on MDN with the music-motion feature matching algorithm, and introduced user control in addition, as depicted in Figure 6.4. The overall system comprised four parts: data preprocessing, motion generation, feature matching, and 3D animation. Firstly, we constructed a music-motion dataset and preprocessed the motion data. Secondly, we set up the LSTM-MDN motion generative model to complete the model training, motion generation, and screening. Then, we extracted the global and local features of the target music and candidate motion data, including rhythm and intensity, and performed hierarchical feature matching, and finally obtained the final choreography result after interpolation of the transition frames. In the step of global feature matching, the system allowed the users to control the speed and spatiality of the movements on their own, so as to synthesize the dance more in line with users' expectations and increase the fun and practicality of the system.

6.3.1 DATASET AND FEATURE EXTRACTION

6.3.1.1 Data Acquisition

In recent years, research on dance synthesis has been mainly based on motion capture data. Although there are some open available human action datasets, most of them are not dance movements, but running, playing, and other sports data. For the research of dance synthesis based on deep learning, motion data plays a key role in the training of the model. Therefore, this chapter constructed a music-dance motion dataset using VMD motion files obtained from the network and their accompanying WAV music files, a total of 192 segments, 1,057,344 frames, about 587 minutes, each of which is an independent piece of choreographer. Furthermore, the movements are classified based on the human experience. According to the style of music and dance,

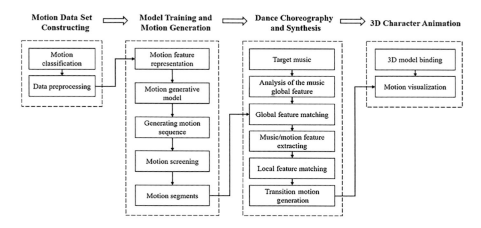

FIGURE 6.4 Workflow of the framework.

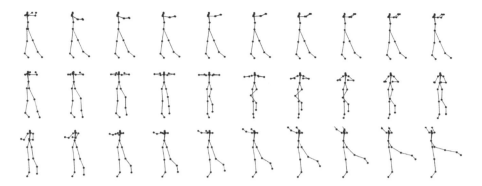

FIGURE 6.5 Pose of modern dance in the dataset (sample frames).

it can be divided into three categories: modern dance, hip-hop dance, and Japanese folk dance. According to the speed, it can be divided into two categories: fast and slow. A representative dance pose snapshot of modern dance in the dataset is shown in Figure 6.5.

6.3.1.2 Data Representation and Feature Extraction

VMD files are hand-made keyframe-based motion data stored in binary form. The file contains information such as the name of the skeleton, the frame number, the relative position of the skeleton, the rotation of the skeleton (expressed in quaternions), and the frame interpolation data. The data of the leg joint chain is based on the Inverse Kinematics (IK) principle. The rest is based on the principle of Forward Kinematics (FK). In this chapter, we preprocessed the original VMD data, including interpolation calculation of the intermediate frame, conversion of the quaternion to Euler angle and IK calculation, and finally represented the motion data as the three-dimensional coordinates of each joint point. Twenty-one key joints, including the pelvis, shoulders, elbows, hands, legs, feet, spine, neck, head, etc., were selected to represent dancers' movements. Finally, the dimension of key frame data decreased from 574 to $21 \times 3 = 63$. The 63-dimensional vector was used as motion feature data for training of the motion generative model.

6.3.2 Dance Movements Generation

To ensure the novelty of synthetic dance movements, this chapter used the deep learning algorithm to generate motion.

6.3.2.1 Generative Model

Here, we introduce the two fundamental models used in our synthesis approach.

6.3.2.1.1 LSTM

Recurrent Neural Networks (RNNs) have been used to get state-of-the-art results for complex time series modeling tasks due to the introduction of directional loops into the structure. Long short-term memory networks (LSTMs) introduce a "gate"

structure on the basis of RNN, which avoids the gradient vanishing of RNN in solving long-term dependency problems. However, for continuous data, if LSTM is directly used for generation, there will be a problem of output stagnation [31].

6.3.2.1.2 MDN

MDN [31] adds a mixture density model after the output of the neural network to parameterize the distribution of several mixture components using the output of the network. The mixture components are usually Gaussian kernel functions. Specifically, the entire network does not output a single position tensor, but rather a probability density function for each dimension in the output tensor. The output variable is expressed as a tensor z, which contains the weight α for defining each mixture component, and the mean μ and variance σ for parameterizing each mixture component.

$$z = \left[z_1^\alpha, \dots, z_m^\alpha, z_{m+1}^\mu, \dots, z_{mc+m+1}^\mu, z_{mc+m+2}^\sigma, \dots, z_{m(c+2)}^\sigma \right] \tag{6.1}$$

Where m is the number of mixture components and c is the dimension of the output data of the neural network.

6.3.2.1.3 Motion Generative Model

In this chapter, we constructed a motion generative model based on MDN referring to the approach of Crnkovic-Friis and Crnkovic-Friis [21], which consists of motion prediction network (neural network) and mixture density model. The schematic diagram of the overall model is shown in Figure 6.6. The motion prediction network is a neural network for learning the internal dependence and mapping relationship between the motion sequence data and predicts the motion of the next frame according to the input. Since the motion data is time-related sequence data, we built a motion prediction network based on the LSTM network structure, which consists of three LSTM layers, three dense layers, and one concatenate. The mixture density model consists of several Gaussian kernel functions. After the output of the LSTM network is parameterized by the mixture density model, the final output is the parameters of the probability density of the spatial position of each joint point in the next frame.

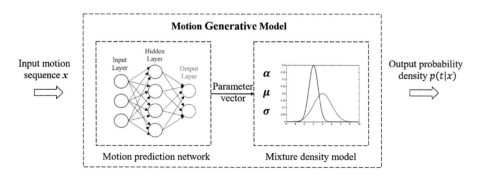

FIGURE 6.6 A schematic diagram of motion generative model based on MDN.

With the parameter vector, the whole mixture density model can be encoded as an error metric E^q, where the error function is a negative log-likelihood function (for the q:th sample):

$$E^q = -\log\left[\sum_{i=1}^{m} \alpha_i\left(x^q\right)\varphi_i(t^q \mid x^q)\right] \tag{6.2}$$

$$\varphi_i(t \mid x) = \frac{1}{\left(2\pi\right)^{\frac{c}{2}} \sigma_i\left(x\right)^c} e^{-\frac{\|t-\mu_i(x)\|^2}{2\sigma_i(x)^2}} \tag{6.3}$$

We used 12 Gaussian distributions to construct a mixture model ($m = 12$), and the number of LSTM nodes per layer is set to 512. During training, the batch size is set to 100, the sequence length of one-time input is 120, the learning rate is 1×10^{-3}, and a total of 500 epochs are trained and optimized by RMS Prop optimizer. When training the motion generation network, the effect of the parameterized mixture density model is achieved by minimizing the error function E^q.

6.3.2.2 Parameter Control

From the variable output from the motion generative model, we can know the spatial distribution probability of each skeletal joint point in the next frame. When calculating the joint position with the above parameters, the following three methods can be used: *the general method* (comprehensively considered the mean and variance), *the mean method* (only considered the mean value), and *the fixed variance method*. There are differences in the dances generated by different parameter control methods. This section chose the most appropriate parameter control method in the process of motion generation by comparing the effects of each method.

For *the general method*, according to the weight α of each Gaussian mixture model, the highest probability one is selected from the m Gaussian distributions to determine the mean and variance of the c joint points, thereby the Gaussian distribution model can be established, from which a point satisfying the distribution is randomly selected to be the spatial position of the joint point; *the mean method* directly took the mean of the Gaussian distribution model as the spatial position of the joint point. *The fixed variance method* set the variance of Gauss distribution model as a fixed constant.

The motions generated by the above three methods have different effects, each having advantages and disadvantages. *The general method* makes full use of the output parameters of the motion generative model, but the generated motion is highly likely to have a sense of shaking during playback. *The mean method* can reduce the probability of incoherence compared with the general method, but it also reduces the richness of the movements. *The fixed variance method* combines the first two methods, but the selection of the variance value becomes crucial, and the selection of the inappropriate effect is counterproductive. After many experiments and observations, we found that the fluency and richness of the motions generated by *the mean method* can be guaranteed, and the visual effect is the best.

6.3.2.3 Motion Screening

To ensure that each frame used in dance synthesis is a truly coherent and high-quality movement, a coherent-based motion screening is required to remove the mutated data.

For a coherent sequence of motions, the motion of adjacent frames should have sufficient similarity, which is reflected in the smaller distance between the corresponding joint points. The motion data used in this chapter is sampled at a frequency of 30 frames per second, and the distance between the positions of the joint points corresponding to the adjacent two frames can be approximated as the speed of the joint at that time. We argued that for a coherent sequence of motions, regardless of the speed of the overall speed, the rate of velocity change between adjacent frames should be small. Therefore, we conducted a coherent screening of motion sequences based on the rate of velocity change, firstly calculating the sum of the absolute values of the first-order differences of the joint speeds of adjacent frames $V(f)$:

$$V(f) = \sum_{k=1}^{c} \left| v(f+1,k) - v(f,k) \right| \tag{6.4}$$

$$v(f,k) = \left\| x_{f+1}^{(k)} - x_f^{(k)} \right\| \tag{6.5}$$

Where f is the sequence number of the frame in the motion segment, x is the motion vector, $x_f^{(k)}$ represents the k-th dimensional motion data of the f-th frame, c is the vector dimension of each frame motion, and $v(f, k)$ represents the speed of the k-th dimensional data of the f-th frame.

When the motion screening is performed, we set the maximum threshold ε_{\max}, and if the f-frame motion satisfies $V(f) \leq \varepsilon_{\max}$, we consider that the motion at that moment is consistent with the requirement of coherence. In order to remove the new sequence whose length is too short after segmentation, the minimum length threshold l_{min} needs to be set, and only the new sequence whose length exceeds the threshold can be saved to the generated motion database.

6.3.3 MULTI-LEVEL MOTION AND MUSIC FEATURE MATCHING

When the choreographer completes the choreography work of a given musical piece, he/she first analyzes the overall characteristics of music, such as style, genre, and emotions expressed, and then determines the general tone of the choreography, such as dance style, emotion, speed, and intensity of the overall movement, and finally begins to arrange the specific dance movements corresponding to each music segment.

Inspired by this, we propose a multi-level music and motion feature matching algorithm. Firstly, the global feature of the target music is analyzed and preliminarily matched with the motion features. Then, considering the matching degree between the local features of the music segments and the motion segments consisted of the rhythm and intensity, the motion sequence matching the target music is obtained. Finally, the adjacent motion segments are connected by interpolation to obtain the final choreography result.

6.3.3.1 Global Music Feature Extraction

Since the classification of datasets relies on the user's intuitive visual and auditory perception rather than specific indicators, this section hopes to exploit the differences in the overall characteristics of music between different categories.

6.3.3.1.1 BPM

The commonly used indicator for measuring the speed of music is Beat Per Minute (BPM), which is simply the number of beats within a one minute interval, corresponding to the actual performance speed of the player. The larger the BPM, the faster the music.

We extracted the BPM of the music in the dataset. The average and the maximum value are shown in Table 6.1. It can be found that for the three dance styles, the average BPM of hip-hop dance is the largest and that of modern dance is the smallest. Observing all types of dance movements, we can find that the overall speed of hip-hop movements is faster than modern dance. That is to say, the larger average BPM of the music corresponds to the faster dance, which is consistent with the intuitive audiovisual experience.

6.3.3.1.2 Note Density

We believe that the more notes per beat in a piece of music, that is, the frequent changes in notes, the richer the musicality of the piece, and the corresponding dance movements should be more variable. Based on this idea, we calculate the average duration (number of frames) of the notes of the entire song. The total number of frames of the music signal $x(n)$ is l_{music}, and the total number of changed notes is n_{note}. First, we performed CQT on the music signal $x(n)$ to obtain $X(n)$ and obtained the frequency amplitude of each frame of the music signal at each semitone. Then, it is considered that the semitone with the largest frequency amplitude in each frame is the note played at the current moment. If the notes played in the adjacent two frames are changed, the total number of notes n_{note} is increased by one:

$$n_{\text{note}} \leftarrow n_{\text{note}} + 1, if \operatorname*{argmax}_{k}\big(X\big(f,k\big)\big) \neq \operatorname*{argmax}_{k}\big(X\big(f+1,k\big)\big) \qquad (6.6)$$

Finally, the average note duration frame $\text{time}_{\text{note}} = l_{\text{music}} / n_{\text{note}}$ is used to measure the note density.

TABLE 6.1

BPM of Music Corresponding to the Dance in the Dataset

Style	Average	Minimum	Maximum	Speed	Average	Minimum	Maximum
Hip-hop dance	**135.01**	92.29	166.71	fast	**128.94**	83.35	172.27
Japanese folk dance	**126.94**	83.35	172.27	slow	**110.83**	74.9	161.5
Modern dance	**113.34**	74.9	139.67				

TABLE 6.2

Note Duration (Frame) of Music Corresponding to the Dance in the Dataset

Style	Average	Minimum	Maximum	Speed	Average	Minimum	Maximum
Hip-hop dance	**1.73**	1.36	2.35	fast	**1.79**	1.32	3.32
Japanese folk dance	**1.84**	1.32	2.37	slow	**2.36**	2.13	3.41
Modern dance	**2.31**	1.74	3.41				

The average number of frames per note of each type of music in the dataset is shown in Table 6.2. According to the data in the table, the speed of note change is proportional to the overall speed of dance. This result is consistent with the BPM results of the music corresponding to the dances, and is also consistent with the intuitive visual and auditory feelings.

6.3.3.2 Global Feature Matching

In Section 6.4, we constructed a music-motion dataset and manually labeled the dance style and speed so as to train five motion generative models corresponding to different styles and speeds. For a new target music, we hope that the global features of the music can be used to determine which type of dance it is most suitable for, and preliminary matching of candidate movements.

6.3.3.2.1 Motion Feature Extraction

When making feature selection, we mainly considered the following two points:

Dances that have some fixed characteristics can be usually summarized as the movement feature of a certain body part. For example, the characteristics of Greek dance are the beating of the foot and the lower jaw of the hip, which can be described as the vertical displacement of the hip and foot joints.

Different types of dance have their specific spatial characteristics, which can be described by the displacement of the skeletal root nodes. For example, the modern dance is more spatial than the Japanese folk dance.

Based on the above considerations, we proposed the following two types of features when matching the global features of motion: the velocity characteristics of skeleton and the spatial features of motion segments.

(1) Velocity features of local skeleton

In this chapter, the distance between the joint positions of the adjacent two frames can be approximated as the velocity of the joint at this moment, and the average arm speed v_i^{Arm} of the action segment N_i is:

$$v_i^{\text{Arm}} = \sum_{f=1}^{L_{\text{Motion}}-1} \frac{\| p_{f+1}^{\text{Arm}} - p_f^{\text{Arm}} \|}{L_{\text{Motion}} - 1} \tag{6.7}$$

Where f is the frame number of the motion segment N_i, L_{Motion} is the length of the motion segment, and P_f^{Arm} represents the position of the arm joint of the f-th frame. The arm joints in the above formula can also be replaced by other joint positions to calculate the average speed of other joints.

In choreography, the specific bones and their range of velocity values v_i^{Bone} can be set as matching conditions to match the motion segments of different speeds, thus choreographing dances with different motion characteristics.

(2) Spatial characteristics of dance

The spatiality of dance is also reflected in the movement path. Spatiality has a very important influence on the effect of dance synthesis. The strong spatiality means that the dance has a wide range of motion paths, which can be described as the larger projection distance of the root on the XOY plane, and vice versa. The spatial metric e_i of the motion segment N_i is:

$$e_i = \sum_{f=1}^{L_{\text{Motion}}-1} \frac{\sqrt{\left(x_{f+1}^{\text{Root}} - x_f^{\text{Root}}\right)^2 + \left(y_{f+1}^{\text{Root}} - y_f^{\text{Root}}\right)^2}}{L_{\text{Motion}}-1} \tag{6.8}$$

Where x_f^{Root} and y_f^{Root} are the x and y coordinates of the root node of the f-th frame.

In choreography, it is possible to match different spatial motion segments by setting a threshold of the motion spatial feature e_i.

6.3.3.2.2 Global Feature Matching

When given the target music, the global feature, namely BPM and the average duration of changed notes, are extracted first. By comparing the values listed in Tables 6.1 and 6.2, the dance style and speed that the target music was most likely to correspond to were determined, so that the motion generative model could be selected.

To make the final choreography movement better reflect the richness of music changes, we made a preliminary matching of the motion segments according to the global music features. As can be seen from the above, the shorter the average duration of the changing notes, the richer the musical expression, the faster the speed of the matching movement should be, and the higher the threshold η_v of the bone velocity should be set, i.e.:

$$\eta \propto \left(1/\text{time}_{\text{note}}\right) \tag{6.9}$$

In addition, we believe that the overall speed of music should be positively correlated with the speed of motion. It is worth noting that: (1) given the target music, the choice of the dance style (i.e., the choice of the motion generative model) is not absolutely unique. The algorithm proposed in this chapter selected a relatively more suitable model according to the overall characteristics of the music. However, other styles of music choreography can be obtained by using other models. (2) The influence of music features on the dance movements is diverse. In future work, the

constraint relationship between high-level features such as music and motion emotion can be further studied.

6.3.3.3 Local Feature Matching Considering Rhythm and Intensity Components

For the problem of local feature extraction and matching of music and motion, this section mainly referred to Shiratori et al. [11].

6.3.3.3.1 Music Feature Extraction

The music segmentation is based on the repeating pattern extraction of notes, the music rhythm features are extracted based on a typical onset-component rhythm evaluation feature, and the musical intensity features are extracted based on sound pressure.

6.3.3.3.2 Motion Feature Extraction

The motion feature extracted its common features with music: rhythm, and intensity. By analyzing the dynamic feature of the whole body joint points, the motion rhythm is extracted according to the key pose [11]. The extraction of motion intensity features is based on the Laban's research [13]. The motion segment is partitioned by taking 16 rhythm lengths. Like music, all features are defined on the scale of the segment.

6.3.3.3.3 Local Feature Matching

The common feature matching of music and motion included rhythm matching and intensity matching. Firstly, the rhythm matching is performed based on the number of synchronized rhythm points based on music and dance moves. At the same time, in order to ensure the connectivity of adjacent motion segments, the connectivity analysis is performed on adjacent motion segments. Then, based on the connectivity of the adjacent motions, the tree depth search algorithm is used to extract all possible result motions. Finally, based on the similarity of intensity histogram, the input audio and all possible motions are matched in intensity to select the best matching dance moves.

6.3.3.4 Transition Motion Generation

In Section 6.4, we got several motion segments that matched the target music. In this section, the adjacent motion segments will be connected on this basis to complete the final dance synthesis.

Since the motion of the segment M is not similar enough to that of its adjacent segment N, we performed interpolation between the end k frames of M and the intermediate motion of N according to the interpolation weight to achieve smooth convergence of movements while still retaining the characteristics of the end of the previous motion segment. The interpolation motion guarantees the coherence of the movement, but there may be unreal movements such as footstep sliding. To avoid the influence of the interpolation motion on the perception, the value of k cannot be too large. In this chapter, $k = 14$ is taken during the experiment.

The length of the motion segment M is m, and the last k frame motion is denoted as $M_{m-k+1,...,m} = \{f_{m-k+1}^M, f_{m-k+2}^M, ..., f_m^M\}$; the first k frame motion of the segment N is denoted as $N_{1,...,k} = \{f_1^N, f_2^N, ..., f_k^N\}$. Firstly, the starting position of the intermediate motion $N_{1,...,k}$ is shifted to the same position as M_{m-k+1}, and then the interpolation motion $P_{1,...,k}$ is synthesized, where $P_{1...k} = \{f_1^P, f_2^P, ..., f_k^P\}$, the node displacement is interpolated linearly:

$$p_i^{P,s} = \alpha(i) f_{m-k+i}^{M,s} + (1-\alpha(i)) f_i^{N,s}, \quad 1 \le i \le k \tag{6.10}$$

$$\alpha(i) = 2 \cdot \left(\frac{i}{k}\right)^3 - 3 \cdot \left(\frac{i}{k}\right)^2 + 1, \quad 0 \le i \le k-1 \tag{6.11}$$

Where $p_i^{P,s}$ represented the coordinates of the s joint point of the i-th frame of the P motion segment, and $\alpha(i)$ is the interpolation weight.

So far, we have completed the dance synthesis.

6.3.4 EXPERIMENTS AND DISCUSSIONS

In this section, we report several qualitative and quantitative experiments to verify the effectiveness of the proposed algorithm.

6.3.4.1 Qualitative Experiments

6.3.4.1.1 Parameter Control Method Experiment

In this experiment, the Japanese folk dance motion generative model saved after 200 epochs of training was used to generate a motion sequence. Given a new 120-frame Japanese folk-dance motion as the initial input, 900 frames of motion are generated by the three parameter control methods: the general method, the mean method, and the fixed variance method. The dance pose snapshots are shown in Figure 6.7.

Through observation, it can be found that the motion generated using the general method is more prone to be incoherent; for the mean method, the generated sequence is smooth and coherent overall, and the computation is simpler because the variance is not considered in the computation process; for the fixed variance method, it is not easy to choose the appropriate variance. We obtained the variance of each frame of the MDN output during the generation of all 900 frames. The maximum value is 5.58, the minimum value is 5.54e-05, the average value is 0.59, and the standard deviation is 0.82. When the fixed variance value is set to 0.5 (shown in Figure 6.7[d]), the result is not satisfactory, indicating that the variance value is too large. In general, the mean method works best, the result of the general method has poor stability, and the quality of the result of the fixed variance method depends largely on the variance setting.

6.3.4.1.2 Motion Screening Algorithm Experiment

In this experiment, 127 motion segments with 900 frames length were generated using the mean method, and coherence screening was performed. Different $V(f)$,

FIGURE 6.7 Comparison of the generated movements by different parameter control methods (frame 200–209). (a) and (b) are motions generated using the general method and the mean method. (c) and (d) are motions generated using the fixed variance method, and the variances are set to 0.1 and 0.5 respectively.

FIGURE 6.8 Motion snapshot that does not satisfy the coherence conditions($\varepsilon_{max} = 20$, $l_{min} = 30$).

maximum threshold ε_{max}, and minimum length threshold l_{min} were set to compare the screening results. The motion snapshot of the unfiltered part (non-coherent) is shown in Figure 6.8, and the detailed information of the motion data before and after the screening is shown in Table 6.3.

The data in Table 6.3 shows that the larger the ε_{max} is set, the more motion data is retained after the screening; the smaller the l_{min} is set, the more motion segments are segmented. The experimental results are in agreement with the theory of the algorithm. According to Figure 6.8, the motion screening algorithm is accurate because the motion that is not passed through the screening is not a coherence dance segment. Therefore, the coherence-based motion screening algorithm proposed in this chapter is effective.

TABLE 6.3
Screening Results Based on Coherence

Motion Data			Info			
	ε_{max}	l_{min}	Total Number of Segments	Data Size	Total Number of Frames	Retention Ratio (%)
Original			127	178.8M	114300	
After	30	60	350	149.8M	95873	83.90
After	20	60	462	104.7M	66930	58.60
After	20	30	840	131.0M	83743	73.30

6.3.4.2 Quantitative Experiments

This section utilized user ratings to analyze the result of three styles of dance synthesis. We invited 35 users to conduct user research, 18 of whom had learning experience in dance, musical instrument, or vocal music. In this experiment, three pieces of target music suitable for generating hip-hop, Japanese folk dance, and modern dance were analyzed and choreographed. In the experiment, the user judged the dance styles of the three clips separately and then scored five grades (1–5 points) on the matching degree of music and dance, the coherence and authenticity of dance movements according to subjective judgment. One point means very bad, and 5 points means very good. We counted the average and variance of the scores of 35 users and took the average as the final score of the experimental segment. The results are shown in Figure 6.9.

We find in Figure 6.9 that hip-hop dance has the highest score of three indicators, followed by the modern dance, and finally the Japanese folk dances. We interviewed

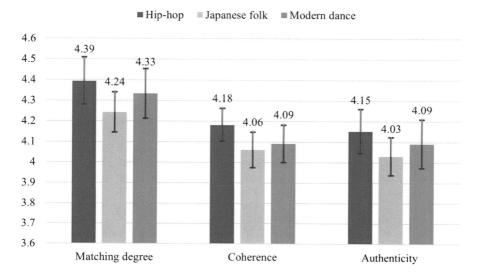

FIGURE 6.9 Comparison of three dance scores.

these users after they completed the test who said that the rhythm of the hip-hop style movement is obvious and the motion range is larger; while the motion range of the Japanese folk dance is generally too small, which indicated that sometimes it is difficult for the user to distinguish whether it is a slight movement or jitter data. According to the scoring results, we can see that the coherence, authenticity, and matching degree of the three styles of dance are all above 4 points, indicating that the users are satisfied with the synthetic dance results. Therefore, the choreography algorithm proposed in this chapter is effective.

6.4 CHAPTER CONCLUSION

In this chapter, we proposed a music-based choreography framework. Through the three steps of motion generation, motion screening, and feature matching, dances matching the target music can be generated, and the coherence of the movement and the consistency with the music can be achieved. Our future work will focus on three major objectives: (1) trying to analyze the high-level features of the motion; (2) trying to analyze the high-level features of music and motion, such as emotions, when matching feature; and (3) considering other evaluation methods of choreography.

REFERENCES

[1] Brand M, Hertzmann A. Style machines. *Siggraph Computer Graphics Proceedings*, 2000:183–192.

[2] Lee J, Chai J, Reitsma P S A, et al. Interactive control of avatars animated with human motion data. *ACM Transactions on Graphics*, 2002, 21(3):491–500.

[3] Bu G, Liu J, Zhang F. The application of the multimedia technology in the dance teaching of college sports. *International Symposium on It in Medicine & Education* 2012.

[4] Gentry S E, Feron E. Modeling musically meaningful choreography. *IEEE International Conference on Systems*. IEEE, 2004.

[5] Rauscher F H, Shaw G L, Ky K N. Listening to Mozart enhances spatial-temporal reasoning: Towards a neurophysiological basis. *Neuroscience Letters*, 1995, 185(1):44–47.

[6] Yu T, Johnson P. Tour Jeté, pirouette: Dance choreographing by computers. *International Conference on Genetic and Evolutionary Computation: Parti*. Berlin: Springer-Verlag, 2003:156–157.

[7] Hainsworth S, Macleod M. Beat tracking with particle filtering algorithms. *IEEE Workshop on Applications of Signal Processing to Audio & Acoustics*, 2003:91–94.

[8] Jensen K, Andersen T H. Beat estimation on the beat. *Applications of Signal Processing to Audio and Acoustics, 2003 IEEE Workshop on*. IEEE, 2003:87–90.

[9] Alankus G, Bayazit A A, Bayazit O B. Automated motion synthesis for virtual choreography. *Computer Animation and Virtual Worlds*, 2005, 16(3/4):259–271.

[10] Lee H C, Lee I K. Automatic synchronization of background music and motion in computer animation. *Computer Graphics Forum*, 2005, 24(3):353–361.

[11] Shiratori T, Nakazawa A, Ikeuchi K. Dancing-to-music character animation. *Computer Graphics Forum*, 2006, 25(3):449–458.

[12] Shiratori T, Nakazawa A, Ikeuchi K. Rhythmic motion analysis using motion capture and musical information. *IEEE International Conference on Multisensor Fusion and Integration for Intelligent Systems*. IEEE, 2003:89–94.

[13] Laban R, Ullmann L. The mastery of movement. *Creative Activities*, 1971:200.

[14] 方丹芳. 音乐驱动的舞蹈动作合成 [D]. 北京: 北京邮电大学, 2018.

[15] Samadani A A, Kubica E, Gorbet R, et al. Perception and generation of affective hand movements. *International Journal of Social Robotics*, 2013, 5(1):35–51.

[16] Tilmanne J, Dutoit T. Expressive gait synthesis using PCA and Gaussian modeling. *International Conference on Motion in Games*. Springer-Verlag, 2010.

[17] Fukayama S, Goto M. Automated choreography synthesis using a Gaussian process leveraging consumer-generated dance motions. *Proceedings of the 11th Conference on Advances in Computer Entertainment Technology*. ACM, 2014:23.

[18] Ofli F, Demir Y, Yemez Y, et al. An audio-driven dancing avatar. *Journal on Multimodal User Interfaces*, 2008, 2(2):93–103.

[19] Ofli F, Erzin E, Yemez Y, et al. Learn2dance: Learning statistical music-to-dance mappings for choreography synthesis. *IEEE Transactions on Multimedia*, 2012, 14(3):747–759.

[20] Wang J M, Fleet D J, Hertzmann A. Gaussian process dynamical models for human motion. *IEEE Transactions on Pattern Analysis & Machine Intelligence*, 2008, 30(2):283.

[21] Crnkovic-Friis L, Crnkovic-Friis L. Generative choreography using deep learning. arXiv preprint arXiv:1605.06921, 2016.

[22] Alemi O, Françoise J, Pasquier P. GrooveNet: Real-time music-driven dance movement generation using artificial neural networks. *Networks*, 2017, 8(17):26.

[23] Tang T, Jia J, Mao H. Dance with melody: An LSTM-autoencoder approach to music-oriented dance synthesis. *2018 ACM Multimedia Conference on Multimedia Conference*. ACM, 2018:1598–1606.

[24] Sutskever I, Vinyals O, Le Q V. Sequence to sequence learning with neural networks. *Advances in Neural Information Processing Systems*. 2014:3104–3112.

[25] Holden D, Saito J, Komura T. A deep learning framework for character motion synthesis and editing. *ACM Transactions on Graphics (TOG)*, 2016, 35(4):138.

[26] Yin W, Kann K, Yu M, et al. Comparative study of CNN and RNN for natural language processing. arXiv preprint arXiv:1702.01923, 2017.

[27] Hinton G, Deng L, Yu D, et al. Deep neural networks for acoustic modeling in speech recognition: The shared views of four research groups. *IEEE Signal Processing Magazine*, 2012, 29(6):82–97.

[28] Franklin J A. Recurrent neural networks for music computation. *INFORMS Journal on Computing*, 2006, 18(3):321–338.

[29] Hochreiter S, Schmidhuber J. Long short-term memory. *Neural Computation*, 1997, 9(8):1735–1780.

[30] Yamane K, Hodgins J. Simultaneous tracking and balancing of humanoid robots for imitating human motion capture data. *2009 IEEE/RSJ International Conference on Intelligent Robots and Systems*. IEEE, 2009:2510–2517.

[31] Bishop C M. *Mixture Density Networks*. Birmingham: Aston University, 1994.

7 Toward Human-AI Collaborative Sketching

Zeyu Wang
The Hong Kong University of Science and Technology
(Guangzhou), Guangzhou, China

Tuanfeng Y. Wang
Adobe Research, London, UK

Julie Dorsey
Yale University, New Haven, USA

7.1 INTRODUCTION

Artists extensively use line drawings to express forms, depict details, and explore ideas. However, creating line drawings for animated shapes is tedious and hard to control, which traditionally relies on the heavy manual labor of tweeners, i.e., artists who create intermediate frames between keyframes. The modern workflow for animation production involves rendering from an animated 3D sequence instead of drawing frame by frame in 2D, which can be more efficient and versatile. Inspired by this 3D-based workflow, we investigate how to efficiently produce a line drawing animation given a 3D sequence while allowing interactive editing of the drawings. Our key observation in enabling this interactive editing pipeline is to interpret a drawing as a *style* for depicting the underlying geometry. Here, a style captures the relationship between stroke placement and geometric properties of the underlying surface. By adopting a keyframe-based framework, we seek to develop a system that facilitates interactive line drawing synthesis by propagating the style of drawings at several keyframes to all other frames. Our system allows intuitive control by enabling users to refine the generated line drawings and iteratively update the results.

There are numerous ways to create a drawing. Even for the same shape, people with different levels of experience for various purposes can employ distinct styles. In this work, our goal is to build an efficient animation authoring tool for line drawings with fixed stroke color and width. This is a commonly studied type of drawing in graphics literature [1–3] and what most people draw in practice. We leave the handling of other artistic choices such as hatching and stippling to future work.

Extracting line drawings from 3D geometry has been discussed under the scope of non-photorealistic rendering (NPR) [4–6]. However, common parameter-controlled NPR approaches fall short in a creative workflow. A set of parameters that can

DOI: 10.1201/9781003406273-7

generate a desired line drawing may not exist. Also, smooth transition between key-frames may not be possible since the parameters often change at target keyframes, and discrete parameters are difficult to interpolate. Most NPR methods only operate on local features, while artists usually have context-dependent and more sophisticated treatment in their drawing.

In our system, we directly allow the user to create line drawings at a few key-frames. With known 3D geometry at each frame, we extract a latent style code that faithfully represents the user's drawings at the keyframes. Our system can then synthesize line drawings at the in-between frames from the underlying geometry by interpolating the latent style codes between the keyframes. Technically, with a given camera, we represent the geometry at each frame as a set of 2D geometric signals, e.g., normal maps, depth maps, and different types of surface curvatures. We adopt a StyleGAN-based generator [7] to produce a line drawing from a 2D feature map learned from the geometric signals and modulated by a latent style code at each frame. We train the network with synthetic line drawings generated by different NPR methods. We propose novel losses to enforce style consistency between synthesized and user-created drawings for better synthesis and interpolation. At runtime, we employ an optimization-based GAN inversion technique to map the input drawings into the latent style space.

We evaluate our system with respect to line drawing synthesis, style interpolation, latent code embedding, and interactive editing. Experiments show that our approach outperforms vanilla style transfer and style interpolation baselines. Our approach produces plausible output that follows the properties of user input and transitions naturally in the animation. Although our network is trained in a case-specific manner, we show that it is easy to generalize to new cases with quick fine-tuning. Users of our system believe the synthesized line drawings are consistent with their style and are useful for efficient and controllable animation authoring.

This chapter is an extended version of *Learning a Style Space for Interactive Line Drawing Synthesis from Animated 3D Models* published at the Pacific Conference on Computer Graphics and Applications in 2022 [8]. It makes the following contributions:

- A pipeline for interactive line drawing synthesis from animated 3D models, which allows users to control the synthesized style using their drawings at keyframes.
- Novel loss terms specifically designed to facilitate interpolation and style/geometry disentanglement for line drawings.
- An optimization-based embedding strategy that makes the network trained on synthetic NPR output generalize to user-created line drawings at runtime.

7.2 RELATED WORK

7.2.1 NON-PHOTOREALISTIC RENDERING

NPR techniques attempt to create artistic styles in contrast with photorealism. These methods usually take a 3D model as input and extract lines by examining differential properties such as surface curvatures and their derivatives. Widely used ones include

suggestive contours [4], ridges and valleys [6], and apparent ridges [5]. Recent deep learning-based methods can produce more stylistic results from 3D shapes or 2D images [3, 9–11]. These results are believed to resemble drawing, but studies have shown that there is still a significant gap between what people and machines draw [1, 12]. In particular, it is difficult to use NPR methods to produce an intended output due to the lack of intuitive control and interpolation space. This becomes more challenging for animation, which involves varying geometry over time. Animators and tweeners have to draw every single frame to create a drawing animation, with little help from digital tools. Our work aims to reduce manual labor in line drawing animation synthesis while allowing intuitive control of the generator by drawing at keyframes.

7.2.2 SKETCH ANIMATION

Sketch animation dates back to rotoscoping [13], where animators trace over movie images projected onto a glass panel frame by frame. Rotoscoping has been effective in producing realistic action, even though it is a tedious process. Digital technologies have provided sketch animation with many new possibilities, such as algorithms and systems for animating vector graphics [14–16], propagating artistic styles [17, 18], and deforming segments driven by video and physical simulation [19, 20]. In particular, the modern 3D animation workflow is widely adopted because it is powerful and versatile, but it involves a different set of user skills from traditional 2D animation. Much work aims to bring these two workflows together, such as methods for augmenting 2D sketches with 3D motion capture data, augmenting 2D sketches with 3D secondary motion, and converting 2D sketches to 3D proxies [21–23]. Inspired by this line of work, our system attempts to facilitate sketch animation by synthesizing sketches from a 3D animation sequence in a consistent style with users' keyframe sketches. We allow users to interactively edit the predicted sketches from our system, and the changes will be propagated to other frames similar to a previous workflow for garment animation [24].

7.2.3 STYLE-DRIVEN IMAGE GENERATION AND EMBEDDING

Generating rasterized drawings in 2D image space can be categorized as a subtopic of general image synthesis with control signals. In early attempts, autoencoder [25] and variational autoencoder [26, 27] are adopted for image synthesis but limited to low resolution. The quality improves significantly with generative adversarial networks [28]; however, the properties of the latent space are still poorly understood [29, 30]. Recently, Karras et al. proposed StyleGAN [31] and its improvements [7, 32], which map a high dimensional noise into a latent space and apply the learned latent feature as style to modulate the weights of a convolutional neural network-based generator. StyleGAN and its subsequent improvements achieve state-of-the-art performance in high-quality image synthesis. Based on the powerful generator, initializing image synthesis with a learned 2D feature map instead of a constant tensor allows explicit control over the spatial structure of a generated image [33]. Inspired by the previous efforts made in this area, we interpret a line drawing as a 3D shape presented with

a specific style. We adopt a StyleGAN-based generator and initialize it with a 2D geometric feature map for geometry/style disentanglement. The inversion of generation is also useful to embed an input image into the latent space. This can be done by projecting the image into latent space via a neural network encoder [34–38] or optimizing the latent code to reconstruct the target image [39–41]. During training, our style encoder learns a style code, while during testing, we adopt the optimization-based embedding technique for better generalization on unseen drawing styles.

7.3 METHODOLOGY

With the given 3D animation sequence, our method addresses two core issues: 1) represent a line drawing as a latent style code at a keyframe, and 2) generate high-quality line drawing images with an interpolated style code for all other frames. This requires us to learn a latent space to capture the style difference between drawings. Here, style in our context refers to stroke placement on a given 3D geometry, not stroke appearance like width, color, and texture. Since the underlying geometry is known, we adopt an autoencoder-like framework to learn the latent space disentangled from geometry (Section 7.3.1). We then train our network (see Figure 7.1) on a synthetic dataset with customized loss terms that encourage the network to generate smooth transitions (Section 7.3.2). At runtime, we adopt an optimization-based GAN inversion process on a user-created line drawing to obtain its corresponding latent representation (Section 7.3.3). The learned latent space, the generator, and the keyframe embedding enable an interactive workflow for line drawing animation synthesis (Section 7.6).

FIGURE 7.1 An interactive pipeline for line drawing animation synthesis. Starting from the given 3D animation a), the user first selects a keyframe (frame 18) and creates a line drawing (highlighted in red box). Our method automatically propagates its style to the rest of the animation b). The user can iteratively add new keyframes (frame 84 in c), frame 54 in d), and frame 30 in e)) and edit line drawings at the keyframes. Our method smoothly blends the style between the keyframes. The user can also delete a keyframe (frame 18 in e)). Our system offers smooth interpolation between input line drawings at the keyframes and automatically updates the drawing animation after each edit.

FIGURE 7.2 Our network architecture. GeoNet E_G learns a 2D geometric feature g for the underlying geometry M_a captured at frame a. StyleNet E_S encodes a drawing I_a at frame a or one with the same style I_b into a 1D latent style code z. A StyleGAN-based generator [7] G is initialized by g and modulated by z at each layer. This pipeline outputs a drawing I'_a generated by G.

7.3.1 LEARNING A LATENT STYLE SPACE

We adopt an autoencoder-like framework to learn a latent style code for an input line drawing, as shown in Figure 7.2. Specifically, we encode the underlying geometry into a 2D feature map via the geometry encoder, E_G, and encode the 2D line drawing into a 1D style code via the encoder, E_S. We utilize a StyleGAN-based generator, G, as our decoder, which takes the 2D geometry feature map as input and is modulated by the 1D style code.

7.3.2 ENCODING GEOMETRY WITH GEONET E_G

Given a 3D animation sequence, we first set camera parameters to put the character in the center of the viewport. We then represent the underlying geometry at each frame with a set of geometric properties. Specifically, we render 1) shading, $N \cdot V$, where N is the normal direction in the world space and V is the view direction pointing to the camera; 2) depth map, dep, distance from the surface to the camera; 3) derivative of the radial curvature, D_κ, used in suggestive contours [4]; 4) positive first principal curvature κ_1; 5) negative first principal curvature κ_2, used in ridges and valleys [6]; and 6) view-dependent curvature κ_r, used in apparent ridges [5], with a resolution of $H \times W$. Each curvature is normalized using its 90th percentile. Figure 7.3 shows an example of the input channels. The geometry encoder E_G encodes the multi-channel map $M_a \in \mathbb{R}^{H \times W \times 6}$ containing geometric properties at frame a as a tensor $g \in \mathbb{R}^{H_s \times W_s \times 512}$:

$$g = E_G\left(M_a\right),$$

where H_s, $W_s = H/16$, $W/16$. We implement $E_G(\,\cdot\,)$ with a set of convolutional neural networks for efficient 2D feature extraction.

$$N \cdot V \qquad dep \qquad D_\kappa \qquad \kappa_1 \qquad \kappa_2 \qquad \kappa_t$$

FIGURE 7.3 Input to GeoNet E_G. We concatenated six geometric properties, i.e., shading, depth map, and four types of surface curvature. Blue represents low values, and red represents high values.

7.3.3 ENCODING DRAWING WITH STYLENET E_S

We represent a line drawing as a single-channel black-and-white image at a resolution of $H \times W$. We adopt a convolutional neural network to extract a 1D vector as style code from the input drawing. We use 1D feature vectors to represent style instead of using 2D feature maps since we do not expect to capture any spatial information. Specifically, starting from a line drawing $I_a \in \mathbb{R}^{H \times W \times 1}$ at frame a, we concatenate it with the corresponding multi-channel geometric map $M_a \in \mathbb{R}^{H \times W \times 6}$. The combined input is then passed through our style encoder E_S to produce a latent style vector $z \in \mathbb{R}^{1 \times 1 \times 2048}$:

$$z = E_S\left(I_a, M_a\right).$$

Note that our training dataset is generated by NPR methods. Therefore, I_a can be labeled as $I_{a,x}$ where x refers to a set of NPR parameters with which the line drawing is generated. We assume the drawings generated with same NPR parameters should be the same style, so one property of our StyleNet E_S should be:

$$E_S\left(I_{a,x}, M_a\right) = E_S\left(I_{b,x}, M_b\right),$$

where a and b are randomly sampled frames.

7.3.4 STYLEGAN-BASED IMAGE GENERATOR G

We choose a StyleGAN-based network as our generator. The original StyleGAN architecture starts from a constant spatial tensor and utilizes a latent noise vector passed through a mapping network to demodulate intermediate layers to control the details of the generated image. Inspired by Sarkar et al. [33], our generator G starts from the learned geometry feature g instead of a constant input. The intermediate layers are then demodulated by the learned style code z in forward passing. G outputs a line drawing $I'_a \in \mathbb{R}^{H \times W \times 1}$ at frame a:

$$I'_a = G\left(g; z\right) = G\left(E_G\left(M_a\right); z\right).$$

7.3.5 Learning for Drawing Generation

A typical image-based generator is usually trained to minimize per-pixel and perceptual differences. In our setup, the generator should also produce images that 1) look like line drawings rather than natural images, and 2) behave like real in-betweening across frames. Specifically, in addition to widely used terms like reconstruction, perceptual, and adversarial losses, we supervise our network training with 1) sparsity loss, to remove gray pixels; 2) interpolation loss, to encourage the generated image to transition smoothly between sampled positions in the latent space; 3) strokeness loss, to encourage strokes at the in-between frames to grow or vanish naturally. We visually explain the loss terms in Figure 7.4 with an intuitive example. The details of our loss terms are as follows.

7.3.6 Reconstruction Loss and Perceptual Loss

For a frame a in the training sequence, we have:

$$L_{\text{recon}} = \left\| I_a - I'_a \right\|_1 ,$$
$$L_{\text{percep}} = \sum_k \left\| \text{VGG}_k \left(I_a \right) - \text{VGG}_k \left(I'_a \right) \right\|_1 ,$$

where $\text{VGG}_k(\cdot)$ is the k^{th} layer of a VGG network pre-trained on ImageNet. We expect line drawings rendered with same NPR parameters to have the same latent style code. We implement this by generating I'_a with the style code learned from another frame

FIGURE 7.4 A toy example explaining our interpolation loss and strokeness loss. Given two line drawings I_1 and I_2, Case 1 shows natural in-betweening, i.e., gradually growing the stroke from I_1 to I_2 in a certain direction. On the contrary, Case 2 and Case 3 present two counterintuitive examples. In Case 2, the stroke does not follow the minimum path principle and goes beyond the range of I_2. In Case 3, instead of growing smoothly in a stable direction, the strokes grow in fragments, which is undesirable. Residuals $|I_t-I_1|$ and $|I_2-I_t|$ further highlight the differences between the three cases.

b rendered with the same NPR parameters x, i.e., $I'_a = G\left(E_G\left(M_a\right); E_S\left(I_{b,x}, M_b\right)\right)$. We also explicitly supervise this property with an intrinsic loss:

$$L_{\text{intrinsic}} = \left\|z_{a,x} - z_{b,x}\right\|_2^2,$$

where a, b are randomly sampled frames, x is a set of parameters used for NPR rendering, $z_{a,x} = E_S(I_{a,x}, M_a)$ and $z_{b,x} = E_S(I_{b,x}, M_b)$.

7.3.6.1 Sparsity Loss

Since our goal is to generate a line drawing with binary strokes, we therefore adopt a sparsity loss to penalize gray pixels in the generated image.

$$L_{\text{sparsity}} = \left\|I'_a\right\|_1.$$

7.3.6.2 Interpolation Loss

It is not obvious to generate in-between styles for any pair of synthetic NPR line drawings, as they may use different methods. Here, we propose a self-supervised loss to encourage a smooth transition between sample pairs in training:

$$L_{\text{interp}} = \sum_k \left\|\text{VGG}_k\left(I'_2\right) - \text{VGG}_k\left(I'_t\right)\right\|_1$$
$$+ \left\|\text{VGG}_k\left(I'_t\right) - \text{VGG}_k\left(I'_1\right)\right\|_1,$$

where $I'_1 = G\left(E_G\left(M_a\right); z_1\right)$ and $I'_2 = G\left(E_G\left(M_a\right); z_2\right)$ are generated images with two different styles z_1 and z_2 for the same frame. $I'_t = G\left(E_G\left(M_a\right); z_t\right)$ is generated with $z_t = (1 - t)z_1 + tz_2$, a randomly sampled style code between z_1 and z_2.

7.3.6.3 Strokeness Loss

Here, we take a closer look at the growing or vanishing of a stroke during style change. A natural way should treat the stroke as a whole and elongate or shorten it in a certain direction instead of placing fragmented segments and connecting them. Therefore, we adopt a strokeness term here to encourage a continuous stroke during interpolation. Specifically,

$$L_{\text{stroke}} = \left\|\text{GauSm}_k\left(\left|I'_2 - I'_t\right|\right)\right\|_{0.5}$$
$$+ \left\|\text{GauSm}_k\left(\left|I'_t - I'_1\right|\right)\right\|_{0.5},$$

where $\text{GauSm}_k(\cdot)$ is the 2D Gaussian smoothing operator with a kernel size of $k = 7$. This is based on our observation that Gaussian smoothing produces more non-zero pixels when the pixels from the input image are more separate from each other.

7.3.6.4 Adversarial Loss

Finally, we apply a standard adversarial loss with a discriminator D when training our network. We refer readers to Karras et al. [7] for more details.

We train our network with a combination of all the loss terms listed above with the same weight. In Section 7.5, we show that the loss terms derived from prior knowledge of strokes leads to better drawing generation and interpolation.

7.3.7 INPUT DRAWING EMBEDDING

At runtime, we allow the user to create a line drawing at a keyframe in the animation. We need to obtain a style code from the input drawing that can faithfully reconstruct itself via our generator. The source of the input drawing can be 1) a NPR rendering of the keyframe with a set of user-specified parameters; 2) manual editing based on 1), e.g., removing or adding strokes; and 3) drawing from scratch over a reference image of the underlying geometry. Due to the huge space of drawing variation and limited capacity of NPR drawing generation, our StyleNet (E_S) only works well with input from 1). To enable an interactive editing workflow with full user control, during test time, we adopt an optimization-based approach to embed an input drawing I_a at keyframe a into the latent style space. Specifically, we compute geometry feature g when a keyframe is selected. We freeze the weights of our generator G and optimize a latent code z^* so that the generated image, $I'_a = G(g; z)$, is similar to the input drawing. Since the gradient of our binary drawing can be unstable for optimization, we adopt a pyramid structure with different levels of blurring, i.e.,

$$z^* = \arg\min_{z} \sum_{k=1,33,65} \left\| \mathrm{GauSm}_k\left(I_a\right) - \mathrm{GauSm}_k\left(I'_a\right) \right\|_1,$$

where k is the kernel size of the Gaussian smoothing operator in pixels. We initialize the optimization with the projection of StyleNet, i.e., $z_0 = E_S(I_a, M_a)$.

7.4 IMPLEMENTATION DETAILS

7.4.1 DATASET PREPARATION

We evaluate our approach on five animation sequences: Mouse [42] (480 frames), Lilly [43] (1,200 frames), Human [44] (3,000 frames), Michelle [44] (200 frames), and Vegas [44] (123 frames). For Human, we use the first 2,000 frames for network training and the rest of the sequence is only used for a generalization test on unseen frames. For each scenario, we use NPR [45] to build a synthetic dataset for network training. For each frame, we use three NPR methods, i.e., suggestive contours, ridges and valleys, and apparent ridges, and sample four thresholds for each. We combine outputs from these methods and generate 64 ($4 \times 4 \times 4$) NPR line drawings for each frame and four additional Canny edge maps [46] generated with different thresholds. For each frame, it takes about 15 seconds on average to generate all 68 line drawings with a resolution of $W, H = 512, 512$. We do not include neural contours [3] in our dataset due to efficiency consideration. We apply commonly used techniques for 2D

FIGURE 7.5 Sample training data for the human character. Our synthetic dataset consists of line drawings generated with different non-photorealistic rendering methods with varying parameters.

data augmentation, including translation, rotation, scaling, and flipping. We show sample training data for Human in Figure 7.5.

7.4.2 DATA COLLECTION FOR EVALUATION

We collect line drawings from three sources to evaluate our system.

1. Similar to the synthetic dataset generation pipeline, we generate unseen NPR line drawings for selected frames from the animation sequence with random sampled NPR parameters. We denote these drawings as NPR.
2. We allow users to edit an NPR line drawing by adding new strokes or erasing existing ones. We build a user interface for this purpose, as shown in Figure 7.6. It allows users to select a frame and load an NPR line drawing from the training set or from NPR. We show a shading image of the geometry at the selected frame in the background with adjustable opacity. Users can draw and erase strokes on the left canvas. We denote these drawings as NPR w/ edits.
3. More experienced users can directly create line drawings from scratch by looking at the reference shading image. We denote these drawings as Freehand.

7.4.3 NETWORK ARCHITECTURE AND TRAINING STRATEGY

Our GeoNet, E_G, is a neural feature extractor built with convolutional layers followed by Parametric Rectifying Linear Unit (PRelu) activation [47] and batch normalization. Starting from the multi-channel geometric signal map $M_a \in R^{512 \times 512 \times 6}$, our network gradually decreases the dimension of the output to 256, 128, 64, and 32, while increasing the number of channels gradually to 32, 64, 256, and 512 after each layer. This results in a 2D geometric feature, $g \in R^{32 \times 32 \times 512}$. Our StyleNet, E_S, adopts a similar architecture but maps the input line drawing $I_a \in R^{512 \times 512 \times 1}$ into a 1D style code, $z \in R^{1 \times 1 \times 2048}$, with five more layers. The architecture of our generator, G, follows StyleGAN2 [7] including bilinear upsampling, equalized learning rate, noise injection at every layer, variance adjustment of residual blocks, and leaky ReLU. The final output of this pipeline is a line drawing image $I' \in R^{512 \times 512 \times 1}$. We trained our network with a learning rate of 0.02 using four NVIDIA V100 GPUs with a batch size of 4. It takes about 48 hours on average to converge in our experiments.

FIGURE 7.6 User interface for drawing, editing, and interactive animation authoring. It allows the user to load an NPR line drawing, edit an existing drawing, or draw from scratch. We show a shading image of the geometry at the target frame in the background with adjustable opacity as a reference. In the animation mode, the user can play the sequence and add, edit, and delete keyframes.

During the drawing embedding step, we implement the optimization using the *optim* package from PyTorch [48]. We choose LBFGS algorithm [49] as our optimizer with a learning rate of 0.1. The optimization takes place on a single NVIDIA V100 GPU for 100 steps for all the cases discussed in this chapter. This optimization takes about 30 seconds for 50 steps on average.

7.5 EXPERIMENTS

In this section, we evaluate our approach with various test cases and show that our approach learns a powerful latent style space for effective line drawing animation synthesis given different types of user input. We then validate our system design choices via ablation studies. We also show that our approach can generalize directly to unseen animation sequences of the same character and can generalize to different animations of another character within a few iterations of fine-tuning.

7.5.1 Evaluation

7.5.1.1 Latent Style Space Embedding

We first evaluate the latent space embedding for a given line drawing. As discussed in Section 7.3.3, the style code directly predicted from an input drawing may not be accurate enough for an edited NPR drawing or one drawn from scratch. In Figure 7.7, we see that the drawing generated from the learned latent style code z is similar to

FIGURE 7.7 Evaluation of latent style code embedding. We test our style embedding approach on different types of line drawings, i.e., (a) NPR, (b) NPR w/ edits, and (c) Freehand. We show generated drawings from 1) learned latent style code z; 2) optimized z without the pyramid strategy; and 3) optimized z with the pyramid strategy (ours). Our approach achieves best reconstruction from the latent embedding. Red arrows highlight challenging areas. Ours achieves the lowest L_1 + VGG error, as shown by the values below each entry.

the target input in general but missing some details, especially for NPR w/ edits and Freehand cases. With latent code optimization, the generated drawing can recover strokes missing from the initial projection. Our pyramid strategy facilitates gradient propagation and leads to better reconstruction compared to the one without the pyramid, as shown by the L_1 + VGG error. In case b), the pyramid strategy helps recover strokes that are missing in the optimization without the pyramid.

7.5.1.2 Disentanglement between Style and Geometry

Since we cast the style as an intrinsic property that depicts the relationship between stroke placement and geometric features, the same drawing style at different frames in a sequence should be mapped to the same place in the latent style space. In other words, no matter which frame the style is learned from, the latent style code should all produce the same drawing for the target frame. Our NPR dataset provides consistent style across frames in a sequence. In Figure 7.8, given a target line drawing I_a at a certain frame a, we randomly pick two other frames b and c from the same sequence. The corresponding drawings with the same style are denoted as I_b and I_c. We show the style code extracted from I_b and I_c can be used to faithfully reconstruct the target drawing I_a.

7.5.1.3 Style Interpolation

Our latent style space is learned from a set of separated NPR line drawings. The dataset itself cannot provide supervision on smooth style transition due to the nature that some NPR parameters are not interpolatable. Instead, our interpolation loss and strokeness loss provide self-supervision for this purpose. Here, we evaluate the performance of our method on interpolating between two projected latent style codes. Starting from style interpolation at a fixed frame, we learn the geometric features g and keep it unchanged during the interpolation. We embed the source and target line

FIGURE 7.8 Disentanglement between geometry and style. Our StyleNet E_S learns an intrinsic latent space for style. For each target NPR line drawing (1st column), we learn the latent style code z from one rendered with the same NPR parameters but at a different frame in the animation sequence (2nd and 4th columns). The drawing reconstruction from the learned style codes is almost identical at the target frame (3rd and 5th columns).

drawings into latent space to obtain the corresponding latent style codes z_{source} and z_{target}. We perform linear interpolation between z_{source} and z_{target} to generate the transitioning line drawings accordingly, as shown in Figure 7.9.

An alternative baseline method for this task is to adopt a vanilla StyleGAN [7]. In the even rows of Figure 7.9, we train a vanilla StyleGAN with the same NPR dataset and perform the drawing embedding with our pyramid-based optimization. Instead of performing interpolation in the style space, we directly perform interpolation in the W space for the vanilla StyleGAN to generate corresponding output. The optimization-based embedding performs reasonably for reconstructing target drawings in the W space [7]. However, without an explicit disentanglement of style and geometry, the interpolation results using the vanilla StyleGAN have heavy artifacts.

In this experiment, we test line drawings from NPR, NPR w/ edits, and Freehand. We show that our method learns a robust latent style space for all the three types of drawings. In Table 7.1, we report the sparsity loss, interpolation loss, and the strokeness loss along the interpolated sequence. We show that our method achieves lower loss, which agrees with the qualitative comparison.

Next, we elaborate on the experiment setup for an animation sequence rather than a static frame. The geometric features g are learned from the underlying geometry at each frame accordingly, while the style code z is still interpolated linearly between the source and target line drawings. As shown in Figure 7.10, our learned latent space supports different types of line drawings for interpolation between the frames. The generated line drawings have a smoothly transitioning style along the sequence. We also visualize the drawing sequence as a trajectory in the 2D embedding space, as

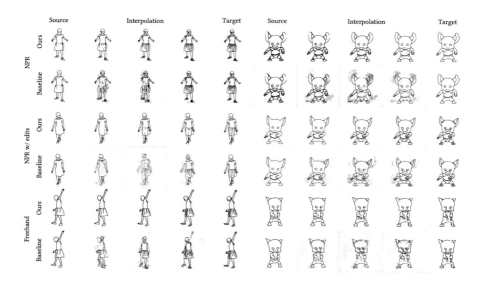

FIGURE 7.9 Style interpolation at a static frame. For each case, the source line drawing (1st or 6th column) and the target (5th or 10th column) are given and embedded into the style space. Linearly interpolated style codes are used to generate transitioning line drawings (2nd–4th or 7th–9th columns). We compare our approach (odd rows) with a baseline method (even rows); vanilla StyleGAN trained with the same dataset. Our approach outperforms the baseline method due to geometry/style disentanglement and drawing-specific supervision during training.

TABLE 7.1
Statistics of Style Interpolation on Static Frame in Figure 7.9

		Lilly			Mouse		
		$L_{sparsity}$	L_{interp}	L_{stroke}	$L_{sparsity}$	L_{interp}	L_{stroke}
NPR	Ours	**0.069**	**0.044**	**0.025**	**0.098**	**0.073**	**0.042**
	Baseline	0.082	0.207	0.113	0.130	0.237	0.181
NPR w/ edits	Ours	**0.054**	**0.047**	**0.020**	**0.075**	**0.097**	**0.034**
	Baseline	0.059	0.275	0.147	0.099	0.190	0.148
Freehand	Ours	0.073	**0.096**	**0.047**	**0.072**	**0.126**	**0.052**
	Baseline	**0.072**	0.283	0.148	0.090	0.244	0.168

Note: We calculate sparsity loss, interpolation loss, and the strokeness loss along the interpolated sequence. We show our method outperforms the baseline approach on style interpolation. Better performances in bold.

shown in Figure 7.11. Specifically, for the test animation, we randomly sample 10k NPR line drawings from our dataset and compute the 512-dimensional VGG feature for each drawing. We apply t-distributed stochastic neighbor embedding (t-SNE) [50] for the VGG features. For the sequences in Figure 7.10, we embed the VGG feature for each entry into the same t-SNE domain. We see that the line drawing

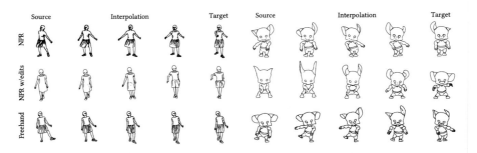

FIGURE 7.10 Style interpolation between dynamic frames. We evaluate our system on animation sequences with dynamic frames using the same experiment setup from Figure 7.9.

FIGURE 7.11 t-SNE visualization of style interpolation between dynamic frames. For the Lilly dataset, we calculate the VGG features for 10k randomly sampled NPR line drawings in the training dataset and embed them into a 2D space via t-SNE [50]. We then calculate the VGG features for each frame in the three clips shown in Figure 7.10. We visualize the three sequences (NPR: red, NPR w/ edits: green, Freehand: blue) with the same 2D embedding. The trajectories indicate that the predicted style interpolation between frames is perceptually smooth and generalized well to unseen styles (NPR w/ edits and Freehand).

animation with linear interpolated style forms a smooth trajectory in the perceptual embedding space. This backs up our observation that the transition between source and target line drawings is smooth and natural.

7.5.2 Ablation Study

We use an ablation study to validate our design choices. Starting from a source edited NPR line drawing, we perform style interpolation on a static frame towards a target edited NPR line drawing. Figure 7.12 shows the effect of the loss terms used in network training. We see that the three losses proposed to self-supervise drawing

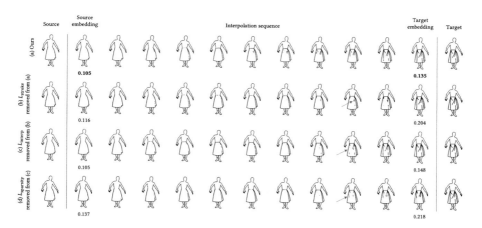

FIGURE 7.12 Ablation study of loss terms. Given the same source and target line drawings, we first embed the drawings to obtain their latent style codes. We linearly interpolated the style codes to generate the in-between drawings. From top to bottom, we first show our method (a), and gradually remove strokeness loss (b), interpolation loss (c), and sparsity loss (d). Reconstruction error is reported for the embeddings of source and target drawings. Red arrows highlight the artifacts in the interpolation. With all the loss terms, our approach performs the best for style interpolation and reconstruction of unseen input line drawings.

interpolation, i.e., sparsity loss, interpolation loss, and strokeness loss, are functioning as expected, as the toy examples discussed in Section 7.3.2. We observe a smoother transition from the source to the target in our full pipeline. We also observe that those losses provide supervision over the gaps between samples in the NPR dataset, which helps the method generalize to unseen input line drawings.

We adopt the same style interpolation setup to evaluate the effect of latent space dimension. We train the same network but reduce the dimension of the latent style space from 2048 to 1024 to 512. After training with the same number of epochs, we compare their style interpolation performance in Figure 7.13. We observe that the quality of line drawing synthesis is improved along with the increase of the latent space dimension, where the model size and training time for each epoch are increased as well. Therefore, our choice of a 2,048-dimensional latent style space is a reasonable tradeoff between training efficiency and network performance.

7.5.3 Generalization

7.5.3.1 Unseen Frames

After training our network with the NPR line drawings rendered from the given 3D animation, we test how well the network generalizes to the unseen frames in the same animation. This happens when an animator edits the 3D animation, e.g., inserts new frames to the given sequence or updates the 3D shape at some existing frames. In Figure 7.14, we apply the trained model on an unseen subsequence from the Human dataset. The style code is obtained from the first frame, which is an edited NPR line drawing, and the style code remains the same for the entire unseen sequence.

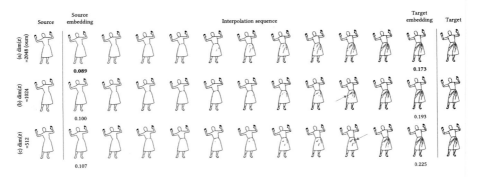

FIGURE 7.13 Ablation study of latent space dimension. We train the same network with a latent space dimension gradually decreasing from (a) 2,048 to (b) 1,024 to (c) 512. With an experiment setup similar to Figure 7.12, we show that a 2,048-dimensional latent space (ours) is more capable of learning diverse drawing styles. Decreasing latent space dimension worsens the performance in drawing embedding and style interpolation.

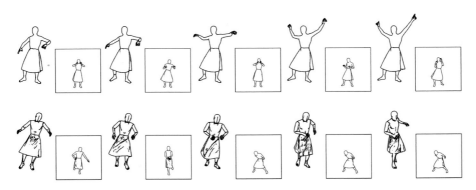

FIGURE 7.14 Generalization to unseen frames. We evaluate our trained model on an unseen subsequence from the same animation. Our model is trained on the first 2,000 frames from the Human animation, while the sequence shown here starts from frame 3,000. We show two styles over the two clips. The nearest neighbor from our training NPR dataset is in the black box. We show that our method generalizes well to unseen frames after training with an animation sequence from the same scenario. This is particularly useful when the 3D animation is modified, as the line drawing animation can be updated automatically without any further manual effort.

The nearest neighbors retrieved from the training dataset indicate that although the target pose is very different from the training dataset, our method generalizes well to the unseen sequence.

7.5.3.2 Unseen Animation

Training our network from scratch is time-consuming due to the complexity of the architecture, especially our StyleGAN-based generator *G*. Alternatively, once a new animation sequence is given, we can make the most use of existing models trained

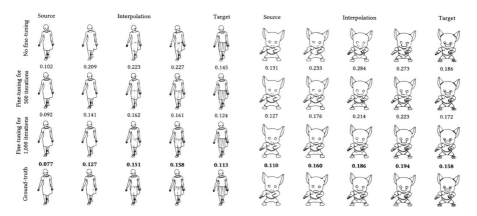

FIGURE 7.15 Generalization to unseen scenarios. Our trained model can be adapted to a different scenario after a few iterations of fine-tuning. Here, we show the results from a model trained on Mouse and tested on Lilly, as well as one trained on Lilly and tested on Mouse. Since our networks learn non-local features for drawing interpolation, directly applying the pre-trained models (~48 hours) without fine-tuning generates artifacts (1st row). The performance improves rapidly after a few iterations (~ 7 to 15 minutes) of fine-tuning (2nd and 3rd rows). We report the L_1 + VGG error between each entry and the corresponding frame generated by the model trained on the target dataset (4th row).

on previous cases. In Figure 7.15, we see that directly applying the model trained on another dataset performs reasonably on style embedding and line drawing reconstruction, while style interpolation generates artifacts at in-between frames. This is because although our training NPR line drawings are generated based on local geometric features, our self-supervision losses break such locality for better line drawing generation during style interpolation. Fortunately, the pre-trained model provides a good starting point for fine-tuning. In both the two test cases shown in Figure 7.15, after 500 iterations of fine-tuning (about 7 minutes), the produced in-between frames are getting reasonable. After 1k iterations (about 15 minutes), the in-between frames converge to plausible transition that is visually indistinguishable from the results generated by the network trained from scratch (Figure 7.9, third row). This observation is supported by quantitative evaluation as the error of the generated in-between frames decreases with fine-tuning.

7.6 APPLICATIONS

With the framework described above, we propose an interactive workflow for line drawing animation authoring. Starting from a 3D animation sequence, 1) we first build our case-specific dataset using NPR methods over all frames of the sequence; 2) with the synthetic dataset, we fine-tune (or train from scratch) our networks GeoNet (E_G), StyleNet (E_S), and Generator (G) with the proposed loss terms; 3) after the training/fine-tuning is done, the user then selects an example line drawing I_a from the NPR dataset to initialize the animation. We obtain the latent code $z_a = E_S(I_a, M_a)$ and generate the line drawing animation for the whole sequence with

$I_k = G(E_G(M_k), z_a)$, $k = 1, 2, 3, \ldots$ Meanwhile, we add z_a at frame a to our keyframe set; 4) the user may view the line drawing animation and decide which frame needs to be modified. The user may select another keyframe b and create a line drawing I_b, as described in Section 7.4.2. We embed I_b into our latent space with the optimization framework to obtain z_b accordingly. z_b at frame b will be added into our keyframe set, after which we update the animation sequence with linear interpolation/extrapolation of z in the keyframe set along the sequence. A keyframe can also be deleted, and the animation will be updated similarly. We extend the user interface developed for line drawing editing with a keyframe select/deselect function and apply it to this interactive authoring workflow.

We invited five users with different levels of drawing expertise to test our prototype system. We show a typical case on Lilly in Figure 7.1. We observe that usually our system offers a plausible line drawing animation that matches users' intention after they select about 3% out of all frames as keyframes and create line drawings for these keyframes. The users recognize the value of our system, as they no longer need to draw every single frame to create an animation. They also appreciate the intuitive control and interactivity that our system provides, in contrast to other methods that generate hard-to-edit results.

7.7 CONCLUSION

In this chapter, we have presented a method for interactive line drawing synthesis from animated 3D models by learning a latent style representation disentangled from the underlying geometry. We conducted comprehensive evaluation on each component of our method and the prototype system as a whole. We show that the proposed approach efficiently learns a meaningful latent style space and results in a powerful line drawing generator that can create clean drawings at a single frame and also interpolate the line drawings naturally along an animation sequence. This plays a critical role in establishing a prototype system that supports interactive authoring of line drawing animation. We have demonstrated such workflow with promising test cases and received positive feedback from our users.

7.7.1 LIMITATIONS AND FUTURE WORK

As a first step in this direction, we simplified our problem to line drawings with fixed stroke appearance like thickness and binary color. This is not enough for professional users to create in a more artistic way. In the future, we will extend our approach and take hatching and stippling into consideration. Recent progress on high-quality image generation [32] may also benefit our system. Incorporating the latest powerful image generator without making our system over-complicated is also an interesting research problem. Collecting line drawings for a data-driven approach is always a challenging task. In this work, we utilize a synthetic dataset to avoid extensively collecting hand-drawn data. Adopting more sketch synthesis techniques may increase the diversity of our dataset, which can be helpful to reduce the gap between a synthetic dataset and real human input. Since the fundamental element of a drawing is stroke, we will explore if using vector strokes instead of raster pixels is a better

way to represent and animate drawings. Finally, it is also an interesting research direction to integrate sketch-based modeling techniques so users can edit the 3D animation sequence at the same time.

REFERENCES

[1] Cole F., Golovinskiy A., Limpaecher A., Barros H. S., Finkelstein A., Funkhouser T., Rusinkiewicz S.: Where Do People Draw Lines? *ACM Trans. Graph.* 27, 3 (Aug 2008), 88:1–88:11.

[2] Li M., Lin Z., Mech R., Yumer E., Ramanan D.: PhotoSketching: Inferring Contour Drawings From Images. In *Proceedings of the IEEE Winter Conference on Applications of Computer Vision* (2019), pp. 1403–1412.

[3] Liu D., Nabail M., Hertzmann A., Kalogerakis E.: Neural Contours: Learning to Draw Lines from 3D Shapes. In *Proceedings of the IEEE Conference on Computer Vision and Pattern Recognition* (2020).

[4] Decarlo D., Finkelstein A., Rusinkiewicz S., Santella A.: Suggestive Contours for Conveying Shape. *ACM Trans. Graph.* 22, 3 (July 2003), 848–855.

[5] Judd T., Durand F., Adelson E.: Apparent Ridges for Line Drawing. *ACM Trans. Graph.* 26, 3 (July 2007), p. 19.

[6] Ohtake Y., Belyaev A., Seidel H.-P.: Ridge-Valley Lines on Meshes via Implicit Surface Fitting. *ACM Trans. Graph.* 23, 3 (Aug. 2004), 609–612.

[7] Karras T., Laine S., Aittala M., Hellsten J., Lehtinen J., Aila T.: Analyzing and Improving the Image Quality of Style-GAN. In *Proceedings of the IEEE Conference on Computer Vision and Pattern Recognition* (2020), pp. 8110–8119.

[8] Wang Z., Wang T. Y., Dorsey J.: Learning a Style Space for Interactive Line Drawing Synthesis from Animated 3D Models. In *Proceedings of Pacific Graphics* (2022), pp. 1–6.

[9] Fish N., Perry L., Bermano A., Cohen-Or D.: SketchPatch: Sketch Stylization via Seamless Patch-Level Synthesis. *ACM Trans. Graph.* 39, 6 (2020), 1–14.

[10] Li Y., Fang C., Hertzmann A., Shechtman E., Yang M.-H.: Im2Pencil: Controllable Pencil Illustration from Photographs. In *Proceedings of the IEEE Conference on Computer Vision and Pattern Recognition* (2019).

[11] Liu D., Fisher M., Hertzmann A., Kalogerakis E.: Neural Strokes: Stylized Line Drawing of 3D Shapes. In *Proceedings of the IEEE International Conference on Computer Vision* (2021), pp. 14204–14213.

[12] Wang Z., Qiu S., Feng N., Rushmeier H., Mcmillan L., Dorsey J.: Tracing versus Freehand for Evaluating Computer-Generated Drawings. *ACM Trans. Graph.* 40, 4 (Aug. 2021). No. 52, pp. 1–12.

[13] Fleischer R.: *Out of the Inkwell: Max Fleischer and the Animation Revolution.* University Press of Kentucky, Lexington, KY, USA, 2005.

[14] CACANI PTE. LTD.: 2D Animation & Inbetween Software - CACANi. https://cacani.sg/, 2022.

[15] Dalstein B., Ronfard R., Van De Panne M.: Vector Graphics Animation with Time-Varying Topology. *ACM Trans. Graph.* 34, 4 (July 2015). No. 145, pp. 1–12.

[16] Kalnins R. D., Davidson P. L., Markosian L., Finkelstein A.: Coherent Stylized Silhouettes. In *ACM SIGGRAPH Papers* (New York, NY, USA, 2003), ACM, pp. 856–861.

[17] Bénard P., Cole F., Kass M., Mordatch I., Hegarty J., Senn M. S., Fleischer K., Pesare D., Breeden K.: Stylizing Animation by Example. *ACM Trans. Graph.* 32, 4 (July 2013). No. 119, pp. 1–12.

[18] Xing J., Wei L.-Y., Shiratori T., Yatani K.: Autocomplete Hand-Drawn Animations. *ACM Trans. Graph.* 34, 6 (Oct. 2015). No. 169, pp. 1–11.

[19] Su Q., Bai X., Fu H., Tai C.-L., Wang J.: Live Sketch: Video-Driven Dynamic Deformation of Static Drawings. In *Proceedings of the CHI Conference on Human Factors in Computing Systems* (New York, NY, USA, 2018), ACM, pp. 1–12.

[20] Willett N. S., Li W., Popovic J., Berthouzoz F., Finkelstein A.: Secondary Motion for Performed 2D Animation. In *Proceedings of the ACM Symposium on User Interface Software and Technology* (New York, NY, USA, 2017), ACM, pp. 97–108.

[21] Jain E., Sheikh Y., Hodgins J.: Leveraging the Talent of Hand Animators to Create Three-Dimensional Animation. In *Proceedings of the Symposium on Computer Animation* (New York, NY, USA, 2009), ACM, pp. 93–102.

[22] Jain E., Sheikh Y., Mahler M., Hodgins J.: Augmenting Hand Animation with Three-Dimensional Secondary Motion. In *Proceedings of the Symposium on Computer Animation* (Goslar, DEU, 2010), Eurographics Association, pp. 93–102.

[23] Jain E., Sheikh Y., Mahler M., Hodgins J.: Three-Dimensional Proxies for Hand-Drawn Characters. *ACM Trans. Graph.* 31, 1 (Feb. 2012). No. 8, pp. 1–16.

[24] Wang T. Y., Shao T., Fu K., Mitra N. J.: Learning an Intrinsic Garment Space for Interactive Authoring of Garment Animation. *ACM Trans. Graph.* 38, 6 (Nov. 2019). No. 220, pp. 1–12.

[25] Hinton G. E., Salakhutdinov R. R.: Reducing the Dimensionality of Data with Neural Networks. *Science* 313, 5786 (2006), 504–507.

[26] Kingma D. P., Welling M.: Stochastic Gradient VB and the Variational Auto-Encoder. In *Proceedings of the International Conference on Learning Representations* (2014), vol. 19, p. 121.

[27] Rezende D. J., Mohamed S., Wierstra D.: Stochastic Backpropagation and Approximate Inference in Deep Generative Models. In *Proceedings of the International Conference on Machine Learning* (2014), pp. 1278–1286.

[28] Goodfellow I., Pouget-Abadie J., Mirza M., Xu B., Warde-Farley D., Ozair S., Courville A., Bengio Y.: Generative Adversarial Nets. In *Advances in Neural Information Processing Systems 27* (2014).

[29] Dosovitskiy A., Tobias Springenberg J., Brox T.: Learning to Generate Chairs with Convolutional Neural Networks. In *Proceedings of the IEEE Conference on Computer Vision and Pattern Recognition* (2015), pp. 1538–1546.

[30] Sainburg T., Thielk M., Theilman B., Migliori B., Gentner T.: Generative Adversarial Interpolative Autoencoding: Adversarial Training on Latent Space Interpolations Encourage Convex Latent Distributions, 2018. arXiv:1807.06650.

[31] Karras T., Laine S., Aila T.: A Style-Based Generator Architecture for Generative Adversarial Networks. In *Proceedings of the IEEE Conference on Computer Vision and Pattern Recognition* (2019), pp. 4401–4410.

[32] Karras T., Aittala M., Laine S., Härkönen E., Hellsten J., Lehtinen J., Aila T.: Alias-Free Generative Adversarial Networks. In *Advances in Neural Information Processing Systems* 34 (2021).

[33] Sarkar K., Golyanik V., Liu L., Theobalt C.: Style and Pose Control for Image Synthesis of Humans from a Single Monocular View, 2021. arXiv:2102.11263.

[34] Richardson E., Alaluf Y., Patashnik O., Nitzan Y., Azar Y., Shapiro S., Cohen-Or D.: Encoding in Style: A Style-GAN Encoder for Image-to-Image Translation. In *Proceedings of the IEEE Conference on Computer Vision and Pattern Recognition* (2021), pp. 2287–2296.

[35] Tov O., Alaluf Y., Nitzan Y., Patashnik O., Cohen-Or D.: Designing an Encoder for StyleGAN Image Manipulation. *ACM Trans. Graph.* 40, 4 (2021), 1–14.

[36] Tewari A., Elgharib M., Bernard F., Seidel H.-P., Pérez P., Zollhöfer M., Theobalt C.: PIE: Portrait Image Embedding for Semantic Control. *ACM Trans. Graph.* 39, 6 (2020), 1–14.

[37] Zhu J.-Y., Krähenbühl P., Shechtman E., Efros A. A.: Generative Visual Manipulation on the Natural Image Manifold. In *Proceedings of the European Conference on Computer Vision* (2016), Springer, pp. 597–613.

[38] Zhu J., Shen Y., Zhao D., Zhou B.: In-Domain GAN Inversion for Real Image Editing. In *Proceedings of the European Conference on Computer Vision* (2020), Springer, pp. 592–608.

[39] Abdal R., Qin Y., Wonka P.: Image2StyleGAN: How to Embed Images into the StyleGAN Latent Space? In *Proceedings of the IEEE International Conference on Computer Vision* (2019), pp. 4432–4441.

[40] Abdal R., Qin Y., Wonka P.: Image2StyleGAN++: How to Edit the Embedded Images? In *Proceedings of the IEEE Conference on Computer Vision and Pattern Recognition* (2020), pp. 8296–8305.

[41] Ulyanov D., Vedaldi A., Lempitsky V.: Deep Image Prior. In *Proceedings of the IEEE Conference on Computer Vision and Pattern Recognition* (2018), pp. 9446–9454.

[42] Zheng M., Zhou Y., Ceylan D., Barbic J.: A Deep Emulator for Secondary Motion of 3D Characters. In *Proceedings of the IEEE Conference on Computer Vision and Pattern Recognition* (2021), pp. 5932–5940.

[43] 3DPEOPLE: 3D People for Your Visualizations and Animations. https://3dpeople.com/, 2022.

[44] ADOBE: Mixamo. https://www.mixamo.com, 2022. 5.

[45] Decarlo D., Finkelstein A., Rusinkiewicz S., Santella A. Suggestive Contour Software: rtsc. https://rtsc.cs.princeton.edu, 2003.

[46] Canny J., A Computational Approach to Edge Detection. *IEEE Trans. Pattern Anal. Mach. Intell.* 8, 6 (Nov 1986), 679–698.

[47] He K., Zhang X., Ren S., Sun J.: Delving Deep into Rectifiers: Surpassing Human-Level Performance on ImageNet Classification. In *Proceedings of the IEEE International Conference on Computer Vision* (2015), pp. 1026–1034.

[48] FACEBOOK: torch.optim. https://pytorch.org/docs/stable/optim.html, 2020.

[49] Liu D. C., Nocedal J.: On the Limited Memory BFGS method for Large Scale Optimization. *Mathematical Programming* 45, 1 (1989), 503–528.

[50] Van Der Maaten L., Hinton G.: Visualizing Data Using t-SNE. *Journal of Machine Learning Research* 9, 11 (2008). pp. 2579–2605.

8 MemoMusic
A Personalized Music Recommendation and Generation Framework Based on Emotion and Memory

Luntian Mou, Yihan Sun, and Yunhan Tian
Beijing University of Technology, Beijing, China

Jueying Li
Cornell University, New York, USA

Juehui Li
Pandora, New York, USA

Yiqi Sun
University of Regensburg, Regensburg, Germany

Yuhang Liu, Zexi Zhang, and Ruichen He
Beijing University of Technology, Beijing, China

Zijin Li
Central Conservatory of Music, Beijing, China

Ramesh Jain
University of California, Irvine, California, USA

8.1 INTRODUCTION

The history of music is the history of humans. Although it is not clear why music was originally created, it is generally accepted that music is one of the most ancient and popular art forms. Music is the art of sound, so it has something in common with

DOI: 10.1201/9781003406273-8

language. But "Music is a very authentic language; it comprises a logic and directly speaks to the soul", according to world-renowned musician and iconic Greek composer Yanni [1]. In this sense, music is more universal than language.

Music is featured by the organization of three basic elements of melody, rhythm, and harmony. These elements and other musical elements are deliberately organized to express specific emotions perceived by or strongly felt by the composers, which are expected to arouse similar feelings in listeners. Thus, music emotion is much dependent on its structure, which means how various musical elements are organized. A well-organized music is effective in delivering a specific emotion; however, for the same piece of music, the perceived emotion could be much different among listeners [2, 3].

This phenomenon is due to three aspects. First, the musical cognitive ability of listeners is different due to different cultural and educational backgrounds, especially the music training of the listeners. Second, different memories could be aroused in different listeners due to different life experiences, which will largely determine the emotion of a person after music listening. For example, the music played on one's wedding ceremony may trigger the memory of the same experience to the listener, and hence produce similar emotional states. Third, the music listening context also is much different among listeners. The music listening context mainly includes the time, the weather, and the scene [4]. People generally have different basic emotional states in the morning, in the afternoon, or late at night – and the weather also matters. People tend to have positive emotional states on a sunny day that turn to negative on a cloudy or rainy day. Furthermore, people would most probably reach certain emotional states in specific instances such as reading a book or playing a sport.

However, existing mainstream music recommendation systems seldom consider the emotional states of listeners because it is difficult to obtain the emotional states of listeners. Currently, there is no such cost-effective solution for monitoring each listener's emotional states. To do that, ideally, we need wearable equipment to gather the physiological signals, such as the Electroencephalogram (EEG), Electrocardiogram (ECG), Electromyography (EMG), and intelligent analysis modules to fuse the multimodal data to estimate the emotional states of listeners. Currently, commercial music recommendation systems such as QQ Music,[1] NetEase Music,[2] and Pandora[3] mainly exploit music playing history, music consumption statistics, and music heat degree estimation based on big data to recommend music to guess what music users might like. Such kind of music recommendation almost totally ignores the emotional states of listeners and also neglects their personalized emotion navigation requirements.

Here, we emphasize the emotion communication feature of music between the composers and listeners. When composing music, the composer must have felt a particular emotion he or she once experienced or just sparked in the brain as an inspiration. At music listening, the music could induce certain emotion in a listener. If the listener has similar life experiences with the composer, he or she may resonate with the music and reach a similar emotional state with the composer despite the fact that the images in the brain of the listeners might be much different from those of the composers. And as different memories unfold during music listening, the emotional states of the listeners will be significantly affected.

Moreover, music is well known for its emotion regulation capability. It is widely used in musical recovery treatment, especially for mental health and language

disability due to trauma [5]. More generally, music is played for improving people's emotional states. For example, light music is often played to make people calm themselves, feel relaxed, and delighted. Ideally, by a sequence of recommended music, the emotional states of listeners should navigate from negative emotional states to more positive emotional states. Intuitively, in the two-dimensional emotion space of valence and arousal [6], if the start point representing the original emotional state falls in the left upper region, the end point after the emotion navigation with one or more pieces of music being played is expected to be located in the right bottom region. In other words, the target point should have a relatively high valence value and relatively low arousal, which can be interpreted as a peaceful delighted state, something similar to the goal of Zen.

Therefore, previously we proposed a personalized music recommendation framework based on emotion and memory, the first version of our MemoMusic [7], which gives special consideration to the memory triggered by the music when estimating the new emotional states after music listening. The effectiveness of MemoMusic was preliminarily verified on a dataset of 60 piano music collected from the three categories of Classical, Pop, and Yanni music, which is usually labeled as New Age Music but preferred to be called contemporary instrumental by Yanni himself. Then, it was extended into MemoMusic 2.0 [8] with a new feature of generating emotion-based music to solve the issue of limited music dataset size at music recommendation. A long short-term memory (LSTM)-based network was used to take in an entire music with expected valence and arousal and output a piece of new music with similar emotion.

Since the quality of generated music was not satisfactory, MemoMusic 2.0 was further developed into MemoMusic 3.0 [9], which not only introduced music theory into music generation, but also considered music listening context at music recommendation. Specifically, LSTM was replaced by Transformer for generating music with better quality, and a sample sequence characterizing the dominant melody of a music with expected valence and arousal was used as the input instead of the entire piece of music. For music listening context, the time, the weather, and the scene will be considered comprehensively. Experiment on a dataset of 180 labeled music has validated the effectiveness of MemoMusic 3.0 in personalized music recommendation and emotional state navigation. From now on, we will just use MemoMusic instead of its different versions.

The rest of this chapter is organized as follows. Section 8.2 presents a brief review on personalized music recommendation, music generation, and music theory. Section 8.3 describes the framework and algorithms of the proposed MemoMusic. Section 8.4 depicts the MemoMusic system design. Section 8.5 details on experiment and results analysis. And Section 8.6 concludes this chapter with future work.

8.2 RELATED WORK

8.2.1 PERSONALIZED MUSIC RECOMMENDATION

Due to the increasing diversity and quantity of music, how to accurately recommend music to meet listeners' preferences has become a challenge for music applications. Intuitively, this issue can be solved by establishing the mapping between music

genre-styles and user preferences. However, although user preferences are relatively stable, they are not static. Instead, they are dynamic and evolving over time. Therefore, personalized music recommendation is giving more and more emphasis on music playing behavior by users. The behavioral information includes the kind of music played at a certain time, and in what scenario if it can be understood. Personalized music recommendation can be roughly summarized into two categories. One is based on similarity of preferences among different people, such as Collaborative Filtering [10]. The other is based on musical features, like Content-Based Filtering [11, 12]. In [13], a model called CAME was proposed to accurately learn music clip content from heterogeneous information networks, which mainly emphasizes the way users interact with music to solve the problem of inaccurate personalized music recommendation.

With the development of personalized music recommendation, information of user preferences is becoming more comprehensive. However, few methods have taken emotion into account, which is an important factor to consider in personalized music recommendation. To fill this gap, more and more researchers have focused on emotion-based music recommendation [14]. Here, emotion has three aspects: emotion delivered by music as expected by the composer, emotion expressed by the performer which could be slightly different than the one expressed by the music score itself, and emotion perceived by the listener [15]. To better represent these emotions in psychological theory, previous studies have established several psychological emotional models [16].

In 1971, Ekman et al. [17] classified emotions by analyzing human facial expressions and then discussed basic emotion [18], proposing the concept of six basic emotions, namely sadness, happiness, fear, anger, surprise, and disgust. In 1993, Lazarus [19] provided a classification of emotions, containing 15 types of emotions. In 2003, Plutsik et al. [20] divided emotions into eight categories. These emotion classification methods use discrete emotion classification models, which cannot take all emotions into account completely. The first quantitative representation of emotions was proposed by Russel et al. [6] in 1980, which mapped emotions to a two-dimensional coordinate system of Valence and Arousal. The larger the valence, the more positive the person; the lower the arousal, the less excited the person. The study summarized 27 different emotional states and planned these emotional states according to the above model to form a two-dimensional flat representation of emotional states. Most emotion-based music recommendation research works to be mentioned later have used this V-A model.

For some representative works on emotion-based music recommendation, Rosa et al. [21] proposed a music recommendation system based on a sentiment intensity metric, which extracts sentences from users' social networks for sentiment intensity calculation, and then conducts recommendation on mobile devices. Similarly, Zangerle et al. [22] also used user profiles on social networks to extract affective information, but they utilized a network to model the relations among users, music, and hashtags from the social network. However, there are many factors that may affect the listener's emotion, such as memory and context.

In a relevant study by Yang et al. [23], the relations between emotions and the values of valence and arousal were quantitatively elucidated. From a psychological perspective, Simon et al. [24] proved that the listener's emotion induced by music has a strong relationship with his or her personality and the state of listening to music.

Therefore, in order to comprehensively consider the important factors of memory and context on music emotion perception, we propose the framework of MemoMusic to achieve the goal of better personalized music recommendation and generation.

8.2.2 DEEP LEARNING-BASED MUSIC GENERATION

Automatic music generation refers to the use of deep learning algorithms to learn patterns of music from a large amount of music data and generate new music. It is one of the most popular categories in AI-Generated Content (AIGC), which has attracted many researchers in recent years. With the advent of large models, more and more digital content production fields are adopting them to achieve better results and higher efficiency. Music generation is one of these fields.

8.2.2.1 Music Generation Models

Deep learning models are used to learn the characteristics of existing music and generate new music. Neural networks are widely used for automatic music generation due to their excellent feature extraction and learning abilities. Recurrent Neural Network (RNN) is a valid model for modeling sequence data, and it is also the first neural network architecture for music generation. Due to the structural characteristics of RNN, it can transform music generation into a problem of predicting the next state of a music sequence of any length. However, even with the addition of loop links between neurons, ordinary artificial neurons may experience signal attenuation when processing information, which means that RNN's memory ability is not strong enough.

Therefore, long short-term memory (LSTM) network model was proposed to retain information as long as possible by adding new gating units. Eck et al. [25] first used LSTM for the generation of Blues Music, which demonstrated its ability to generate music with proper structure. Later, the Lookback-RNN and Attention-RNN proposed by Magenta from Google Brain [26] showed their abilities in capturing the long-term structure of music, and thus became the models used by most studies in music generation for a time.

With the development of generative models that can model the distribution of training samples, it is considered more suitable for them to be applied in generation tasks. The most typical generative models once were Variational Auto Encoder (VAE) and Generative Adversarial Networks (GAN). The idea of GAN is to train the two networks of Generator and Discriminator and achieve mutual promotion through the game between the two networks. After adversarial training, the generated music is more natural and harmonious [27]. Yang et al. [28] proposed a GAN-based MiDiNet, which used CNN as a generator to generate melody (a series of MIDI notes) and a discriminator to learn the distribution of melodies. Besides GAN, VAE is another popular generative model designed as a structure of encoder to decoder. MusicVAE [29] designed a hierarchical decoder to ensure that the information of the latent code is always utilized during the decoding process.

Recently, Transformer has shown its powerful potential in music modeling due to the attention mechanism. Similar to natural language processing tasks, the Transformer model in music generation can also use self-attention mechanism and multi-head attention mechanism to capture the dependency relationships between different

positions in the input sequence [30], so as to better represent the music information. Simultaneously, by introducing positional encoding [31], the information of different positions in the note sequence can be retained, further improving the performance of the model.

There have been significant advances in music generation based on Transformer models. Music Transformer [32] was successfully introduced for applying Transformer to music generation for the first time. It works well on music generation in that the model can learn long-term structure of music, and the duration of the output music reaches the level of minutes. Huang et al. [33] introduced Pop Music Transformer, which is specifically designed to generate pop piano compositions. The model can learn the characteristics of rhythm and chords, then generate expressive and dynamic pop piano works. MuseNet [34] based on Transformer was a music generation model developed by OpenAI. It can generate various types of music, including Classical, Rock, Jazz, etc. Compared with other music generation models, MuseNet can generate relatively high-quality music.

Although the application of Transformer models in the field of music has become a highly anticipated research direction for its ability to generate high-quality creative musical works, it is still challenging to generate music with a specific condition, especially with an expected emotion represented by specific valence and arousal values, due to the gap between high-level semantics and low-level features. Therefore, in addition to the powerful deep learning models, we need to study conditional music generation.

8.2.2.2 Conditional Music Generation

Music generation based on machine learning starts with imitation. To verify whether the model can learn the characteristics of music itself, many studies have begun to focus on conditional music generation. The current conditional music generation can be divided into two categories based on different types of given conditions: music generation based on low-level conditions and music generation based on high-level conditions.

8.2.2.2.1 Music Generation Based on Low-Level Conditions

Low-level conditions are often elements within music that can be directly learned and understood by the model, such as melody, chords, and rhythm. One of the topical studies is the mutual generation of melody and chord. In songwriting, melody and chords are interdependent and interact with each other, so the principle of keeping the melody for the model to generate the corresponding chord or keeping the chord for the model to automatically generate a melody that can match it is more in line with the human compositional mindset.

Some representative research has progressed on the use of melody as a condition for chord generation. Sun et al. [35] proposed the orderless Neural Autoregressive Distribution Estimation (NADE) for melody harmonization, which inputs melody sequences and corresponding chord sequences with partial mask to Bidirectional LSTM-based network for training. Chen et al. [36] defined surprise contour according to the deriving entropy variations and proposed a controllable framework based on conditional variational autoencoder, which can help users harmonize the melody with different chord both in coherence and divergence.

On the other hand, it is more challenging to generate melody from an existing chord or a controlled chord progression than to generate a melody as a conditional chord. MidiNet proposed by Yang et al. [28] can generate melodies from scratch by following chord sequences or by adjusting the melody of previous bars, even among other possibilities. The interesting part is that the model will produce different results each time with the same start melody given. BebopNet proposed by Hakimi et al. [37] forms a pipeline for Jazz Music generation with a given chord progression, and the generated piece will be optimized by collecting users' taste and preferences. The above are some examples of the work related to music generation based on low-level conditions, and the main goal of this work is to generate music with both harmony and diversity, just as composers do. However, the two aspects mentioned above are only parts of composition since each piece of music has a corresponding style and the emotions the composer wants to convey. Therefore, it is necessary to conduct research on music generation under those higher-level feature conditions.

8.2.2.2.2　*Music Generation Based on High-Level Conditions*

As generative tasks evolve to high level, the conditions for music generation are no longer limited to the elements of music, but tend to be high-level semantics or features, such as style, description of different modalities, or even emotion of music. Unlike low-level conditions, high-level conditions are more abstract and cannot be directly input and easily encoded by the model. Therefore, finding a reasonable method that can translate these high-level features into a form that can be understood and learned by the model is the focus of the research.

Recently, generating a specific style of music has become one of the popular areas of research. Music style refers to the way in which various musical elements are combined in a musical context with individuality. The combination of these elements can produce a significant or unique musical effect. Most of the studies on style-based music generation have been conducted from style imitation learning and style transfer of musical pieces. BandNet proposed by Zhou et al. [38] chose a reliable unconditional music sequence as the seed of generate process at the beginning and introduced music theory into the generation network to minimize the reliance on manual intervention in composing after generation. Choi et al. [39] presented an interesting method to generate a different style of music performance by aggregating the performance embedding with melody after encoding, and the combined input will be decoded to infer the expected music performance.

As the generate condition becomes more and more extensive, it has been extended to more modalities, so the model is required to be more powerful and creative. MusicLM proposed by Google [40] is a text-conditional music generation model that generates high-fidelity music from text descriptions. It is worth noting that the timbre of music can be humming, singing, whistling, or an instrument. In addition to generating music based on text descriptions, matching music to videos is also a challenging task. Gan et al. [41] has generated a piece of music for a video clip of a silent instrument playing. The music corresponds to the performance in the video, as if it were the original video's own soundtrack. There are many other studies on cross-modality music generation that attempt to add more creativity to the task.

Another condition that has been explored by researchers is emotion. There are still many challenges for machines to convey specific emotions in the generated music as human composers do. This is due to the difficulty in defining quantitative relationships between emotions and low-level features of music. Research introduced next are attempts to make the machine understand musical emotions as much as possible through various methods. Ferreira et al. [42] presented a generative LSTM model that takes emotion into account in music generation and proposed a music dataset with human-annotated emotion tags and implemented the model to generate music clips with certain emotions. MorpheuS, proposed by Herremans et al. [43], considered the tension of music that can evoke emotions and measured the generated pieces based on the musical structures.

To better relate low-level musical features to high-level semantics, Herremans et al. [44] presented a framework called Music FaderNets, which clusters low-level features and constructs links between them and the corresponding high-level emotional features by Gaussian Mixture Variational Autoencoders. At the same time, the high-level emotional features would be changed by controlling the low-level features during generation, thus controlling the emotion of the generated music like "sliding faders". Based on this work, Herremans et al. [45] further refined the correspondence between chords and emotions by correlating emotion labels with the values of valence and arousal, as well as finding the correspondence between chord types and emotion labels so as to set specific valence and arousal values of a chord type according to the above relationship. When generating music based on emotion, a machine was required to understand the emotions expressed by the music and incorporate them into the generation process.

As seen from previous studies, it is difficult to establish a quantitative relation between emotion and lower-level features of music. Therefore, when generating a new music with expected emotion, we decided to introduce music theory as a constraint.

8.2.3 MUSIC THEORY

The emotions induced by music are among others not only related to each person's personality and the context when listening to music, but also related to various musical elements contained in the music pieces. Rhythm, melody, harmony, tempo, volume, articulation, timbre, tonality, musical structure, etc., are all key elements in musical compositions that can influence human emotions [46, 47].

However, it is difficult to isolate the various elements of music and to treat them as separate entities. This is because a melody, when heard, naturally contains the basic components of pitch, rhythm, tempo, volume, and timbre. The interval and chordal relationships between the notes can be subsumed into certain tonalities, and the musical structure of the section is also revealed as the music flows through time. Thus, musical characteristics are often perceived as combinations of musical elements.

A tiny difference in one of these combinations can give the listener a completely different feeling, but in general, a faster tempo, a higher volume, and a steady rhythm are fundamentals for a more positive emotional experience [48]. Harmonious interval relationships and less complex chord structures also give the listener a more comfortable feeling [49]. For specific music structures, there is research that

concludes that different music structures will provoke different emotions in the listener. As the listener becomes more exposed to music, the emotional experience becomes stronger [50]. Using the structure of music to stimulate emotions is usually achieved by changing the syntax of the music phrase, so it is important to find the dominant fragment of the whole music piece that plays a key role in expressing music emotion.

Due to the social attributes of expressing emotions, music has become a psychotherapy method for improving social and communication skills. Especially for patients with Autism Spectrum Disorders (ASD), music is a powerful therapeutic and educational tool. Quintin [51] has shown that adults with ASD show typical activation of neural circuitry associated with reward and emotion processing. In order to enhance the mental health of the listener through music, our original intention was to use existing compositions or generate new compositions that match the mood of the listener – and then progressively navigate the listener's mood to more positive emotional states with more positive music. For example, if a listener's mood corresponds to a sad, slow piece in a minor key at the beginning, giving the listener a hug with the matched music first, and then having him listen to pieces with more energetic rhythms, more harmonic chords or pieces with a modulation from a minor key to a major key, may lead the listener to a more positive mood at the end.

Therefore, to establish a music dataset with labeled emotions both for music recommendation and music generation, we chose pieces with a relatively simple compositional structure within the available MIDI tracks. We have prioritized pieces that have a very clear tonality and a classical compositional structure. As we want to make a personalized music recommendation platform, we have tried to include pieces that have a variety of styles, speeds, rhythms, and expressed a wide range of emotions.

To solve the issue of emotion-based personalized music recommendation, inspired by the personalized health navigation work pioneered by Jain [52, 53] and Picard [54], we propose a personalized music recommendation and generation framework based on emotion and memory, which is called MemoMusic, and its details will be given in Section 8.3.

8.3 THE FRAMEWORK AND ALGORITHMS OF MemoMusic

The goal of MemoMusic is to recommend or generate music for listeners to regulate their emotional states to improve mental health. Since the music generation module with LSTM we used before still lacks stability and can hardly generate music to convey the expected emotion to listeners, we used Transformer for music generation and introduced music theory to constrain the generated music. As for personalized music recommendation, we comprehensively considered music emotion, the emotional states of the listener, and possible memories triggered by music. We also included context that mainly refers to the time, the weather, and the scene when listening to music. All these factors impact the listener's emotional states to some extent, which in turn will affect the emotional experience of the listener when listening to a piece of music. Moreover, to solve the issue of limited labeled music, we applied music theory in generating new music with similar emotion to a sample music with

labeled emotion. In the following subsections, we will introduce the framework of MemoMusic and the details of personalized music recommendation considering context and music generation combing music theory.

8.3.1 THE FRAMEWORK OF MEMOMUSIC

The framework of MemoMusic is shown in Figure 8.1, which is composed of the two branches of personalized music recommendation and music generation. As mentioned before, personalized music generation is just to solve the issue of limited music to recommend due to possible resource constraint at practical deployment. Therefore, the two branches share the same algorithm for emotion navigation. The workflow of MemoMusic is as follows. The mode of recommendation or generation can be configured at the beginning. For both recommendation mode and generation mode, the modified current emotional state of the listener will be calculated comprehensively after the listener inputs his or her initial emotional state and the music listening context. Then, by considering the listener's favorite music and warming up the experience of the listener, the first music with similar valence and arousal values to the emotional state of the listener will be recommended or generated. Further, after playing one music, MemoMusic will estimate the next emotional state of the listener by comprehensively considering the emotion of the music played, the emotional state of the listener before listening to the music, emotion induced by possible memory triggered by the music and input in text by the listener during music listening, and the music listening context.

FIGURE 8.1 The framework of MemoMusic.

To achieve the effect of emotion navigation, MemoMusic recommends or generates the next music that generally has a slightly higher valence and a similar or slightly lower arousal to the next emotional state of the listener, so that the listener can reach a more positive emotional state after a round of music listening, which includes four pieces of music in the experiment. If MemoMusic is in generation mode, the emotion navigation algorithm will remain the same, and the valence and arousal values estimated will be sent to the generation module as an emotional constraint. At the same time, the corresponding music with the estimated valence and arousal will be selected as a sample to serve as conditional generation. Considering that the dominant fragment of a music can represent the primary emotion of the music, it will be extracted and used as the leading sheet to generate a new music with similar emotion. Detailed methods of personalized music recommendation and music generation will be introduced in Sections 8.3.2 and 8.3.3, respectively.

8.3.2 MUSIC RECOMMENDATION BASED ON EMOTION, MEMORY, AND CONTEXT

As our ultimate goal is to navigate the emotional state of a listener to a more positive state, we designed the recommendation process as follows. We would provide a piece of music that has similar valence and arousal values to the listener's current emotional state to give the listener a warm hug in the sense of empathy. Then, the emotional state of the listener will be navigated to the target state with relatively high valence and relatively low arousal step by step with corresponding music.

Since we want to navigate an individual to a more positive emotional state by recommending several music in turn, we primarily consider the initial emotional state of the listener and the emotion of a music to be listened to as an external stimulator. During the process of music listening, a memory could be triggered in the listener. The memory is about a special scene when the music once was heard. Very likely, the listener will be affected by the emotion associated with the memory. Additionally, the listener's emotional states could also be influenced by the environment and the events happening around him or her. Thus, we propose to consider the music listening context, i.e., the time, the weather, and the scene the listener is in.

The basic idea is that better context will affect the emotional states of the listener positively, while worse context will affect the listener negatively. We quantitatively define the Valence-Arousal coefficients and offsets under different contexts (see Tables 8.1–8.3 for details) based on the relevant research in Section 8.2. The specific

TABLE 8.1
V-A Values Based on Time

Time Span	V-A Coefficient	V-A Offsets
0:00-7:59	−0.3	−1
8:00-10:59	+0.3	+1
11:00-14:59	0	0
15:00-16:59	−0.3	−1
17:00-23:59	0	0

TABLE 8.2
V-A Values Based on Weather

Weather	V-A Coefficient	V-A Offset
Clear	0	0
Overcast or rainy	−0.3	−1
Scorching	−0.3	−1
Frigid	−0.3	−1

TABLE 8.3
V-A Values Based on Scene

Scene State	V Offset	V Coefficient	A Offset	A Coefficient
Mad	−2	−0.6	+2	+0.6
Negative	−2	−0.9	−1	−0.3
Low mood	−1	−0.3	−1	−0.3
Calm	0	0	−2	−0.6
Positive	+1	+0.3	+1	+0.3
Excited	+2	+0.6	+2	+0.6
Full of Love	+2	+0.9	+2	+0.9

parameter setting method first divides contextual factors into three aspects: time, weather, and scene. Relevant research shows that people are in their worst mood from 3:00 to 5:00 p.m. and from midnight to 8:00 a.m. in a day, so the offset of valence during these periods is set to −1. From 8:00 a.m. to 11:00 a.m., people are generally in their best mood, so the offset of valence during this period is set to 1. The offset of valence during the remaining periods can be set to 0.

For the weather, sunny days have little impact on people's emotions, so the offset of valence for this weather is 0. However, weather conditions such as rain, snow, heat, and cold have a negative impact on people's emotions, so the offset of valence under these weather conditions is set to −1. The system time is obtained from the device used by the listener in the experiment, while the weather and the scene are chosen by the listener.

To reflect the impact of memories triggered by music, the parameter V_{memory} was introduced and corresponding weights were given to calculate the listener's emotional states. The proportion of memory in emotional changes is calculated by calling an API of "sentiment classify" provided by Baidu.[4] Taking valence as an example, the basic valence calculation formula is:

$$V_f = V_{predict} + weight \times V_{memory} \tag{8.1}$$

where $V_{predict}$ is the systematic calculation of the valence value after music listening without taking the impact of memory into account. V_{memory} is used to evaluate the impact of memory on the valence value. Moreover, the weight would be dynamic for

TABLE 8.4
The Context Enhanced Estimation of Valence

Algorithm 1: The Context Enhanced Estimation of Valence

Input: System time; Weather; Scene; Memory; User selected initial valence value V_{user}; Music valence value

Output: The estimated valence value V_f

1. Obtain the value V_{offset_time} and *coe_time* corresponding to the time from Table 1;
 Obtain the value V_{offset_wea} and *coe_wea* corresponding to the weather from Table 2;
 Obtain the value V_{offset_sce} and *coe_sce* corresponding to the scene from Table 3;
2. Calculate the value of V_{offset}: $V_{offset} = V_{offset_time} + V_{offset_wea} + V_{offset_sce}$;
3. Calculate the value of coe: $coe = coe_time + coe_wea + coe_sce$;
4. According to the algorithm of MemoMusic1.0, calculate the value V_{memory} of Valence related to the memory, the value ΔV of Valence's variation due to the music being listened to, and the value *weight* for memory;
5. If it's before the first music recommendation starts: $V_{predict} = V_{user}$; $V_f = V_{offset} + V_{predict}$; $V_{prev} = V_f$;
6. else: $V_{predict} = V_{prev} + (1 + coe)\Delta V$; $V_f = V_{offset} + V_{predict} + weight \times V_{memory}$; $V_{prev} = V_f$;
7. Output V_f as the estimation result of valence

different listeners due to their individual states to achieve the effect of personalized recommendation. The weight is computed as follows:

$$weight = \frac{\sum_{i_mem} \left(\dfrac{V_{after} - V_{before}}{V_{mem} - 0.5} \right)}{N_{mem}} \tag{8.2}$$

where $\Sigma_{i_mem}()$ means summing up all memory inputs in the previous round. V_{after} is the listener's self-reported valence after listening to the music, and V_{before} is the valence before listening to the music. Both these two values are reported by the user directly. $V_{mem} - 0.5$ is used to better recognize if the memory is positive or negative because the range of original values returned by the API is [0,1], where 0 is the most negative and 1 is the most positive.

The updated valence estimation with context added is shown as Algorithm 1 (Table 8.4). Since the emotional states directly selected by the listener cannot objectively reflect the listener's real emotional states, we modify the listener's emotional states by considering the context selected by the listener to determine his or her real emotional states and recommend the most suitable music accordingly. V_{offset} represents the valence changed caused by the context factor, which is added to the original valence value to obtain the listener's modified valence value.

After each step of music recommendations, the listener's emotional state will change accordingly. We define a coefficient "*coe*" for contextual factors to affect emotional states and introduced them into the emotion navigation algorithm. The influence of weather and time on the offset values and coefficients of Valence and Arousal is proportional, and the coefficient value is three-tenths of the initial value. After the next emotional state of the listener has been estimated, the music in database that is the closest in terms of VA values would be selected and recommended to the user, and the distance metric used is Euclidean Distance.

Repeating the recommendation process of MemoMusic can enable the estimation of the listener's emotional states more and more accurately, and can in turn recommend more appropriate music to the listener, leading the listener's emotional states to develop in a more enjoyable and calm direction.

8.3.3 MUSIC GENERATION BASED ON EMOTION AND MUSIC THEORY

8.3.3.1 Music Generation Model

Transformer is a model of encoder-decoder architecture, the core of which is self-attention mechanism. Each encoder and decoder module consists of a multi-head self-attention sub-layer, a fully connected sub-layer, and a residual connection. Transformer can model music sequence as same as text in that they both belong to time series and have certain regularity.

In MemoMusic, four attention layers are used to better obtain the long-term music sequence dependency relationships, the model structure of which is shown in Figure 8.2. The custom embedding sizes are adopted with different types of tokens [55], and the maximum size of embedding is used to form a larger vocabulary size. What's more, we use the relative attention [32] as attention type for reducing memory requirement of each layer and catching longer dependencies. The input token of the model represents current event token by music tokenization.

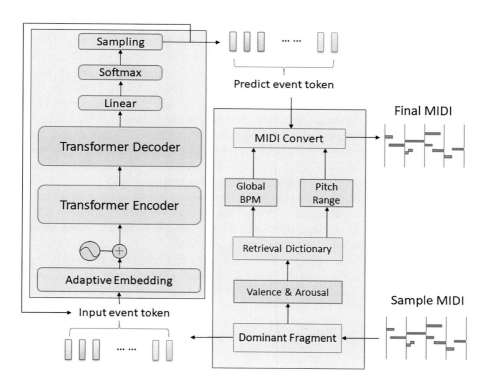

FIGURE 8.2 Automatic music generation enhanced by music theory.

8.3.3.2 Music Representation

The key issue of music representation is to accurately describe the elements in a piece of music so that the model can obtain complete music information. Music can usually be analyzed as time series, but it is also different from normal time series in that there is a certain structural relationship within music from the perspective of composition. For example, music usually determines the specific position of notes according to bars and beats. The MIDI-like representation is general and easily encoded; therefore, it is a good choice as the format for the input data.

Among the studies related to the use of MIDI-like representations of music, most of them use the method in [56] to record Note-on and Note-off of each note, while using Time-shift to align the start times of music. However, it is hard for MIDI-Like representation to convert all the information, such as rhythm, tempo, beat, and other metrical information. Moreover, this kind of representation does not follow the logic of human composition and therefore cannot accurately capture the overall structure of the music.

To better reflect the structure, pop music Transformer [33] proposed REMI, an event-based representation that replaced Note-off with Note duration and used Position and Bar to describe the specific beat position of notes. Compared to MIDI-Like representation, REMI representation encodes both notes and metrical structure information as events, then inputs all the events as group tokens for modeling. REMI has proved to be more efficient than MIDI-Like due to embedding music prior knowledge in data representation.

According to the characteristics mentioned above, we adopt event-based music tokenization as music representation. In the preprocessing stage, all music pieces are uniformly regarding 4th note as one beat and four beats per bar. At the same time, a Python package madmom[5] is used to identify the beats in the music, and 480 ticks are inserted between adjacent beats as the minimum statistical time unit, so that the absolute time of all music pieces can be matched to a relative time. For Pop music and Yanni music, the minimum note duration will be set to 120 ticks, or 16th notes. For Classical music, the minimum note duration will be set to 60 ticks, or 32nd notes. As for chord recognition, we use chorder[6], which represents chord with root, quality, and bass. To simplify the information and reduce the generation complexity, we sort chord according to different types of music. The suspended chords are neglected, while dominant 7th chords are also neglected in Classical music.

As for music tokenization, we count all tokens into seven categories: bar, position, tempo, chord, pitch, duration, and velocity. This is also the basic information MIDI uses to describe a piece of music. However, it is not feasible to sort all tokens simply in chronological order when the music lasts a long time.

To further simplify the sequence length, inspired by Compound Word [55], four group events are further defined: Tempo, Chord, Note, and Boundary. Besides, there are some rules for the occurrence of tokens in these four types of events. For example, after a Tempo event has been determined, the tempo token tends to be maintained for a period of time. Likewise, the chord token in Note event will keep the following chord type until the end of the Chord event, and sometimes the note has no corresponding chord type. Therefore, "Continue" token and "Unknown" token are introduced to ensure the number of tokens predicted by the model in each step are the same. For each type of event, the initial values of all tokens are supposed to be 0.

8.3.3.3 Conditional MIDI Music Generation

To better achieve the goal of generating music with desired emotion, a music piece with labeled valence and arousal values is given as a sample to ensure generating music under a specific emotional condition. The whole generation process is operated as recurrent prediction. For example, the given sample sequence is $(x_1, x_2, ..., x_t)$; then the generation should predict the successive sequence $(y_{t+1}, y_{t+2}, ..., y_{t+L})$ step by step with each step inputting one event to the trained model, where L is the generation length. Furthermore, to improve the randomness and richness of music elements, the temperature sampling strategy [57] is used in the final step.

To achieve a better navigation result on the listener's emotional states, we introduced music theory to the generation process. Since annotating a whole piece of music with only one Valence value and one Arousal value cannot effectively capture the full range of emotional information in the music – and it is challenging to establish a clear relationship between specific emotions and musical elements based solely on VA annotation values – we have decided to focus on extracting the dominant segments from each piece of music. Here, we define a dominant segment as a music segment that appears repeatedly in the musical work and possesses a cohesive musical structure.

Usually, musical segments with iconic melodies are repeated multiple times within the same musical composition, and these segments often evoke emotional resonance in the listeners. Therefore, we believe that using dominant segments as primers for music generation can establish a strong connection between emotions and corresponding musical elements. This approach allows for the preservation of the majority of emotional information in the music, resulting in the creation of music that might deliver specific emotions.

We invited music professionals to assist us in identifying the dominant segments of each music piece in the database and representing these segments in a similar manner to event tokens. When generating music, we take a small portion of segmented dominant fragments and use the preceding tokens as the prompt sequence to generate the rest of the music. The number of tokens in the prompt sequence varies for different types of music, primarily due to variations in their complexity. For simpler and more structured pop music, we use the first five event tokens as the prompt sequence. For Classical music and Yanni music, which are known for their complex and varied compositions, we use the first 50 event tokens as the prompt sequence. This approach not only captures the emotional content of the music but also reflects the original music's corresponding VA values while maintaining a certain level of randomness in generation.

As mentioned in Section 8.2.3, musical elements can influence the emotions expressed in music from a compositional perspective. Therefore, we adjust the music elements generated by the model using music theory to better align with the emotional condition during the final conversion from tokens to MIDI. We focused on restricting two musical elements: pitch range and global tempo.

The pitch range is an important factor that reflects the emotions of music. The magnitude of pitch changes indirectly reflects the fluctuations of the music's emotions, and the pitch range will affect the emotional tone of the music itself. We conducted a statistical analysis of the pitch range associated with the VA values for each genre of music in the database. When generating music with a specific VA, we limit

the output notes based on the statistically determined pitch range. For notes that are outside the pitch range, we adjust the octave up or down to maintain their relative pitch until they are within the pitch range associated with the specific VA value.

For the other element, the global tempo of all music in the database is categorized and statistically classified based on the corresponding VA value. When generating music segments with the corresponding VA, the global tempo remains consistent with the previous statistical tempo. This ensures that the tempo of the music does not suddenly change due to the randomness of generation.

8.4 THE SYSTEM OF MemoMusic

The system of MemoMusic is basically deployed on the Aliyun[7] development platform. Furthermore, we use the Elastic Compute Service (ECS) to run the entire system. We deploy the back end and front end code using the Aliyun workbench and select the Aliyun Relational Database Service (RDS) as our cloud database platform. In the following subsections, we will introduce the interface and the database of the MemoMusic system respectively.

8.4.1 THE INTERFACE OF MEMOMUSIC

As for system interface, we utilize the React module to design a Valence-Arousal (VA) canvas. This canvas is a class-based component that provides users with a space to input emotional responses. The VA canvas module demonstrates a clear implementation of modular and responsive design, offering an intuitive interface for user interaction and contributing to the comprehensive data collection process. The component's state includes multiple attributes that handle user input, screen dimensions, image display, and validation checks. These attributes form the foundation of the user interaction module in this project. Users are able to click within a Cartesian coordinate system and select coordinates that reflect their valence (V) and arousal (A), thus providing data for subsequent analysis. The canvas design is shown in Figure 8.3(a) and (c), while the music playing and evaluation interfaces are shown in Figure 8.3(b) and (d), respectively.

The first step is to initialize the state and set the dimensions of the canvas. Additionally, the canvas will be resized to maintain responsiveness when the window size changes to accommodate different devices. To manage user input, the x and y coordinates will be updated and displayed as dots of different colors, depending on the user's input. Then the user input will be validated after determining the emotional coordinate points. Within the render method, various UI elements are conditionally rendered based on the state attributes and props. These elements include two images serving as the background and interactive points, text elements for user guidance, and a dropdown menu for rating and familiarity selection. Finally, a button component is displayed to capture user input and trigger the validation process.

8.4.2 THE DATABASE OF MEMOMUSIC

As for the database, we use an Entity Relationship Diagram (ERD) to describe the entire structure of the MemoMusic system. The ERD follows the basic normal forms of database design principles, ensuring that the database has no redundancy or

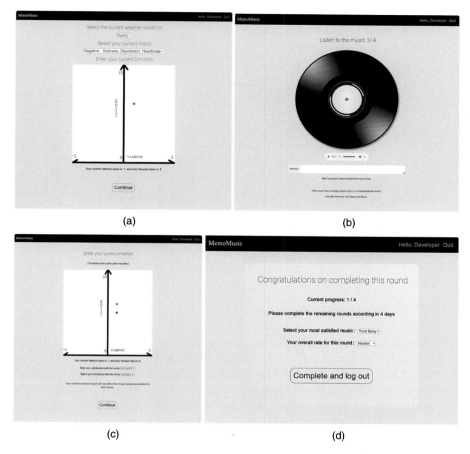

FIGURE 8.3 The experiment interfaces of MemoMusic. (a) VA report before a round of experiment. (b) Music playing. (c) VA report after one music. (d) Evaluation after a round of experiment.

conflicts. The entire diagram consists of five entities, namely Music, Memory, User, Context, and Experiment (see Figure 8.4). All the entities are represented by rectangles, and their relations are represented by diamond shapes. To provide a clearer structure, we have omitted attributes in this figure and focused solely on illustrating the relationships between the entities. A User participates in an Experiment, while Music, Memory, and Context influence each round of the Experiment.

The Music entity has six attributes, with music identifier MID as the primary key. Name and Type represent the name and type of music, respectively. V and A are pre-labeled valence and arousal values for each piece of music. The MemoMusic system plays these music pieces through links stored in the URL attribute.

The User entity primarily contains a user's personal information, including ID numbers, username, password for login, preferred music type, occupation, age, gender, level of music training, and level of interest in music.

The Experiment entity records basic information for each round of the experiment. The Exp Num indicates which round the user is currently in. The Start Time

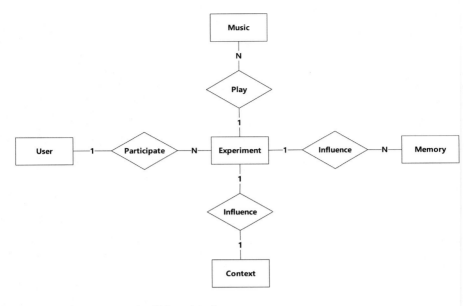

FIGURE 8.4 ERD graph of MemoMusic system.

and End Time attributes record the duration of this round of the experiment. Initial V-A and Final V-A denote the valence and arousal values of the user before and after the experiment, respectively. The Experiment entity also has two subjective evaluations. Eval represents the user's favorite piece in this round, while Recommend Rate represents the user's overall evaluation of the current round. It is ranked from 1 to 5, with 1 indicating dissatisfaction and 5 indicating satisfaction.

As for the Memory entity, all the analysis features are derived from the API "sentiment classify" provided by Baidu. The Positive and Negative attributes indicate whether the sentence describing music memory has a positive or negative sentiment, while Confidence represents the level of credibility assigned by the API interface. Sentiment is the overall sentiment tendency value obtained by combining the three attributes mentioned above. It is represented by 0 (negative), 1 (neutral), and 2 (positive).

The last entity is Context, which includes Time, Weather, and Scene, which can also influence user's emotion during the experiment. V-A Begin and V-A Coefficient are the initial value and corresponding coefficient of V-A before user listening to music according to their context.

8.5 EXPERIMENT AND ANALYSIS

In order to evaluate the performance of MemoMusic, we invited some participants to join in our four-round experiment for both personalized music recommendation (first and fourth rounds) and music generation (second and third rounds). One hundred and thirty-seven users have signed up with the MemoMusic system and 47 have completed all four rounds of experiment. Since not all users took part in the whole four

rounds, we decided to put the first and fourth rounds together as the recommendation process, and the second and third rounds together as the generation process.

8.5.1 Dataset

The dataset consists of 180 pieces of piano music from three categories: Classical, Pop, and Yanni music. Yanni music is the music composed by the world-renowned composer Yanni, who says, "Music is an incredibly direct language. It bypasses language and logic, and speaks directly to your soul". So, music is the way Yanni communicates his feelings of life with his audiences. In general, Yanni music is emotional, inspiring, and imagery. Thus, Yanni music is speculated as easy to trigger memories.

As mentioned above, we used the Valence-Arousal model to represent the emotion of music and the self-reported emotional states of the participants after listening to the music as well. The valence has an integer value in the range of $[-5, 5]$, while arousal is in the range of $[0, 10]$. Nine volunteers who are either music professionals or experienced music fans helped label the V-A value of each piece of music, resulting in the final V-A values taking the medians. Examples of valence and arousal labeling values of the three categories of music are shown in Table 8.5. For more details of our dataset, readers can check all used music and their labels on github.[8]

8.5.2 Experiment Description

The experiment was conducted in four rounds, during which participants were required to listen to four pieces of music in each round. In the experiment, music pieces selected from the dataset would be recommended directly to participants in the first and fourth rounds. Instead, newly generated music pieces would be played in the other two rounds.

At the beginning of each round, participants' music listening contexts were obtained through a brief questionnaire, while their initial emotional states were acquired using a Valence-Arousal coordinate map. The X-axis ranges from -5 to 5, representing valence from extremely negative to extremely positive. The Y-axis ranges from 0 to 10, indicating arousal from no excitement to utmost excitement.

Within a round of experiment, we provided participants with four pieces of music based on their initial V-A values and their subsequent estimated V-A values after listening to the music. Before the end of each musical piece, participants wrote down the memories triggered by the music. After each piece of music, participants reported the V-A values of their current emotional states on the map, along with their satisfaction and familiarity with the music. After completing a round of experiments, participants were asked to choose their favorite music piece and rate their overall satisfaction.

8.5.3 Experimental Results

The participants were divided into three categories according to their music preferences: Classical music lover, Pop music lover, and Yanni music lover. All participants

TABLE 8.5
Examples of MemoMusic Dataset and Corresponding V-A Values

Classical Music	V	A	Pop Music	V	A	Yanni Music	V	A
BWV 807	3	5	A Comme Amour	-3	3	Almost A Whisper	1	4
Canon In D	4	4	Always With Me	3	3	Blue	3	6
Chopin C Sharp	-2	1	Castle In The Sky	-3	1	Breathe	2	5
Chopin E Flat	5	8	Da Yu	-2	2	Butterfly Dance	5	7
KV 265	4	4	Despacito	3	7	Enchantment	4	6
La Campanella	4	9	Kiss The Rain	-2	2	Farewell	-4	6
La Plus Que Lente	2	5	My Heart Will Go On	2	4	If I Could Tell You	-3	8
None Shall Sleep	1	4	Pirates Of The Caribbean	4	10	In The Mirror	3	7
The Blue Danube	5	10	Remember Me	-2	6	In The Morning Light	2	6
The Swan	4	6	Rhapsody In Blue	1	5	In Your Eyes	3	6
Trumpet Voluntary	3	5	River Flows In You	2	3	Marching Season	0	10
Turkish March	5	9	Summer	5	5	Nightingale	2	7
Brahms Lullaby	3	3	This Is The Moment	2	3	Nostalgia	-2	9
Clair De Lune	1	6	Three Inches Of Heaven	-3	3	One Man's Dream	1	6
Moonlight Sonata	-4	7	Spirited Away Theme	-2	4	The Flame Within	0	5
Love'S Sorrow	3	6	Melody Of The Night 5	-3	3	The Mermaid	-2	7
Minuet In G Major	3	5	When Love Became The Past	-4	4	The Rain Must Fall	4	7
Prelude And Fugue	1	5	Mariage D'Amour	-4	2	To The One Who Knows	3	5
Sonata No.17 In D Minor	-3	8	Those Bygone Years	-2	4	When Dreams Come True	2	6
Standchen	-1	5	Farewell	-4	2	Whispers In The Dark	1	5

were required to choose their level of receiving music training before the first round of experiment. Figure 8.5 shows the distribution of the three types of participants and the music training they received. It can be seen that most of the participants have not received professional music training. As shown in Figure 8.6, nearly half of the participants are on-campus students, with a small percentage of participants having music-related jobs. Many participants gave us feedback on their experience after the experiment, and we have organized and summarized these valuable comments.

There is a difference in the overall satisfaction of participants between rounds of music recommendation and generation. Figure 8.7 indicates that the rates given by participants in recommendation rounds are generally greater than 3, which shows that most of the music recommended by MemoMusic can satisfy the users. At the same

Participants' experiences of music training

	Yanni music lover	Pop music lover	Classical music lover
No training	16	55	15
Amateur training	6	14	3
Professional training	13	11	1

FIGURE 8.5 Music training received by the participants.

Occupation of participants

- Student
- Music-related work
- Research-related work
- Other

45%
37%
12%
6%

FIGURE 8.6 Occupation of participants.

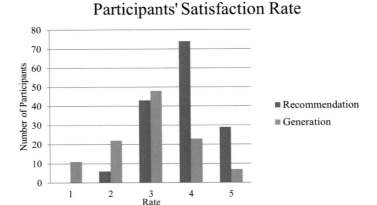

FIGURE 8.7 Participants' satisfaction toward different rounds of music.

time, most of the rates of generation rounds tend to be in the middle, indicating that there is still a gap between the quality of generated music and recommended music.

Heat maps in Figure 8.8 reflect that the arousal and valence change after a round of recommendation (Figure 8.8a) and generation (Figure 8.8b). It can be clearly seen that the arousal of most participants was at a low level before music listening and rose after a round of music recommendation or music generation and finally arrived at an intermediate level.

When it comes to valence, the effects of recommended music and generated music on participants were different. After a round of recommendation, the number of participants with intermediate valence did not change much, while the number of participants with low valence decreased compared with that before the experiment. On the contrary, the number of participants with high valence increased compared with that before the experiment. Interestingly, before generation round, the number of participants with valence at 0 is the largest, and after a round of experiment, the number of participants with valence at 2 is the largest. This result can prove that the music generated does increase the valence value of participants.

Figure 8.9 reflects the average changes of valence and arousal of participants of a round. Round 3 of generation and round 4 of recommendation are selected. It can be seen that both valence and arousal are on the rise. It is worth noting that after listening to the fourth music of the recommendation round, the average arousal of participants decreased.

To compare the quality of music generation between MemoMusic 3.0 and MemoMusic 2.0, we analyzed the participants' feedback of their memories. The memories given by the participants are divided into positive memory and negative memory. From Figure 8.10 we can see that the positive memories triggered by the generated music in MemoMusic 2.0 is about 50%, while in version 3.0 it has increased to more than 70%. It indicates that music generated by MemoMusic 3.0 makes users feel better than that of the previous version.

Arousal and Valence Change for Recommendation Round

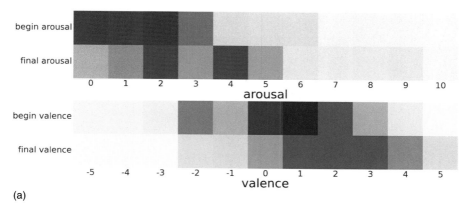

(a)

Arousal and Valence Change for Generation Round

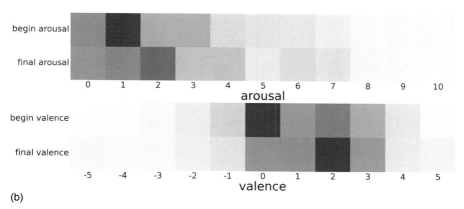

(b)

FIGURE 8.8 Changes of valence and arousal after experiment. (a) recommendation round. (b) generation round.

In MemoMusic, dominant music fragments from the database were utilized as primers in the generation algorithm. We compare the difference in listeners' memories after listening to original music and generated music based on a dominant fragment. For example, one participant associated the music with the early morning and felt calm after listening to both pieces. Meanwhile, another participant thought of the beginning of an epic when hearing the original tune but wrote "A spring walk on the road where cherry blossoms fall" when hearing the generated one.

After completing four rounds of the experiment, we were pleased and surprised to receive positive feedback regarding the regulatory effects of MemoMusic on the participants' emotions. Some participants reflected that their irritable mood had been quelled and improved during the course of our experiment. Some participants were

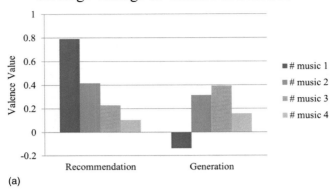

(a)

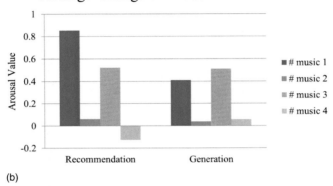

(b)

FIGURE 8.9 Average change of valence and arousal in a round. (a) valence. (b) arousal.

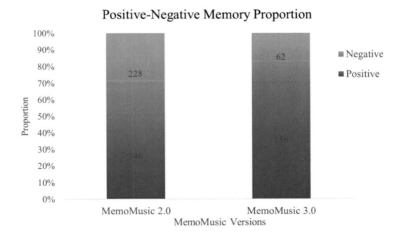

FIGURE 8.10 Positive-negative memory proportions in generation round by MemoMusic 2.0 and MemoMusic 3.0.

also amazed to discover that music has a greater impact on emotions than they had anticipated through our experiment.

To clearly compare the prompt music and the generated music, we transcribed one generated piece and its corresponding prompt piece into musical scores. It can be seen from Figure 8.11 that the model, which incorporates music theory, is able to learn some aspects of the melody and structure of the original song. However, there is still a significant disparity in the interval relationship of the melody between the generated music and the prompt music. In addition, there are still some aspects of the chord progression and rhythm in the generated music that are unreasonable.

(a)

FIGURE 8.11 Music scores of (a) Prompt music sequence. (*Continued*)

(b)

FIGURE 8.11 (CONTINUED) Music scores of (b) Generated music sequence.

8.6 CONCLUSION

In order to regulate people's emotions through music, we propose a personalized music recommendation and generation framework based on emotion and memory called MemoMusic, and it takes into account the memories triggered by the music when estimating the new emotional states after music listening. To accurately estimate the emotional state of a listener after music listening, we propose a comprehensive approach that considers the current emotional state of the listener, the emotion of

the music being played, the possible memory triggered by the music, and the context of music listening. The context includes the time, weather, and scene, the three factors that can influence the listener's emotional state.

For music generation, music theory is utilized to generate music with desired emotion using a Transformer model. Experimental results have demonstrated the effectiveness of MemoMusic in terms of personalized music recommendation, music generation, and emotion navigation. Yet, there are still some issues that need to be resolved in our future work. For example, the parameters in emotion estimation should be learned instead of being manually set. Additionally, the quality of generated music needs to be significantly improved, and the length of generated music should be extended to several minutes.

NOTES

1 https://y.qq.com/
2 https://music.163.com/
3 https://www.pandora.com/
4 https://ai.baidu.com/tech/nlp_apply/sentiment_classify
5 https://github.com/CPJKU/madmom
6 https://github.com/joshuachang2311/chorder
7 https://www.aliyun.com/
8 https://github.com/MZhexin/MemoMusic-Dataset

REFERENCES

[1] Yanni official website. www.yanni.com
[2] Yi-Hsuan Yang, Chia Chu Liu and Homer H. Chen. "Music Emotion Classification: A Fuzzy Approach." *ACM Multimedia* (2006): 81–84, New York, NY, USA.
[3] Yi-Hsuan Yang, Ya-Fan Su, Yu-Ching Lin and Homer H. Chen. "Music Emotion Recognition: The Role of Individuality." *Proceedings of the ACM International Multimedia Conference and Exhibition* (2007): 13–21, Augsburg, Bavaria, Germany.
[4] Simon Liljeström, Patrik N. Juslin and Daniel Västfjäll. "Experimental Evidence of the Roles of Music Choice, Social Context, and Listener Personality in Emotional Reactions to Music." *Psychology of Music* 41 (2013): 579–599.
[5] Daniel E. Gustavson, Peyton L. Coleman, John R. Iversen, Hermine H. Maes, Reyna L. Gordon and Miriam D. Lense. "Mental Health and Music Engagement: Review, Framework, and Guidelines for Future Studies." *Translational Psychiatry* 11 (2021): 370.
[6] Jonathan Posner, James A. Russell and Bradley S. Peterson. "The Circumplex Model of Affect: An Integrative Approach to Affective Neuroscience, Cognitive Development, and Psychopathology." *Development and Psychopathology* 17 (2005): 715–734.
[7] Luntian Mou, Jueying Li, Juehui Li, Feng Gao, Ramesh Jain and Baocai Yin. "MemoMusic: A Personalized Music Recommendation Framework Based on Emotion and Memory." *IEEE 4th International Conference on Multimedia Information Processing and Retrieval* (2021): 341–347, Tokyo, Japan.
[8] Luntian Mou, Yiyuan Zhao, Quan Hao, Yunhan Tian, Juehui Li, Jueying Li, Yiqi Sun, Feng Gao and Baocai Yin. "Memomusic Version 2.0: Extending Personalized Music Recommendation with Automatic Music Generation." *IEEE International Conference on Multimedia and Expo Workshops* (2022): 1–6, Taipei City, Taiwan.

[9] Luntian Mou, Yihan Sun, Yunhan Tian, Yiqi Sun, Yuhang Liu, Zexi Zhang, Ruichen He, Juehui Li, Jueying Li, Zijin Li, Feng Gao, Yemin Shi and Ramesh Jain. "MemoMusic 3.0: Considering Context at Music Recommendation and Combining Music Theory at Music Generation." *IEEE International Conference on Multimedia and Expo Workshops* (2023): 296–301, Brisbane, Australia.

[10] Diego Sánchez-Moreno, Ana Belén Gil González, María Dolores Muñoz Vicente, Vivian Félix López Batista and María N. Moreno García. "A Collaborative Filtering Method for Music Recommendation Using Playing Coefficients for Artists and Users." *Expert Systems with Applications* 66 (2016): 234–244.

[11] Rahimpour Cami Bagher, Hamid Hassanpour and Hoda Mashayekhi. "User Preferences Modeling Using Dirichlet Process Mixture Model for a Content-Based Recommender System." *Knowledge-Based Systems* 163 (2019): 644–655.

[12] Guoqiang Zhong, Haizhen Wang and Wencong Jiao. "MusicCNNs: A New Benchmark on Content-Based Music Recommendation." *International Conference on Neural Information Processing* Part I 25 (2018): 394–405, Siem Reap, Cambodia.

[13] Dongjing Wang, Xin Zhang, Dongjin Yu, Guandong Xu and Shuiguang Deng. "CAME: Content- and Context-Aware Music Embedding for Recommendation." *IEEE Transactions on Neural Networks and Learning Systems* 32 (2020): 1375–1388.

[14] Tiancheng Shen, Jia Jia, Yan Li, Yihui Ma, Yaohua Bu, Hanjie Wang, Bo Chen, Tat-Seng Chua and Wendy Hall. "PEIA: Personality and Emotion Integrated Attentive Model for Music Recommendation on Social Media Platforms." *AAAI Conference on Artificial Intelligence* (2020): 206–213, New York, NY, United States.

[15] Rosalind W. Picard. *Affective Computing*. MIT Press, Cambridge, Massachusetts, 1997.

[16] Vybhav Chaturvedi, Arman Beer Kaur, Vedansh Varshney, Anupam Garg, Gurpal Singh Chhabra and Munish Kumar. "Music Mood and Human Emotion Recognition Based on Physiological Signals: A Systematic Review." *Multimedia Systems* 28 (2021): 21–44.

[17] Paul Ekman and Wallace V. Friesen. "Constants across Cultures in the Face and Emotion." *Journal of Personality and Social Psychology* 17(2) (1971): 124–129.

[18] Paul Ekman. "An argument for Basic Emotions." *Cognition & Emotion* 6 (1992): 169–200.

[19] Richard S. Lazarus. "From Psychological Stress to the Emotions: A History of Changing Outlooks." *Annual Review of Psychology* 44 (1993): 1–21.

[20] Robert Plutchik. "Emotions and Life: Perspectives from Psychology, Biology, and Evolution." *Psychology & Marketing* 22(1) (2002): 97–101.

[21] Renata L. Rosa, Demsteneso Z. Rodriguez and Graca Bressan. "Music Recommendation System Based on User's Sentiments Extracted from Social Networks." *IEEE Transactions on Consumer Electronics* 61 (2015): 359–367.

[22] Eva Zangerle, Chih-Ming Chen, Ming-Feng Tsai and Yi-Hsuan Yang. "Leveraging Affective Hashtags for Ranking Music Recommendations." *IEEE Transactions on Affective Computing* 12 (2018): 78–91.

[23] Yi-Hsuan Yang and Jen-Yu Liu. "Quantitative Study of Music Listening Behavior in a Social and Affective Context." *IEEE Transactions on Multimedia* 15 (2013): 1304–1315.

[24] Simon Liljeström, Patrik N. Juslin and Daniel Västfjäll. "Experimental Evidence of the Roles of Music Choice, Social Context, and Listener Personality in Emotional Reactions to Music." *Psychology of Music* 41 (2013): 579–599.

[25] Douglas Eck and Jürgen Schmidhuber. "Finding Temporal Structure in Music: Blues Improvisation with LSTM Recurrent Networks." *Proceedings of the 12th IEEE Workshop on Neural Networks for Signal Processing* (2002): 747–756, Martigny, Switzerland.

[26] Elliot Waite. "Generating Long-Term Structure in Songs and Stories." Web blog post. Magenta 15, no. 4 (2016).

[27] Jie Gui, Zhenan Sun, Yonggang Wen, Dacheng Tao and Jieping Ye. "A Review on Generative Adversarial Networks: Algorithms, Theory, and Applications." *IEEE Transactions on Knowledge and Data Engineering* 35 (2020): 3313–3332.

[28] Li-Chia Yang, Szu-Yu Chou and Yi-Hsuan Yang. "MidiNet: A Convolutional Generative Adversarial Network for Symbolic-Domain Music Generation." *Proceedings of the 18th International Society for Music Information Retrieval Conference* (2017): 324–331, Suzhou, China.

[29] Adam Roberts, Jesse Engel, Colin Raffel, Curtis Hawthorne and Douglas Eck. "A Hierarchical Latent Vector Model for Learning Long-Term Structure in Music." *35th International Conference on Machine Learning* (2018): 4364–4373, Stockholm, Sweden.

[30] Ankur P. Parikh, Oscar Täckström, Dipanjan Das and Jakob Uszkoreit. "A Decomposable Attention Model for Natural Language Inference." *Proceedings of the Conference on Empirical Methods in Natural Language Processing* (2016): 2249–2255, Austin, Texas, USA.

[31] Zihang Dai, Zhilin Yang, Yiming Yang, Jaime Carbonell, Quoc V. Le and Ruslan Salakhutdinov. "Transformer-XL: Attentive Language Models beyond a Fixed-Length Context." *Proceedings of the 57th Annual Meeting of the Association for Computational Linguistics* (2019): 2978–2988, Florence, Italy.

[32] Cheng-Zhi Anna Huang, Ashish Vaswani, Jakob Uszkoreit, Noam Shazeer, Ian Simon, Curtis Hawthorne, Andrew M. Dai, Matthew D. Hoffman, Monica Dinculescu and Douglas Eck. "Music Transformer: Generating Music with Long-Term Structure." *7th International Conference on Learning Representations* (2019), New Orleans, LA, United States.

[33] Yu-Siang Huang and Yi-Hsuan Yang. "Pop Music Transformer: Beat-Based Modeling and Generation of Expressive Pop Piano Compositions." *Proceedings of the 28th ACM International Conference on Multimedia* (2020): 1180–1188, Virtual, Online, United States.

[34] Abhilash Pal, Saurav Saha and R. Anita. "Musenet: Music Generation Using Abstractive and Generative Methods." *International Journal of Innovative Technology and Exploring Engineering* 9(6) (2020): 784–788.

[35] Chung-En Sun, Yi-Wei Chen, Hung-Shin Lee, Yen-Hsing Chen and Hsin-Min Wang. "Melody Harmonization Using Orderless Nade, Chord Balancing, and Blocked Gibbs Sampling." *2021 - 2021 IEEE International Conference on Acoustics, Speech and Signal Processing* (2020): 4145–4149, Virtual, Toronto, ON, Canada.

[36] Yi-Wei Chen, Hung-Shin Lee, Yen-Hsing Chen and Hsin-Min Wang. "SurpriseNet: Melody Harmonization Conditioning on User-controlled Surprise Contours." *International Society for Music Information Retrieval Conference* (2021): 105–112, Virtual, Online.

[37] Shunit Haviv Hakimi, Nadav Bhonker and Ran El-Yaniv. "BebopNet: Deep Neural Models for Personalized Jazz Improvisations." *International Society for Music Information Retrieval Conference* (2020): 117–124, Virtual, Online, Canada.

[38] Yichao Zhou, Wei Chu, Sam Young and Xin Chen. "BandNet: A Neural Network-based, Multi-Instrument Beatles-Style MIDI Music Composition Machine." *Proceedings of the 20th International Society for Music Information Retrieval Conference* (2019): 655–662, Delft, Netherlands.

[39] Kristy Choi, Curtis Hawthorne, Ian Simon, Monica Dinculescu and Jesse Engel. "Encoding Musical Style with Transformer Autoencoders." *37th International Conference on Machine Learning* (2020): 1877–1886, Virtual, Online.

[40] Andrea Agostinelli, Timo I. Denk, Zalán Borsos, Jesse Engel, Mauro Verzetti, Antoine Caillon, Qingqing Huang, Aren Jansen, Adam Roberts, Marco Tagliasacchi, Matthew Sharifi, Neil Zeghidour and Christian Havnø Frank. "MusicLM: Generating Music From Text." *ArXiv* abs/2301.11325 (2023).

[41] Chuang Gan, Deng Huang, Peihao Chen, Joshua B. Tenenbaum and Antonio Torralba. "Foley Music: Learning to Generate Music from Videos." *Lecture Notes in Computer Science (Including Subseries Lecture Notes in Artificial Intelligence and Lecture Notes in Bioinformatics) 12356 LNCS* (2020): 758–775.

[42] Lucas N. Ferreira and Jim Whitehead. "Learning to Generate Music with Sentiment." *Proceedings of the 20th International Society for Music Information Retrieval Conference* (2019):384–390, Delft, Netherlands.

[43] Dorien Herremans and Elaine Chew. "MorpheuS: Generating Structured Music with Constrained Patterns and Tension." *IEEE Transactions on Affective Computing* 10(4) (2019): 510–523.

[44] Haohao Tan and Dorien Herremans. "Music FaderNets: Controllable Music Generation Based on High-Level Features via Low-Level Feature Modelling." *ArXiv* abs/2007.15474 (2020).

[45] Dimos Makris, Kat R. Agres and Herremans Dorien. "Generating Lead Sheets with Affect: A Novel Conditional seq2seq Framework." *2021 International Joint Conference on Neural Networks* (2021): 1–8, Virtual, Shenzhen, China.

[46] Klaus R. Scherer, Marcel R. Zentner and Annekathrin Schacht. "Emotional States Generated by Music: An Exploratory Study of Music Experts." *Musicae Scientiae* 5 (2001): 149–171.

[47] Leonard B. Meyer. *Emotion and Meaning in Music*. The University of Chicago Press, Chicago, 1956.

[48] Patrick Gomez and Brigitta Danuser. "Relationships between Musical Structure and Psychophysiological Measures of Emotion." *Emotion* 7(2) (2007): 377–387.

[49] Stefan Koelsch, Thomas Fritz, D. Yves V. Cramon, Karsten Müller and Angela D. Friederici. "Investigating Emotion with Music: An fMRI Study." *Human Brain Mapping* 27 (2006): 239–250.

[50] John A. Sloboda. "Music Structure and Emotional Response: Some Empirical Findings." *Psychology of Music* 19 (1991): 110–120.

[51] Eve-Marie Quintin. "Music-Evoked Reward and Emotion: Relative Strengths and Response to Intervention of People With ASD." *Frontiers in Neural Circuits* 13 (2019)

[52] Nitish Nag and Ramesh Jain. "A Navigational Approach to Health: Actionable Guidance for Improved Quality of Life." *Computer* 52(4) (2018): 12–20.

[53] Nitish Nag, Hyungik Oh, Mengfan Tang, Mingshu Shi and Ramesh Jain. "Towards Integrative Multi-Modal Personal Health Navigation Systems: Framework and Application." *ArXiv* abs/2111.10403 (2021).

[54] Terumi Umematsu, Akane Sano and Rosalind W. Picard. "Daytime Data and LSTM Can Forecast Tomorrow's Stress, Health, and Happiness." *41st Annual International Conference of the IEEE Engineering in Medicine and Biology Society* (2019): 2186–2190, Berlin, Germany.

[55] Wen-Yi Hsiao, Jen-Yu Liu, Yin-Cheng Yeh and Yi-Hsuan Yang. "Compound Word Transformer: Learning to Compose Full-Song Music over Dynamic Directed Hypergraphs." *35th AAAI Conference on Artificial Intelligence* (2021): 178–186, Virtual, Online.

[56] Sageev Oore, Ian Simon, Sander Dieleman, Douglas Eck and Karen Simonyan. "This Time with Feeling: Learning Expressive Musical Performance." *Neural Computing and Applications* 32(4) (2020): 955–967.

[57] Ari Holtzman, Jan Buys, Li Du, Maxwell Forbes and Yejin Choi. "The Curious Case of Neural Text Degeneration." *8th International Conference on Learning Representations* (2020), Addis Ababa, Ethiopia.

9 Algorithmic Composition Techniques for Ancient Chinese Music Restoration and Reproduction
A Melody Generator Approach

Tiange Zhou
School of Future Design, Beijing Normal University,
Zhuhai, China

9.1 INTRODUCTION

The field of Algorithmic composition, both in research and application, has historically centered on European art music theory analysis and industrialization. This focus is understandable given the rich tradition and influence of European music, but it also means that other cultural musical practices have often been overlooked. If one were to investigate music traditions outside of the European-centered discourse, they would undoubtedly find systematic music composition practices in numerous formats, with Ancient Chinese music standing out as a prime example. However, many Chinese musical traditions experienced a tendency towards oversimplification under the combined influences of colonialism, globalization, and modernity throughout the 20th century. This shift was further exacerbated by music schools worldwide, including those in Chinese-speaking regions, which placed an overemphasis on European art music in their education systems. As a result, contemporary music practitioners, including composers and performers, have often only been exposed to a superficial understanding of the ancient Chinese music treasures during their practices. Additionally, the traditional Chinese music studies conducted by researchers have mainly relied on written materials, which are not easily adapted for use in restoration, reproduction, or international cultural exchange within the field of music education. This has further limited the accessibility and appreciation of these ancient musical traditions.

DOI: 10.1201/9781003406273-9

During the development of a computer-aided dance-music collaborative creation system, with a focus on ballet, contemporary dance, and ancient Chinese dance, I encountered a serious shortage of audio and digitized materials in the traditional Chinese music category on a global scale. This lack of resources not only presents a challenge for the project but also highlights the need for greater attention to and preservation of these underrepresented musical traditions. Therefore, to address this issue, I decided to design and develop an algorithmic composition tool based on traditional Chinese music theory study capable of automatically generating promising music. In this chapter, I would like to focus on the generation tool of melodic continuation development based upon the traditional Chinese music form Baban. The hope is that this tool will help bridge some gaps between traditional and contemporary music practices, as well as facilitate greater understanding and appreciation of traditional Chinese music by providing an accessible and user-friendly path for the music creators in the contemporary world. Moreover, by incorporating the rich and diverse musical elements from traditional Chinese music into modern compositions, we can open new avenues for artistic exploration and innovation.

This can ultimately lead to a more dynamic and engaging musical environment that embraces the beauty and depth of various cultural influences. And certainly, by expanding the scope of algorithmic composition research and application to include non-European musical traditions, such as traditional Chinese music, we can foster greater cultural diversity and understanding in the field of music education. This will not only help to preserve and revitalize ancient musical practices but will also encourage cross-cultural collaboration and exchange, enriching the global music community. Ultimately, this will contribute to a richer and more inclusive global music landscape that celebrates the contributions of all cultures and traditions, rather than focusing solely on one dominant perspective. By nurturing a deeper appreciation for the vast array of musical forms and styles from around the world, we can pave the way for a more harmonious and diverse artistic future that transcends cultural boundaries and brings people together through the language of music.

9.2 COMPUTER MUSIC GENERATION AND STRATEGY OF MUSICAL REPRESENTATION

Hidden Markov Models (HMMs) and Recurrent Neural Networks (RNNs) – and in particular, long short-term memory (LSTM) variants – constitute central approaches in the realm of generative music. They each represent different methodologies and yield unique results, hence their comparative analysis offers a comprehensive perspective on the potential advantages and disadvantages of each, particularly in the specific area of melodic generation. HMMs have long been a cornerstone in the development and application of algorithmic composition, becoming widely adopted since the late 20th century. Their capability to learn and generate sequences, characterized by a high degree of structure and predictability, is often commended (Roads, 1996). The true strength of HMMs is encapsulated in their inherent capacity to model the transition probabilities between different states within a given sequence. By understanding these probabilities, HMMs can construct new sequences that closely reflect the statistical properties of the original input, while maintaining an inherent

structural integrity (Eck & Schmidhuber, 2002). However, HMMs do present some significant limitations. Perhaps the most notable of these is their Markovian property, which confines them to considering only the immediate previous state when predicting subsequent states. This limitation is highly significant within the domain of music, where long-term dependencies, such as the relationships between the tonic and dominant, or the thematic elements and their variations, are integral to the compositional structure and aesthetic appeal (Briot & Pachet, 2020). Additionally, HMMs are prone to the problem of overfitting, especially when dealing with intricate and high-dimensional music data (Pearce Wiggins, 2004). In essence, the model can become overly specific to the training data, leading to underperformance when attempting to generalize to new data. Overfitting is usually mitigated by restricting the complexity of the model, but this solution often comes at the expense of detail and expressive power, resulting in a less satisfactory musical output (Briot & Pachet, 2020).

In contrast, Recurrent Neural Networks (RNNs) – and specifically, long short-term memory (LSTM) variants – propose a different approach to generative music. LSTMs were designed with the intention of addressing the limitations inherent in HMMs and conventional RNNs, particularly in relation to modeling long-term dependencies (Hochreiter Schmidhuber, 1997). They accomplish this through the incorporation of gating units, which serve to regulate the flow of information through the network, allowing the model to retain or discard information over extended time periods, thereby ensuring a comprehensive understanding of the data's temporal structure. The ability of LSTM models to learn and model long-term dependencies has proven to be immensely advantageous in music generation. LSTM-based models have demonstrated a remarkable capacity to generate music that maintains a coherent structure over extended periods. These models can capture and represent long-term relationships that are largely inaccessible to HMMs, providing a rich and nuanced musical output (Huang et al., 2018). Furthermore, LSTMs generally exhibit a greater degree of robustness against overfitting compared to HMMs, as they can learn from a substantially larger amount of data and generalize more effectively to new data (Pascanu et al., 2013). However, it is important to note that LSTMs do come with their own set of limitations. The process of training LSTMs can be computationally intensive and time-consuming. Additionally, the complexity of their internal workings can often be challenging to interpret, making the process of optimizing and troubleshooting these models a complex task (Karpathy et al., 2015).

Nonetheless, despite these challenges, the advantages provided by LSTM models, particularly their capacity for modeling long-term dependencies and robustness against overfitting, make them a compelling choice for melodic generation. They possess the ability to generate melodies that not only adhere closely to the statistical properties of the original data but also encapsulate complex and long-term musical structures that are so vital to the fabric of music. They allow for a rich, nuanced representation of musical data that goes beyond simplistic patterns, capturing the essence of musical creativity and innovation. This makes the LSTM a promising direction for the future of generative music, with potential applications extending across the diverse landscapes of music creation – from composition and arrangement to improvisation and performance (Briot & Pachet, 2020).

Certainly, the LSTM's capacity for learning and modeling complex patterns in data over time enables it to generate music that is not only technically coherent but also expressive and musically engaging. This capability is demonstrated in several studies where LSTM-based models were found to generate music that listeners rated as more enjoyable and human-like compared to music generated by other methods (Huang, 2018). Moreover, while the complexity and computational demands of LSTMs present certain challenges, these are offset by the continuous advancements in computational power and the development of more efficient training methods. Additionally, the evolving field of explainable AI offers promising avenues for improving the interpretability of LSTM models, which could mitigate some of the issues related to their complexity (Karpathy et al., 2015).

The strategies for musical representation are a crucial aspect of algorithmic composition in this research (Nierhaus, 2009). To create music using computational methods, it is necessary to represent musical information in a way that can be processed by a computer (Loy, 2006). I would like to discuss the chosen strategy in this research for musical representation in algorithmic composition, as well as discuss the reason why other strategies would be less suitable for research purposes. The chosen one is one common strategy for representing music in algorithmic composition, which is to use symbolic representations such as MIDI or MusicXML (Selfridge-Field, 1997). These formats allow composers to represent music using a set of discrete symbols that can be easily processed by a computer. For instance, MIDI represents music using a series of digital messages that describe the pitch, duration, and velocity of each note (Collins et al., 2003). MusicXML is an XML-based format that enables composers to represent more complex musical structures such as chords and multiple voices (Cope, 2005). Symbolic representations have several advantages for algorithmic composition. They are relatively simple and easy to process computationally, which makes them well-suited for real-time applications such as interactive performance systems (Dean Bailes, 2010). They also allow composers to work with abstract musical structures without being tied to specific sounds or timbres (Roads, 1996).

People may be curious about why the research did not work on direct audio representations, which could capture the sound waveforms produced by musical instruments or voices. It is because even though they could provide a more detailed and nuanced view of the music than symbolic representations, including timbre, dynamics, and articulation, they have significant limitations (Roads, 1996). One limitation is that they are computationally expensive to process. Audio signals are typically large and complex, which makes them difficult to work with in real-time applications (Dean Bailes, 2010). Another limitation is that audio representations can be difficult to work with in terms of musical structure. While they capture all aspects of the sound, they do not provide a clear representation of the underlying musical structure (Cope, 2005). Meanwhile, to generate more abstract musical materials that fit the purpose of assisting composers in their creative routines without taking away their joyfulness of authentic creativity, analyzing the way composers work in their creative routines would be a better way to achieve this goal (Nierhaus, 2009). Especially in traditional Chinese music, such as Baban, which we have been working on in this research, the main notes of the melody are the platforms for musicians to add more creative ideas upon.

9.3 UNDERSTANDING MUSIC FORM, MORPHOLOGY, AND ITS CULTURAL SIGNIFICANCE

In the realm of music theory, the concept of musical form and morphology has been widely explored and discussed, with various scholars offering unique perspectives on the subject. Italian composer and scholar Giorgio Netti, for instance, has presented a rather poetic interpretation in his article *"Distance la durata"* that the study of musical morphology, which focuses on discerning salient patterns and constants within a given structure, seeks to uncover the inherent order and hierarchy that underpin the organization and coherence of a musical composition. This method enables observers to comprehend and appreciate the dynamic interplay among the relationships that form the foundation of musical pieces. In morphological analysis, music is viewed as a living, interconnected system that more closely resembles an organism rather than a static object that can be disassembled into its constituent parts. Expanding upon this conceptual framework, the process of life formation during the prenatal stage provides an intriguing structural parallel to the investigation of musical morphology. The progression from the initial fertilization of the egg by the spermatozoid, through the formation of the morula, blastocyst, embryo, and eventually the fetus, mirrors the development from the general to the particular in music. This complex process unfolds simultaneously across inner, middle, and outer dimensions, culminating in the emergence of a distinctive form at the moment of birth.

The elaborate and seemingly miraculous nature of this process, with its ability to overcome numerous obstacles and challenges, inspires a sense of awe and wonder. This feeling of amazement, along with the recognition of the delicate balance of forces at play, resonates with the experience of engaging with a musical piece. Within such a composition, an array of relationships and structures converges to forge a harmonious and cohesive whole. The concept of form, which Netti describes as existing within the interstices of a complex, finished body, is a tangible memory or trace left behind in time by the life that has passed through the structure. This notion is centered around the interaction of three key elements: structure, life, and time.

These elements transform into three forces when interconnected: the first, structure, is predominantly static and does not act in isolation. It provides the framework within which the other elements interact. The second element, life, represents the flow and continuity in which everything is immersed and transformed. Entirely dynamic in nature, life acts indiscriminately when separated from the structural element. The third and final element, time, encompasses the whole and allows the other two elements to exist, both statically and dynamically.

In this context, time is understood as the duration of exposure of the structure to the flow of life. The intricate interplay between these elements and forces within the musical form offers a rich avenue for further exploration and analysis. By examining the relationships among structure, life, and time, researchers can gain deeper insights into the ways in which musical compositions are shaped, as well as the processes by which they evolve over time. This holistic approach not only enhances our understanding of the underlying organization and coherence of a musical piece but also illuminates the dynamic and transformative nature of music as an art form. Moreover, the poetic perspective on form highlights the importance of recognizing

and appreciating the intangible aspects of music that elude strict categorization or quantification. By considering the traces left behind by the life that has passed through a musical structure, one can better grasp the essence of a composition, which may be more fully understood through an exploration of the interactions among its constituent elements and forces.

In addition, Netti has posited that in the context of art, form is the manifestation of a specific dynamic equilibrium among various dimensions, which materialize within a musical work. The intensity of this equilibrium, according to Netti, fluctuates in response to the depth of the experience of the conception of difference that it materializes, as well as the multiplicity of listening, views, and senses that it proposes and encourages. Moreover, Austrian composer and scholar Wolfram Schurig, in his article – "Musical Morphology - On the Connection between Structure, Shape, and Transformation" – has further contributed to this discourse by arguing that a perceptually rooted conception of morphology necessitates an understanding of structure that encompasses both phenomenologically describable characteristics and the semantic encoding of materials. Schurig posits that shape is the materialization of structure; however, it is not automatically identifiable as such. Instead, shape becomes discernible as structure when the structural elements are processed as sonic components during the shaping procedure, thereby endowing them with meaning.

According to Schurig, this sense of meaning is derived from an understanding of the connection between the intentional inner allocation of component parts – or the construction of shape and the musical context that arises from its transformation – or through which this transformation itself emerges. Consequently, construction operates both constructively and deconstructively, participating in the creation and dissolution of shapes, which, in this context, dissolution simply refers to a state of uncertainty concerning the subsequent processual stage.

Certainly, the relationship between music form and cultural identity is multifaceted, with the two influencing and shaping one another in complex ways. Music has long been recognized as a powerful means of expressing individual and collective identities, as well as a means of fostering connections between people within a shared cultural context. This interplay between music and culture can be examined through various lenses, including the ways in which musical forms are informed by cultural practices and how these forms, in turn, reinforce or challenge cultural identities (Mahnkopf, C., Cox, F., & Schurig, W., eds., 2004). Cultural identity can be understood as the sense of belonging and attachment to a particular culture, which is shaped by shared values, beliefs, practices, and experiences. Music is often regarded as an important element of cultural identity, as it has the capacity to express and reinforce these shared elements, as well as to provide a means of connecting with others within the culture. Since music form refers to the organization and structure of a musical composition, encompassing elements such as melody, harmony, rhythm, texture, form, and the historical music form in different cultures has given birth and raised through its own unique life and musical activities through history.

The relationship between music form and cultural identity can be examined from various perspectives, including the ways in which musical forms are influenced by cultural factors, how these forms are used to express and reinforce cultural identities, and the extent to which musical forms can challenge or transform cultural identities.

Western classical music is a rich example of the relationship between music form and cultural identity. The development of Western classical music, spanning from the medieval period to the present day, has been marked by significant changes in musical form, which can be seen as reflecting broader cultural shifts and evolving notions of identity. For example, the transition from the polyphonic texture of the Renaissance to the homophonic texture of the Baroque period can be understood as reflecting a shift in cultural values, with the emphasis on individual voices in the polyphonic texture giving way to a focus on the unity and coherence of the overall musical texture in the homophonic style.

Indonesian Gamelan music provides another example of the relationship between music form and cultural identity. Gamelan is an ensemble music tradition from Indonesia, primarily associated with the islands of Java and Bali, and is characterized by its distinctive instruments, which include metallophones, gongs, and drums. The music is highly structured, with complex interlocking rhythms and melodies, and is often accompanied by dance or theatrical performances. The form of Gamelan music is closely tied to the cultural context in which it is performed, with the music and its accompanying rituals serving to reinforce a sense of cultural identity and community. African-American spirituals are also a powerful example of the ways in which music form can both reflect and shape cultural identity. Spirituals are a genre of religious songs that emerged among enslaved African-Americans in the United States, blending elements of African musical traditions with European hymns and other influences. The form of spirituals is characterized by their call-and-response structure, repetition, and use of syncopation, as well as their deeply emotive and often improvisational nature (Loy, G., & Lehman, B., 2008).

These features not only reflect the cultural heritage of their creators but also served to foster a sense of shared identity and community among enslaved African-Americans who used spirituals as a means of expressing their faith, resilience, and hope for freedom and a better future. Chinese traditional music form, according to music theorists Li Xi An and Zhao Dong Mei in their research, also embodies the aesthetic principles and logical thinking patterns of the Chinese people through history, reflecting a mode of thought distilled from centuries of musical practice and is in harmony with the natural laws of music. The influence of Chinese traditional music form on musical structure is multifaceted and multidimensional, with applications ranging from the macroscopic overall structural layout, which ensures a balanced proportion and length within a complete musical work, to the microscopic regulation of each core material that constitutes the music. This approach facilitates the organization and development of musical materials in a manner that exhibits a thorough and rigorous logic.

While there are certain commonalities between Chinese and European music in terms of structural principles, such as the use of thematic echoes, continuations, variations, and cyclical principles, Chinese traditional music is characterized by its monophonic system and numerous folk forms. This distinction places a greater emphasis on the logic of melodic organization and development in the composition process. Furthermore, since the aesthetic of Chinese traditional music form is influenced by the concept of natural time and space, it is allowing for a flexible variation in the duration of the unit "beat" within a certain scale. This flexibility distinguishes

Chinese traditional music from its European counterparts and contributes to its unique aesthetic and structural qualities.

9.4 BABAN MODEL

The *Baban* model is a representative concept in traditional Chinese music history and theory that refers to a specific structure used in instrumental ensemble repertoires. The term *Baban* literally means "eight beats", and it is used to describe a rhythmic pattern that consists of eight beats divided into two groups of four (Li, X., & Zhao, D., 2020). This pattern is repeated throughout a piece of music, creating a sense of continuity and structure. The history of the *Baban* model can be traced back to the Tang Dynasty (618–907 CE), when it was first used in court music. Over time, it became an important part of Chinese instrumental ensemble music, particularly in the southern regions of China (Thrasher, A. R., 1989). The *Baban* model was often used as a framework for improvisation, with musicians adding their own variations and embellishments to the basic rhythmic pattern. In addition to its use in instrumental ensemble music, the *Baban* model also played an important role in Chinese opera.

In traditional Chinese opera, each character has their own musical theme or leitmotif, which is based on the *Baban* model. These themes are used to convey the character's emotions and personality, and they are often repeated throughout the opera. This traditional model is typically notated using a system known as the 68 format. This system uses two numbers to represent each beat: the first number indicates which beat of the group of four it is (1 or 2), while the second number indicates how many beats have passed since the beginning of the piece (1–8). The 68 format allows musicians to easily read and interpret rhythmic patterns based on the *Baban* model. It also allows for flexibility and improvisation within this framework, as musicians can add their own variations while still maintaining the basic structure of the piece (Li, X., & Zhao, D., 2021).

Indeed, the *Baban* model exemplifies a versatile and adaptable framework, accommodating an extensive array of variations and improvisations, thus showcasing the richness and diversity of the musical form. Here are several examples of variations on the *Baban* model: *Da Baban* (Big Baban) is one of the most common variations, and it is often used as a basis for improvisation in Chinese instrumental ensemble music. *Da Baban* consists of 68 beats divided into two groups of four, with each group repeated four times. The first group is typically played with a strong emphasis on the first beat, while the second group has a more flowing, melodic quality. *Xiao Baban* (small baban) is also a variation of the *Baban* model, which is shorter than *Da Baban*, with only 56 beats divided into two groups of four. It is often used in Chinese opera to accompany dialogue or action scenes. *Liuban* (six ban) is another variation of the "Baban" model that consists of 60 beats divided into two groups of four. It is often used in southern Chinese instrumental ensemble music and has a more lyrical quality than *Da Baban* (big baban). *Sanban* (three ban) is a variation on the *Baban* model that consists of three groups of three beats each, for a total of nine beats. It is often used in Chinese opera to accompany dance scenes. *Wu Ban* (five ban) is another variation that consists of five groups of three beats each, for a total of 15 beats. It has a more complex rhythmic structure than other variations and

(a) (b) (c)

FIGURE 9.1 Instruments. (a) Liuqin. (b) Sanxian. (c) Yueqin.

is often used in instrumental ensemble music to showcase virtuosity and improvisation skills. *Si Ban* (four ban) is a variation that consists of four groups of three beats each, for a total of 12 beats. It has a more compact structure than other variations and is often used in Chinese opera to accompany dialogue or action scenes. *Liuqin Ban* is a variation specifically designed for the liuqin, a traditional Chinese plucked string instrument (Figure 9.1). It consists of 68 beats divided into two groups of four, with each group repeated four times. The liuqin player uses a variety of techniques to create different textures and timbres within this structure.

Each variation of *Baban* model has its own unique qualities and characteristics, and they are often used in different contexts or for different purposes. For example, some variations are used for improvisation or virtuosic display, while others may be used to accompany specific scenes or emotions in Chinese opera. In addition to these variations on the *Baban* model, many other rhythmic structures and patterns are also utilized in Chinese music. For example, the *Sanxian Ban* is a variation on the "Baban" model specifically designed for the sanxian, a three-stringed plucked instrument (Figure 9.2). It consists of 68 beats divided into two groups of four, with each group repeated four times. The sanxian player uses a variety of techniques to create different textures and timbres within this structure. Another example is the *Yueqin Ban*, a variation specifically designed for the yueqin, a plucked string instrument similar to a mandolin (Figure 9.3). It consists of 60 beats divided into two groups of four, with each group repeated three times. The yueqin player uses a variety of techniques to create different textures and timbres within this structure.

The basic or classic 68-Beat Structure, which is what the research is focusing on, consists of eight beats divided into two groups of four, with each group repeated four times. This structure provides a framework for improvisation and creativity while still maintaining a sense of continuity and structure. What is important to understand about the *Liuban/Baban* structure is that it exists as both a melodic ideal and a form in the ears of traditional musicians. In a manner not unlike the 12-bar blues form, some elements such as cadence tones and phrase lengths are more or less fixed, while

FIGURE 9.2 Baban music analysis.

FIGURE 9.3 Baban music example from A to D phrases.

specific aspects of melody are flexible. Meanwhile, as we have discussed previously, it should not be ignored that in traditional Chinese music, tempo and rhythm changes are often used to create contrast and variation within a piece. These changes can be gradual or sudden, and can occur at various points throughout the piece. One technique used in the ***Baban*** model is augmentation, which involves slowing the tempo of the melody and adding weak sub-beats and melodic filler. The purpose of augmentation is to create a sense of elegance or refinement within the melody. By slowing the tempo, musicians can add more detail and nuance to their performance while still maintaining a sense of continuity with the overall rhythmic pattern.

The number of weak sub-beats added depends on the degree of tempo decrease. With moderate tempo decreases, only a single weak beat is added, while with larger tempo decreases, often three (and sometimes as many as seven) weak beats are commonly used. In addition to augmentation, other techniques such as rubato and accelerando can also be used to create tempo-rhythm changes within the ***Baban*** model. Rubato refers to a slight variation in tempo that creates a sense of flexibility and expressiveness within the melody. This technique is often used to highlight certain notes or phrases within the rhythmic pattern and can create a sense of tension or release within the piece. Accelerando refers to a gradual increase in tempo over time. This technique can create a sense of excitement or urgency within the melody and build momentum towards a climactic point in the piece. Upon thorough examination of the musical excerpts designated from ***Chaoshan Da Baban***, **Banban** from Chaoshan Guangdong area, and the Qing dynasty score collection (Rongzhai, ed., 1814) in Figure 9.2, respectively, a number of salient features necessitate in-depth analysis (Figure 9.2).

Primarily, it is discerned that both melodies encompass a cumulative total of 68 beats. The pertinence of this observation lies in the historical abbreviation ***Baban***, which corresponds to ***Liu Ba Ban*** (six eight ban) and denotes the number 68 within

the context of beats. As a result, the 68-beat structure exemplifies a canonical **Baban** model. Moreover, each melody comprises eight distinct phrases, further elucidating the multifaceted nature of the term ban (beat), which not only signifies beats but also encompasses phrases. Furthermore, in both instances, most of the phrases, with the exception of the fifth, consist of eight beats. This observation facilitates a comprehensive interpretation of the **Baban** concept as a nested representation of the number eight, where one instance of eight is embedded within another. It is also noteworthy that the **Baban** model occasionally embodies musical structures that are multiples of eight, such as 16 or 24, further expanding the understanding of its compositional framework. One may observe that the fifth phrases within these two melodies exhibit distinctive characteristics in relation to the overall musical structure. Specifically, these phrases comprise 12 beats, diverging from the typical pattern of eight beats per phrase observed in the remaining portions of the compositions. This phenomenon is referred to as **Kuowu** (extend five), signifying the elongation of the fifth phrase.

While it generally adheres to a structure consisting of the original eight beats augmented by an additional four beats, the implementation of this convention exhibits flexibility within actual musical compositions. In Figure 9.3, a comparative analysis can be conducted to further explore the nuances of the compositional practice within the **Baban** model, specifically examining the fifth phrases with and without the previously mentioned extension. This analysis includes the investigation of the fifth phrase containing 12 beats in Example A, eight beats in Example B, nine beats in Example C, and even seven beats in Example D, which can be conducted to further elucidate the nuances of this compositional practice (Figure 9.3).

Another important aspect of the Basic 68-Beat Structure is its use of cadence points (cadence points refer to specific points within the rhythmic pattern where there is a sense of resolution or completion). These cadence points are often associated with specific notes or chords that provide a sense of tonality or key. If we look into the first example **Baban** model from the "Chaozhou Repertoire", in this basic 68-Beat structure, cadence points occur at the end of each eight-beat phrase. These cadence points indicate an overall modal orientation of "*do*" and "*sol*", in which "*re*" appears at some interim cadences. This modal orientation provides a sense of tonality or key within the rhythmic pattern and allows musicians to improvise and vary their melodies while still maintaining a sense of continuity and structure. These phrases are identified with both phrase numbers and letters above their beginnings. There are essentially two contrasting motifs, understood as the first theme in phrase 1 and second theme in phrase 3. The remaining phrases are structurally related to these motifs and their rhythms. In contour, the melody starts on "*mi*" in the low–intermediate range, with a repetition in phrase 2 and an extension in phrase 3. The melody then moves to "*sol*" in phrase 4, followed by a repetition of the motif in phrase 5. In phrases 6 and 7, the melody moves to "*la*" and then returns to "*sol*" before reaching the final cadence point in phrase 8.

Upon closely examining the individual phrases, one can discern the microstructure within each phrase, constructed from smaller units. In the **Chaoshan Da Baban** (big baban from Chaoshan area) example illustrated in Figure 9.2, the first and second phrases exhibit analogous initial units. Concurrently, both phrases feature a structure comprising three beats, followed by two beats, and concluding with three

beats. This arrangement deviates from the symmetry commonly found in many European melodies. The structure of the eight-beat phrases can manifest in diverse combinations, reflecting the multifaceted nature of the musical composition. These combinations include a compound of three beats followed by two beats and concluding with another three beats, as observed in phrases 1, 2, 4, and 7; a compound consisting of four beats, followed by another four beats, and finally an additional two beats, as exemplified in phrase 3; or a more symmetrical compound comprising four beats followed by another four beats, as demonstrated in phrases 6 and 9. Moreover, in the musical excerpt from *Xian Suo Bei Kao*, as depicted in Figure 9.3, phrase 7 demonstrates an alternative composition characterized by a compound of five beats followed by three beats, further emphasizing the versatility of melodic structures within the context of the music. This variety illustrates the complexity and flexibility inherent within the melodic structure.

9.5 DATABASE AND THE ENCODING PROCESS FOR PREPROCESSING

In this research, the traditional Chinese melody database for melodic continuation generation training is mainly from KernScores, an online database of musical data created to assist projects dealing with the computational analysis of musical scores. The database currently consists of over 5 million notes and is in a format suitable for processing with the Humdrum Toolkit for Music Research. The website also provides automatic translations into several other popular data formats for digital musical scores. The KernScores website was developed to organize musical scores in the Humdrum **kern data format originating from a variety of musical sources. The website was designed to allow easy access to the data for students doing projects and coursework in CCARH courses about musical information and computational music analysis at Stanford University.

Students work on projects during the second quarter in these classes, primarily facilitated by the Humdrum Toolkit for Music Research. The Humdrum file format is text-based, allowing for easy viewing and editing in any standard text editor. This makes it an ideal format for computational analysis of musical scores, as it can be easily processed by computer programs. The Humdrum Toolkit for Music Research is a collection of software tools that can be used to analyze music encoded in the Humdrum file format. The KernScores database was created by Craig Stuart Sapp, who is affiliated with both Stanford University and Royal Holloway, University of London. Sapp is a leading expert in digital musicology and has published numerous articles on topics related to computational music analysis.

The database contains a wide variety of musical scores from different genres and time periods. Some examples include classical music from the Baroque, Classical, Romantic, and Modern eras; folk music from various cultures around the world; and popular music from different decades. The Essen folk song data collection is one of the most important sources from Kernscores. In 1982, Helmuth Schaffrath and his associates at the Hochschule für Musik in Essen, Germany, commenced the assembly of the Essen Collection as they endeavored to develop an innovative technique for expeditiously and precisely transcribing printed musical notation into a computer-compatible

format, subsequently termed the Essen Associative Code, or "EsAC" (Schaffrath, 1997). The initial dissemination of the collection encompassed approximately 6,500 folk songs gleaned from a multitude of 19th-century Volkslied publications. Up to today, the Essen Collection contains 10,356 monophonic songs across the world, including 2,246 songs from China. In addition to the KernScores Essen Collection, the seeds materials for generating melodic continuation are 156 songs digitized by the author into Humdrum format from the "Baban Model and the Variations-Score Collections" assembled by Chinese music theorists Li Xi An and Zhao Dong Mei. The whole data collection can be processed with the Humdrum Toolkit very conveniently for the symbolic music melodic continuation generation in this research. This allows researchers to focus on developing new methods and techniques for analyzing musical data.

In order to implement the deep learning process using long short-term memory (LSTM) networks via the TensorFlow-Keras framework, the dataset was preprocessed into a consolidated file containing time sequence objects utilizing the music21 toolkit (Cuthbert, M. S., & Ariza, C., 2010), a sophisticated software suite designed for computer-assisted musicology built upon the Python programming language. This versatile toolkit enables users to investigate a wide array of musicological inquiries through the application of computational methods. Such inquiries encompass the analysis of extensive musical datasets, generation of musical examples, instruction of fundamental music theory, editing of musical notation, exploration of the interplay between music and cognitive processes, and the composition of music through algorithmic or direct approaches.

The adaptability of music21 renders it an invaluable asset for both scholars and enthusiasts seeking to employ computational techniques to enhance their comprehension of music. In Figure 9.4, the encoding process for the preprocessing in this research is vividly depicted, showcasing the transformation of a musical score-*Jiao Fu Diao* (Woodcutter's Song) into the Humdrum **kern format (second example), ultimately resulting in the generation of the time-sequence object (third example). Moreover, a JSON mapping (fourth example) has been developed to ensure that rest information, denoted by ["r,"] and duration information, represented by [","], illustrates a 16th note prolongation can also be interpreted as integers during the RNN-LSTM training process. Therefore, the first step of the training is a Python script designed to preprocess a dataset of musical pieces for the purpose of training a model. Specifically, it is tailored towards the preparation of a dataset of pieces in kern format for a sequence-based model, likely for tasks such as music generation or music classification. Here's a summary of its core functionalities.

The first notable function is to load songs in kern (dataset path), which traverses a given directory structure and uses the music21 library to parse and load all files in kern format. Kern is a simple ASCII notation for music that is compatible with many types of software, including music21. Second step, filter by Duration: the script then checks if the loaded songs have acceptable durations, where acceptable durations are specified in the ACCEPTABLE DURATIONS list. This is accomplished via having acceptable durations (song, acceptable durations) function. Third step, transpose Songs: the transpose (song) function is used to transpose all songs to either C Major or A Minor. This is done to normalize the key of all songs and reduce the complexity of the model's learning task. Fourth step, encode Songs: the encode song (song, time

Original melody in score

Humdrum **kern format

*M2/4	{8d
*k[f#]	8g
*G:	8g
{8d	8g
8g	=5
8g	8a
16g	8dd
16g	16a
=1	16g
8a	8a}
4.dd}	=6
=2	{8dd
{16dd	16a
16gg	16g
4dd	16e
8a	16d
=3	8e
4.g	=7
8r}	2d}
=4	=

Time-Sequence Object

(Bar 1-4): 55 _ 60 _ 60 _ 60 60 62 _ 67 _ _ _ _ _ _ 67 72 67 _ _ _ 62 _ 60 _ _ _ _ _ r _

(Bar 5-8): 55 _ 60 _ 60 _ 60 _ 62 _ 67 _ 62 60 62 _ 67 _ 62 60 57 55 57 _ 55 _ _ _ _ _ _ _ _

JSON mapping of all the existing pitch/rest/duration information in the database

{
	"88": 8,	"84": 17,	"66": 26,	"55": 35,	"67": 44
"60": 0,	"56": 9,	"61": 18,	"68": 27,	"/": 36,	
"82": 1,	"86": 10,	"83": 19,	"77": 28,	"59": 37,	}
"78": 2,	"90": 11,	"85": 20,	"62": 29,	"75": 38,	
"73": 3,	"76": 12,	"53": 21,	"48": 30,	"65": 39,	
"74": 4,	"98": 13,	"64": 22,	"54": 31,	"52": 40,	
"72": 5,	"r": 14,	"95": 23,	"70": 32,	"91": 41,	
"57": 6,	"50": 15,	"71": 24,	"93": 33,	"63": 42,	
"_": 7,	"69": 16,	"79": 25,	"58": 34,	"81": 43,	

Final melodic information for training:

(Bar 1-4): 35 7 0 7 0 7 0 0 29 7 44 7 7 7 7 7 44 5 44 7 7 7 29 7 0 7 7 7 7 7 14 7

(Bar 5-8): 35 7 0 7 0 7 0 7 29 7 44 7 29 0 29 7 44 7 29 0 6 35 6 7 35 7 7 7 7 7 7 7

FIGURE 9.4 Encoding process.

step=0.25) function is used to convert the songs into a time-series-like representation, where each item in the encoded list represents 'min duration' quarter lengths. Fifth step, create Single File Dataset: in creating single file dataset (dataset path, file dataset path, sequence length), all songs are collated into a single file, with a specific delimiter added between each song. This is useful for training sequence models that require a large single corpus of text, such as certain types of recurrent neural networks (RNNs). Sixth step, create Mapping: the create mapping (songs, mapping path) function is used to create a mapping of all unique symbols (notes, rests, and carried notes) found in the songs to unique integer values. This converts the symbolic representation of the songs into a numerical representation that can be processed by a machine learning model. Seventh step, convert Songs to Integers: the convert songs to int (songs) function converts the encoded songs into integer format using the previously defined mapping. Moreover, generate Training Sequences: the generate training sequences (sequence length) function is used to generate input and output sequences for training the model. The input and output sequences are derived from the integer representation of the songs and are one-hot encoded to make them suitable for training a categorical model. Furthermore: the main() function orchestrates the above steps: preprocessing the kern files, creating a single file dataset, creating a mapping, and preparing for generating training sequences. However, the call to actually generate the training sequences is commented out in the provided code. In essence, this script carries out the necessary preprocessing steps to prepare a musical dataset for training a sequence-based machine learning model, likely for tasks such as music generation or classification.

9.6 TRAINING THE NETWORK AND MELODY GENERATION

The step right after the preprocessing is to write a Python script as an implementation of a long short-term memory (LSTM) neural network model designed for sequence prediction problems. This approach leverages various libraries, including music21 for musicology, TensorFlow Keras for creating and training the neural network, and os and json for general-purpose operations. The first section of the script involves importing the necessary libraries. Additionally, the function 'generate training sequences' and the constant 'SEQUENCE LENGTH' are imported from a local module named preprocess. To provide flexibility, several constants are defined to specify the dataset paths, model parameters, and training parameters. To construct and compile the LSTM model, the script utilizes the 'build model' function. This model consists of an input layer, a single LSTM hidden layer with a specified number of units, a dropout layer for regularization to mitigate overfitting, and a dense output layer with a softmax activation function. In the context of multi-class classification problems, softmax is particularly useful as it converts a vector of numbers into a probability distribution. During compilation, the model employs the Adam optimizer with a specified learning rate, 'accuracy' as the metric, and the sparse categorical cross-entropy loss function for optimization during training.

The 'train' function is responsible for the training process of the neural network model. It starts by generating training sequences using the 'generate training sequences' function from the preprocess module. Subsequently, it builds the model

using the 'build model' function and trains it on the generated sequences. The training data is processed in batches, and the number of epochs (full iterations through the dataset) is defined by the constant 'EPOCHS'. Upon completion of training, the model is saved to a specified location. Once the trained module is ready, the code is organized into a class called 'MelodyGenerator'. This class provides methods for loading a pre-trained LSTM model, generating a new melody based on a seed sequence, and saving the generated melody to a MIDI file. In the 'init' method of the 'MelodyGenerator' class, the pre-trained LSTM model and a mapping file that maps musical symbols to integers are loaded.

The 'generate melody' method uses the pre-trained LSTM model to generate a melody from a seed sequence. The seed sequence is a string of musical symbols that serves as the starting point for the melody. The melody generation process occurs in a loop, where the model predicts the next note based on the current seed, which is then appended to the melody, and the process is repeated. The 'generate melody' method also includes a 'temperature' parameter that influences the randomness of the melody generation. Higher temperature values make the melody generation more unpredictable, while lower values make it more deterministic. The 'sample with temperature' function is a helper function that rescales the probabilities returned by the model based on the temperature and then samples an index from the probability distribution. The index corresponds to a musical symbol in the mapping file. The 'save melody' method is used to save the generated melody to a MIDI file. The melody, represented as a list of musical symbols, is converted to music21 note and rest objects, which are then written to a MIDI file.

In the main function, an instance of the 'MelodyGenerator' class is created, a seed sequence is defined, a melody is generated from the seed sequence, and the generated melody is saved to a MIDI file. To generate the conventional 68-beat **Baban** model, one could determine the initial note or phrase and subsequently construct a sequence consisting of 272 steps in total. This can be interpreted as four steps per quarter note, repeated 68 times. By following this approach, you have the flexibility to generate diverse melodies using the LSTM model for sequence prediction problems.

In addition to the methods mentioned earlier, the 'MelodyGenerator' class also includes other useful methods. For example, there might be a method called 'load model' that allows loading a pre-trained LSTM model from a specified location. This method would be helpful if you want to use a different pre-trained model for melody generation. Another method could be 'set temperature', which enables adjusting the temperature parameter for melody generation dynamically. This flexibility allows you to experiment with different temperature values and observe the impact on the generated melodies. Additionally, the 'MelodyGenerator' class might provide a method named 'generate seed sequence' that automatically generates a random seed sequence based on predefined rules or musical patterns. This can be useful when you want to explore new melodies without specifying a particular seed sequence.

The following two examples (Figure 9.5a and b) are two rather satisfied generative melodic results of the conventional **Baban** model through the RNN-LSTM. These figures represent the output of the 'MelodyGenerator' class when applied to the LSTM model, showcasing the model's ability to generate diverse and satisfying melodic sequences based on the specified parameters and seed sequences.

FIGURE 9.5 Generative Baban melody results. (a) Example one. (b) Example two.

In addition to the core functionalities mentioned earlier, the 'MelodyGenerator' class can be extended to include various other methods that enhance its versatility and usability. One significant extension is the ability to load different models. The 'load model' method can be modified to accept a model type or name as an argument. This modification would provide users with the flexibility to seamlessly switch between different pre-trained LSTM models. Such flexibility is particularly valuable

when experimenting with various models tailored to different musical styles or genres. It allows users to explore the nuances of different models and adapt them to specific musical contexts. Dynamic temperature adjustment is another enhancement that can be integrated into the 'MelodyGenerator' class. Building upon the previously mentioned 'set temperature' method, this feature could enable users to dynamically adjust the temperature during the melody generation process. This dynamic control over temperature empowers users to create melodies that evolve in complexity or mood as they progress. It opens possibilities for generating music that transforms and adapts in response to changing artistic intentions. To stimulate creativity and exploration, consider implementing a 'generate seed sequence' method within the 'MelodyGenerator' class. This method would automatically generate a random seed sequence based on predefined musical patterns or rules. Musicians and composers could use this feature as a creative tool, providing them with unexpected musical starting points and inspiring novel compositions. It fosters experimentation and pushes the boundaries of musical creativity.

Adding a melody evaluation method to the class can be beneficial for users seeking to assess the quality of generated melodies objectively. This method could calculate metrics like melody complexity, harmony, or adherence to certain musical rules. By offering a quantitative assessment of generated melodies, users gain valuable insights into their musical creations. It aids in fine-tuning the generative process and aligning it with specific musical goals. For musicians seeking inspiration or collaborative composition, the 'MelodyGenerator' class could introduce an interactive mode, where users can input partial melodies and the model generates continuations. This real-time interaction can be a valuable tool for musicians looking to spark new musical ideas, improvisation, or collaborative music creation. It bridges the gap between human creativity and AI-generated music.

To enhance the practicality of the 'MelodyGenerator' class, consider expanding the 'save melody' method to include options for customizing exported MIDI files. Users could adjust settings such as tempo, instrument choice, or key signature to tailor the generated music to their specific needs. This customization adds a layer of versatility, allowing musicians to integrate AI-generated music seamlessly into their compositions. Furthermore, enabling real-time performance with the LSTM model through a dedicated method can be a game-changer for musicians or music creators who do not have years of professional experience. This feature would also allow musicians to generate melodies on the fly during live performances or jam sessions, offering spontaneity and creativity in musical expression.

The figures showcasing the generative melodic results of the conventional **Baban** model through the RNN-LSTM are not just theoretically appealing but also serve as empirical evidence of the model's capabilities. These representations are potent tools for conveying the potential of your implementation to various stakeholders, including researchers, musicians, and enthusiasts. To provide a comprehensive understanding, it's valuable to accompany these figures with contextual information. Describing the musical attributes of the generated melodies – such as tempo, key, and emotional qualities – offers a deeper insight into the generative process. Additionally, providing details about the parameters and seed sequences used for each generative example can guide others in achieving similar results and encourage experimentation (Figure 9.6).

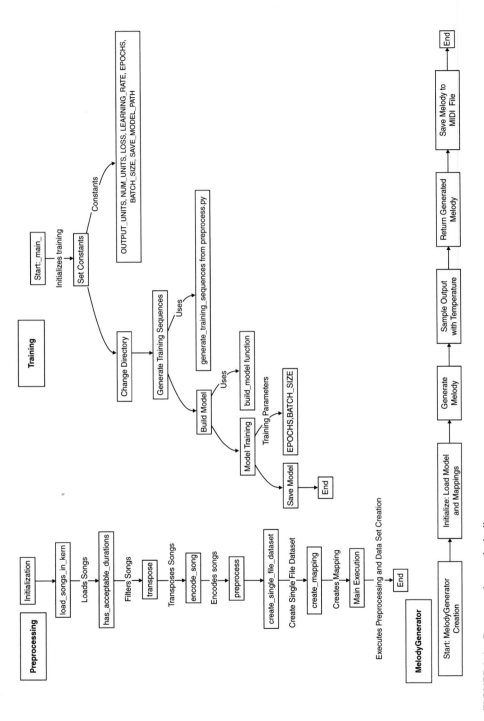

FIGURE 9.6 Programming analysis diagrams.

9.7 CONCLUSION AND FUTURE DEVELOPMENT

The main goal of this research is to provide possibilities for professional musicians and non-professional music aficionados interested in creating works based upon the traditional Chinese melodic format ***Baban***. Certainly, reproducing intangible cultural heritage such as ancient Chinese music presents unique challenges rooted in its rich history and complexity. One major obstacle is ensuring the survival of these ancient melodies, many of which have been passed down orally and via hand-written notations for generations. Over time, melodies may become disjointed or altered beyond recognition, making it challenging to restore them to their original state. Ancient Chinese music knowledge was spread primarily via apprenticeship and master-disciple relationships. Given today's busy lifestyles and priorities, fewer young individuals seem willing to devote the dedication necessary for mastering ancient melodies, prompting fears over potential losses of expertise as these musical traditions fade over time.

Therefore, one effective solution to these difficulties lies in applying deep learning tools derived from traditional melody generators based on RNN-LSTM to combine with an expansive database of ancient Chinese music melodies. Deep Learning-powered systems can be trained on large datasets of historical musical compositions to accurately analyze and generate music reminiscent of ancient Chinese melodies. One key benefit of traditional melody generators lies in their capacity to reconstruct fragmented or damaged ancient melodies. By taking incomplete notations or recordings and reconstructing those that are missing, the system can reliably restore original compositions with faithful recreations of missing portions. Restoring ancient music can play an essential part in conserving cultural heritage and expanding knowledge about ancient Chinese musical traditions. Traditional melody generators also serve as educational tools, making it simpler for aspiring musicians to master ancient Chinese music and perform it effectively. The system can offer interactive tutorials for instrument playing techniques, historical tonal variations, and rhythmic patterns – providing access to traditional music education while encouraging younger generations to become engaged with their cultural heritage.

Traditional melody generators play an essential part in revitalizing and adapting ancient Chinese music for contemporary audiences, providing vital restoration services as well as education on this genre of music. By synthesizing historic melodies with contemporary musical trends, The systems can craft innovative compositions that resonate with multiple audiences. Combining tradition and innovation can add new life to ancient Chinese music, making it more approachable and accessible to a broader audience. Recovering intangible cultural heritage within ancient Chinese music melodies presents many obstacles, yet deep learning tools such as traditional melody generators trained with RNN-LSTM is one potential solution to meet them. The system can assist in the restoration of fragmented melodies, act as educational resources, and adapt ancient music for modern use. By harnessing technology to preserve ancient melodies authentically, we can ensure their cultural legacy thrives for future generations of audiences to enjoy and appreciate.

FUNDING

This research was funded by Beijing Normal University Future Design Seeds Fund.

REFERENCES

Collins, N., McLean, A., Rohrhuber, J., & Ward, A. (2003). Live coding in laptop performance. *Organised Sound*, 8(3), 321–330.

Cope, D. (2005). *Computer models of musical creativity* (p. xi462). MIT Press.

Cuthbert, M. S., & Ariza, C. (2010). music21: A toolkit for computer-aided musicology and symbolic music data.

Dean, R. T., & Bailes, F. (2010). A risefall temporal asymmetry of intensity in composed and improvised electroacoustic music. *Organised Sound*, 15(2), 147–158.

Eck, D., & Schmidhuber, J. (2002). A first look at music composition using LSTM recurrent neural networks. *Istituto Dalle Molle Di Studi Sull Intelligenza Artificiale*, 103(4), 48–56.

Hochreiter, S.,& Schmidhuber, J. (1997). Long short-term memory. *Neural Computation*, 9(8), 1735–1780.

Karpathy, A., Johnson, J., & Fei-Fei, L. (2015). Visualizing and understanding recurrent networks. arXiv preprint arXiv:1506.02078.

Li, X., & Zhao, D. (2020). *Chinese traditional musical form studies*. Modern Press.

Li, X., & Zhao, D. (2021). *Research on Baban and its variants*. Modern Press.

Loy, G., & Lehman, B. (2008). Musimathics: The mathematical foundations of music. *Physics Today*, 61(12), 54.

Mahnkopf, C., Cox, F., & Schurig, W., eds. (2004). *Musical morphology*. Vol. 2. Wolke.

Pascanu, R., Mikolov, T., & Bengio, Y. (2013, May). On the difficulty of training recurrent neural networks. In *International Conference on Machine Learning* (pp. 1310–1318). PMLR.

Roads, C. (1996). *The computer music tutorial*. MIT Press.

Rongzhai, ed. (1814). Xian Suo Bei Kao, 1814.

Selfridge-Field, E. ed. (1997). *Beyond MIDI: The handbook of musical codes*. MIT Press.

Thrasher, A. R. (1989). Structural continuity in Chinese Sizhu: The "Baban" model. *Asian Music*, 20(2), 67–106.

Briot, J. P., & Pachet, F. (2020). Deep learning for music generation: Challenges and directions. *Neural Computing and Applications*, 32(4), 981–993.

Pearce, M., & Wiggins, G. (2004). Improved methods for statistical modelling of monophonic music. *Journal of New Music Research*, 33(4), 367–385.

Huang, C. Z. A., Vaswani, A., Uszkoreit, J., Shazeer, N., Hawthorne, C., Dai, A. M., … & Eck, D. (2018). Music transformer: Generating music with long-term structure (2018). arXiv preprint arXiv:1809.04281.

Nierhaus, G. (2009). *Algorithmic Composition: Paradigms of Automated Music Generation*. Springer Science & Business Media.

Schaffrath, H. (1997). The Essen Associative Code: A Code for Folksong Analysis. In *Beyond MIDI: The handbook of musical codes*, 43.

10 Understanding Music and Emotion from the Brain

Haifeng Li
Harbin Institute of Technology, Harbin, China

Hongjian Bo
Shenzhen Academy of Aerospace Technology, Shenzhen, China

Lin Ma, Jing Chen, and Hongwei Li
Brain-Inspired Intelligence and Neural Engineering Research Center, Harbin Institute of Technology, Harbin, China

10.1 BACKGROUND

Music is a language for human beings to express thoughts and feelings. It represents and inspires emotions through the difference in melody, the speed of the rhythm, the height of the volume, the change of the harmony, and the different kinds of timbre [1]. Music can induce more profound and lasting emotional experiences than emotional words, pictures, and movies. Therefore, music is an ideal tool for studying human emotional activities. With the development of human brain imaging technology, various physiological measures are used to extract emotional-related information. Early in 1935, Hevner found a significant emotional difference in listening to different emotional music at the behavioral level [2]. Scientists gradually found that the emotions evoked by music involved some brain regions, including the limbic system [3], the hypothalamus and insula [4], the memory-related hippocampus, and the frontal cortex [5]. Compared with other techniques, electroencephalogram (EEG) signals, which record electrical activity along the scalp by electrodes, have very high temporal resolution and could reflect the dynamic activity of the human brain. Tervaniemi et al. found that unhappy music could induce a more significant late positive potential (LPP) [6], which could be used to identify people's emotional states based on the EEG signals.

Although the current research on music emotion recognition has achieved many results, there are numerous problems in music emotion recognition. The main reason is that music emotions are not entirely contained in music. Music data alone is not enough to fully recognize musical emotions. The study on how listeners felt about Chinese pop music indicated that the spectral power of EEG could be used in

interpreting music-induced emotions [7]. EEG proved to be very useful in both scientific and clinical applications. Tandle et al. proposed a system based on the hemispheric asymmetry of frontal theta power to estimate emotional rejoinders through music listening [8]. High-level feature extraction methods have been gradually developed based on early time-frequency features, such as nonlinear dynamics and brain network complexity analysis [9].

Early work on emotion recognition from EEG goes back as far as 1997 [10]. In the past several years, various signal-processing methods have been proposed to improve the EEG-based emotion recognition. Previous studies [11, 12] provided a comprehensive overview of the existing works in emotion recognition based on EEG signals. Feature extraction is a critically significant step in the EEG-based emotion recognition framework. Basically, features from EEG can be distinguished into time domain, frequency domain, and time-frequency domain. The time domain features aim to identify and detect the temporal information in the brain activity. A study [13] used the amplitude and latency of ERPs as features for EEG-based emotion classification. However, detecting ERPs related to emotions is challenging since the onset is usually unknown.

Other features, such as Hjorth features [14], Fractal Dimension [15, 16], and Higher Order Crossings (HOC) [17], have been used to characterize EEG time series. The frequency-domain feature aims to capture the relative amplitudes and phase information of specific oscillation frequencies. The most popular frequency-domain features are band power [18] and Higher Order Spectra (HOS) [19]. These features could be extracted from different frequency bands, e.g., delta (1–3Hz), theta (4–7Hz), alpha (8–13Hz), beta (14–30Hz), and gamma (31–49Hz). With this kind of method, it is not possible to determine when a particular frequency occurs. The time-frequency domain features bring up the temporal information by considering the dynamical changes of the spectrum. The most used time-frequency analyses for feature extraction were the short-time Fourier Transform [20], Wavelet Transform [21], and Hilbert-Huang transform [22].

Music emotion computing models can be mainly divided into traditional machine learning models and deep learning models. Traditional machine learning models include partial least squares, perceptron algorithms, support vector machines, etc. [23]; deep learning models mainly include LSTM and its variants, CNN, AlexNet, and other models. The deep learning model can learn more general multi-layer abstract representations from low-level features to high-level concepts from data. Deep learning models for music emotion recognition can effectively merge the gap between the low-level features and high-level notions of music signals [24].

To sum up, some achievements have been made in the cognition of music, but it is not difficult to find that there are three main challenges:

1. A significant gap exists between the existing cognitive experimental methods of acoustic features and the actual music listening state. Most of the stimuli used in the experiments are either artificially made or sound clips. Moreover, specific tasks have been followed in the cognitive experiment, which is different from the actual state of listening to music.

2. The experimental paradigms of sound and music are different, which makes it impossible to compare them accurately.
3. How to improve the recognition rate of emotion classification based on EEG signals through the cognitive principles of emotions is still under exploration.

This chapter is organized as follows. Section 10.1 briefly introduces the experiment procedure. Section 10.2 addresses the fundamental analysis methods for brain activity. The relationship between music features and brain response is detailed in Section 10.3. Then, the dynamic analysis method is proposed. The music emotion computing model is built in Section 10.5.

10.2 COGNITIVE EXPERIMENT DESIGN

Music features can be divided into three levels: acoustic, elemental, and structural feature [25]. Acoustic features are descriptions of physical quantities for sound signals. The element features describe the music forms for various music segments in terms of harmony, tonality, and tempo. The structural features describe high-level features for long-term music objects. Therefore, music emotion computing mainly includes two aspects: (1) music emotion feature extraction; (2) music emotion recognition model.

10.2.1 MUSIC LISTENING COGNITIVE EXPERIMENT

The music-listening cognitive experiment is designed with no task to simulate the environment of music appreciation. First, 40 piano sonata episodes were selected by emotional tags, and the highlight parts were intercepted manually. After the emotional score rating, 16 music clips were chosen as the final stimuli. Then, each subject was asked to sit in an armchair in a quiet room in shaded daylight. Before the experiment, each participant filled out a questionnaire. Then, they were given instructions on the experiment protocol and the meaning of the different scales used for self-assessment. The discrete 9-point Self-Assessment-Manikin (SAM) Scales is used for rating valence and arousal [26]. The ratings are on a 9-point scale ranging from 1 to 9. The valence scale is from sad to happy. The arousal scale is from calm to excited. After the sensors were placed and their signals checked, the participants performed a practice trial to familiarize themselves with the system.

The music clips were presented in a random order (Figure 10.1). There were 16 trials, each of which included three parts: (a) 15 s of the spontaneous EEG recording; (b) 30 s of music listening, during which central visual fixation was requested to reduce eye movement; (c) another 15 s of the spontaneous EEG recording. At the end of each trial, participants performed a self-assessment of valence and arousal.

There are some benefits of this design: 1) through the joint analysis of these three stages, the "inspiring-keeping-fading" process of emotional changes could be revealed in Figure 10.2; 2) The spontaneous EEG parts could calm the impact of the previous music stimulus; 3) the response strength evoked by different emotional music could be easily measured by comparing different stages.

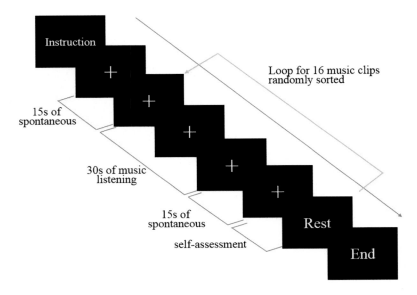

FIGURE 10.1 The cognitive experiment process of music-evoked emotions.

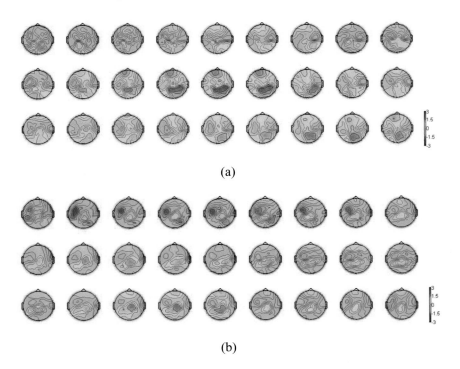

(a)

(b)

FIGURE 10.2 The time course dynamic topographic distribution of EEG α band power evoked by music (brain topographic maps were plotted per second). (a) Brain changes of listening to high valence music. (b) Brain changes of listening to low valence music.

10.2.2 SHORT-TIME SOUND COGNITIVE EXPERIMENT

An auditory emotion cognition experiment is designed to compose between long-time music and short-time sound. The experimental samples are mainly considered from two aspects: short-term analysis techniques could be applied to compare with current work, and the other is to analyze the long-time brain components through the method proposed in this part.

The research on musical feature cognition contains a lot of content, such as pitch, timbre, rhythm, melody, etc. Then, based on the emotional tags, 93 samples were selected with a length of 1–2 seconds from 259 sounds among three emotional sound libraries: IADS2, Montreal, and MEB. The experimental design adopts a task-independent practical method. The entire experiment is divided into two parts: listening to the sound while collecting EEG signals; and listening to the sound and evaluating the Valence-Arousal (VA) dimensional emotions. The EEG acquisition experiment adopts the 1-back experimental paradigm in which 20% may repeat the previous sound. The experimental process is shown in Figure 10.3. In addition, 51 volunteers evaluated the emotions of each segment online. The SAM assessment was also used here. A total of 20 volunteers (undergraduates between 19 and 25 years old) participated in the experiment. The experiment included 12 blocks, and each block lasted about five min. There was a one-min rest between the blocks. The whole experiment was about 60 min.

The sound samples used in the experiment were simple sounds without complex objects, such as crying, laughing, and wind blowing. The emotional response and evaluation of sounds are the primary functions of human cognition. For example, people will be irritable when they hear noise, be pleasant when they listen to birds in the jungle, and be frightened when they hear thunder. The sound samples were mainly selected from two aspects: one was the emotional labels, which needed to cover different emotions. The other was the object attribute of the sound, including human voice and mechanical sound.

All samples were classified as living/non-living and high/low valence. Then, event-related potential (ERP) analysis was performed. The results are shown in Figure 10.4. Compared with non-living sounds, no ASR component [27] was found, but new emotional-related components, called Emotion Specific Response (ESR), were found around 400ms. This indicates a cognitive difference of the human brain's response at 450ms. In addition, the ESR component of emotions is about 100ms later than the ASR component of object attributes, indicating that the processing of emotions in the human brain involves more neural regulation.

FIGURE 10.3 The experimental flow of sound-induced emotion.

FIGURE 10.4 ERP analysis of sound-evoked emotions. (a) ERP of living and non-living sounds. (b) ERP of high and low valence sounds.

10.3 AUTOMATIC ACOUSTIC EVENT DETECTION

Brain responses to discrete short sounds have been studied intensively using the ERP analysis. The EEG signal is divided into epochs time-locked to stimuli of interest. To extract functional ERP components, it is necessary to know the precise onset of the sound to align the epochs with time. Under this constraint, pure sound or simple notes were used in traditional cognitive studies. However, pure sound or simple notes do not represent the music.

According to the characteristics of cognitive activities, the human brain is sensitive to mutational events. The onset that causes the EEG changes is called the event point, shown in Figure 10.5. Not all mutations are the event points. They should satisfy the following two rules:

1. The amplitude of this point fluctuates obviously. The amplitude must be relatively large enough to cause a significant response in the human brain.
2. There is no significant fluctuation before the event point; that is, the mutation is relatively smooth before the event points.

Based on these characteristics, an algorithm for automatically detecting event points based on a sliding window is proposed. The principle is to find the event onsets of the EEG by changing points of the musical features. First, a sliding window is applied to

FIGURE 10.5 The event point with small amplitude and large fluctuations.

the musical feature, which lasts three seconds. Then, the peak points were calculated based on the fluctuation rule. The peak threshold is given by the average 20% top value in this window. Finally, because of the stability rule, a 1.5-second length before the event point is used in the stationary calculation. If there is no peak point in this period, which is no larger than 30% of its event point value, it is considered that there is no obvious fluctuation, and it meets the requirements of the event point definition. The advantage of this algorithm is that the threshold is automatically updated while the window is sliding. The specific calculation steps are as follows:

1. Extract the acoustic features of the music episode;
2. Detect the event points by the automatic detection algorithm based on a sliding window;
3. Check the smoothness 1.5 seconds before the event point;
4. If there is no peak point larger than 30% of its event point value, it is considered the event point.

Considering the comparison requirement and the space limitation, two kinds of acoustic features should be extracted. One is a common time-domain feature as "short-time energy", and another is a complex frequency-domain feature as "roughness". The EEG signal process is as follows:

1. Filtering: a 0.5–30 Hz bandpass filter removes high-frequency interference and retains the practical components.
2. Artifact removal: Independent Component Analysis (ICA) is generally adopted to remove the blink components from multi-channel EEG signals.
3. Epoch: after removing artifacts, the EEG signals are segmented by event points in each channel of the EEG signal.
4. Baseline correction: the first 100ms of each segment is used as the baseline for correction to eliminate the influence of the sensor drift.
5. Averaging: align all segments by time and average them to get the ERP waveform.

To prove the selection effect of the event points, the same number of random points were selected simultaneously. It was found that the ERP waveform diagram of the event points can see the practical acoustic components, and the mean value of the waveform diagrams of the random points approaches 0, as shown in Figure 10.6.

By analyzing the EEG signals while music listening, we found the following results:

1. Based on the results of the grand average ERP, the N1-P2 components of the auditory features were found in roughness within 100–200ms, as shown in Figure 10.6a.
2. We also found the acoustic late positive potential (LPP), which could further prove the effectiveness of this method.
3. Brain activities were plotted by each electrode on the topographic map by time step, which showed the differences in the neural process of acoustic features. The main activated brain areas of N1-P2 components were found at the parietal area in 100–200ms, while the central area of the LPP in 300–700ms is the occipital area, as shown in Figure 10.7.

FIGURE 10.6 The ERP waveform chart evoked by acoustic feature (roughness). (a) ERP of CZ electrode. (b) ERP of OZ electrode.

FIGURE 10.7 The EEG topography chart evoked by acoustic feature (roughness).

10.4 FEATURE SIMILARITY ANALYSIS

How to extract useful information from complex EEG signals is very important for emotion recognition. Although many research results on emotion recognition are based on EEG, there are still many problems: 1) how to induce multiple emotions more conveniently and effectively; 2) how to express the relationship between emotional activity and brain regions, and find emotion-related EEG features; 3) how to improve the recognition rate of emotion classification based on EEG signal through the cognitive principles of emotions. All of these are still challenging issues in emotion recognition based on EEG. Therefore, it is urgent to study new theories and methods to support the development of affective computing based on EEG signals.

10.4.1 REPRESENTATIONAL SIMILARITY ANALYSIS

Representational Similarity Analysis (RSA) [28] is one of the primary methods of functional magnetic resonance imaging analysis. Its principle is to evaluate whether two systems could represent the cognitive tasks similarly. Representational Dissimilarity Matrix (RDM) is the most crucial step in the RSA algorithm. RDM represents the relationship between feature vectors, which describes the similarity between brain activities under different conditions. If these matrices look the same on different systems, they represent information in a similar way. RDM has the following advantages: RDM could describe the neural activity in different features and brain regions [29]. Secondly, it transforms the feature vectors of different systems into spatial relations, which abstracts the feature relations in different systems into a unified representation space.

As shown in Figure 10.8, the upper part represents system A (such as acoustic features); the lower part represents system B (such as brain activities by EEG); and RDMs for systems A and B are in the middle position. The information they represent is similar if these RDMs look the same on different systems. This way,

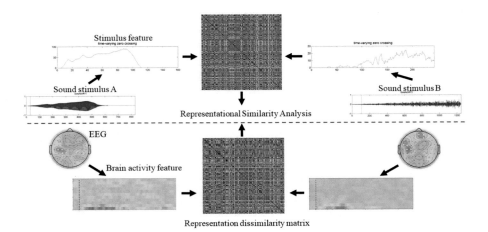

FIGURE 10.8 The EEG topography chart evoked by acoustic feature (roughness).

multi-scale, multi-modal, and multi-dimensional correlations and differences can be measured and analyzed. Nima et al. used the RSA method to prove that large-scale EEG data analysis could observe brain dynamics more extensively than a single study [30].

10.4.2 THE CONSTRUCTION OF DISSIMILARITY MATRIX

The basis of RDM analysis is to construct the feature vector. RDM is a diagonal symmetric matrix obtained by computing the neural representation space vector V with each other. The brain's response to the information is encoded in patterns of neural activities. In fMRI data, neural activities are usually presented by voxels, which are volume elements in brain images. For example, the 1000 voxels in the fMRI region of interest are considered a feature vector V in the neural representation space. In the EEG signals, the electrode voltages and features could also be regarded as feature vector V. Euclidean distance and Pearson correlation coefficient are usually used in the relation calculation. The relationship between RDMs is usually calculated by the rank correlation distance method, shown in Figure 10.9. After obtaining the feature dissimilarity matrix (FDM) and label dissimilarity matrix (LDM) from EEG features and emotion labels, the feature similarity score S could be calculated. The calculation steps are as follows: First, the selected feature needs to be as consistent as possible with the emotion labels. That is, the higher the similarity between FDM and LDM, the better the expression of emotion by the feature. Moreover, the selected

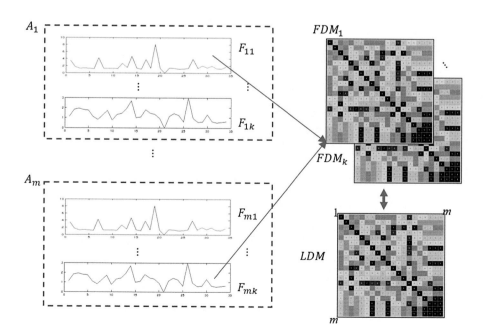

FIGURE 10.9 The construction of feature dissimilarity matrix (FDM) and label dissimilarity matrix (LDM).

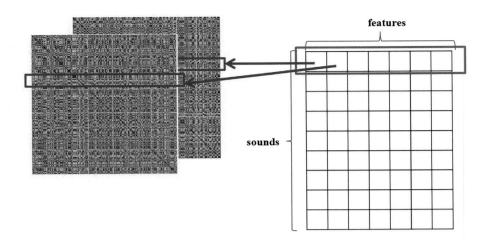

FIGURE 10.10 The calculation process of dissimilarity score.

feature needs to be as different as possible from other features. That is, the higher the degree of dissimilarity, the less overlap in feature expression, and the higher the recognition effect.

First, calculate the similarity of the FDM and LDM matrices as the similarity score S_1. The calculation formula is as follows:

$$S_1 = \frac{\text{FDM} \times \text{LDM}}{\|\text{FDM}\| \times \|\text{LDM}\|} \qquad (10.1)$$

Secondly, according to the dissimilarity matrix FDM_k of the features F_1, F_2, \ldots, F_k, the sum of the similarities between each sample and the others is calculated as the score of the i-th feature of the sample. The final dissimilarity score S_2 is the sum of all features, as shown in Figure 10.10. Finally, the total score for a given feature is $S = S_1 + S_2$. By scoring S for feature similarity, the most relevant feature could be found.

10.5 TEMPORAL DYNAMICS ANALYSIS

The principles of microstate analysis are the quasi-stable periods of topographies, which have been used to study the resting state of the human brain based on the topography of the EEG signals [31, 32]. More particularly, the changes in electric field configurations could be described by a limited number of microstate classes, which remain stable for around 80–120ms before abruptly transitioning to another configuration. EEG microstates might represent and characterize the dynamic neuronal activity of conscious contents. The main idea of the method is shown in Figure 10.11.

10.5.1 MICROSTATE SEGMENTATION

Global Field Power (GFP) measures whole-brain responses to events and describes rapid changes in brain activity. GFP is the standard deviation of all electrodes at a

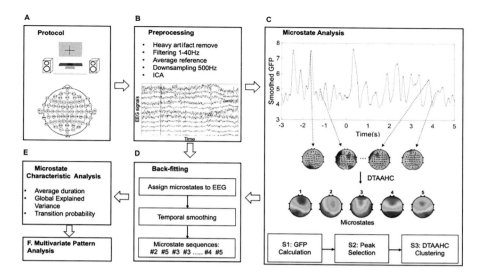

FIGURE 10.11 The schema of the methodology. The main six steps are: (a) The auditory emotional experimental design. (b) The pre-processing for EEG signals. (c) The proposed microstate analysis to identify the microstates. (d) Back-fitting to obtain the microstate sequences. (e) Microstate characteristics extraction as features. (f) Multivariate pattern analysis for emotion recognition.

given time. It is often used to measure the global brain response to an event or to characterize the rapid changes in brain activity.

For each subject, GFP was calculated for each sample time according to Equation 10.2, where N denotes the number of electrodes, $u_i(t)$ is the measured voltage of a specific electrode at time t, and $\overline{u}(t)$ is the average voltage of the N electrodes at the respective sample time t.

$$\mathrm{GFP}(t) = \sqrt{\frac{\sum_{i=1}^{N}\left(u_i(t) - \overline{u}(t)\right)^2}{N}}$$

(10.2)

For each participant, the GFP of each trial is calculated. After smoothing GFP with a Gaussian-weighted moving average of 50-time points, topographies at GFP peaks were collected and fed into the clustering algorithm to identify the microstates.

10.5.2 MICROSTATES TEMPLATE EXPLORATION

The microstates template exploration method is used to select the number of microstate categories. The selection of the microstate categories mainly refers to two indicators. The first indicator is the global explained variance (GEV), which measures the similarity between the microstate categories obtained by clustering and each EEG topology. The second indicator is the cross-validation criterion (CV). This measure

is related to the residual noise. GEV is frequently used to quantify how well the microstate classes describe the data. The higher GEV, the better. It is influenced by the dimensionality of the data. The total global explained variance (GEV) is the sum of the GEV values over all microstate classes:

$$\text{GEV} = \sum_l \text{GEV}_l \tag{10.3}$$

The GEV_l value for a specific microstate class with label l is:

$$\text{GEV}_l = \frac{\sum_t \text{GFP}_t^2 \cdot C_{V_t,M_l}^2 \cdot \delta_{l,L_t}}{\sum_t \text{GFP}_t^2} \tag{10.4}$$

$$\delta_{l,L_t} = \begin{cases} 1 \ if \ l = L_t \\ 0 \ if \ l \neq L_t \end{cases} \tag{10.5}$$

$$C_{V_t,M_l} = \frac{\sum_i V_{ti} M_{li}}{\sqrt{\sum_i V_{ti}^2} \cdot \sqrt{\sum_i M_{li}^2}} \tag{10.6}$$

The spatial correlation C_{V_t, M_l} between instantaneous EEG topography V_t and the candidate microstate class M_l can be calculated by Equation 10.6, where V_{ti} is the voltage of i-th electrode of instantaneous EEG at time t (local peak index) and M_{li} denotes topography of the microstate class l.

10.5.3 MICROSTATES BACK-FITTING

Calculate the similarity between the topology at the local maximum value of the GFP curve (it can also be the topology at each time point) and the topology of each microstate category and specify the period according to the microstate topology with the most similarity. A sequence of microstates, resulting in a series of alternating microstates, is expected to be distinct and could explain the original EEG topographies as much as possible. EEG microstate sequences are symbolic time series associated with the underlying neurophysiological activity. Global map dissimilarity (GMD) is used to measure the topographic differences of microstate maps, independent of electric strength. It is defined as

$$\text{GMD} = \sqrt{\frac{1}{N} \sum_{i=1}^{N} \left(\frac{u_i - \bar{u}}{GFP_u} - \frac{v_i - \bar{v}}{GFP_v} \right)^2} \tag{10.7}$$

where u_i and v_i are the voltages of two specified microstates, and \bar{u} and \bar{v} are the average voltages of the N electrodes. GMD ranges from 0 to 2, where 0 indicates topographic homogeneity and 2 indicates topographic inversion.

10.5.4 THE PROPOSED DUAL THRESHOLD-BASED AAHC

Atomize and agglomerate hierarchical clustering (AAHC) is a bottom-up hierarchical clustering wherein the number of clusters is initially large and progressively diminishes.

Here, we propose a new clustering method to automatically determine the optimal number of microstate classes during clustering. Compared with AAHC, the proposed algorithm considers the microstate topographic similarity. Microstates are expected to be distinct for microstate analysis and could explain the original EEG topographies as much as possible. Therefore, two optimization criteria are used to estimate the quality of the microstate classes' topographical maps during iterations. First, the cluster with the lowest GEV is freed and reassigned to the surviving clusters. Second, the clusters are merged if the GMD between the candidate microstate classes is lower than 0.1. In addition, the iteration stops when the criterion GEV reaches the threshold.

Although we made a minor alteration to the AAHC algorithm, the new method could automatically identify the optimal microstate classes and reduce the computational cost. After microstate classes are identified, the original individual EEG data can be labeled as a microstate sequence by fitting back these microstate classes to topographies at the sample point. Temporal parameters can be extracted as features for further analysis and can be compared between different experimental conditions or subjects' groups.

10.5.5 MICROSTATE CLASS SPATIAL TOPOGRAPHIES

The group-level clustering revealed nine optimal microstate classes for emotionally evoked EEG. These nine microstate topography templates are illustrated in Figure 10.12a. The topographies are labeled as #1–9. For dataset 2, the microstate analysis identified 10 microstates for emotional music-evoked EEG (see Figure 10.12b).

The performance of the microstate segmentation algorithm is reported in terms of the GEV, which estimates the portion of EEG point topography that microstates could explain. For dataset 1, the nine EEG microstate classes explained around 85% of the data in global field power peaks. The GEV of each microstate class ranged from 6.55 to 11.25% (see Figure 10.12c). For dataset 2, ten microstates explained 86% of the variance of all global field power peaks. Correspondingly, the GEV of each microstate class fluctuates between 6.73 and 11.68%.

10.6 MUSIC EMOTION RECOGNITION

In this part, a music emotion computing model is built based on music and EEG features. The music features are projected onto the EEG features through the sparse canonical correlation method to obtain the new music feature vectors containing EEG information. The support vector machine was used to train and test the new music feature vectors, and good recognition results were obtained in both the self-built and public databases. The proposed method combines the advantages of EEG signals that can reflect the most intuitive and accurate emotional expression. At the same time,

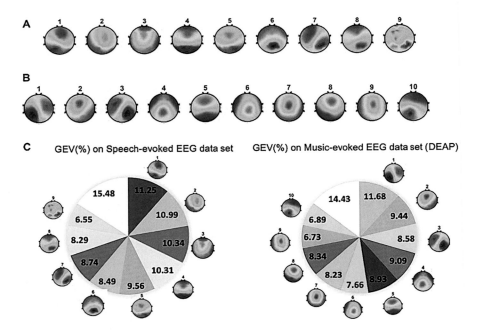

FIGURE 10.12 The topographical maps of the microstates across subjects. (a) Microstates from emotion cognitive experiment. (b) Microstates from music-evoked datasets. (c) The global explained variance (GEV) of each microstate for two datasets.

our approach has good transferability. When the EEG samples are representative, the projection vector is universal and can be directly used in other music databases.

10.6.1 Music Feature Extraction

The cognition experiment is based on Section 10.2.1. All music features were extracted in units of frames. The window length for feature extraction was 25ms, and the window move was 10ms. A total of 103-dimensional music features was extracted. The music features used in this chapter are shown in Table 10.1.

10.6.2 EEG Feature Extraction

EEG channels were re-referenced using a typical average. A band-pass filter with 0.1 and 40Hz cutoff frequencies were then applied. Then, the Independent Component Analysis (ICA) was used to separate the EEG signals into independent signals. We removed artifact signals such as electrooculograms and electromyograms and restored the remaining signals to obtain a clean EEG signal. Finally, the data were down-sampled to 250Hz.

After pretreatment, EEG feature extraction was performed on each electrode. EEG features were also extracted in units of frames. The window length for feature extraction was 25ms, and the window move was 10ms. A total of 29-dimensional

TABLE 10.1
The Music Features Used in This Section

Type	Feature Description	Dimension
Basic Audio Features	Root Means Square	1
	Zero Crossing Rate	1
	Energy	1
	Loudness	1
Spectral Features	Spectral Centroid	1
	Spectral Flux	1
	Flatness	1
	Entropy	1
	Roughness	1
	kurtosis	1
Musical Features	MFCC	13
	MFCC Difference	13
	Chroma	12
	Key Strength	24
	Mode	1
Other Features	Perceptual Linear Predictive Cepstral Coefficients (PLP)	12
	PLP Difference	12
	F0	1
	Voicing Probability	5
Total		103

TABLE 10.2
The EEG Features Used in This Section

Type	Feature Description	Dimension
Time Domain	Statistics of Signal	7
	Hjorth Features	3
	Higher Order Crossings	6
	Non-stationary Index	1
	Fractal Dimension	1
Frequency Domain	Power Spectral Density	5
	Differential Entropy	1
	ERS/ERD	5
Total		29

EEG features were extracted for each electrode. The EEG features used in this chapter are shown in Table 10.2. According to previous research [13], it was found that the brain regions related to emotion mainly involve the frontal and central areas. Sixteen electrodes located in the frontal and central regions were chosen. Therefore, the EEG feature dimension of a single subject is 29*16 = 464 dimensions.

10.6.3 SPARSE CANONICAL CORRELATION ANALYSIS

Canonical correlation analysis (CCA) can extract a correlation via canonical variates obtained from a pair of multivariate datasets by maximizing a linear correlation. CCA aims to find a^T and b^T that maximize the correlation coefficient. The optimization problem can be solved by singular value decomposition (SVD). However, the traditional CCA method has over-fitting issues, especially when the feature dimension is very large. To prevent the model from over-fitting and improve the generalization ability of the model, we introduce sparse into the optimization goal of CCA. The sparse optimization problem is as follows.

In this section, we assume that there are two heterogeneous sets of N feature vectors: $X_1 \in R^{m \times n}$, $X_2 \in R^{p \times n}$. The formal representation is as follows:

$$X = \begin{bmatrix} X_1 \\ X_2 \end{bmatrix} E[X] = \begin{bmatrix} \mu_1 \\ \mu_2 \end{bmatrix} \Sigma = \text{Var}(X) = \begin{bmatrix} \Sigma_{11} & \Sigma_{12} \\ \Sigma_{21} & \Sigma_{22} \end{bmatrix} \tag{10.8}$$

Where Σ is covariance matrix, Σ_{11} is the covariance matrix of X_1, Σ_{22} is the covariance matrix of X_2, Σ_{12} is the covariance matrix of X_1 and X_2, and Σ_{21} is the covariance matrix of X_2 and X_1.

To calculate the correlation between two sets of variables, we linearly combine X and Y to calculate the Pearson correlation coefficient.

$$\text{corr}(u,v) = \frac{a^T \Sigma_{12} b}{\sqrt{a^T \Sigma_{11} a} \sqrt{b^T \Sigma_{22} b}} \tag{10.9}$$

In the above formula, $u = a^T X_1$, $v = b^T X_2$.

CCA aims to find a^T and b^T that maximizes the correlation coefficient. Writing this problem as the following optimization problem:

$$\text{Maximize } a^T \Sigma_{12} b$$
$$\text{Subject to: } a^T \Sigma_{11} a = 1, \, b^T \Sigma_{22} b = 1 \tag{10.10}$$

To solve this optimization problem, we suppose $a = \Sigma_{11}^{-1/2} u$, $b = \Sigma_{22}^{-1/2} v$. Substituting into the above formula, we can get the following formula:

$$a^T \Sigma_{11} a = 1 \Rightarrow u^T \Sigma_{11}^{-1/2} \Sigma_{11} \Sigma_{11}^{-1/2} u = 1 \Rightarrow u^T u = 1$$
$$b^T \Sigma_{22} b = 1 \Rightarrow v^T \Sigma_{22}^{-1/2} \Sigma_{22} \Sigma_{22}^{-1/2} v = 1 \Rightarrow v^T v = 1$$
$$a^T \Sigma_{XY} b = u^T \Sigma_{11}^{-1/2} \Sigma_{XY} \Sigma_{22}^{-1/2} v \tag{10.11}$$

That is, we can convert the optimization goal represented by formula (10.11) into the following formula:

$$\underbrace{\arg\max}_{u,v} u^T \Sigma_{11}^{1/2} \Sigma_{12} \Sigma_{22}^{1/2} v$$
$$\text{s.t.} u^T u = 1$$
$$v^T v = 1 \tag{10.12}$$

At this point, we can construct matrix K and perform singular value decomposition on matrix K to solve the above optimization problem.

$$K = \Sigma_{11}^{-\frac{1}{2}}\Sigma_{12}\Sigma_{22}^{-\frac{1}{2}} = d_1 u_1 v_1^T + d_2 u_2 v_2^T + \cdots + d_k u_k v_k^T \tag{10.13}$$

The final optimization problem is as follows:

$$\underset{u,v}{\arg\min}\|K - duv^T\|_F^2$$

$$\text{s.t. } \|u\|_2^2 = 1, \|v\|_2^2 = 1 \tag{10.14}$$

The above optimization problem can be solved by singular value decomposition (SVD). However, the traditional CCA method has over-fitting problems, especially when the feature dimension is very large. To prevent the model from over-fitting and improve the generalization ability of the model, we introduce sparse into the optimization goal of CCA. The sparse optimization problem is as follows:

$$\underset{u,v}{\arg\min}\|K - duv^T\|_F^2 + \lambda\phi(u) + \tau\psi(v)$$

$$\text{s.t. } \|u\|_2^2 = 1, \|v\|_2^2 = 1 \tag{10.15}$$

Where $\lambda\phi(u)$, $\tau\psi(v)$ are the constraint functions of v and u. Solving the above problem, the sparse projection vector can be computed.

10.6.4 EXPERIMENTAL PROCESS

The calculation process of the model is shown in Figure 10.13.

1. **Sparse CCA modeling**: Perform feature extraction and down-sampling on the music data in the model set and perform feature extraction on the EEG data to obtain the aligned music features and EEG features on the time scale. Compared with EEG features, music features are unique. And EEG features are different because of the subjects' individuation. Therefore, this method uses all subjects' EEG features to find a common projection vector. Through Sparse CCA modeling, we can get two projection vectors, so that when the music feature and EEG feature are projected in this direction, the correlation coefficient is the largest.

2. **Training**: After modeling, the projection vector can be gotten by SCCA. Extract the music features in the training set. Then, calculate the projection vector using the music feature in the training set and projection vector. Send the projection vector and emotion labels to the SVM classifier to train the SVM classifier.

3. **Testing**: Extract the music features in the testing set. Then, calculate the projection vector using the music feature in the testing set and projection vector. Send the projection vector to the trained SVM classifier for recognition.

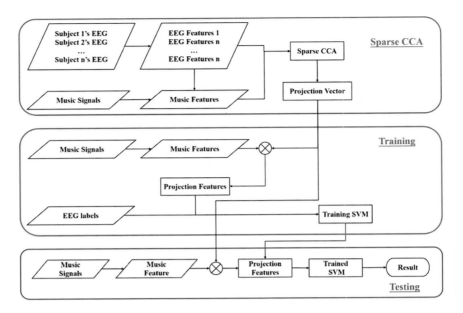

FIGURE 10.13 The calculation process of emotion recognition.

TABLE 10.3
The Experiment Results in the Self-Built Database

	Accuracy		
	Valence (%)	Arousal (%)	Valence and Arousal (%)
Original Features	87.5	81.3	68.8
PCA	87.5	87.5	62.5
Projection Features	99.0	99.0	87.5

The experiment results show that under the two-class task, whether it is based on valence or arousal, the projection feature can reach an accuracy rate of 99%. Under the four-class task, the accuracy rate has also reached 87.5%, both significantly higher than the original music features and the music features after PCA, shown in Table 10.3.

Due to the length of the experiment, only 16 music samples were used, and the experiment conclusions were not convincing. To verify our method's effectiveness and transferability, we used the projection vector calculated from 16 pieces of music in the cognitive experiment on the public dataset to verify its effect. For this experiment we use the Mediaeval Emotion in Music. It contains a total of 744 audio files. Each audio file is labeled with Arousal/Valence values.

Here, we also set up three classification tasks: a two-class classification task based on valence, a two-class classification task based on arousal, and a four-class classification task based on valence and arousal. The data distribution of different tasks is shown in Table 10.4.

TABLE 10.4

The Data Distribution of Different Tasks in Mediaeval Emotion in Music

	Low Valence	High Valence	Total
Low Arousal	287	120	407
High Arousal	72	265	337
Total	359	385	744

TABLE 10.5

The Experiment Results in the Mediaeval Emotion in Music

	Accuracy		
	Valence (%)	Arousal (%)	Valence and Arousal (%)
Original Features	82.4	79.6	67.2
PCA	75.4	74.3	60.4
Projection Features	89.3	84.7	68.6
PCA+MLP [33]	74.0	69.0	57
CNN [34]	91.1	82.5	70.4
LSTM [35]	92.5	86.7	71.1

The music feature extraction in the Mediaeval Emotion in Music dataset is the same as that in the previous experiment. Using the 16 pieces of music and corresponding EEG features in the cognitive experiment as the modeling dataset, the Mediaeval Emotion in Music dataset was divided into the training and testing sets by a five-fold cross-validation method. The SVM was also used as a classifier. The recognition results on the testing set are shown in the Table 10.5.

According to the recognition results, the accuracy rate is significantly higher than the original music features after PCA. The results indicate that some EEG information is incorporated into the music features after projection. Compared with others' research, our method works better than others that also use machine learning methods. This experimental result fully demonstrates our method is effective and transferable. Compared with deep learning methods, our approach is slightly worse than CNN and LSTM in accuracy rate. However, the number of music features used in CNN or LSTM is much higher than those used in our method. Our method is more concise when the recognition effect is similar.

10.7 CONCLUSION

The methods proposed in this chapter also have limitations. First, its mobility depends on whether the EEG data is representative. When the EEG data source has a particular emotional tendency, it will cause a deviation in the projection of the music features. Some subjects' personalized information would be introduced into the projection vector, resulting in a decline in accuracy rate. Secondly, the music features

and EEG features extracted in this chapter are limited. The influence of music features or EEG features not used in this chapter on music emotion recognition needs to be verified by experiments.

Music is when a composer expresses his thoughts and emotions to the audience through specific sound structures and melodic changes. Accurate recognition of music emotions could achieve harmonious interaction between human and machine emotions, and has excellent application prospects in various fields. For example, in daily life, real-time emotion recognition can help people adjust their emotional state in a timely manner and change their current emotional state through music, reducing accidents caused by emotional factors. In the field of medicine, exploring the cognitive patterns of human emotions is of great significance for treating emotional disorders. Understanding the relationship between music and emotion from the brain has three benefits:

1. Allows students to control musical instruments or software using their brain signals, providing a unique and interactive way to engage with music.
2. Understands individual learning styles and preferences. Tailor music instruction based on this information to optimize the learning process for each student.
3. Provides real-time feedback and stimulation techniques to monitor and regulate emotional states during music therapy sessions, which could help rehabilitate the brain in individuals with neurological conditions.

Music emotion computing is facing the challenge of high-speed information acquisition and massive data processing. It is an inevitable trend inspired by the complex and high-speed information processing mechanisms of the human brain. At the same time, with the help of powerful computing power, it could also provide a systematic scientific calculation basis for the development of cognitive science. At present, the research on music cognition is still in the initial stage. With the rapid development of brain imaging techniques and signal processing technology, research based on cognition and computation has received more and more attention with the development of cognitive science and computer science. The research on music cognition and computation is of great significance and plays an irreplaceable role in human-computer interaction systems. Through in-depth analysis, the cognitive mechanism of the brain towards acoustic features can be revealed, providing a solid foundation for music computation and creation.

REFERENCES

[1] Juslin, P.N. and D. Västfjäll, Emotional responses to music: the need to consider underlying mechanisms. *Behavioral & Brain Sciences*, 2008. 31(5): p. 559–575.
[2] Hevner, K., The affective character of the major and minor mode in music. *American Journal of Psychology*, 1935. 47(1): p. 103–118.
[3] Koelsch, S., Towards a neural basis of music-evoked emotions. *Trends in Cognitive Sciences*, 2010. 14(3): p. 131–137.
[4] Blum, K., et al., Do dopaminergic gene polymorphisms affect mesolimbic reward activation of music listening response? Therapeutic impact on Reward Deficiency Syndrome (RDS). *Medical Hypotheses*, 2010. 74(3): p. 513–520.

[5] Zatorre, R.J. and V.N. Salimpoor, From perception to pleasure: music and its neural substrates. *Proceedings of the National Academy of Sciences*, 2013. 110(supplement_2): p. 10430–10437.

[6] Partanen, E., et al., Prenatal music exposure induces long-term neural effects. *PloS one*, 2013. 8(10): p. e78946.

[7] Mao, M. and P.P. Rau, *EEG-based measurement of emotion induced by mode, rhythm, and MV of Chinese pop music*. 2014, Springer. p. 89–100.

[8] Tandle, A., et al., *Estimation of valence of emotion from musically stimulated EEG using frontal theta asymmetry*. 2016, IEEE. p. 63–68.

[9] Hu, L. and Z. Zhang, *EEG signal processing and feature extraction*. 2019: Springer.

10] Musha, T., et al., Feature extraction from EEGs associated with emotions. *Artificial Life and Robotics*, 1997. 1(1): p. 15–19.

[11] Alarcao, S.M. and M.J. Fonseca, Emotions recognition using EEG signals: a survey. *IEEE Transactions on Affective Computing*, 2017. 10(3): p. 374–393.

[12] Jenke, R., A. Peer and M. Buss, Feature extraction and selection for emotion recognition from EEG. *IEEE Transactions on Affective computing*, 2014. 5(3): p. 327–339.

[13] Frantzidis, C.A., et al., Toward emotion aware computing: an integrated approach using multichannel neurophysiological recordings and affective visual stimuli. *IEEE transactions on Information Technology in Biomedicine*, 2010. 14(3): p. 589–597.

[14] Mehmood, R.M. and H.J. Lee, EEG based emotion recognition from human brain using Hjorth parameters and SVM. *International Journal of Bio-Science and Bio-Technology*, 2015. 7(3): p. 23–32.

[15] Liu, Y. and O. Sourina, *Real-time fractal-based valence level recognition from EEG*. 2013, Springer. p. 101–120.

[16] Sourina, O. and Y. Liu, A fractal-based algorithm of emotion recognition from EEG using arousal-valence model. In *Proceedings of the International Conference on Bio-inspired Systems and Signal Processing*. 2011. p. 209–214.

[17] Petrantonakis, P.C. and L.J. Hadjileontiadis, Emotion recognition from EEG using higher order crossings. *IEEE Transactions on information Technology in Biomedicine*, 2009. 14(2): p. 186–197.

[18] Rozgi C.V., S.N. Vitaladevuni and R. Prasad, *Robust EEG emotion classification using segment level decision fusion*. 2013, IEEE. p. 1286–1290.

[19] Hosseini, S.A., et al., *Higher order spectra analysis of EEG signals in emotional stress states*. 2010, IEEE. p. 60–63.

[20] Lin, Y., et al., EEG-based emotion recognition in music listening. *IEEE Transactions on Biomedical Engineering*, 2010. 57(7): p. 1798–1806.

[21] Mohammadi, Z., J. Frounchi and M. Amiri, Wavelet-based emotion recognition system using EEG signal. *Neural Computing and Applications*, 2017. 28: p. 1985–1990.

[22] Zong, C. and M. Chetouani, *Hilbert-Huang transform based physiological signals analysis for emotion recognition*. 2009, IEEE. p. 334–339.

[23] Seo, Y.S. and J.H. Huh, Automatic emotion-based music classification for supporting intelligent IoT applications. *Electronics*, 2019. 8(2): 164.

[24] Chen, X. and S. Yang, Research progresses in music emotion recognition. *Journal of Fudan University(Natural Science)*, 2017. 56(2): 136–148.

[25] Sawata, R., T. Ogawa and M. Haseyama, Novel audio feature projection using KDLPCCA-based correlation with EEG features for favorite music classification. *IEEE Transactions on Affective Computing*, 2017. 10(3): p. 430–444.

[26] Morris, J.D., Observations: SAM: the Self-Assessment Manikin; an efficient cross-cultural measurement of emotional response. *Journal of Advertising Research*, 1995. 35(6): p. 63–68.

[27] Levy, D.A., R. Granot and S. Bentin, Processing specificity for human voice stimuli: electrophysiological evidence. *Neuroreport*, 2001. 12(12): p. 2653–2657.

[28] Kriegeskorte, N., M. Mur and P.A. Bandettini, Representational similarity analysis-connecting the branches of systems neuroscience. *Frontiers in Systems Neuroscience*, 2008: p. 4.

[29] Chen, P.A., et al., Intersubject representational similarity analysis reveals individual variations in affective experience when watching erotic movies. *NeuroImage*, 2020. 216: p. 116851.

[30] Bigdely-Shamlo, N., et al., Automated EEG mega-analysis II: cognitive aspects of event related features. *NeuroImage*, 2020. 207: p. 116054.

[31] Khanna, A., et al., Microstates in resting-state EEG: current status and future directions. *Neuroscience & Biobehavioral Reviews*, 2015. 49: p. 105–113.

[32] Michel, C.M. and T. Koenig, EEG microstates as a tool for studying the temporal dynamics of whole-brain neuronal networks: a review. *Neuroimage*, 2018. 180: p. 577–593.

[33] Medina, Y.O., J.R. Beltrán and S. Baldassarri, Emotional classification of music using neural networks with the MediaEval dataset. *Personal and Ubiquitous Computing*, 2022. 26(4): p. 1237–1249.

[34] Sarkar, R., et al., Recognition of emotion in music based on deep convolutional neural network. *Multimedia Tools and Applications*, 2020. 79: p. 765–783.

[35] Chaki, S., et al., Attentive RNNs for continuous-time emotion prediction in music clips. In *Proceedings of the 3rd Workshop of Affective Content Analysis*, 2020. p. 36–46.

11 Music Question Answering
Cognize and Perceive Music

Yun Tie and Wenhao Gao
Zhengzhou University, Zhengzhou, China

Xiaobing Li, Di Lu, and Qingwen Zhou
Central Conservatory of Music, Beijing, China

Jiessie Tie
University of Toronto, Toronto, Canada

Lin Qi
Zhengzhou University, Zhengzhou, China

11.1 INTRODUCTION

Humanity has loved music since ancient times. In China, it originated 2,500 years ago when the ≪Book of Songs≫ was divided into three different parts: ≪Feng≫, ≪Ya≫, and ≪Song≫. From the transition to the "Qing Yue stage" to the "Yan le" stage in the Tang and Song Dynasties, music and its carriers have always played an irreplaceable role in enriching people's lives. Since modern times, the development of music has shown a more diversified momentum with more and more styles, such as classical, country, jazz, hip-hop, rock, and so on. With the advent of the Internet age, the development and dissemination of music has also taken a ride. People can enjoy music anytime, anywhere on mobile phones and computers. Music streaming services have grown enormously over the past few decades. With the rapid development of artificial intelligence and deep learning technology, people have made remarkable progress in acoustics, etc., and many excellent models have emerged. The proliferation of these excellent models has greatly improved the machine's ability to process visual and language information, and promoted the rapid development of related fields.

Simultaneously, more and more researchers have studied music-related fields and made rapid progress in areas such as music creation and music emotion analysis. However, music is a kind of auditory art. As far as music itself is concerned, it can't be understood easily or seen, and it cannot directly convey semantic information.

DOI: 10.1201/9781003406273-11

Although music permeates every aspect of people's life, the general public still has obstacles in understanding music, and it is difficult for ordinary people to directly understand the information they want from music by hearing it. In terms of music content understanding, work has been slow. Although several related tasks have been put forward, these are not enough to fully cognize music.

Music automatic tagging is designed to describe the features and attributes of music through a series of labels. These labels can include instruments, styles, emotions, rhythms, and more. Music automatic tagging utilizes machine learning and computer vision techniques to analyze and process audio signals, enabling the automatic extraction and prediction of music feature labels. This approach helps people conveniently search, classify, and manage music – and also contributes to the development of music recommendation systems.

Music subtitles serve the purpose of providing a brief description or summary of the music. They are usually created manually to convey the themes, emotions, or stories of the music. Music subtitles can include lyrics, titles, and brief introductions, helping listeners better understand and experience the music composition. They are commonly used in music videos, radio broadcasts, and music performances.

This chapter therefore proposes the Music Question Answering (MQA), which combines the power of artificial intelligence and deep learning algorithms to process complex patterns and relationships within music data. It goes beyond mere annotations or descriptions by providing users with insightful and relevant answers to their queries about music. With MQA, individuals can explore the themes, genres, emotions, instruments, and other aspects of music in a more interactive and engaging manner.

The underlying technology behind MQA involves training advanced models using large-scale datasets that encompass a wide range of musical styles, compositions, and characteristics. These models can then be fine-tuned to handle specific domains or subgenres of music. Through an iterative process of training, evaluation, and refinement, the performance and accuracy of the MQA system can be continuously improved. MQA can provide better help in music content understanding and promote people's understanding and appreciation of music.

MQA has wide application potential. First of all, in the field of music research, MQA can help researchers analyze and explain complex musical structure, style evolution, and other issues. It can accelerate the acquisition and sorting of music information and provide more comprehensive and accurate reference for music scholars. Secondly, when it comes to music education, MQA can provide students with a more interactive and personalized way of learning. By asking questions to MQA, students can get information about musical compositions, backstories, playing techniques, etc., and get inspiration and guidance from them. In addition, MQA helps popularize music. For the average listener, sometimes they may be interested in the meaning, background, or track information of a particular song. MQA can provide easy access to relevant information to increase their understanding and appreciation of musical works. We hope this can be a new chapter in music cognition.

The MQA task takes music and questions as inputs to the model and predicts the corresponding answers to the questions as outputs to the model. The task aims to help people understand music by answering questions about it. When people hear a piece

of music, maybe they want to know the types of musical instruments and style, but for those who have not received professional training, it is difficult to directly find the above information from simply hearing it. For example, it's hard to tell how many instruments there are in this music.

The MQA also gives us an insight into music content. Different people have different needs for music cognition. What low music education people understand about music is mostly at a shallow level. For example, they may ask, "Does this music use the piano?" But for those who have a foundation in music theory, they tend to focus more on deeper information and ask more specific questions, such as, "How many kinds of percussion instruments are used in this music?" In order to solve these problems, we refer to the linear modulation model [1], which performs well in the field of visual question answering, and the practice of Haytham et al. [2] and propose a music cognitive understanding method based on feature linear modulation, aiming to help the model accurately predict the answers to relevant music cognitive problems. In this method, Musicnn, which is a set of pre-trained musically motivated convolutional neural networks for music audio tagging, was used to extract the main features of music information. Glove vector, which is an unsupervised learning algorithm that learns vector representations for words, was used to encode the problem, and then several auxiliary linear modulators were used to modulate the music features and text features respectively. Experiments on MQA dataset showed that the accuracy of this method was 71.13%. Compared with other methods, this model performs well and can answer the question of music cognition and understanding accurately. An example of MQA dataset is shown in Figure 11.1.

Our main contributions can be summarized as follows:

- We put forward the MQA task, which we believe can help people cognize and perceive music.
- We made the first music question answering dataset, MQA dataset, and divided it into seven categories: instrument, tempo, style, emotion, performance, language, and volume, which are some fundamental elements of the music. At the same time, according to the main source of the questions, MQA dataset divided into two categories: basic question and depth question.

Q:What style of music is it? Q:Is it sung in English?
A:Jazz. A:No.

FIGURE 11.1 Examples of MQA dataset. Given music and question, the model predicts answers.

- We tested the performance of multiple models on MQA dataset and achieved an accuracy of 71.13% on the best model Musicnn-MALiMo (spectrum, $i = 4$), which meets the requirements of MQA.

The article is organized as follows. The second section introduces the related work of MQA. The third section introduces the MQA dataset. The fourth section introduces the experimental model. The fifth section discusses experiments and results analysis. The last is the results and prospects.

11.2 RELATED WORK

In this section, we mainly introduce relevant work from two aspects, music perception and other question answering.

11.2.1 Music Perception

In recent years, researchers have made many explorations into music-related fields. Since music perception involves a wide range of knowledge in the field of music, rather than focusing only on the specific element of music emotion like music emotion analysis, we introduce the two most relevant tasks here, automatic music annotation and music captioning.

Automatic music labeling originated in the 20th century. The method used at that time mostly utilized statistics and simple mathematical methods to classify music [3]. In recent years, with the rapid development of artificial intelligence, researchers have begun using deep learning algorithms to automatically label music. Many outstanding models have been born in this field, which can be employed to represent the characteristic information of music.

Jordi et al. [4] explored the impact of two different input information on the model: one is a hypothesis-free model with a small filter, and the music is input as a wave file; the other is domain knowledge – using convolutional neural networks to learn timbre and temporal characteristics, music is input as a spectrogram. The authors experimentally demonstrate that the music domain hypothesis is relevant when insufficient training data is available, showing that waveform-based models outperform spectral-based models in large-scale data scenarios.

Harmonic CNN [5] utilizes trainable band-pass filters and harmonic stacked time-frequency representations of the input. The trainable filter brings more flexibility to the model, which is a music representation model that exploits the inherent harmonic structure of audio signals, and improves the performance of the model by treating harmonics as channels. In the past two years of work, contrastive learning has become an important method for automatic music labeling. Compared with traditional supervised methods, contrastive learning can obtain better generalized representations. Jane et al. [6] combined insights from a simple image contrastive learning framework [7] and a breakthrough in audio representation learning in the temporal domain [5] to propose a music contrastive learning framework.

We also provide a data augmentation pipeline for music audio to form an efficient framework for contrastive learning and self-supervision of representations of music raw waveforms. By comparing the representations learned by predictive encoding, the authors compare the effectiveness of this model framework with more complex self-supervised learning frameworks and evaluate them on the downstream automatic music labeling task. Christos et al. [8] proposed to use music source association as a pair generation strategy in the context of contrastive music representation learning. By modifying the contrastive loss function, information about the presence or absence of a specific source was included, so that the model could point to the selected music source. Specific features improve the training speed and performance of the model. In [9], the authors propose a new method that combines multiple types of information related to music using cross-modal contrastive learning, which enables simultaneous learning of audio features from heterogeneous data. The authors align latent representations obtained from music playlists by maximizing the coherence between these modality representations using a contrastive loss, while also investigating the importance of including multiple sources of information when training embedding models.

[10] proposed the butter model to generate music caption through the potential representation of music, but there are still many aspects to be further improved. [11] used the sequence-to-sequence model to perceive music by generating a series of labels and called them description. Obviously, this is not considered, which still belongs to music tags. [12] used audio caption to generate music caption, such as <up-beat acoustic guitar tune>. This description is too simple and involves fewer music features, which cannot help us understand music comprehensively. The most commonly used datasets are the Magna Tag a Tune (MTAT) [13] and the Million Song Dataset (MSD) [14].

11.2.2 QUESTION ANSWERING

Visual Question Answering (VQA) originated from image question answering and was first proposed by Anatol et al. in 2015 [15]. This opened the precedent for visual question answering. Since then, many researchers have begun to explore and study in this direction and have made continuous progress. At present, in the direction of visual question answering, the mainstream methods that exist mainly use deep learning networks to learn the internal relationship between input and output. According to the main characteristics of the constructed neural network, the existing visual question answering model can be divided into three categories, namely, the method based on attention mechanism, the method based on memory network, and the method based on external knowledge. These methods are also the mainstream methods for question answering tasks.

The attention mechanism is inspired by the human visual attention mechanism, and its purpose is to allocate limited computer resources to important information features, thereby improving the operating efficiency of the computer. In the visual question answering task, the models mentioned in literature [16] use the attention mechanism to effectively locate the key features in the visual and text information,

and filter and remove the key features by assigning higher attention weights to the key information. Relevant visual or textual information greatly improves the overall performance of the model.

The main idea of the method based on memory network is to design a memory storage network to store complex visual information in the form of memory. Initially, Kumar et al. [17] proposed a dynamic memory network to solve the text question answering task, which was then spread. Scholars such as Xiong [18] further expanded it and proposed a dynamic memory network for multi-modal tasks and achieved better results in image question answering.

Fan et al. [19] designed a memory storage structure for video and text questions when solving video question answering tasks. Each structure can be read and written separately, and the video information is regarded as a series of ordered events by time. When a new event occurs, the network will use the read operation to read the existing information in the memory storage structure and then combine the current information to record the information change into the memory storage structure through the write operation. Through such continuously updated read and write operations, the network can understand the entire sequence from a global perspective and improve the overall performance of the model.

The visual question answering task requires the model to answer questions related to visual information, and when the content of the question are some common-sense questions, external prior knowledge can be used to improve the question answering ability of the model [20]. An explicit triplet is proposed to represent multimodal knowledge, thereby associating visual objects and factual answers with implicit relationships. To bridge the heterogeneity gap, the authors propose three objective losses in learning triplet representations from complementary views – embedded structure, topological relations, and semantic space – by adopting pre-training and fine-tuning learning strategies to gradually build up the basics and domain-specific multimodal knowledge for predicting answers [21].

A multimodal answer verification method using external knowledge is proposed. The idea is to verify a set of possible candidate answers based on knowledge retrieval of specific answers. Unlike most existing methods, which search for answers in a large number of often unrelated facts, their goal is to learn how to extract relevant knowledge from a noisy source and be accepted by each candidate answer – and how to validate candidates using that source. [22] A new question-and-answer method based on object region knowledge is proposed, which utilizes explicit visual information of object region in both knowledge retrieval stage and answer prediction stage, uses language image association pre-training model to locate objects, and then uses object information to retrieve different types of external knowledge. Finally, these knowledge and object region visual features are integrated into a unified Transformer-based answer prediction model to predict answers, and good results are obtained.

The authors [23] utilize a novel dual-channel graph convolutional network (GCN) to better combine the advantages of visual and textual information. Different GCN networks capture relationships between different objects. This approach effectively extracts correlations between visual and textual information through

graph convolutional operations. [24] summarized the dialog in the video, and then used soft temporal attention for localization over long inputs in the process of multimodal fusion. It even outperformed human evaluators who have never watched any whole episode before. [25, 26] employ heterogeneous graphs to enhance model performance and achieve impressive experimental results. These methods utilize heterogeneous graph representations to model different types of data and relationships between them through graph convolutional operations. [27, 28] primarily focus on text-based visual question answering (VQA) tasks, which involve reasoning about text and other visual content in images to answer questions. These methods reason about both textual and visual content to accurately answer text-based questions. [2] is the closest to our work – they verified the superiority of the proposed network in temporal reasoning by making their own Diagnostic Audio Question Answering (DAQA) dataset. However, the audio files of DAQA dataset are spliced together with multiple sound files, which is obviously different from the idea of MQA. Common datasets in this field are Movie QA [29], TVQA [30], and Know ITVQA [31].

11.3 THE MUSIC QUESTION ANSWERING DATASET

In this section, we provide an overview of the MQA dataset, the first dataset designed specifically for MQA. We discuss the background behind its creation, the detailed production process, and provide a comprehensive analysis of the dataset.

11.3.1 PRODUCTION OF MQA DATASET

To realize the task of MQA, we have made MQA dataset, which is generated on the basis of MTAT [13]. MTAT is a dataset containing a large number of music and music annotation tags – it contains 25,863 music clips. Each piece of music lasts 29s. Each audio clip is supplied with a vector of binary annotations of 188 tags. To determine the main inquiry object of MQA, we referred to commonly used music analysis methods [32] and identified the music elements people often pay attention to in cognitive music analysis. By examining the music content that receives significant attention in music analysis, we combined it with the tags available in the MTAT dataset. As a result, we selected 59 tags as the principal music elements for formulating MQA questions, and these labels were manually annotated. These elements were further categorized into seven main categories: instrument, tempo, style, emotion, performance, language, and volume. Some categories also include subclasses to provide more detailed information. The number of music elements contained in each category is shown in Table 11.1.

The MQA dataset is built by extracting audio clips from different types of music. They are traditional music, rock music, blues, classical music, and pop music, so it is diverse and representative. The selection of labels is based on a comprehensive consideration of the main aspects of concern in music analysis to provide comprehensive music information in the MQA task. MQA dataset is a triplet dataset of <music, questions, answers>. The music part uses the original music part of MTAT, with a

TABLE 11.1
The Number of Music Elements Contained in Each Category

Categories	Subclasses	Number
Tempo		2
Performance		7
Volume		2
Language		6
Instrument	Percussion	4
	Wind	6
	String	8
	Keyboard	3
Emotion	Positive	2
	Negative	4
	Neutral	5
Style	Pop	9
	Classical	1

length of 29s. In the question part, there are two types of volunteers to ask questions. The first type was made up of ten music majors from Communication University of China, and the second was 20 ordinary students who had not received music training. Everyone put forward questions according to their preferences. The questions were mainly about the specific music elements or the category of music.

The process of generating answers involved matching each question with suitable music samples from the MTAT dataset and determining the answer based on the associated tags. To ensure diversity, we attempted to select music samples with fewer occurrences of the same tag. For instance, if the question was, "Does this music use the piano?" the answer would be primarily based on the presence or absence of the "piano" tag in the selected music sample. Finally, the selected questions, the matched music, and the answers determined according to the tags are retained as a set of data samples.

In the entire dataset, the range of answers considered in this chapter for counting questions is (0, 1, 2, 3), and the number of samples corresponding to different answers for each question is the same. For the question whose answer is <Yes/No>, the number of samples of different answers corresponding to the question in the dataset is the same. Different questions will appear repeatedly, but the maximum number of times each question appears is $10N$; N is the number of different answers that may correspond to the question, and each piece of music will only appear once.

At the same time, all the questions were divided into two categories: in-depth questions and basic questions, according to the difference between the main focus of the two groups of volunteers on musical elements. The questions from students without professional training mainly focus on speed, language, volume, and musical instruments. We refer to these questions as basic questions. In contrast, the questions from music majors mainly focus on style, emotion, and performance. These are

referred to as depth questions. Notably, both the category of musical instruments and the counting question belong to the depth question, such as <Are percussion instruments used in this song?> and <How many wind instruments are used in this song?>. This is because music majors also pay attention to these musical elements.

In the process of generating answers, we select appropriate music samples based on the question type and determine the answers based on relevant labels. For depth questions, the answers may be specific instrument names or quantities, while for basic questions, the answers may be descriptive information such as speed or volume. By categorizing questions into depth questions and basic questions, the MQA dataset can more comprehensively cover different types of music-related questions, thereby promoting the development and research of music question answering algorithms. This categorization also considers the differences in focus on musical elements between music majors and non-majors, making the dataset more representative and practical.

11.3.2 DATASET ANALYSIS

We generated a total of 4,350 groups of data, including 3,480 groups for training and 870 groups for testing. Figure 11.2 shows the proportion of different types of questions. Figure 11.3 is the proportion of depth questions in four categories. It can be seen from the figure that general interrogatives account for a large proportion. The longest question of all contained 11 words: <How many kinds of percussion music are used in this music?>; the shortest question contains only three words: <Is it jazzy?>. There are 2,020 in-depth questions, which are in four categories: emotion, style, performance, and instrument. The distribution of the first three words of each question is shown in Figure 11.4. The longest question, <How many kinds of percussion instruments are used in this music?>, contains 11 words, and the shortest

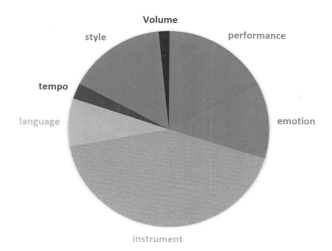

FIGURE 11.2 The proportion of different types of questions.

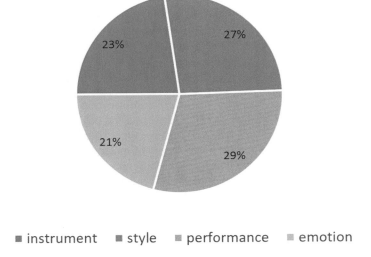

FIGURE 11.3 The proportion of depth questions in four categories.

FIGURE 11.4 The distribution of the first three words for each question.

question, <Is it jazz?>, contains only three words. There are 63 answers in total, of which <yes>, <no>, <0>, <1>, and <2> are the most frequent. Other answers are specific eigenvalues, such as <piano>, <classical music>, and <fast>. Figure 11.5 shows the frequency of each answer.

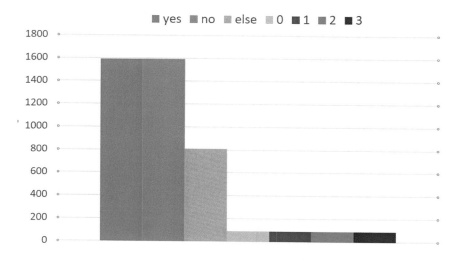

FIGURE 11.5 The frequency of each answer.

11.4 METHODOLOGY

This section mainly introduces our experimental model. The MQA task

$$\text{Music} + \text{Question} \rightarrow \text{Answer} \qquad (11.1)$$

is formulated as a multi-class classification question, and all models are trained to maximize the likelihood of the correct answer P *(Answer | Music, Question)*. We will introduce the experimental model in three parts: music feature extraction, linguistic feature extraction, and fusion processing. There is no consideration of only questions and only music.

11.4.1 CONV-LSTM

This model consists of a multi-layer convolutional network and a two-layer LSTM (Long Short-Term Memory). It is designed to extract music features and generate answers based on questions. The convolutional network plays a crucial role in extracting music features. It is composed of five convolutional blocks and two standard convolution layers. Each block consists of two convolution layers, which are followed by Batch Normalization (Batch Norm) and Rectified Linear Unit (ReLU) nonlinearity. After the second convolution layer in each block, a max pooling layer with a window size of 2 × 2 and a stride of 2 is applied. Following the convolution blocks, there are two standard volume layers with Batch Norm and ReLU activations.

Finally, a global average pooling operation is performed for each channel. To process the questions, pre-trained Glove [33] word embeddings are utilized. Each word in the question is transformed into a 300-dimensional Glove vector. These word

embeddings are then inputted into a two-layer LSTM with 512 units per layer. The LSTM layers sequentially process the word embeddings and generate a comprehensive representation of the question. Both the music features extracted by the convolutional network and the question representation generated by the LSTM are concatenated together. This combined representation is fed into a fully connected neural network with a single hidden layer consisting of 1,024 units and ReLU activations. The neural network takes this concatenated representation as input and predicts an answer based on the learned patterns and relationships between the music features and the corresponding question.

11.4.2 MUSICNN-LSTM

This module uses Musicnn [34] to extract music features. It includes two parts: front end and back end. Shared back end consists of three CNN layers (with 512 filters each and two residual connections) and two pooling layers. We removed the deny layer and the sigmoidal output. Following the original work, two front ends are used for experiments. For waveform front end, this model consists of seven layers of 1D CNN, and the number of filters in each layer is 128, 128, 128, 256, 256, 256, 512. For spectrogram front end, we retain the branch design of timbral features and temporary feature. We use 300-dimensional Glove embedding to represent linguistic features and then encode them through a two-layer LSTM with 512 units per layer. Both representations are concatenated and fed to a fully connected neural network with a single hidden layer of 1,024 units and ReLUs to predict an answer.

11.4.3 MUSICNN-MALiMO

This module can be seen in Figure 11.6. The model uses MALiMo [2] to fuse feature information. It consists of a main module and two auxiliary controllers. Each auxiliary controller contains a two-layer LSTM and a linear transformation layer. LSTM with 512 units per layer encodes the extracted features. The model uses a pre-trained Musicnn network to extract music features. Musicnn consists of two front ends and a shared back end. For the waveform front end, this model consists of seven layers of 1D CNN, and the number of filters in each layer is 128, 128, 128, 256, 256, 256, 512. For the spectral front end, we retain the branch design of timbre features and temporal features, and the shared back end includes three CNN layers and two pooling layers; each CNN layer has 512 filters and two residual connections. Passing the music through the pre-trained Musicnn, the shared back end outputs the feature vector E of the music element and inputs a two-layer LSTM to obtain the music coded representation m:

$$m = \text{LSTM}(E) \tag{11.2}$$

For the question text, each question sentence can be regarded as an ordered sequence composed of a series of English words, each word is embedded in a 300-dimensional pre-trained Glove vector, the length of the question is fixed as L, and the length of the

FIGURE 11.6 An overview of the model. We use pre-trained Musicnn to extract music features and encode the question with Glove vector. MALiMo module fuses the information and predicts the answer. The upper right shows that different colors refer to different neural network layers.

sentence smaller than L are filled with 0 to get the representation of the current question $W = \{w_i\}_{i=1}^{L}$, where w_i represents the embedding vector of the first word. This is then fed into a two-layer LSTM for encoding, producing a feature representation of the question q:

$$q = \text{LSTM}(W) \tag{11.3}$$

The model fuses feature information using a linear multi-auxiliary controller (MALiMo), which consists of a main module and two auxiliary controllers. Each auxiliary controller consists of a two-layer LSTM and a linear variation layer. Each layer of LSTM contains 512 units, which are used to generate feature representations of questions and music $\{q, m\}$. The linear variation layer maps this feature representation to modulation parameters $(\gamma(i, 1), \beta(i, 1))$ and $(\gamma(i, 2), \beta(i, 2))$, represents the number of main module Blocks. These two parameters are used to adjust the intermediate representation of the main module, and the process of obtaining the modulation parameters is expressed by the formula,

$$(\gamma, \beta) = f_i(f) \tag{11.4}$$

Among them f_i is a neural network, which is a language feature representation or a music feature representation. Each MALiMo main module consists of two linear modulation layers, where each linear modulation layer consists of a convolutional layer containing 128 3×3 filters and ReLU, followed by another containing 128 3×3 filters, Batch Norm, the convolutional layer of eigen linear modulation and ReLU, and the residual connections output from the two ReLUs accept the modulation parameters (γ, β) from the auxiliary controller. For the nth linear modulation layer, its function can be formulated as:

$$F\left(H_n^{(i)} \middle| \gamma_n^{(i)}, \beta_n^{(i)}\right) = \gamma_n^{(i)} H_n^{(i)} + \beta_n^{(i)} \tag{11.5}$$

The main module of MALiMo can then be formulated,

$$\text{MALiMo}\left(H_n^{(i)} \middle| \gamma_n^{(i,k)}, \beta_n^{(i,k)}\right) = \gamma_n^{(i,k)} H_n^{(i,k)} + \beta_n^{(i,k)} \tag{11.6}$$

In the formula, $H_n^{(i)}$ is the feature map of the front-end convolutional layer, $\left(\gamma_n^{(i,k)}, \beta_n^{(i,k)}\right)$ representing the modulation parameters from the auxiliary controller.

Two different feature representations are transformed into parameters by a linear transformation layer respectively, and then the main output is adjusted by a modulation layer. Finally, the output is fed back to a fully connected network consisting of a hidden layer with 1,024 units and ReLU, and then a SoftMax layer is used to predict the probability of each candidate answer:

$$p_i = \text{softmax}(W_i f) \tag{11.7}$$

where p_i is the probability that the ith answer is correct and W_i is a learnable parameter. Finally, the answer with the highest prediction probability is selected as the answer output.

11.5 EXPERIMENTS

The evaluation metrics are quantitative measures of the model's performance, and different metrics are selected for different types of learning tasks. Commonly used metrics for classification question answering tasks include accuracy, precision, recall, etc. Accuracy represents the model's ability to correctly answer questions. Specifically, accuracy is calculated as the number of questions correctly answered by the model divided by the total number of questions. Accuracy, also known as the accuracy rate, is an evaluation metric for the prediction results. Recall, also known as the recall rate, refers to the proportion of the number of correctly classified positive samples to the number of true positive samples. In classification question answering tasks, accuracy is one of the most commonly used evaluation metrics. It measures the model's ability to accurately answer questions and is an important performance metric. A higher accuracy indicates that the model's answers are more accurate and reliable. Calculating accuracy is straightforward – simply divide the number of questions correctly answered by the model by the total number of questions to obtain the accuracy rate.

Recall is also a commonly used evaluation metric in classification question answering tasks. It focuses on the model's ability to identify true positive samples. A higher recall indicates that the model can better identify positive samples and has good recall capability. Recall is calculated by dividing the number of correctly classified positive samples by the number of true positive samples. These evaluation metrics are applied in classification question answering tasks to objectively measure the model's performance, verify its ability to accurately answer questions, and identify positive samples. By analyzing these evaluation metrics, the quality of the model can be assessed, and targeted improvements and optimizations can be made.

In this chapter, all models use accuracy to evaluate performance. The calculation formula is as follow:

$$\text{Accuracy} = T/A \tag{11.4}$$

where T represents the number of correct questions predicted by the model, and A represents the number of all questions in this test.

During the experiment, the music preprocessing is conducted in the following manner. If the model employs a convolutional network to extract music features, each music segment is divided into frames of 25 ms duration with a step of 10 ms. A Hamming window is then applied to each frame to reduce spectral leakage. From each frame, 64 log-Mel Frequency Spectral Coefficients (MFSCs) are extracted. These coefficients represent the distribution of frequencies in the audio signal and provide valuable information for music analysis. In the case of using Musicnn, a pretrained model is utilized, which has been trained on the entire MTAT (Music and Audio Tags) dataset. This dataset consists of a large collection of annotated music

tracks, making it a suitable choice for pre-training the Musicnn model. By training on a diverse set of music data, the model can learn general music representations that could be applicable to various music-related tasks.

To optimize the model's performance, the Adam optimizer is employed, as described in reference [35]. Adam is an adaptive optimization algorithm that combines the benefits of both AdaGrad and RMSProp. It dynamically adjusts the learning rate for each parameter during training, which can lead to faster convergence and better optimization results. The initial learning rate for the Adam optimizer is set to 10^{-4}, but it may be adjusted based on specific requirements or empirical findings. Furthermore, several general training strategies are applied to enhance the overall performance of the model. Early stopping is implemented, which monitors the model's performance on a validation set during training. If the model's performance stops improving or starts deteriorating, training is halted early to prevent overfitting and save computational resources.

In addition to early stopping, learning rate warming up is utilized. This strategy involves gradually increasing the learning rate at the beginning of training to help the model escape from potential local minima and promote faster convergence. By starting with a smaller learning rate and gradually increasing it, the model can explore the parameter space more effectively. These preprocessing steps and training strategies are employed to ensure that the music data is properly prepared for analysis and to optimize the model's performance. The combination of frame-based feature extraction, pre-trained models, appropriate optimization techniques, and general training strategies contributes to the effectiveness and efficiency of the music processing experiment.

Based on the model configuration proposed in Section 11.4, we conducted experiments on the MQA dataset and obtained the following results. Table 11.2 shows that Musicnn-MALiMo achieved the best experimental performance. In general, the Conv-LSTM model performed poorly with only 37.47% accuracy. However, after incorporating Musicnn to extract music features, the model's performance significantly improved, indicating that Musicnn is reliable in extracting music features compared to Conv. We also observed that the spectrogram front end outperformed the other front end of Musicnn. This can be attributed to the structure of using two branches in the spectrogram front end.

The addition of the MALiMo module resulted in less improvement in the model's performance. We hypothesize that this is because there are few questions in the dataset that require fusion reasoning on features. By classifying questions based on the type of answer, we found that the Yes/No category had the highest accuracy in each model. This is because for general interrogative sentences, the entire model can be treated as a binary classifier.

The Else class, which includes specific element-related answers, was most affected by the inclusion of Musicnn. The accuracy of answering such questions depends heavily on the music feature extraction ability of the network. After adding the MALiMo module, the Count class exhibited the most significant improvement in accuracy. This suggests that compared to the other two question types, this category requires a higher level of reasoning ability from the model. In conclusion, our experiments demonstrate that Musicnn-MALiMo performs best on the MQA dataset.

The incorporation of Musicnn enhances the model's music feature extraction capabilities, particularly with the use of the spectrogram front end. The MALiMo module contributes to improved accuracy, especially in reasoning-based questions. Our findings contribute to a better understanding of the performance and implications of different models on the MQA task.

In the process of the Musicnn-MALiMo model experiment, this chapter also counts the model effect corresponding to the number of different MALiMo modules and the parameters of the model as a whole, and the results are shown in Table 11.3. It can be seen that as the number of MALiMo modules increases, the accuracy of the model to answer questions increases. For the waveform front end, the most obvious improvement is 5.04% when $i = 1$; for the spectrum front end, the most obvious improvement is 5.68% when $i = 2$. At the same time, the parameter quantity of the whole model is also increasing. On the basis of $i = 1$, each additional MALiMo module will bring about 0.86 M parameter quantity to the whole model. But when $i > 2$, adding a MALiMo module brings little improvement to the model. When $i = 4$, the improvement effect of the waveform front end is only 0.04%, and the improvement effect of the spectrum front end is only 0.12%. Therefore, considering the comprehensive analysis, the performance of using two MALiMo is the best, so in Tables 11.2 and 11.4, use two MALiMo modules to test.

In order to discuss the effects of different models on depth question, we made statistics from the results. As can be seen in Figure 11.7, the contribution of MALiMo module to depth question is quite significant. For different front ends, it has increased

TABLE 11.2
Performance of Different Models

Methods	Yes/No	Count	Else	All%
Conv-LSTM	43.36	22.7	10.2	37.47
Musicnn-LSTM (Waveform)	63.32	31.25	42.23	59.49
Musicnn-LSTM (Spectrogram)	65.25	31.42	47.68	61.69
Musicnn-MALiMo (Waveform, $i = 2$)	68.26	47.25	53.73	60.7
Musicnn-MALiMo (Spectrogram, $i = 2$)	72.3	48.63	57.56	70.65

TABLE 11.3
The Effect and Overall Parameter Amount Corresponding to the Number of Modules

Number of Modules	Waveform Front-End	Number of Waveform Front-End Parameters	Spectrum Front-End	Number of Spectrum Front-End Parameters
$i = 0$	59.49	8.35M	61.69	8.95M
$i = 1$	64.53	10.76M	64.97	11.36M
$i = 2$	66.7	11.62M	70.65	12.22M
$i = 3$	66.83	12.48M	71.01	13.08M
$i = 4$	66.87	13.34M	71.13	13.94M

TABLE 11.4

Musicnn-MALiMo (Spectrogram, i = 2)'s Performance on Different Categories of Questions

Categories	Accuracy %
Instrument	74.59
Emotion	63.66
Tempo	70.21
Style	58.23
Permeance	68.75
Volume	69.92
Language	68.93
All	70.65

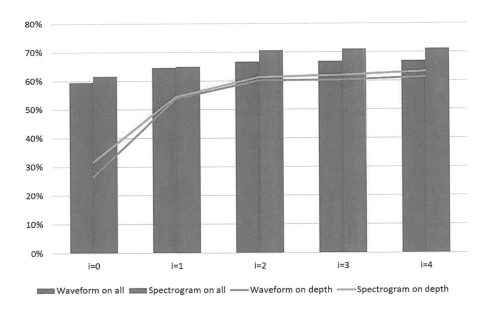

FIGURE 11.7 Performance of different models on depth questions.

by 27.35% and 22.84%, respectively. However, with the increase of the number of MALiMo, its effect on depth question is not obvious, and its effect on all questions is also not obvious. We think this is caused by the small dataset, which will also be the focus of our work in the next step. Under Musicnn-MALiMo (spectrum, i = 2), we also counted the experimental effects under different classifications, as shown in Table 11.4. The model has good experimental results in instrument (74.59%), tempo (70.21%), and volume (69.92%), but poor performance in style (58.23%) and emotion (63.66%). Our best model (Spectrogram, i = 4) obtained 71.13% accuracy, which met the requirements of MQA task.

11.6 CONCLUSION AND PROSPECT

Music is a form of auditory art that cannot be directly understood, and it does not convey semantic information. In order to enhance people's understanding of music and improve music comprehension, we have introduced the Music Question Answering (MQA) task, which takes music and questions as inputs and predicts answers as outputs. This can help people understand what the music contains, such as the instrument, tempo, emotion, and so on. We also developed the first music quiz dataset based on the MTAT dataset. This dataset includes not only simple questions but also deeper questions, requiring the model to possess both basic question answering ability and reasoning skills for addressing complex inquiries.

To tackle these challenges, our model draws inspiration from the Multiple Auxiliary Controllers for Linear Modulation (MALiMo) approach. Additionally, we conduct comparative experiments using different network models to evaluate the performance of the MQA task. The results indicate that the Musicnn-MALiMo model (with spectrum, $i = 4$) achieves the highest performance (71.13%), meeting the fundamental requirements of the MQA task. We also analyze the ability of the MALiMo module in handling deep questions and the accuracy of different question types under similar circumstances. In future work, we will focus on developing more comprehensive datasets and improving the music feature extraction networks.

In conclusion, Music Question Answering (MQA) is an innovative approach that holds great promise for advancing music content understanding. By leveraging AI and deep learning techniques, MQA aims to create a more interactive and personalized way of learning music. With its potential to revolutionize music research, education, and various industries, MQA opens new avenues for exploring and appreciating the rich world of music. We encourage broader participation in this task and hope to advance the field of music comprehension.

REFERENCES

[1] Perez E, Strub F, Vries H D, Dumoulin V, & Courville A C, FiLM: Visual reasoning with a general conditioning layer. *AAAI Conference on Artificial Intelligence*, 2017.
[2] Fayek H M, Johnson J, Temporal reasoning via audio question answering. *IEEE/ACM Transactions on Audio, Speech, and Language Processing*, 2020, 28: 2283–2294.
[3] Tzanetakis G, Cook P, Musical genre classification of audio signals. *IEEE Transactions on Speech and Audio Processing*, 2002, 10(5): 293–302.
[4] Pons J, Nieto O, Prockup M, et al., End-to-end learning for music audio tagging at scale. arXiv preprint arXiv:1711.02520, 2017.
[5] Lee J, Park J, Kim K L, et al., SampleCNN: End-to-end deep convolutional neural networks using very small filters for music classification. *Applied Sciences*, 2018, 8(1): 150.
[6] Spijkervet J, Burgoyne J A, Contrastive learning of musical representations. arXiv preprint arXiv:2103.09410, 2021.
[7] Chen T, Kornblith S, Norouzi M, et al., A simple framework for contrastive learning of visual representations. *International Conference on Machine Learning*. PMLR, 2020: 1597–1607.
[8] Garoufis C, Zlatintsi A, Maragos P, Multi-source contrastive learning from musical audio. arXiv preprint arXiv:2302.07077, 2023.

[9] Ferraro A, Favory X, Drossos K, et al., Enriched music representations with multiple cross-modal contrastive learning. *IEEE Signal Processing Letters*, 2021, 28: 733–737.

[10] Yixiao Zhang, Ziyu Wang, Dingsu Wang, and Gus Xia, Butter: A representation learning framework for bi-directional music-sentence retrieval and generation. *Proceedings of the 1st workshop on NLP for music and audio (nlp4musa)*, 2020, pp. 54–58.

[11] Tian Cai, Mandel M I, and He D, Music auto-tagging as captioning. *Proceedings of the 1st Workshop on NLP for Music and Audio (NLP4MusA)*, 2020, pp. 67–72.

[12] Manco I, Benetos E, Quinton E, and Fazekas G, Muscaps: Generating captions for music audio. *2021 International Joint Conference on Neural Networks (IJCNN)*. IEEE, 2021, pp. 1–8.

[13] Law E, West K, Mandel M I, Bay M, and Stephen Downie J, Evaluation of algorithms using games: The case of music tagging. *ISMIR*, 2009: 387–392.

[14] Bertin-Mahieux T, Ellis D P, Whitman B, & Lamere P, The Million Song Dataset. *International Society for Music Information Retrieval Conference*, 2011.

[15] Antol S, Agrawal A, Lu J, et al., VQA: Visual question answering. *Proceedings of the IEEE International Conference on Computer Vision*, 2015: 2425–2433.

[16] Jang Y, Song Y, Yu Y, et al., Tgif-qa: Toward spatio-temporal reasoning in visual question answering. *Proceedings of the IEEE Conference on Computer Vision and Pattern Recognition*, 2017: 2758–2766.

[17] Kumar A, Irsoy O, Ondruska P, et al., Ask me anything: Dynamic memory networks for natural language processing. *International Conference on Machine Learning*. PMLR, 2016: 1378–1387.

[18] Xiong C, Merity S, Socher R, Dynamic memory networks for visual and textual question answering. *International Conference on Machine Learning*. PMLR, 2016: 2397–2406.

[19] Fan C, Zhang X, Zhang S, et al., Heterogeneous memory enhanced multimodal attention model for video question answering. *Proceedings of the IEEE/CVF Conference on Computer Vision and Pattern Recognition*, 2019: 1999–2007.

[20] Ding Y, Yu J, Liu B, et al., Mukea: Multimodal knowledge extraction and accumulation for knowledge-based visual question answering. *Proceedings of the IEEE/CVF Conference on Computer Vision and Pattern Recognition*, 2022: 5089–5098.

[21] Wu J, Lu J, Sabharwal A, et al., Multi-modal answer validation for knowledge-based VQA. *Proceedings of the AAAI Conference on Artificial Intelligence*, 2022, 36(3): 2712–2721.

[22] Lin Y, Xie Y, Chen D, et al., Revive: Regional visual representation matters in knowledge-based visual question answering. arXiv preprint arXiv:2206.01201, 2022.

[23] Qingbao Huang, Jielong Wei, Yi Cai, Changmeng Zheng, Junying Chen, Ho-Fung Leung, and Qing Li, Aligned dual channel graph convolutional network for visual question answering. *Proceedings of the 58th Annual Meeting of the Association for Computational Linguistics*, 2020, pp. 7166–7176.

[24] Engin D, Schnitzler F, Ngoc QK Duong and Avrithis Y, On the hidden treasure of dialog in video question answering., *Proceedings of the IEEE/CVF International Conference on Computer Vision*, 2021: 2064–2073.

[25] Park Jungin, Lee Jiyoung, and Sohn Kwanghoon, Bridge to answer: Structure-aware graph interaction network for video question answering. *Proceedings of the IEEE/CVF Conference on Computer Vision and Pattern Recognition*, 2021: 15526–15535.

[26] Jiang Pin and Han Yahong, Reasoning with heterogeneous graph alignment for video question answering. *Proceedings of the AAAI Conference on Artificial Intelligence*, 2020: vol. 34, pp. 11109–11116.

[27] Wang Xinyu, Liu Yuliang, Shen Chunhua, ChetNg Chun, Luo Canjie, Jin Lianwen, Chan Chee Seng, van den Hengel Anton, and Wang Liangwei, On the general value of evidence, and bilingual scene-text visual question answering. *Proceedings of the IEEE/CVF Conference on Computer Vision and Pattern Recognition*, 2020: 10126–10135.

[28] Singh A, Natarajan V, Shah M, Yu Jiang, Xinlei Chen, Batra D, Parikh D, and Rohrbach M, Towards VQA models that can read. *Proceedings of the IEEE/CVF Conference on Computer Vision and Pattern Recognition*, 2019: 8317–8326.

[29] Tapaswi M, Yukun Zhu, Stiefelhagen R, Torralba A, Urtasun R, and Fidler S, Movieqa: Understanding stories in movies through question-answering. *Proceedings of the IEEE Conference on Computer Vision and Pattern Recognition*, 2016: 4631–4640.

[30] Lei Jie, Yu Licheng, Bansal Mohit, and Berg Tamara L, Tvqa: Localized, compositional video question answering, arXiv preprint arXiv:1809.01696, 2018.

[31] Garcia N, Otani M, Chenhui Chu, and Yuta Nakashima, Knowit vqa: Answering knowledge-based questions about videos. *Proceedings of the AAAI Conference on Artificial Intelligence*, 2020, 34: 10826–10834.

[32] Nicholas Cook, *A guide to musical analysis*, Oxford University Press, USA, 1994.

[33] Pennington J, Socher R, and Manning C D, Glove: Global vectors for word representation. *Proceedings of the 2014 Conference on Empirical Methods in Natural Language Processing (EMNLP)*, 2014: 1532–1543.

[34] Pons J, Nieto O, Prockup M, Schmidt E, Ehmann A, and Serra X, End-to-end learning for music audio tagging at scale. arXiv preprint arXiv:1711.02520, 2017.

[35] Bahdanau D, Kyunghyun Cho, and Yoshua Bengio, Neural machine translation by jointly learning to align and translate, arXiv preprint arXiv:1409.0473, 2014.

12 Emotional Quality Evaluation for Generated Music

Wei Zhong
Communication University of China, Beijing, China

Hongfei Wang and Lin Ma
Communication University of China, Ministry of Education, Beijing, China

Long Ye and Qin Zhang
Communication University of China, Beijing, China

12.1 BACKGROUND

Music is a universal language that has the ability to evoke emotions in human beings. From the earliest forms of music to the modern era, music has been used to convey a range of emotions such as happiness, sadness, anger, love, and peace. Music expresses emotions in a unique way, such as melodic ups and downs, rhythmic leaps, different styles of timbres, and intricate structural interweaving. The same melody with different harmonic accompaniment, different rhythmic changes, gives the music multiple emotional connotations.

With the advancement of technology, computers can now compose music with the help of machine learning algorithms. These algorithms can generate music that is pleasing to the ear, but the question remains: can they generate music that evokes emotions? One way to evaluate the emotional quality of machine-generated music is through subjective evaluation by human listeners. However, the subjectivity of this method limits its effectiveness and consistency.

In addition to the subjectivity of listener scoring, there are other challenges in evaluating the quality of generated music. One such challenge is the lack of a standardized measurement scale for evaluating the emotional quality of music. Another challenge is the difficulty in capturing the nuances of different emotional states in music.

To address these challenges, objective evaluation methods have been introduced in the field of emotional music generation, which can measure various dimensions of generated music such as melody, harmony, rhythm, and timbre, and provide a quantitative assessment of these dimensions. One of the advantages of objective evaluation

DOI: 10.1201/9781003406273-12

methods is that they provide a more consistent evaluation of the quality of generated music. They can also provide a more comprehensive assessment of the emotional quality of music by capturing the nuances of different emotional states in music. Another advantage is that they can provide a more objective assessment of the quality of generated music by removing the subjectivity of listener scoring.

In conclusion, music is an art form that can evoke emotions in human beings. The quality evaluation of machine-generated music is an important research area in the field of emotional music generation. The use of objective evaluation methods can provide a more consistent and comprehensive assessment of the emotional quality of machine-generated music and address the limitations of subjective evaluation methods.

12.2 MUSIC GENERATION METHODS

The field of machine composition has undergone tremendous progress in recent years. Thanks to the rapid development of Artificial Intelligence (AI), researchers have begun to explore the potential of using music information to create high-quality music. Meanwhile, a variety of modeling approaches has been derived to achieve high-quality music generation.

The existing modeling approaches can be broadly classified into three main categories: structural-property-based models [1–7], psychology-based models [8–17], and data-driven models [18–26]. The structural-property-based models are based on the principles of music theory and use mathematical algorithms to generate music that adheres to those principles. The psychology-based models are based on the idea that music is a powerful emotional medium, and they attempt to generate music that elicits specific emotional responses in listeners. The core idea behind data-driven models is to learn and reconstruct the input music samples for generating music with similar realism as the input data.

12.2.1 STRUCTURAL-PROPERTY-BASED APPROACH

Instead of focusing on the "perception of the human brain", the core idea of the music generation approach is to analyze the structural properties of music, such as melody and rhythm, and model them to generate the corresponding sounds [27].

For the music generation methods based on music theories [1–7], researchers use structural properties of music such as melody, rhythm, and pitch for modeling and simulation. This approach contains two main implementations. One is to directly model the structural properties of music, such as melody generation algorithms [1–3], to automatically learn to generate melodies. The other is to construct music generation models based on structural properties [4–7], such as generating models by extracting melodies as conditional embeddings. However, the existing music generation algorithms based on structural properties are mostly automatic and lack interaction with users, not supporting modifying or regenerating music fragments. As a result, the composers often need repeated revisions to complete a piece of music before they can get the final work.

12.2.2 Psychology-Based Approach

The psychology-based music generation approach [8–17] explores "the way the human brain perceives sound" and constructs music fragments similar to the perception of real music so as to generate music with the authenticity of human ear perception.

Through the analysis of music fragments, researchers have proposed modeling approaches based on perceptual information, such as emotional music generation models [8–11], music generation models for different genres [12–14], and music stylization models [15–17]. However, the empirical formulas of such psychology-based music generation models are often difficult to make precise construction, too dependent on researchers' personal experience, and easy to ignore the connection between the structural characteristics of music itself and information representation. And thus, how to design generative models that combine music characteristics is an important research direction of current psychology-based music generation methods.

12.2.3 Data-Driven Approach

The core idea of the data-driven music generation methods [18–26] is to learn and reconstruct the input music samples to generate music with similar realistic perception to the input data. Since the data-driven method no longer requires complex model calculations for generating music, or constructing accurate models similar to human brain perception, it has obvious advantages in terms of algorithmic efficiency and musical realism. Researchers have successfully generated music for a variety of instruments such as piano pieces [18–21], violin pieces [22–24], and drum pieces [25, 26], and have achieved good results in audio quality.

With the development of deep learning, DeepMind proposed WaveNet structure [28], which extracts data by point-by-point sampling and applies to the original waveform generation of speech and music. DeepMind also proposed two generation models, Parallel WaveNet [29] and WaveRNN [30], further improving the computational and generation efficiency. As a representative generative model, the C-RNN-GAN was proposed by Mogren [31], which constructs the RNN-based generator and discriminator to generate classical piano music in MIDI format by processing continuous data representations with RNNs.

In 2020, OpenAI Lab pioneered a machine learning framework JukeBox [32] for automatic music generation, which uses the convolutional neural networks (CNN) [33] to encode the original audio samples and a vector quantization variational auto-encoder (VQ-VAE) [34] to compress the music into discrete space to generate music in different genres, such as hip-hop, rock, heavy metal, etc. With the ability to process discrete sequences, the structure of transformer variants has also achieved excellent results in the field of music generation. Amazon proposed Transformer-GAN [35] to allow discrete sequences to be optimized in GANs, which uses a pre-trained Span-BERT model for the discriminator of GAN and designs the Gumbel-Softmax trick to obtain a differentiable approximation of the sampling process.

12.3 EMOTIONAL MUSIC GENERATION METHODS

12.3.1 REPRESENTATIVE EMOTION MODEL

Constructing music generation models based on emotion information is one of the key techniques in psychological modeling. There are two main categories of emotion models in the existing research works: discrete models [36] and continuous models [37].

A representative of discrete models is the Hevner music emotion model [36], which is a ring model consisting of eight emotion categories that represent human emotions through more typical adjectives, as shown in Figure 12.1(a). Each of these sectors represents an emotion category, and there is a progressive transformation relationship between adjacent categories. The main representative of the continuous music emotion model is the Russell model [37], which is based on two dimensions of arousal and valence to describe emotions. Valence represents different levels of responses between negative and positive, and is closely related to many responses such as the individual's physiological functioning and cognitive activity in the brain. Arousal represents subjective emotional responses at different levels from relaxation to tension. In the Russell model as shown in Figure 12.1(b), the music emotions are divided into four categories of labels according to the above two dimensions, corresponding to four different dimensions of emotions Q1, Q2, Q3, and Q4.

In recent years, most of the works related to emotional music generation have used the Russell model of musical emotion [37] as the basis for data annotation, in which the generation tasks containing two kinds of labels and four kinds of labels have been derived, respectively. The emotion music generation model proposed in [38] uses the emotion labels Q1 (high arousal-high valence), Q2 (low arousal-high valence), Q3 (high arousal-low valence), and Q4 (low arousal-low valence) to represent the coordinates of Russell emotion model, as shown in Figure 12.1(b).

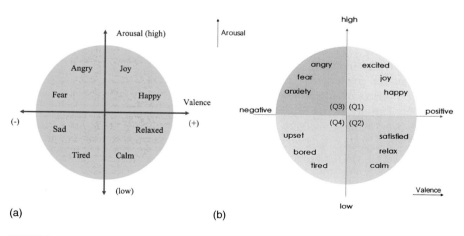

FIGURE 12.1 Music emotion models. (a) Hevner emotion model [36]. (b) Russell emotion model [37].

In summary, since the continuous music emotion model is more likely to reflect the state classification of individual emotions, this section will focus on the research related to the generation and recognition of emotional music based on the Russell emotion model.

12.3.2 Current Emotional Music Generation Networks

The emotional music generation networks are a type of AI model designed to create music that conveys specific emotions to the listener. The goal of these networks is to generate music that not only sounds good but also evokes a desired emotional response in the listener, such as happiness, sadness, or relaxation.

One of the key challenges in developing emotional music generation networks is identifying the features of music most closely associated with specific emotions. Researchers have identified a number of different features commonly used to describe the emotional content of music, such as tempo, pitch, and timbre. These features can be measured and analyzed using a variety of techniques, such as spectral analysis and machine learning algorithms.

The emotional music generation networks are typically trained using large datasets of music labeled with emotional tags or descriptors. These datasets can teach the network how to recognize and reproduce specific emotional characteristics in music. For example, the network might be trained to recognize the differences between the music that is sad and the music that is happy, and then use this knowledge to generate new music that conveys the desired emotional tone.

Early studies on emotional music generation are relatively few, and the types of emotions are relatively simple. As music generation technologies matured, the researchers no longer focused on improving the sound quality, but instead focused on making machines learn the interactive perceptual information that music itself conveys to listeners and constructing music generation models based on perceptual information so as to restore listeners' real feelings.

Several different types of emotional music generation networks have been developed, each with their own strengths and weaknesses. Some networks are based on traditional machine learning algorithms, while others use more advanced deep learning techniques such as CNNs and RNNs. These models can be trained on a wide range of musical genres and styles, from classical to pop to jazz, and used to generate music for a variety of different applications.

In 2020, Ferreira et al. [39] first proposed an emotional music generation model based on deep learning methods, breaking the research gap in this direction. This model used the Russell emotion model as the basis for constructing an emotional music dataset in MIDI format, named VGMIDI, which contains both positive and negative emotion tags. Referring to the emotion text generation method proposed by Radford et al. [40], the literature [41] also constructed an emotion music generation network based on a multi-layer LSTM network, combined a logistic regression network to construct a music emotion analysis model, and used a genetic algorithm to optimize the weight parameters of the emotion music analysis model. In 2021, the Huang's team at National Taiwan University embedded the emotion labels into residual convolutional network and constructed a four-category emotion music generation

model based on the Russell emotion model as well. This work presented the first emotion music dataset of EMOPIA [41] based on the popular music tracks, which contains two audio formats of Audio and MIDI, and can be applied to both emotion music generation tasks and emotion music analysis tasks.

Despite the advances that have been made in the field of emotional music generation networks, many challenges still need to be overcome. One challenge is developing models able to capture the complex and often subtle emotional nuances present in music. Another challenge is finding ways to evaluate the emotional content of the generated music objectively, as the subjective evaluations can be influenced by a wide range of factors such as personal preferences and cultural background.

In summary, the deep learning-based music generation methods provide a new way of thinking for emotional music generation. These methods realize the construction of emotion music generation models with embedded emotion tags and use subjective evaluation with the respective emotion analysis models as evaluation indexes. At present, the task of emotion music generation is still in the early stage of exploration, and most of the existing works only focus on the mapping relationship between music and emotion tags. Due to the higher complexity and diversity of emotional expressions in music, it is often more challenging to learn the quality evaluation between music and emotional expressions. In the next section, we focus on the current state of quality evaluation of generated music and further present our proposed objective quality evaluation method based on the emotion recognition model.

12.4 QUALITY EVALUATION OF EMOTIONAL MUSIC GENERATION

The quality evaluation of generated music is mainly divided into subjective and objective evaluation, and the existing methods are mainly subjective, while the development of objective methods is still in the initial stage.

How to evaluate the emotion perception of generated music efficiently and accurately is one of the key elements to improve the robustness of the model. In such a context, the research on the evaluation of generated music oriented to emotion perception has received widespread attention from academia and industry.

12.4.1 SUBJECTIVE QUALITY EVALUATION

The subjective quality evaluation methods in emotional music generation are used to assess the emotional response of human listeners to the generated music. These methods rely on human subjects to evaluate and rate the emotional qualities of the music based on their own perceptions and feelings.

There are various subjective quality evaluation methods used in the emotional music generation research. One of the most commonly used methods is the self-assessment manikin (SAM) technique, which involves using graphical figures to represent different levels of valence, arousal, and dominance.

Another type of method is the use of questionnaires and surveys to gather feedback from listeners. These questionnaires can include open-ended questions, Likert

scales, semantic differential scales, or other rating systems to assess the emotional response to the generated music.

The goal of using subjective quality evaluation methods is to assess the effectiveness of the music generation algorithms in eliciting the desired emotional responses in human listeners. By analyzing the feedback obtained from these methods, researchers can identify the strengths and weaknesses of the algorithm and make improvements to enhance the emotional expressiveness of the generated music.

The subjective quality evaluation methods are essential tools in emotional music generation, as they allow for the evaluation of the emotional impact of the generated music on human listeners, providing insights into the effectiveness of the algorithm and potential areas for improvement.

12.4.2 OBJECTIVE QUALITY EVALUATION

The evaluation criteria for machine composition are currently dominated by subjective and objective evaluations. The subjective evaluation methods, such as surveys and questionnaires, are widely used to assess the emotional response of listeners to generated music. However, they have several limitations, including subjectivity bias, variability between listeners, and difficulty in replicating results.

To address these limitations, the objective evaluation methods have been introduced in emotional music generation. These methods use computational techniques to analyze objective features of generated music, such as pitch, tempo, and harmony, to assess the emotional content. The objective evaluation methods have several advantages over subjective ones, including the objectivity, consistency, and reproducibility of the results. In addition, the objective evaluation methods can be used to complement the subjective evaluations, providing a more complete understanding of the emotional content of generated music. By combining the subjective and objective evaluation methods, researchers can improve the accuracy and reliability of their evaluations and ultimately improve the quality of generated music.

Since the emotion expressed by music is the core of music, how to measure the emotional dimension in music generation becomes a key issue. There are two ways of objective quality evaluation for emotional music: direct and indirect. The first one can indirectly detect the emotional response of music to the subject by using physiological signals such as brain waves [42, 43], skin electricity, and facial electromyography. The second one directly extracts and analyzes the features of music fragments by analyzing the emotional changes of music, avoiding the collection of personal information of the subject. The way of acquiring signals such as EEG usually requires a lot of human and equipment resources, having limitations in the selection of subjects and being time-consuming. In contrast, the direct analysis of audio features is not limited by subjects' privacy, psychological factors, environmental factors, etc. It can obtain a network model with high universality by training a large amount of data and establish a mapping between audio features and emotional information in a short period of time to obtain accurate music emotion information.

The key to the task of music emotion analysis lies in how to make the model learn the connection between audio features and music emotion expressions autonomously.

In recent years, the research works related to music emotion analysis have been divided into three main categories: pure music emotion analysis models [38], music emotion analysis models combining the semantics of lyrics [44–46], and multi-label music emotion analysis models [47, 48]. The pure music emotion analysis models are mainly applied to the emotion analysis of instrumental tracks, such as piano pieces, violin pieces, pop accompaniment, etc. This method is modeled by intercepting music fragments and extracting the corresponding audio characteristics. The music emotion analysis models combined with the semantics of lyrics need not only to consider the transformation of music piece, but also to understand the emotion expressed by the text. This kind of work achieves music emotion analysis by fusing music features with semantic information modeling. The multi-label music emotion analysis models no longer focus on the transformation of the music itself, but concentrate on local or overall tagging information such as singer, gender, rhythm, song style, and other basic information of the music, and analyze the statistical correlations between the data.

12.5 OBJECTIVE QUALITY EVALUATION FOR GENERATED EMOTIONAL MUSIC BASED ON EMOTION RECOGNITION MODEL

In this section, we propose a new objective evaluation approach for the evaluation of emotion quality of the generated music.

12.5.1 PROPOSED FRAMEWORK

In this subsection, we propose to evaluate the quality of emotional music generation from the perspective of emotion recognition. In the proposed method as shown in Figure 12.2, we firstly use the statistical chi-square test and Pearson correlation

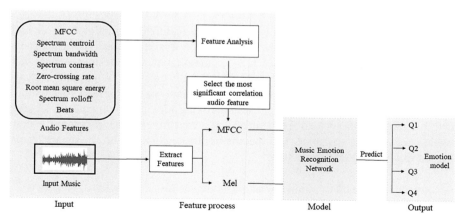

FIGURE 12.2 Framework of the proposed emotional quality evaluation algorithm for generated music.

coefficient to analyze the correlation between different audio features and emotion categories. And then for feature extraction, the audio features with most significant correlation are picked out and fused together with the Mel spectrum to send to the constructed network. Finally, we build a residual convolution network to predict the emotion category of the generated music, realizing the purpose of emotion quality evaluation.

12.5.2 FEATURE SELECTION

In the traditional emotional music evaluation methods, the emotion of music is often evaluated through the statistical feature analysis. The commonly used statistical analysis methods include descriptive statistics, hypothesis testing, cluster analysis, and regression analysis. Among them, the descriptive statistics and hypothesis testing methods directly calculate the statistical values of samples to measure the correlation between variables, while the cluster analysis and regression analysis often use a large number of sample data for modeling to explore their correlations. Combined with the quality evaluation task of emotional music generation, it is more appropriate to directly use descriptive statistics and hypothesis testing methods to analyze the statistical values of audio samples, measuring the correlations between audio features and emotional categories.

The above statistical analysis methods are not only easy to understand and implement, but also do not require parameter estimation and training process – and additionally, can be used for feature analysis process in multi-categorization problems, such as music emotion analysis, genre identification, and other sparse labeling tasks. Around the task of evaluating the quality of emotion music generation, the chi-square test can be used to discern the correlation between audio features and emotion categories, while the Pearson correlation coefficient can calculate the magnitude of the correlation between them.

12.5.2.1 Analysis of Emotional Music Features Based on Chi-Square Test

In order to explore the correlation between audio features of emotional music and emotional categories, the chi-square test is used in this section as one of the tools for emotional music feature analysis. It is a common hypothesis testing method that measures the correlation between variables by directly calculating the statistical values of the samples and is often used for correlation analysis comparing two and more samples with categorical variables. The underlying idea is to compare the degree of fit between the theoretical frequencies and actual frequencies to obtain the correlation between the variables. The specific implementation of the chi-square test is divided into the following five steps:

1. Assuming the distribution law of the aggregate X is P when the aggregate is discrete, where X denotes the audio characteristics,

$$P\{X = x_i\} = p_i, \ i = 1, 2, \cdots. \tag{12.1}$$

2. The value range of the overall X is divided into k independent intervals as A_1 = $(a_0, a_1]$, $A_2 = (a_1, a_2]$, ..., $A_k = (a_{k-1}, a_k]$, where a_0 can take negative infinity, a_k can take positive infinity, and the number of samples contained in the independent intervals is not less than five.

3. The number of sample values located in the i-th interval A_i is recorded as the number of group frequencies f_i, and the sum of the group frequencies is equal to the sample size.

4. When the hypothesis is true, the probability that the value of the overall X is located in the i-th interval A_i can be calculated from the overall distribution p_i. Therefore, p_i is the theoretical frequency of the sample values located in the i-th interval A_i.

5. When the hypothesis is true, the frequency f_i/n of the sample value in the n trials located in the i-th interval A_i is close to the probability p_i; when the hypothesis is false, the difference between f_i/n and p_i is large. Based on the above idea, Pearson proposed the test statistic:

$$X^2 = \sum_{i=1}^{k} \left(f_i - np_i \right)^2 \bigg/ np_i. \tag{12.2}$$

That is, the overall sample obeys a cardinal distribution with degrees of freedom of $k - 1$ under the assumptions that hold.

During the emotional music feature analysis, the variable X is the statistical value of audio features such as Mel-frequency cepstral coefficients (MFCC), spectrum centroid, spectral bandwidth and acoustic spectral contrast, and the variable Y is the emotional categories Q1, Q2, Q3, and Q4. Table 12.1 gives some sample interval frequencies of the mean of MFCC on the EMOPIA dataset. It can be obtained from Table 12.1 that, if the variable X is assumed to be the mean of MFCC, and there is a correlation between X and emotion category represented by the variable Y, the degrees of freedom, the value of the statistic X^2, and critical value can be calculated based on the frequency of mean MFCC in the sample interval $(0, 1]$ and $(1, 2]$. If the value of the statistic X^2 is smaller than the critical value, the hypothesis is valid, i.e., there is a correlation between the mean value of MFCC and emotion category, and vice versa, the hypothesis is not valid.

TABLE 12.1

Frequency of Some Sample Intervals of the Mean Characteristics of MFCC on the EMOPIA Dataset

Emotion Category	(0, 1]	(1, 2]	Total Number
Q1	56	28	94
Q2	34	56	90
Q3	32	27	59
Q4	27	30	57

12.5.2.2 Analysis of Emotional Music Features Based on Pearson's Correlation Coefficient

When using the chi-square test to verify the existence of correlation between the audio features and emotion categories, in order to further obtain the magnitude of correlation between each type of audio features and emotion categories, the Pearson correlation coefficient can be calculated to reflect the degree of correlation between them.

The Pearson correlation coefficient is defined as the entropy of the covariance and standard deviation between the two variables, and its calculation is given as

$$r = \frac{1}{n-1} \sum_{i=1}^{n} \left(X_i - \frac{\bar{X}}{\sigma_x} \right) \left(Y_i - \frac{\bar{Y}}{\sigma_y} \right),$$ (12.3)

where r denotes the correlation coefficient, X_i denotes the statistical value of each type of audio feature, Y_i denotes the corresponding emotion label, $X_i - \bar{X}/\sigma_x$, \bar{X}, and σ_x are the standard score, mean and standard deviation of the sample X_i, respectively. The range of r indicates the degree of correlation, and the closer to ± 1, the stronger the positive (negative) linear correlation.

In the process of calculating the correlation coefficients of audio features and emotional categories, in order to further enhance the effectiveness of numerical analysis and avoid the phenomenon of negative numbers in the values, it is necessary to standardize the experimental data. The specific process is as follows:

$$\text{data}_{norm_x} = \frac{\left(\text{data}_x - \min(\text{data}_x) \right)}{\left(\max(\text{data}_x) - \min(\text{data}_x) + \varepsilon \right)},$$ (12.4)

where data_x denotes the original audio feature data, data_{norm_x} denotes the normalized audio feature data, i.e., the data used to calculate the correlation coefficient, ε denotes the hyperparameter setting to prevent a denominator of 0, and ε is set to $1e-5$. Taking the audio feature of MFCC as an example, Table 12.2 shows the numerical comparison of some sample data before and after processing. It can be seen from Table 12.2 that, the raw data after standardization does not contain negative or large numerical values, and the standardized raw data is in the same order of magnitude.

After normalization, Eq. (12.3) can be used to calculate the correlation coefficients r between the statistical values of each type of audio feature X_i and the emotional category Y_i, separately. By calculating the entropy of the covariance and standard deviation of the above two variables, the absolute value of the correlation coefficient r is obtained to reflect the degree of correlation between each category of audio features and emotion category. The larger the absolute value of the correlation coefficient, the stronger the correlation. When the correlation coefficient is greater than zero, it indicates a positive correlation, and vice versa, it indicates a negative correlation.

TABLE 12.2

Numerical Comparison of Some Sample Data of MFCC Before and After Standardization

Mean Value of MFCC		Standard Deviation of MFCC		Variance of MFCC	
Raw Data	Standardized Data	Raw Data	Standardized Data	Raw Data	Standardized Data
−11.51	0.62	75.32	0.55	5673.65	0.42
−5.87	0.24	56.54	0.72	3196.98	0.62
0.07	0.76	44.7	0.28	1998.5	0.17
−12.24	0.39	91.13	0.52	8304.76	0.39
2.91	0.45	35.33	0.49	1248.26	0.36
1.07	0.39	43.63	0.60	1903.2	0.47
0.1	0.82	40.22	0.36	1617.59	0.23
−2.42	0.78	44.84	0.34	2010.54	0.22

12.5.3 MUSIC EMOTION RECOGNITION NETWORK

In order to evaluate whether the emotion representation of the generated music is consistent with the real one, we design a music emotion recognition network as shown in Figure 12.3. The proposed network uses a 1D convolution combined with three residual blocks. As shown in Figure 12.3, the Mel spectrum and, most significantly, the correlated audio feature MFCC, are selected as the input features. After the processing of three residual blocks, the feature fusion is performed in different dense layers. Finally, the emotion category of generated music is predicted by the fully connected layer.

In the residual convolution block shown in Figure 12.3, the 1D convolutional layers are colored from light to dark to indicate that the number of channels is changing with a growing trend of base 16 and multiplicity N, where N is taken as 1, 2, and 3.

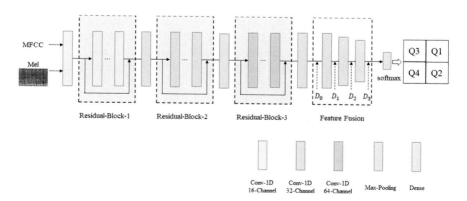

FIGURE 12.3 Proposed music emotion recognition network.

Firstly, the input 1D convolutional layer is used to keep the input data consistent with the channels of the residual network, i.e., to change the feature dimension using convolution. Next, the features output from the convolutional layer is fed sequentially into three residual convolutional blocks, and every two residual convolutional blocks are connected by a maximum pooling layer. The features of the residual convolutional blocks are calculated as follows:

$$x_{l+1} = h\left(x_l\right) + F\left(x_l, W_l\right), \tag{12.5}$$

where x_l represents the input audio features of the current layer, $h(x_l)$ represents the dimensional transformation of the 1×1 convolution of x_l to match the channel number of the output layer, and $F(x_l, W_l)$ represents the residual convolution block. Each residual convolution block $F(x_l, W_l)$ consists of two convolutional layers cascaded as,

$$F\left(x_l, W_l\right) = \mathrm{Conv}_2\left(\mathrm{ReLU}\left(\mathrm{BN}\left(\mathrm{Conv}_1\left(x_l, W_l\right)\right)\right)\right). \tag{12.6}$$

Among them, $\mathrm{Conv}_{i=1,2}$ denotes the 1D convolutional layer and BN denotes the feature normalization process to alleviate the overfitting during network training. ReLU is the activation function layer, which is used to overcome the gradient disappearance during the gradient update process and further improve the model convergence speed. With the increasing depth of the model, the jump link of the residual convolution is not only easy to optimize, but also can effectively alleviate the gradient disappearance problem appearing in the neural network.

For the audio features output from the residual convolutional blocks, we perform feature fusion at different layers of D_0, D_1, D_2, and D_3, respectively, where D_0 denotes the direct fusion of the output features of the residual convolutional network, and D_1, D_2, and D_3 denote the feature fusions after the first, second, and third fully connected layers, respectively. The calculation of feature fusion is given as,

$$f_{\mathrm{mix}} = D_i\left(f_1, f_2\right), \ i = 0, 1, 2, 3. \tag{12.7}$$

Among them, f_1 and f_2 respectively represent the Mel spectral features and the most significantly correlated audio features outputted by the three residual convolution blocks, $D_{i=0,1,2,3}$ represents the selection of the fusion layer, and f_{mix} represents the fused features. Finally, the fused features f_{mix} are used to predict the emotion classification of music by softmax activation function.

The specific parameters of the above network structure are set as follows: the number of channels in the input convolutional layer is 16 and the size of the convolutional kernel is 3; the number of convolutional layer channels in the "Residual-Block-1" is 16 and the size of the convolutional kernel is 3; the number of convolutional layer channels in the "Residual-Block-2" is 32 and the size of the convolutional kernel is unchanged; the number of convolutional layer channels in the "Residual-Block-3" is 64 and the size of the convolutional kernel is unchanged; the perceptual field size of maximum pooling layer is 2; the dropout is set to 0.8, and

the number of neurons in the first, second, and third fully connected layers are 512, 256, and 128, respectively; the number of emotion categories predicted by softmax is 4. In the model training process, the cross-entropy loss function is used to optimize the distribution between the actual and desired output probabilities.

12.5.4 EXPERIMENTS

This section will provide relevant experiments and result analysis from three aspects: emotional music feature analysis, music emotion recognition, and quality evaluation of generated music. Firstly, the statistical analysis results of eight emotional music features are presented, and the most significantly correlated audio features are selected through feature analysis, which are then fused with Mel spectrum for feature fusion. Then, we evaluate the performance of the proposed emotion recognition model and apply it to the quality evaluation of emotional music generated by the state-of-the-art methods.

12.5.4.1 Experiment on Emotional Music Feature Analysis

In the experimental part, the audios in WAV format from the publicly available emotion music dataset of EMOPIA [41] are selected to verify the effectiveness of the algorithm proposed in this chapter. For the analysis of emotional music features, the correlation between audio features and emotional categories and their correlation degree are analyzed by the chi-square test and Pearson correlation coefficient. Based on the numerical analysis results, the audio features with the most significant correlation are selected and fused with Mel spectrum in the music emotion recognition model.

In the process of analyzing emotional music features, the extraction of audio features is first implemented through Python's open-source toolkit Librosa, and the statistical values of each type of audio features are calculated. Among them, the mean, standard deviation, and variance are calculated for MFCC, spectrum centroid, spectrum bandwidth, acoustic spectrum contrast, zero-crossing rate, root mean square energy, and acoustic spectrum attenuation characteristics, while the total number and average value are calculated for the beats. Next, the statistical values of the above eight audio features are calculated by the chi-square test and Pearson's correlation coefficient in turn with the significant probabilities of the emotional categories and their correlation coefficients. The top eight audio features and their statistical values are given in Table 12.3, ranked according to the sum of significant probabilities and correlation coefficients.

As can be seen from Table 12.3, the standard deviation, mean, and variance of MFCC rank first, second, and fifth in terms of significant probability and correlation coefficient, respectively. According to the theory of Pearson's correlation coefficient, when the correlation coefficient is greater than 0.5, a strong correlation can be considered between the two variables. Taken together, the correlation coefficients of MFCC in terms of standard deviation, mean, and variance are all greater than 0.5, indicating a strong correlation between MFCC and emotional categories. From the perspective of statistical calculation, the above significant probabilities and correlation coefficients

TABLE 12.3

Top Eight Audio Features and Their Statistical Values

Audio Features	Statistical Values	Significant Probability	Correlation Coefficient	Total
MFCC	Standard deviation	0.7307	0.6448	1.3755
MFCC	Mean	0.6251	0.6401	1.2591
Zero-crossing rate	Variance	0.5708	0.4686	1.0394
Spectrum centroid	Mean	0.4824	0.4604	0.9428
MFCC	Variance	0.3452	0.5905	0.9357
Spectrum bandwidth	Mean	0.2712	0.6281	0.8993
Root mean square energy	Mean	0.3222	0.5762	0.8984
Spectrum bandwidth	Standard deviation	0.2597	0.4209	0.6806

illustrate that the MFCC has the most significant correlation with emotion categories among the eight audio features. Therefore, in the music emotion recognition experiments, the MFCC is selected as the audio features with the most significant correlation for feature fusion with the Mel spectrum to enhance the robustness of the features and thus further improve the recognition accuracy.

12.5.4.2 Experiment on Music Emotion Recognition

For the proposed music emotion recognition model, this subsection designs feature fusion experiments and compares them with existing work to verify the effectiveness of the proposed model. In the model training process, we use the audio data in the format of WAV from the emotion music dataset of EMOPIA [41]. The computer configuration is NVIDIA GeForce RTX2080 with 10G RAM based on TensorFlow. In addition, the iteration is 50, the batch number is 32, and the learning rate is 0.001. The experiments are performed on both four-category and two-category emotion recognition tasks, where the two-category classification includes the arousal and valence dimensions in Russell's emotion model [37].

In the feature fusion experiments, the impact of feature fusion of Mel spectrum and MFCC at different layers are verified on the accuracy of music emotion recognition tasks in four and two categories. Table 12.4 shows the accuracy of music emotion recognition using feature fusion at four different network layers, which are represented by the feature fusion layers of D_0, D_1, D_2, and D_3 in the music emotion recognition network shown in Figure 12.3. It can be seen from Table 12.4 that the feature fusion at different layers has a certain impact on the accuracy of music emotion recognition. For the emotion recognition tasks in the four classification and arousal dimension of two classification, the feature fusion at the layer D_1 can achieve the highest recognition accuracies of 0.865 and 0.912, respectively. This indicates that feature fusion at the layer D_1 can enable the model to fully learn the data distribution of different emotional audios, while passing through more fully connected layers can actually reduce the effectiveness of the features. For the emotion recognition task in the valence dimension of two classification, selecting the layer D_2 for feature

TABLE 12.4

Accuracy of Music Emotion Recognition Based on Feature Fusion at Different Layers

Feature Fusion Layers	Four Classification	Two Classification -Arousal Dimension	Two Classification -Valence Dimension
Feature fusion-D_0	0.784	0.803	0.765
Feature fusion-D_1	**0.865**	**0.912**	0.743
Feature fusion-D_2	0.839	0.765	**0.809**
Feature fusion-D_3	0.813	0.784	0.657

fusion can achieve the highest recognition accuracy of 0.809, indicating that feature fusion at the layer D_2 can enable the model to fully learn the classification rules of audio data.

In order to further verify the effectiveness of the proposed music emotion recognition model, we compare it with the existing representative models of logistic regression [41] and S-Chunk-ResNet [41] in the four-category and two-category recognition tasks, as shown in Table 12.5. It can be seen from Table 12.5 that by only using the Mel spectrum as the basic audio feature, the proposed model achieves the recognition accuracies of 0.843 and 0.724 respectively in the four-category and valence dimension of two-category recognition tasks. Compared to the logistic regression model [41], there are improvements of 61.19% and 29.75% respectively, while compared to the S-Chunk-ResNet model [41], the improvements are 24.52% and 2.84%.

In contrast, the logistic regression model [41] achieves the highest recognition accuracy of 0.919 in the arousal dimension of two-category classification task, which is 1.21% higher than the residual convolutional network using only a single feature of Mel spectrum. This indicates that in the case where the same Mel spectrum feature is used, the proposed network has better generalization ability than the logistic regression and S-Chunk-ResNet [41]. On the other hand, compared with single Mel

TABLE 12.5

Comparison Results with the Existing Representative Models of Logistic Regression [41] and S-Chunk-ResNet [41]

Feature-Model	Four Classification	Two Classification -Arousal Dimension	Two Classification -Valence Dimension
Logistic regression model [41]	0.523	**0.919**	0.558
S-Chunk-ResNet [41]	0.677	0.887	0.704
Mel spectrum-Residual convolutional network	0.843	0.908	0.724
Feature Fusion-Residual convolutional network	**0.865**	0.912	**0.809**

spectrum feature, the recognition accuracies after feature fusion have been improved to some extent. Specifically, the recognition accuracies of our network with feature fusion have been improved by 2.61%, 0.44%, and 11.74% in the four-category as well as the arousal and valence dimensions of two-category recognition tasks, respectively. In particular, our feature-fused network achieves a recognition accuracy of 0.912 in the arousal dimension of two-category classification task, which is comparable to the performance of logistic regression model [41]. This also validates that the proposed residual convolutional network can further improve the recognition accuracy through feature fusion.

12.5.4.3 Experiment on Quality Evaluation of Emotional Music Generation

From the perspective of music emotion recognition, this section applies the proposed music emotion recognition model to the quality evaluation task of emotional music generation. For the objective evaluation, the generated music by the existing representative algorithms LSTM+GA [49], CP Transformer [41], and GRU+SF [50] are tested on both of four-category and two-category emotion recognition tasks. Four test samples are selected from music clips generated by each of the above three algorithms on the four-classification as well as arousal and valence dimensions of two-classification tasks, respectively. During the experiment, we use the proposed model to identify the emotion categories of generated music and calculate the accuracy as the evaluation index for its emotional quality. The experimental results are shown in Table 12.6.

It can be seen from Table 12.6 that compared with LSTM+GA [49], the recognition accuracies of generated music by GRU+SF [50] have been improved by 49.06%, 9.21%, and 8.00%, respectively in the four-category as well as arousal and valence dimensions of two-category recognition tasks. Compared with CP Transformer [41], the recognition accuracies of GRU+SF [50] have been increased by 8.22%, 2.47%, and 12.50% in the four-category as well as arousal and valence dimensions of two-category recognition tasks, respectively. The experimental results indicate that GRU+SF [50] can better restore the audio characteristics of music and obtain higher recognition accuracy, which is consistent with the objective evaluation results as analyzed in [50].

TABLE 12.6

Quality Evaluation Results of Emotion Music Generated by the Existing Representative Algorithms [41, 49, 50] in Terms of Subjective and Objective Evaluation Metrics

Model	Objective Evaluation			Subjective Evaluation		
	4Q	Arousal	Valence	Humanness	Richness	Consistency
LSTM+GA [49]	0.53	0.76	0.75	2.59	2.74	2.60
CP Transformer [41]	0.73	0.81	0.72	3.31	3.22	3.26
GRU+SF [50]	**0.79**	**0.83**	**0.81**	**3.48**	**3.72**	**3.84**

To further verify the reliability of the proposed objective evaluation method, we also conduct the subjective evaluation on the generated music by LSTM+GA [49], CP Transformer [41], and GRU+SF [50]. In the subjective evaluation experiment, humanness, richness, Sand consistency of emotional expression are selected as indicators for generated music quality evaluation. The test samples consist of 12 generated music clips, of which four are generated by each of the above three methods. We collect the evaluation results of ten subjects as shown in Table 12.6. It can be seen from Table 12.6 that GRU+SF [50] generates music with the highest scores in humanness, richness, and consistency of emotional expression. This also verifies that by applying the proposed emotion recognition model to the objective evaluation of emotion quality for generated music, the obtained results are consistent with those of subjective evaluation. It should be noticed that the higher the recognition accuracy of the music emotion recognition model used, the more reliable the results of its use for emotion quality evaluation of generated music. This further indicates that it is effective to design emotional quality evaluation algorithms for generated music from the perspective of music emotion recognition.

12.6 CONCLUSION

Music has always been an art form closely related to human emotions. The relationship between music and emotions has been studied extensively, with many researchers exploring the mechanisms of how music can elicit different emotions in human beings. With the advancements in technology, music generation models have been developed that can generate emotionally expressive music. However, evaluating the quality of the generated music is still a challenge, as there is a lack of standardized measurement scales for emotional quality.

One of the main challenges in evaluating the quality of generated music is the subjectivity of listener scoring. In this regard, the proposed framework offers a new objective approach for the evaluation of emotional quality of the generated music. The proposed method firstly utilizes the statistical chi-square tests and Pearson correlation coefficients to analyze the correlation between different audio features and emotion categories. The audio features that have the most significant correlation with emotion categories are then picked out and fused with the Mel spectrum for feature extraction. The extracted features are then fed into a residual convolution network to predict the emotion category of the generated music.

The proposed framework offers several advantages over existing evaluation approaches. Firstly, it is based on objective evaluation, which provides a more consistent and comprehensive assessment of the emotional quality of machine-generated music. Secondly, it introduces emotion recognition to perform the evaluation, which can capture the nuances of different emotional states in music. Thirdly, it removes the subjectivity of listener scoring, making the evaluation process more objective. It is expected that this approach will become a valuable tool in the development of music generation systems in the future.

The prospects of this work are promising and could lead to several exciting developments in the field of music generation and emotion recognition. While the proposed framework presents a significant step towards objective evaluation of emotional

quality in machine-generated music, there are several directions for future research and enhancement:

1. Refinement of Feature Selection

 Further research can focus on refining the selection of audio features most relevant for capturing emotional nuances in music. This could involve exploring more advanced feature extraction techniques or incorporating additional modalities, such as lyrics or semantic information, to enhance the emotional representation.

2. Multi-Modal Approaches

 Integrating multiple modalities, such as audio and visual cues, could provide a more holistic understanding of emotional expression in music. Combining audio features with visual representations of music-related parameters, like rhythm and melody, could lead to a more comprehensive emotion recognition model.

3. Larger and Diverse Datasets

 Expanding the dataset used for training and evaluation to encompass a wider range of musical genres, cultures, and emotional contexts would contribute to a more robust and generalizable model. A diverse dataset can help the model better capture the variability in emotional expression across different musical styles.

4. Standardization of Evaluation Metrics

 As the field of emotionally expressive music generation advances, it would be valuable to work towards standardized evaluation metrics for emotional quality. Such metrics could help establish benchmarks and facilitate comparisons between different music generation models.

In conclusion, the proposed framework sets the stage for a variety of exciting research directions. By continuing to explore these avenues, the field could see significant advancements in both music generation and emotion recognition, leading to enhanced human-machine interaction and creative expression.

REFERENCES

[1] Yu-Hua Chen, Yu-Hsiang Huang, Wen-Yi Hsiao, Yi-Hsuan Yang. Automatic Composition of Guitar Tabs by Transformers and Groove Modeling. *Proceeding of the 22nd International Society for Music Information Retrieval Conference*, 2020.

[2] Shuqi Dai, Zeyu Jin, Celso Gomes, Roger B. Dannenberg. Controllable Deep Melody Generation via Hierarchical Music Structure Representation. *Proceeding of the 23rd International Society for Music Information Retrieval Conference*, 2021.

[3] Jian Wu, Changran Hu, Yulong Wang, Xiaolin Hu, Jun Zhu. A Hierarchical Recurrent Neural Network for Symbolic Melody Generation. *IEEE Transactions on Cybernetics*, 2020, 50(6): 2749–2757.

[4] Izaro Goienetxea, Iñigo Mendialdua, Igor Rodriguez Rodriguez, Basilio Sierra. Statistics-based Music Generation Approach Considering both Rhythm and Melody Coherence. *IEEE Access*, 2019, 7: 183365–183382.

[5] Yihao Chen, Alexander Lerch. Melody-Conditioned Lyrics Generation with SeqGANs. *Proceeding of IEEE International Symposium on Multimedia*, 2020.

[6] Goren Orly, Eliya Nachmani, Lior Wolf. A-Muze-Net: Music Generation by Composing the Harmony based on the Generated Melody. arXiv preprint arXiv: 2111.12986, 2021.

[7] Kyoyun Choi, Jonggwon Park, Wan Heo, et al. Chord Conditioned Melody Generation with Transformer based Decoders. *IEEE Access*, 2021, 9: 42071–42080.

[8] Jacek Grekow, Teodora Dimitrova Grekow. Monophonic Music Generation with a Given Emotion Using Conditional Variational Autoencoder. *IEEE Access*, 2021, 9: 129088–129101.

[9] C. F. Huang and C. J. Li. The Automated Emotional Music Generator with Emotion and Season Features. *Proceeding of the 3rd International Conference on Music and Emotion*, 2013: 11–25.

[10] M. Rishi, G. Shivali, G. Shweta. Sentimozart: Music Generation based on Emotions[C]. *Proceeding of the International Conference on Agents and Artificial Intelligence*, 2018.

[11] Kaitong Zheng, Ruijie Meng, et al. EmotionBox: A Music-Element-Driven Emotional Music Generation System Using Recurrent Neural Network. arXiv preprint arXiv: 2112. 0856, 2021.

[12] Shangzhe Di, Zeren Jiang, et al. Video Background Music Generation with Controllable Music Transformer. *Proceeding of the 29th ACM International Conference on Multimedia*, 2021: 2037–2045.

[13] Valentijn Borghuis, Luca Angioloni. Pattern-based Music Generation with Wasserstein Autoencoders and PRC Descriptions. *Proceeding of the International Joint Conference on Artificial Intelligence*, 2020: 5225–5227.

[14] Aydingün Anil, B. Denizcan, et al. Turkish Music Generation Using Deep Learning. *Proceeding of the 28th Signal Processing and Communications Applications Conference*, 2020: 1–4.

[15] Mateusz Modrzejewski, Konrad Bereda, Przemyslaw Rokita. Efficient Recurrent Neural Network Architecture for Musical Style Transfer. *Proceeding of the International Conference on Artificial Intelligence and Soft Computing*, 2021.

[16] Yu Quan Lim, Chee Seng Chan, Fung Ying Loo. ClaviNet: Generate Music with Different Musical Styles. *IEEE Multimedia*, 2021, 28(1): 83–93.

[17] Jia Wei Chang, Jason C. Hung, Kuan Cheng Lin. Singability-Enhanced Lyric Generator with Music Style Transfer. *Computer Communications*, 2021, 168: 33–53.

[18] A. Graves. Generating Sequences with Recurrent Neural Networks. arXiv preprint arXiv: 1308.0850v5, 2014.

[19] Yi-Hui Chou, I-Chun Chen, Chin-Jui Chang, Joann Ching, Yi-Hsuan Yang. MusicBERT: Symbolic Music Understanding with Large-Scale Pre-Training. *Proceeding of the Annual Meeting of the Association for Computational Linguistics*, 2021.

[20] Ryo Kinoshita, Eiji Hayashi. Performance Information Editing System for Player Piano Aiming at Human-like Performance. *Journal of Robotics Networking and Artificial Life*, 2020, 8(2): 99–103.

[21] D. Molero, S. Santiago, et al. A Novel Approach to Learning Music and Piano based on Mixed Reality and Gamification. *Multimedia Tools and Applications*, 2020(4): 1–22.

[22] S. Mengyi, J. Tsai. Automatic Generation of Piano Score Following Videos. *Transactions of the International Society for Music Information Retrieval*, 2021, 4(1): 29–41.

[23] G. Sebastian, S. Davide, B. Daniel, et al. A Data-Driven Approach to Violin Making. *Scientific Reports*, 2021, 22(1): 9455.

[24] Ko Chantelle, O. Lora. Construction and Performance Applications of an Augmented Violin: TRAVIS II. *Computer Music Journal*, 2021, 44(2–3): 55–68.

[25] Jen Yi-Hsin, Chen Tsung-Ping, Sun Shih-Wei, Su Li. Positioning Left-Hand Movement in Violin Performance: A System and User Study of Fingering Pattern Generation. *Proceeding of the 26th International Conference on Intelligent User Interfaces*, 2021: 208–212.

[26] T. M. Hung, B. Y. Chen, Y. T. Yeh, et al. A Benchmarking Initiative for Audio-Domain Music Generation Using the Free-Sound Loop Dataset. *Proceeding of the 23rd International Society for Music Information Retrieval Conference*, 2021.

[27] Emi Seki, Sho Kamei, Hisakazu Hada. PlARy: Sound Augmented Reality System Using Video Game Background Music. *Proceeding of the 24th ACM Symposium on Virtual Reality Software and Technology*, 2018, 112: 1–2.

[28] O. Aaron, S. Dieleman, H. Zen, et al. WaveNet: A Generative Model for Raw Audio. arXiv preprint arXiv: 1609.03499v2, 2016.

[29] Aaron Oord, Yazhe Li, et al. Parallel WaveNet: Fast High-Fidelity Speech Synthesis. *Proceeding of the International Conference on Machine Learning*, 2018: 3918–3926.

[30] Nal Kalchbrenner, Erich Elsen, et al. Efficient Neural Audio Synthesis. *Proceeding of the International Conference on Machine Learning*, 2018.

[31] Mogren Olof. C-RNN-GAN: Continuous Recurrent Neural Networks with Adversarial Training. arXiv preprint arXiv: 1611.09904, 2016.

[32] Prafulla Dhariwal, Heewoo Jun, et al. Jukebox: A Generative Model for Music. arXiv preprint arXiv: 2005.00341, 2020.

[33] Y. LeCun, B. Boser, et al. Convolutional Networks for Images, Speech, and Time Series. *The Handbook of Brain Theory and Neural Networks*, 10, 3361, 1995.

[34] Oord Aaron, O. Vinyals, et al. Neural Discrete Representation Learning. arXiv preprint arXiv: 1711.00937, 2017.

[35] Muhamed Aashiq, et al. Symbolic Music Generation with Transformer-GANs. *Proceedings of the AAAI Conference on Artificial Intelligence*, 35(1), 2021.

[36] K. Hevner. Experimental Studies of the Elements of Expression in Music. *American Journal of Psychology*, 1936, 48: 246–268.

[37] J. A. Russell. A Circumplex Model of Affect[J]. *Journal of Personality and Social Psychology*, 1980, 39(6): 1161–1178.

[38] N. F. Lucas, W. Jim, et al. Learning to Generate Music with Emotion. *Proceeding of the 22nd International Society for Music Information Retrieval Conference*, 2020.

[39] L. N. Ferreira and J. Whitehead. Learning to Generate Music with Emotion. arXiv preprint arXiv: 2103.06125, 2021.

[40] Alec Radford, Rafal Jozefowicz, Ilya Sutskever. Learning to Generate Reviews and Discovering Emotion. arXiv preprint arXiv: 1704.01444, 2017.

[41] Hsiao-Tzu Hung, Joann Ching, et al. EMOPIA: A Multi-Model POP Piano Dataset for Emotion Recognition and Emotion-based Music Generation. *Proceeding of the 23rd International Society for Music Information Retrieval Conference*, 2020.

[42] Fatemeh Hasanzadeh, Mohsen Annabestani, M. Sahar. Continuous Emotion Recognition during Music Listening Using EEG Signals: A Fuzzy Parallel Cascades Model[J]. *Applied Soft Computing*, 2021, 101: 107028.

[43] Syed Naser Daimi and Goutam Saha. Influence of Music Liking on EEG Based Emotion Recognition[J]. *Biomedical Signal Processing and Control*, 2021, 64: 102251.

[44] Jacek Grekow. Music Emotion Recognition Using Recurrent Neural Networks and Pretrained Models. *Journal of Intelligent Information Systems*, 2021, 57(3): 531–546.

[45] Eunjeong Stella Koh, D. Shlomo. Comparison and Analysis of Deep Audio Embeddings for Music Emotion Recognition. *Proceeding of the AAAI Conference of the Artificial Intelligence*, 2021: 15–22.

[46] Renato Panda, Ricardo Malheiro, P. P. Rui. Novel Audio Features for Music Emotion Recognition. IEEE Transactions on Affect *Computing*, 2020, 11(1): 85–99.

[47] C. Juan Sebastián Gómez, et al. Language-Sensitive Music Emotion Recognition Models: Are We Really There Yet? *Proceeding of IEEE International Conference on Acoustics, Speech, and Signal Processing*, 2021: 576–580.

[48] Paolizzo Fabio, P. Natalia, et al. A New Multilabel System for Automatic Music Emotion Recognition. *Proceeding of IEEE International Workshop on Metrology for Industry*, 2021.

[49] N. F. Lucas, W. Jim, et al. Learning to Generate Music with Sentiment. *Proceeding of the 22nd International Society for Music Information Retrieval Conference*, 2020.

[50] L. Ma, W. Zhong, X. Ma, et al. Learning to Generate Emotional Music Correlated with Music Structure Features[J]. *Cognitive Computation and Systems*, 2022, 4(2): 100–107.

13 A Deep Drift-Diffusion Model for Image Aesthetic Score Distribution Prediction

Xin Jin, Xinning Li, Heng Huang, Xiaodong Li, Chaoen Xiao, and Xiqiao Li
Beijing Electronic Science and Technology Institute, Beijing, China

13.1 INTRODUCTION

As an important research direction in the field of computer vision, the visual aesthetic quality of the image has received attention in recent years. Human visual aesthetics are subjective [1], and everyone's understanding of beauty is different, which brings great challenges to visual aesthetic research. Subjective evaluation is a method of measuring the aesthetic quality of images through human visual perception. The aesthetic quality of images is evaluated through the aesthetic feelings and emotional reactions of human observers. The advantage of this method is that the results are more consistent with people's subjective feelings, but the results are greatly influenced by individual differences. However, in social practice, people have a common tendency for beauty. For example, the winning works in the painting competition are considered beautiful by most judges. This common aesthetic view promotes the emergence of computational aesthetics [2] and makes it possible to establish a model to predict people's aesthetic activities.

At the same time, given the explosive growth of digital photography on the Internet and social networks, there is an increasing demand for high-quality aesthetic images. Image aesthetic evaluation has received more and more attention due to its huge application potential. For example, current engines will retrieve and provide users with high aesthetic quality photos and guide aesthetic-driven image enhancement through aesthetic quality discriminators. Another example is mobile photography guidance. With the popularity of smartphones, people are accustomed to using mobile phones to record their lives. Aesthetics-driven photography guidance can help users take better photos [3]. Hence, it is desirable to automatically assess the aesthetic quality of the images.

DOI: 10.1201/9781003406273-13

Most previous works tried to use photography knowledge to guide the construction of artificial aesthetic features such as vivid color, the rule of thirds, symmetry, and regional contrast. Yan et al. [4] proposed a high-level feature extraction method and designed high-level semantic aesthetic features based on photographic knowledge. Their system can distinguish between high-quality and low-quality images in aesthetic evaluation tasks. However, these hand-craft and predefined features have limited representation ability, which is still a challenging task, although these features have shown encouraging results.

With the deep learning methods that have shown great success in various computer vision tasks, more work has recently focused on using a deep convolutional neural network to extract effective aesthetic features. Image aesthetics assessment is typically cast as a classification or regression problem. Generally, the category or score of the image will be used as an indicator to distinguish the level of aesthetic quality, and these approaches often combined some other information, such as object, scene, and attribute, to guide the task of aesthetic assessment. In the classification problem, a common aesthetic evaluation task is to classify images into two categories: aesthetic high quality and aesthetic low quality. This rough classification helps people initially evaluate the aesthetic quality of images. Another study increased the classification category to 10 [5], improving the prediction accuracy of image aesthetic quality evaluation, which is similar to regression. In the regression problem, the network usually adds a fully connected layer and a regression layer after the feature extraction layer. Trained models can score images and help people quantitatively evaluate the aesthetic quality of images.

However, everyone has different ideas about what is beautiful. In other words, the process of giving an aesthetic evaluation of a picture may be quite different for different people. Two pictures of the same score label may have different evaluation processes. Figure 13.1 shows six images and the associated aesthetic scores distribution from the Aesthetic Visual Analysis (AVA) database [6]. The aesthetic scores are rated from 1 to 10, and the vertical axis of the histogram represents the number of ratings. Each line has the same score, but the aesthetic distribution is different – although the higher the aesthetic score, the more attractive. However, the use of a single label cannot effectively express the potential difference in human aesthetics. Therefore, using a single label is not enough to reflect the aesthetic psychology of the user. In contrast, aesthetics distribution prediction is a more reasonable way to evaluate the diversified aesthetics of images. Some works use aesthetic rating distributions as ground-truth, and then use various loss functions such as Kullback-Leibler (KL) divergence, cumulative Jensen-Shannon (CJS) divergence [7], or earth mover's distance (EMD) [8]. However, most methods are not considering the reason for the aesthetic distribution, but are more focused on reducing the distribution loss. In this chapter, we propose a Deep Drift-Diffusion (DDD) model inspired by psychologists to predict aesthetic score distribution from images. The DDD model simulates various positive and negative attractors and a disturbance factor based on the deep image features so that the psychological processes among users can be effectively expressed. The experimental results in public aesthetic image datasets (AVA [6] and Photo.net [9]) reveal that our novel DDD model outperforms the state-of-the-art methods on aesthetic score distribution prediction.

FIGURE 13.1 Examples of images and their aesthetic score distribution from AVA dataset. The aesthetic scores are rated from 1 to 10, and the vertical axis of the histogram represents the number of ratings.

The main contributions of this chapter are as follows:

1. The first work that embeds drift-diffusion psychological model into deep convolutional neural networks;
2. The combination of a dynamic model in psychology and score distribution prediction of visual aesthetics;
3. Our work has the potential of inspiring more attention to model the psychological process of aesthetic perception beyond just modeling the aesthetic assessment results.

The rest of this chapter is organized as follows. Section 13.2 mainly introduces related works, including computational visual aesthetics, image aesthetics assessment, score distribution prediction, and subjectiveness of aesthetics, which inspired the idea of this chapter. Section 13.3 mainly introduces our Deep Drift-Diffusion (DDD) model, which can predict the aesthetic score distribution of images. The model combines the deep convolutional neural networks and the dynamic drift model from psychology and simulates the psychological processes of aesthetic perception of raters. Section 13.4 mainly introduces our experiments, including experimental design, experimental process, and results analysis. In Section 13.5, we summarize the chapter and consider further research directions in the future. We hope the work can inspire more attention to model the psychological process of aesthetic perception.

13.2 RELATED WORK

Before starting our work, we summarized the related research and introduced previous works from four perspectives: Computational Visual Aesthetics, Image Aesthetics Assessment, Score Distribution Prediction, and Subjectivity of Aesthetics. Computational visual aesthetics aims to establish a computational model to predict the aesthetic characteristics and visual perception mechanism of images and videos. Image aesthetic evaluation is one of the important research directions in the field of computational visual aesthetics, committed to achieving automatic image aesthetic quality evaluation with the help of computer technology. Because a single aesthetic score cannot effectively reflect the potential differences in people's aesthetics, the prediction of score distribution is receiving increasing attention from researchers and has generated many valuable works. Due to the subjectivity of aesthetics, methods such as Gaussian distribution cannot fully fit the human rating distribution. The dynamic model in psychology sparked our thinking. These works helped us identify the problems in current research and inspired our methods.

13.2.1 COMPUTATIONAL VISUAL AESTHETICS

Computational Aesthetics [10] is an interdisciplinary discipline that covers multiple disciplines such as computer science, artificial intelligence, mathematics, and aesthetics. It aims to use computer and mathematical methods to study issues in the field of aesthetics, thereby enabling us to better understand art and aesthetics. It involves many different research fields, including computer graphics, machine

learning, computer vision, natural language processing, and so on. The purpose of computational aesthetics is to explore the psychological and cognitive mechanisms of people's perception, appreciation, and evaluation of artistic and aesthetic works, and to use computer technology to simulate and explain these processes.

Birkhoff [11] proposed a mathematical theory of aesthetics that aims to provide a rigorous framework for understanding the subjective experience of beauty and art. He believes that the experience of beauty is based on three basic elements: order, consistency, and complexity, which can be quantified using mathematical tools such as entropy, probability, and group theory. This book opens the way for quantitative aesthetics research. Computational aesthetics is also closely related to computer-generated art. Computer-generated art can generate various artistic forms, such as painting, music, dance, and literary works, using computer software and hardware.

Computational visual aesthetics [12] is an interdisciplinary field that integrates technologies such as computational vision, aesthetics, and deep learning. It aims to establish computational models to predict the aesthetic characteristics and visual perception mechanisms of images and videos. The research content of computational visual aesthetics mainly includes the extraction of aesthetic features, aesthetic evaluation, and aesthetic generation. The current popular research method is to extract aesthetic features such as color, texture, contrast, balance, proportion, and shape, and then construct aesthetic evaluation and aesthetic generation models based on aesthetic features. Computational visual aesthetics has a wide range of applications, including digital art, film and games production, virtual reality, and other fields.

In the early stages of computational aesthetics, the knowledge accumulated in the field of experimental aesthetics provided assistance for manual feature extraction, which in turn promoted progress in the field. Computational technology also enables experimental aesthetics to analyze large-scale data more efficiently. The emergence of deep learning has greatly improved the feature extraction ability of models, allowing researchers to obtain a large number of aesthetic features without relying on professional knowledge, and thus predict the aesthetic quality of images. However, the use of deep learning models has led to issues such as poor interpretability of methods and the inability to reflect human aesthetic subjectivity.

13.2.2 IMAGE AESTHETICS ASSESSMENT

Image aesthetic evaluation is one of the most important research directions in the field of computational visual aesthetics, and it is also the first step in computational visual aesthetics. By analyzing human activities, researchers have identified many image attributes and photography rules that affect human aesthetics. With the help of computer technology, they have achieved automatic aesthetic quality evaluation, which can provide aesthetic classification or scores for images. In past decades, researchers on the topic of image aesthetic assessment have drawn much attention to 1D output: binary classification [9, 13–15] and aesthetic scoring [16]. The binary classification is to give a binary label of image aesthetics: high or good and low or bad. But this aesthetic assessment method is rough. The aesthetic quality evaluation is usually a comprehensive and complex evaluation process, which is not suitable for simply using binary classification to establish models. The aesthetic scoring is to give

a continuous numerical score of image aesthetics: 0–1 or 0–10, the higher, the better. Aesthetic scoring can assess the aesthetic quality of images and help people quantify their perception of beauty.

However, only a 1D binary label or aesthetic score cannot fully describe the subjectiveness of aesthetic assessment. As claimed in Jin et al. [7], an image with similar scores may differ in the score distributions, which are histograms of scores given by multiple image reviewers. The scores are the mean of the score distributions. The other statistics of the distribution such as variations, skewness, and kurtosis can be quite different from the images with similar scores.

In past decades, image aesthetics assessment was mainly through the human aesthetic perception of image features and photography rules. The features included the spatial distribution of edges, color distribution, hue, blur, etc. [13]. Meanwhile, drawing was mainly based on some specific rules in photography, such as the low depth-of-field indicator, the colorfulness measure, the shape convexity score, the familiarity measure [9], the rule of thirds [6], etc. With the development of feature extraction technology, features based on high-level aesthetic principles had emerged, such as high-level semantic features based on the subject and background division [17], features based on scene types and related contents [18]. Yiwen Luo et al. [17] studied professional photography technology to extract the theme area from the perspective of professional photographers. The rest of the photo is considered background.

According to the photographer's different treatment of theme areas and background areas, they define and extract the characteristics from the theme area and the entire photo. They have developed five advanced semantic characteristics, including Clarity Contrast, Lighting, Simplicity, Composition Geometry, and Color Harmony. Sagnik Dhar et al. [18] designed a method for automatically extracting advanced visual aesthetic features, which include: composition attribute features that reflect whether the image layout conforms to photography composition rules; image content attribute features that reflect the presence of objects such as faces, animals, and scene types in the image; and sky lighting attribute features that reflect the natural lighting conditions of the image. Their experiments showed that models trained on advanced aesthetic features have significantly higher prediction accuracy than models trained on low-level aesthetic features. These studies have promoted the development of image aesthetic assessment.

With the continuous advancement of deep learning research in recent years, CNN-based deep learning models were widely used in the classification and regression of aesthetics. Kao et al. proposed multi-task learning [14]; they led the relevant items between tasks to the framework and made the utility of the appreciation of aesthetic and semantic labels more effective. Kong et al. and Chandakkar et al. utilized the relative aesthetics [16] to select the new datasets of images from the datasets with the pairs of related labels and trained the related image pairs to obtain the aesthetic ranking with higher accuracy. Sheng et al. adopted attention-based multi-patch aggregation to adjust the weight of each patch in the training process, the results of which improved learning effectively [15].

To overcome the normal distribution problem of aesthetic dataset labels, Xin Jin et al. [19] constructed an aesthetic mixed dataset. The dataset can be used for aesthetic quality classification tasks and aesthetic attribute regression tasks, and the data

distribution of labels is more reasonable. They proposed the Aesthetic Adaptive Block (AAB), which can handle images with any aspect ratio. They also proposed a multi-task training strategy based on pseudo labels and used meta-weighted networks to provide weights for training samples. In another work [20], Xin Jin et al. proposed an aesthetic attribute scoring method based on feature fusion. This method is the first to apply the Efficient Channel Attention (ECA) module to aesthetic attribute scoring tasks. They designed external attribute features of the input image, including lighting, color, and composition features, and combined these features with high-level aesthetic features extracted from the backbone network to train an aesthetic attribute multitasking network. These works have improved the accuracy of predicting aesthetic scores and the interpretability of aesthetic scoring models.

13.2.3 Score Distribution Prediction

In addition to extracting features from images and building models to directly predict aesthetic scores, many researchers also indirectly predict aesthetic scores by predicting the aesthetic score distribution of human ratings. Because a single aesthetic score cannot effectively reflect potential differences in people's aesthetics, images with the same score may have different aesthetic score distributions of human ratings. The advantage of predicting the distribution of scores is that it can improve the interpretability of aesthetic models and make the results more convincing. Simulating the human grading process can better reflect the subjectivity of evaluation and the aesthetic preferences of the group. To this end, researchers have performed a lot of valuable work. Recently, some methods were proposed to use modified or generated score distributions for binary classification and numerical assessment on aesthetics [21–23]. Wu et al. [24] used many visual features as inputs to the prediction model. By analyzing and processing these features, they discovered some features that are particularly important for visual quality evaluation, such as the uniformity of color distribution and image contrast. The pioneering work of Wu et al. proposed a modified support vector regression algorithm to predict the score distribution in two small aesthetic datasets, before the large scale AVA dataset [6] released and the popularity of deep CNN.

Most recently, Jin et al. proposed a CNN based on the cumulative distribution with Jensen-Shannon divergence (RS-CJS) [7] to predict the aesthetic score distribution of human ratings, with a reliability-sensitive learning method based on the kurtosis of the score distribution. They encode the input image into a feature vector, then use neural networks to process the feature vector, and finally output a probability distribution vector of aesthetic quality scores. They quantify the differences between multiple distribution vectors by calculating their cumulative Jensen-Shannon divergence to obtain a probability distribution of aesthetic scores. The method eliminates the requirement of the original full data of human ratings. Experiments on open aesthetic datasets have shown that their method is effective, and we will compare our method with theirs in the experiment.

Talebi et al. proposed a CNN based on Earth Mover's Distance (EMD) loss [8] to predict the aesthetic score distribution of human ratings. They use the predicted distribution to infer the mean score to guide the enhancement of images. They named

the network Neural Image Assessment (NIMA). Talebi et al. attempted various back-bone networks and conducted experiments on different aesthetic datasets. The model can effectively predict the distribution of human opinion scores, not just the average score. Inspired by the human visual system, Xiaodan Zhang et al. proposed the GPF-CNN architecture and GIF module [25]. The former can learn to focus on the important regions of the top-down neural attention map to extract fine detail features. The latter can adaptively fuse global and local features based on the input feature map. Gengyun Jia et al. considered that the aesthetic characteristics of images are a global feature [26], and resizing pictures during model training will affect the aesthetic characteristics. So, they were applying ROI pooling on feature maps of their aesthetic distribution model. Qiuyu Chen et al. [27] proposed an adaptive dilated convolution network to explicitly relate the aesthetic perception to the image aspect ratios while preserving the composition. Hui Zeng et al. created a comprehensive loss function to handle different aesthetic assessment tasks. Chaoran Cui et al. [28] developed a novel deep neural model that can enhance image aesthetic evaluation by collecting information from object classification and scene recognition.

13.2.4 SUBJECTIVENESS OF AESTHETICS

The human ratings are quite subjective [29]. Unlike image recognition, people may give different scores to one image in the aspect of aesthetics. Chaoran Cui et al. [28] also drew this conclusion from the entropy of the AVA [6]. Through analysis of a database containing photos, user evaluations, and user reviews, Kim et al. [29] conducted a comprehensive investigation of the subjectivity of the quality of aesthetic photos. They realized the issue of aesthetic quality evaluation is essentially subjective, but they also prove that the subjectivity level of photos can be automatically predicted through visual analysis, and its accuracy is similar to the average level of aesthetic quality. Their experimental results also indicate that the reaction time of aesthetic assessment has a relationship with the average aesthetic level and degree of subjectivity.

The Gaussian distribution is the best-performing model for only 62% of images in AVA. Examples of non-Gaussian distribution of human ratings are shown in Figure 13.2. Four images are from the AVA database with low, middle, and high scores. The state-of-the-art method RS-CJS can predict Gaussian-like distributions well but fails in the two ends: the low and the high non-Gaussian distributions. Even some distributions in the middle are non-Gaussian, such as the one shown in the third line. The others are the skewed ones and can be best fitted by the Gamma distribution [6]. The mean score is greatly influenced by the low and high extremes of the rating scale, which makes it inappropriate to be a robust estimation of the whole distribution, especially when the distribution is skewed. For skewed distributions, the median value appears to be more appropriate to describe the distributions than the mean value [24]. Before our work, many methods have achieved good performance on score distributions, such as the method of [7, 8, 25, 26, 28]. However, most of them follow the Gaussian's model. The mean score of the predicted distributions is always falling into [4:6]. This is because they have adopted a direct regression method. Sixty-two percent of the distributions approximately follow Gaussian, which leads

Input images Ground-truth Predicted by RS-CJS

FIGURE 13.2 Examples of non-Gaussian distributions of AVA ratings with low, middle, and high scores. The state-of-the-art method RS-CJS can predict Gaussian-like distributions well but fails in the two ends: the low and the high non-Gaussian distributions. Even some distributions in the middle are non-Gaussian, such as the one shown in the third line.

the regression results to be as similar as Gaussian distributions [7, 22]. Thus, we need not only to learn the results of human ratings but also to find the underline processes of human ratings. The math models such as Gaussian or Gamma cannot well model the aesthetic score distribution. We should find a psychological model that describes the processes of aesthetic perception.

Tae-Suh Park et al. [30] made a thoroughly analysis of the consensus of visual aesthetic perception. They used the skewness-kurtosis maps (S-K map) to measure and visualize the consensus of aesthetic scores. The function is defined as $K = S^2 + 1$. Figure 13.3 is the skewness-kurtosis maps of AVA score distributions. In each sub-plot, the horizontal axis and the vertical axis are the skewness and the kurtosis, respectively.

FIGURE 13.3 The skewness-kurtosis maps of AVA score distributions. In each sub-plot, the horizontal axis and the vertical axis are the skewness and the kurtosis, respectively. Each point represents an image in AVA. The number in each sub-plot indicates the score section of images. In the last sub-plot, we plot all the points together.

Each point represents an image in AVA. The number in each sub-plot indicates the score section of images. In the last sub-plot, we plot all the points together.

As shown in Figure 13.3, the skewness and kurtosis of a score distribution are the high moments compared with mean and variance. With the assistance of S-K maps, they find four patterns of aesthetic score distributions from the AVA dataset: a wide kurtosis range, consensus asymmetry, the 4/3 power law regime, and the tag effect. None of the Gaussian or Gamma distribution can model the four patterns, especially the wide range of kurtosis. They analyze the experimental data from the higher moments, skewness, and kurtosis. They believe the kurtosis of score distribution is a good measurement standard for consensus between scoring people and is a crux factor in modeling the aesthetic assessment process. The kurtosis to asymmetric on negative assessment is coordination with the lessons obtained in other emotional studies. For the 4/3 power regime, this means interaction between multiple subjects behind the phenomenon. We can similarly model the aesthetic assessment process. For the mode of tag effect, a photo with more variance in its ratings is usually unconventional, and the consensus may be a more "hardwired" attractive factor.

According to the analysis of the problem, they established a model to quantitatively simulate the four aesthetic score distribution patterns observed in the AVA

dataset. They propose to use a dynamic psychological processes model to model the processes of aesthetic perception, not only the aesthetic assessment results. To understand the relationship between the model and its characteristics from the perspective of the four patterns, they first analyzed a static model with multiple attractors and then expanded it into a dynamic model. Based on the 4/3 power law regime and the wide kurtosis range, Tae-Suh Park et al. modeled the dynamic process of the interaction between positive and negative attractors with ambient Gaussian noise. The level of consensus between the S-K plane and the difference between the tags is determined by the tag-specific attractors' configuration. They studied important factors that affect visual aesthetic perception in the field of psychology, including color tone, brightness, color saturation, and spatial layout.

People have group preferences for these factors, such as preferring some colors, brighter images, and golden segmentation composition ratios. They summarized these factors that affect visual aesthetic perception and divided them into two categories: negative and positive. They understood the process of visual aesthetic perception as the result of the interaction between positive and negative factors and constructed a static model using the probability distribution. To overcome the problems in the static aesthetic evaluation model, they proposed a dynamic drift-diffusion model based on the static model. The model they finally proposed can give aesthetic evaluation through the space-time interaction between multiple attractors under random noise. This model can simulate the four patterns of aesthetic score distribution observed in the AVA dataset. In the discussion part of the work of Tae-Suh Park et al. [30], they hope that future research will combine a dynamic model in psychology and score distribution prediction of visual aesthetics.

13.3 THE PROPOSED DDD MODEL

In this section, we analyzed the subjectivity of human aesthetic activities and found the core reason why Gaussian distribution cannot well fit human ratings. Therefore, we propose a dynamic drift model based on psychology to predict the aesthetic score distribution of images. By combining the number of positive attractors and negative attractors, our model can predict 49 different psychological processes. We provided a detailed introduction to the design concept and methodology of the model and explained how it simulates the perception process of human visual aesthetics. To deepen understanding, we also introduced the structure and training methods of the model.

13.3.1 SUBJECTIVENESS ANALYSIS

To simulate the visual perception process of human aesthetics, we need to analyze the statistical analysis of current data to discover the subjective laws of human aesthetics. In this regard, the work of Jin et al. [7] has great reference value. They make a statistical analysis of subjectiveness or diversity of the opinion among annotators in a large-scale database for aesthetic visual analysis (AVA) [6]. This dataset is specifically constructed to learn more about image aesthetics. All those images are directly downloaded from dpchallenge.com, an online photography social network.

People can upload pictures and ratings on the website. Images will be classified according to photography challenges and ranked based on the average score given by people.

Naila Murray et al. collected approximately 255,000 images, as well as their scores and annotations, to form the AVA dataset. For each image in AVA, there is an associated distribution of scores (1–10) voted by different viewers. The number of votes that each image gets ranges from 78 to 549, with an average of 210. The evaluators include both amateur photography enthusiasts and professional photographers, and their opinions represent the aesthetic psychological activities of both amateur and professional individuals when evaluating the same image. This rating has strong representativeness and research value.

It is observed that most images' mean values are located in [4:7]. Images in this interval are not easy to classify to a high-low label. Most images' standard deviation values are larger than 1:25, which shows the diversity of the human ratings for the same image. Images with mean score values from four to seven tend to have a low absolute value of the skewness and can be considered as those with symmetrical score distributions. Images with mean score values lower than four and greater than seven can be considered as those with positively and negatively skewed score distributions, respectively. This is likely due to the non-Gaussian nature of score distributions at the extremes of the rating scale. Within each range of the mean scores, some images exist with high absolute values of kurtosis values (after normalized by minus 3), which are considered as those with unreliable score distributions [7]. There exists a wide range of kurtosis. This is the core reason that Gaussian distribution can not well fit the human ratings. Therefore, we propose a new method to simulate human ratings.

13.3.2 THE DEEP DRIFT-DIFFUSION MODEL

Inspired by Tae-Suh Park et al. [30], we propose a Deep Drift-Diffusion (DDD) model based on psychology to predict the aesthetic score distribution of images. The DDD model combines the deep convolutional neural networks of artificial intelligence and the dynamic drift model from psychology [31–34]. The DDD model simulates various positive and negative attractors and a disturbance factor based on the deep image features. Figure 13.4 is the simulation of the psychological processes of aesthetic perception of one rater. As shown in Figure 13.4, a person's aesthetic view is regarded as a process of being attracted by positive factors and influenced by negative factors. Suppose the initial score of a figure is 5 (5 in AVA), then the score will be disturbed by white noise. When a positive factor attracts the evaluators, the score will increase according to an exponential distribution. When the evaluator is affected by negative factors, the score will decrease according to an exponential distribution. In this example, there are three positive attractors and three negative attractors. The final score is about 2.5.

Time factor sometimes affects the model results in some specific tasks. But the AVA dataset is from an online website. The photo reviews are given sufficient time to find the advantages and disadvantages of the aesthetics. Thus, the time factor does not affect the results. Although there is no temporal component to the decision process in

FIGURE 13.4 The simulation of the psychological processes of aesthetic perception of one rater. From the middle score (5 in AVA), the score will be disturbed by white noise. When a positive factor attracts the rater, the score will increase according to an exponential distribution, and vice versa. In this example, there are three positive attractors and three negative attractors. The final score is about 2.5.

the AVA dataset, the time factor in the process of psychological evaluation does not directly affect the outcome of the evaluation. The drift-diffusion model is described in Eq. 13.1.

$$v = \text{MiddleScore} + \sum_{i=1}^{m} E_{\text{pos}} - \sum_{i=1}^{n} E_{\text{neg}} + W \tag{13.1}$$

where E_{pos} and E_{neg} follow exponential distribution (Eq. 13.2). W is our modified white noise, as shown in Eq. (13.3). U is a uniform random distribution.

$$E = 0.5 * e^{-0.5*U(0,10)} \tag{13.2}$$

where the parameter 0.015 is from [30].

$$W = 0.015 * U(-1,1) \tag{13.3}$$

Positive attractors represent the fluctuations of the score caused by good aesthetic factors, which can be simply interpreted as the advantages of the picture discovered by the viewer. While negative attractors are the opposite. The computational methods of E_{pos} and E_{neg} are consistent. Since they represent the same psychological status in

the model, they must be characterized by the same distribution. According to this formula, one person's score is represented at a time of running. The score distribution can be recalculated by determining the result of the formula for the number of times in the AVA images, thus generating training and testing labels. One example of 20 raters on one image with various ratios of *m:n* is shown in Figure 13.5.

FIGURE 13.5 All possible score changes caused by n, m, and their corresponding histograms.

We list all possible score changes caused by *n*, *m*, and their corresponding histograms. We fit the ground-truth score distributions using the Gaussian model and our DDD model respectively. The number of positive and negative attractors is determined by an exhaustive search. The ones who get the smallest distance between the simulated and the ground-truth distributions are selected. The upper bound of the number of positive or negative abstractors is 7, which is determined by experiments. The value above 7 does not decrease the fitting errors anymore. Besides, to accurately calculate the exact positive and negative attractors, we enumerated the combination of all positive and negative attractors. Thus, we simulate 49 categories of psychological processes.

Through the combination of the number of positive and negative attractors, we can form 49 different specific quantitative relationships, which can represent 49 different psychological processes. And Tae-Suh Park and others [30] have only four psychological processes. Four examples of the fitted results are shown in Figure 13.6.

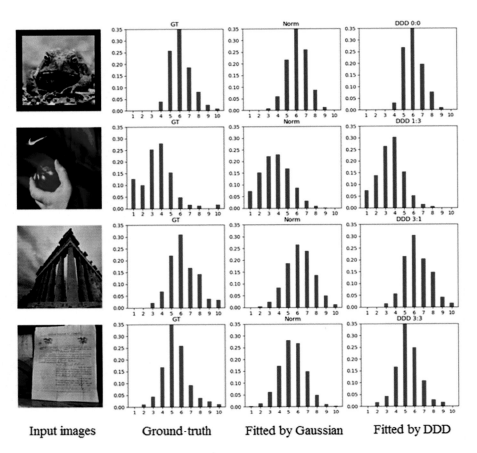

Input images Ground-truth Fitted by Gaussian Fitted by DDD

FIGURE 13.6 Examples of the fitting using Gaussian and our DDD model. Obviously, in the two extreme ends, the results of our DDD model are more similar as ground-truth values. Images are from AVA dataset.

FIGURE 13.7 The architecture of the proposed deep drift-diffusion model. The ResNet-50 is our baseline CNN.

Examples were fitted using the Gaussian model and DDD model. Obviously, in the two extreme ends, the results of our DDD model are more similar to ground-truth values. Besides, we make the numerical evaluation of the fitted results. Details are in Section 13.4.4.

The architecture of our DDD model is shown in Figure 13.7. We use a ResNet-50 as our baseline model. Then we attach a multi-task regression module that contains the number of the positive (m) and the negative (n) attractors. The regression module mainly consists of fully connected layers, which use the features extracted from the previous module for numerical regression. The fitted model parameters are used as the ground-truth labels for training. When evaluating our models in the experiments, we compare the distributions generated by our predicted parameters m and n with the original ground-truth score distributions.

13.4 EXPERIMENTS

In this section, we conducted experiments to verify the performance of our proposed model. We introduced the dataset used for training and testing the model, namely AVA and Photo.net. The images and annotations of these two datasets are sourced from public photography-sharing communities and are rated by both professional and amateur photographers, making them highly reliable and having strong reference value. We also provided details on the experiment implementation and evaluation metrics. The analysis of the experimental results is the main focus of this section. Compared to other methods, our DDD model is simple and efficient, fitting human ratings better than the Gaussian distribution and outperforming existing methods in predicting the aesthetic score distribution.

13.4.1 DATASETS

To the best of our knowledge, the AVA dataset and the Photo.net [9] dataset are the only two publicly available datasets with ground-truth aesthetic score distributions. These two datasets are popular in the computational aesthetic community. We evaluate our DDD model on both AVA dataset [6] and Photo.net dataset [9]. We compare our models with the state-of-the-art methods of score distribution prediction tasks. Our DDD model outperforms all the state-of-the-art methods.

13.4.1.1 AVA

The AVA dataset [6] is a list of image IDs from DPChallenge.com, which is an online photography social network. There are a total of 255,530 photographs, each of which is rated by 78–549 persons, with an average of 210 aesthetic ratings ranging from 1 to 10. The evaluators include both amateur photography enthusiasts and professional photographers, and their opinions represent the aesthetic psychological activities of both amateur and professional individuals when evaluating the same image. This rating has strong representativeness and research value. The images and metadata in the AVA dataset are sourced from DPChallenge.com. People can upload pictures and ratings on the website. Images will be classified according to photography challenges and ranked based on the average score given by viewers.

Naila Murray et al. collected approximately 255,000 images, as well as their scores and annotations, to form the AVA dataset. There are 963 annotations for photography challenges in the dataset, including a large number of different themes. The dataset includes three label types: Aesthetic annotations, Semantic annotations, and Photographic style annotations. Aesthetics annotations are often used in the evaluation of image aesthetics. They also analyzed these data to understand people's aesthetic preferences. With the help of the AVA dataset, researchers have explored many methods for image aesthetic evaluation and achieved good results in predicting aesthetic scores and score distribution. We follow the standard partition method of the AVA dataset in previous work [6, 7, 16, 37–39]. The training and testing sets contain 235,599 and 19,930 images, respectively.

Photo.net [9] is a large online photo sharing community that has attracted many photography enthusiasts since its establishment. Similar to DPChallenge.com, users can upload their photography works for others to browse. Many photography enthusiasts and professional photographers rate and comment on photos, and professional photographers also make professional judgments on photos from technical perspectives such as lighting, color, and composition. The diversity of raters ensures generality in the ratings. Many photos are rated based on aesthetics and originality, both of which reflect the subjectivity of the rater. The higher the score, the better.

In the field of computational visual aesthetics, many researchers obtain data and annotations from Photo.net to form datasets. Each image in the Photo.net dataset is rated by at least ten users to evaluate the aesthetic quality from 1 to 7. Due to some unavailable links on the photo.net website, we collect 15,582 images in all. We follow the partition ratio in previous work [9, 40]. The training and testing sets contain 13,582 and 2,000 images, respectively. For the aesthetic quality classification task, we also follow [9, 40] and choose the average score of 5.0 as median aesthetic ratings. The images with an average score larger than $5 + \delta$ are designated as high-quality images, and those with an average score smaller than 5 as low-quality images. We set δ to 0 in the experiment, which is more challenging than that with setting δ to other values [6].

13.4.2 IMPLEMENTATION DETAILS

We fix the parameters of the layers before the first fully connected layer of a pre-trained GoogLeNet model and ResNet model [41] on the ImageNet and fine-tune all fully connected layers on the training set of the AVA dataset. We use the Caffe

framework to train and test our models. The learning policy is set to step. Stochastic gradient descent is used to train our model with a mini-batch size of 48 images, a momentum of 0.9, a gamma of 0.5, and a weight decay of 0.0005. The max number of iterations is 120,000. The training time is about five hours and eight hours using Titan X Pascal GPU.

13.4.3 EVALUATING INDICATOR

This chapter uses several indicators to measure results. The evaluation rules follow those in [7]. These functions are usually used in computer vision and pattern recognition tasks to calculate the differences between two distributions or feature vectors. In the following formula, y is the ground-truth score histogram, and \hat{y} is the predicted score histogram by models. The cumulative distribution function Y of the probability distribution function y is defined as follows:

$$Y(i) = \sum_{j=1}^{i} y(i) \tag{13.4}$$

PED is the Euclidean distance of two probability distribution functions. It is as follows:

$$l^{PED}(y, \hat{y}) = \sum_{i=1}^{z} \left(y(i), \hat{y}(i)\right)^2 \tag{13.5}$$

PCE is the cross-entropy of the two probability distribution functions. It is as follows:

$$l^{PCE}(y, \hat{y}) = -\sum_{i=1}^{z} \left[y(i)\log\left(\hat{y}(i)\right) + \left(1 - y(i)\right)\log\left(1 - \hat{y}(i)\right) \right] \tag{13.6}$$

PJS is the symmetrical version of the Jensen-Shannon divergence of the two probability distribution functions. It is as follows:

$$l^{PJS}(y, \hat{y}) = \frac{1}{2}\left[\sum_{i=1}^{z} \left(y(i)\log\frac{y(i)}{m(y, \hat{y})} + \sum_{i=1}^{z} \hat{y}(i)\log\frac{y(i)}{m(y, \hat{y})} \right) \right] \tag{13.7}$$

where $m(y, \hat{y}) = \frac{1}{2} y(i) + \frac{1}{2} \hat{y}(i)$.

CED [24] is the Euclidean distance of the two cumulative distribution functions. It is as follows:

$$l^{CED}(y, \hat{y}) = \sum_{i=1}^{z} \left(Y(i) - \hat{Y}(i) \right)^2 \tag{13.8}$$

Wu et al. [24] used the CED as the loss function to predict the ordinal basic human ratings. It can be derived from the squared earth mover's distance (EMD2) by Le Hou et al. [23].

CJS [7] is the Euclidean distance of the two cumulative distribution functions. It is as follows:

$$l^{CJS}(y,\hat{y}) = CJS(y\|\hat{y}) \tag{13.9}$$

The symmetrical discrete cumulative Jensen-Shannon divergence ($CJS(y_1\|y_2)$) of two score histograms y_1 and y_2 is defined as follows:

$$\frac{1}{2}\left[\sum_{i=1}^{Z}Y_1(i)\log\frac{Y_1(i)}{\frac{1}{2}Y_1(i)+\frac{1}{2}Y_2(i)} + \sum_{i=1}^{Z}Y_2(i)\log\frac{Y_2(i)}{\frac{1}{2}Y_2(i)+\frac{1}{2}Y_2(i)}\right] \tag{13.10}$$

PCS [42] is the Chi-square distance of the two probability distribution functions. It can predict the mean score and standard deviation from the score distribution. It is as follows:

$$l^{PCS}(y,\hat{y}) = \frac{1}{2}\sum_{i=1}^{Z}\frac{\left(y(i)-\hat{y}(i)\right)^2}{y(i)+\hat{y}(i)} \tag{13.11}$$

PKL [43] is the symmetrical version of the Kullback-Leibler divergence of the two probability distribution functions. It is as follows:

$$l^{PKL}(y,\hat{y}) = \frac{1}{2}\left[\sum_{i=1}^{Z}\left(y(i)\log\frac{y(i)}{\hat{y}(i)} + \sum_{i=1}^{Z}\hat{y}(i)\log\frac{y(i)}{\hat{y}(i)}\right)\right] \tag{13.12}$$

Wang et al. [43] designed a loss function based on the Kullback-Leibler (KL) divergence and applied it to their work. They modeled the rating distribution of each image as Gaussian distribution and jointly predicted its mean and standard deviation. Experimental results on the AVA dataset show that the KL-based loss function performs better in specific tasks.

EMD [8] is the Earth mover's distance and is defined as the minimum cost to move the mass of one distribution to another. It is as follows:

$$l^{EMD}(y,\hat{y}) = \left(\frac{1}{Z}\sum_{i=1}^{Z}\left|Y(i)-\hat{Y}(i)\right|^r\right)^{\frac{1}{r}} \tag{13.13}$$

Talebi et al. proposed a CNN based on EMD loss [8] to predict the aesthetic score distribution of human ratings. They used the predicted distribution to infer the mean score to guide the enhancement of images. Le Hou et al. [23] proposed to use the squared earth mover's distance (EMD2) in loss functions for CNN training to consider the class relationships. Their experiments show that this method outperforms the convolutional neural network based on cross-entropy.

We calculated the numerical evaluation results on the test set, using the mean divergences to evaluate the difference between the output score and the ground-truth score. The mean divergences are defined as:

$$\frac{1}{N}\sum_{i=1}^{N} l\left(y,\hat{y}\right) \tag{13.14}$$

where $l = \{l^{PED}, l^{PCE}, l^{PJS}, l^{PCS}, l^{PKL}, l^{CED}, l^{CJS}\}$ defined above and N is the size of the test set.

In addition, we also used **MSE** (Mean Square Error) to measure the error between the predicted score of the model and the ground-truth score. It is the most commonly used regression loss function in deep learning regression tasks. It is as follows:

$$\text{MSE}\left(y,\hat{y}\right) = \frac{1}{N}\sum_{i}\left(y(i)-\hat{y}(i)\right)^2 \tag{13.15}$$

N is the number of samples. $y(i)$ is the predicted score, and $\hat{y}(i)$ is the ground-truth score.

RMSE (Routed Mean Square Error) measures the deviation between the predicted score and the ground-truth score. RMSE is the accumulation of squared errors before the square root, which amplifies the impact of larger errors on the results. Therefore, it is more sensitive to the abnormal values in the data. It is as follows:

$$\text{RMSE} = \sqrt{\frac{1}{N}\sum_{i}\left(y(i)-\hat{y}(i)\right)^2} \tag{13.16}$$

N is the number of samples. $y(i)$ is the predicted score, and $\hat{y}(i)$ is the ground-truth score.

Class. Acc. indicates whether the prediction score is consistent with the ground-truth score in the binary classification task when the dividing line is 5. It is as follows:

$$\text{Accuracy} = \frac{TP+TN}{T+N} \tag{13.17}$$

TP is the true positive samples. TN is the true negative samples. P is the positive samples. N is the negative samples.

13.4.4 SCORE DISTRIBUTION PREDICTION

We first make the numerical evaluation of the fitted results on the Gaussian model and our DDD model. As shown in Table 13.1, in the middle, the Gaussian model wins our DDD a little, while at the two extreme ends, the DDD model can fit better than the Gaussian model does. In addition, the DDD fits the four moments of the aesthetic distributions much better than the Gaussian does, as shown in Table 13.2.

We compare our DDD model with the method of RS-CJS [7], which uses 1/3 GoogLeNet and the RS-CJS loss. The evaluation rules follow those in [7]. The numerical results are shown in Table 13.3 (AVA) and 13.4 (Photo.net). For a fair comparison, we also use 1/3 GoogLeNet to replace the ResNet-50 in Figure 13.7. Besides, we modify the regression targets of our DDD to the μ and σ of the fitted Gaussian distributions. The numerical results in Tables 13.3 and 13.4 reveal that our DDD model beats the Gaussian model and the RS-CJS, which directly fit the results no matter using 1/3 GoogLeNet, ResNet-50, or ResNet-101. The performances of the Gaussian model are even worse than RS-CJS [7].

We also give some visualized comparison results in Figure 13.8. Different psychological processes can be predicted by our DDD model with different ratios of m and n. Scores of most images of the AVA dataset are in the range of [4, 6]. Thus, the NIMA [8] and RS-CJS [7] tend to output distributions in the middle. The mean scores of their distributions also fall in [4, 6]. The regression errors are less influenced by the image with very low or very high scores. The Gaussian distribution can not fit the original distribution well. The predicted distributions of our DDD model fit well the ground-truth distributions. We can not only get output middle scores but also low and high scores. Besides, the images with middle scores can be divided by the different ratios of m and n of the DDD model, which represent different kinds of psychological processes.

TABLE 13.1
The Fitting Errors by Gaussian and DDD, We Use RMSE (Rooted Mean Square Error) to Evaluate the Errors

Methods	1-2	2-3	3-4	4-5	5-6	6-7	7-8	8-9	All
Gaussian	0.117	0.063	0.030	**0.309**	**0.305**	**0.274**	0.276	0.524	0.0302
DDD Model	**0.026**	**0.030**	0.030	0.311	0.309	0.275	**0.265**	**0.310**	**0.0294**

TABLE 13.2
The Fitting Errors of Four Moments by Gaussian and DDD, We Use MSE (Mean Square Error) to Evaluate the Errors

Methods	μ(MSE)	σ (MSE)	skew (MSE)	kurt (MSE)
Gaussian	≈0	0.0001	0.1951	1.0391
DDD Model	≈0	0.0001	**0.0805**	**0.4725**

TABLE 13.3

The Comparison of Aesthetic Distribution Prediction on AVA Dataset

Methods	PED↓	PCE↓	PJS↓	CED↓	CJS↓	PCS↓	PKL↓	EMD↓	Class. Acc. ↑
Gaussian(ResNet-101)	0.162	2.817	0.048	0.254	0.050	0.076	0.381	-	-
RS-CJS(1/3GoogleNet) [7]	0.158	2.760	0.037	0.260	0.040	0.068	0.323	-	80.08%
NIMA(inception-v2) [8]	0.168	2.693	0.028	0.137	0.029	0.044	0.081	0.050	81.51%
Hui Zeng et al. [35]	-	-	-	-	-	-	0.101	0.065	80.81%
Chaoran Cui et al. [28]	0.127	-	-	-	-	-	0.094	-	-
Gengyun Jia et al. [26]	-	-	-	-	-	-	-	0.041	82.50%
Dong Liu et al. [36]	-	-	-	-	-	-	-	-	81.81%
Xiaodan Zhang et al. [25]	-	-	-	-	-	-	-	0.045	81.81%
DDD(1/3GoogLeNet)	0.142	2.729	0.028	0.177	0.026	0.051	0.153	0.044	81.59%
DDD(MobileNet-v1)	0.125	2.669	0.022	0.138	0.019	0.042	0.092	0.031	80.43%
DDD(ResNet-50)	0.109	2.667	0.020	0.129	0.015	0.035	0.071	0.026	82.63%
DDD(ResNet-101)	**0.105**	**2.640**	**0.019**	**0.122**	**0.013**	**0.028**	**0.065**	**0.023**	**82.65%**

TABLE 13.4

The Comparison of Aesthetic Distribution Prediction on Photo.net Dataset

Methods	PED↓	PCE↓	PJS↓	CED↓	CJS↓	PCS↓	PKL↓	EMD↓	Class. Acc. ↑
Gaussian(1/3GoogLeNet)	0.313	2.351	0.097	0.348	0.066	0.179	1.432	0.075	73.54%
RS-CJS(1/3GoogLeNet) [7]	0.305	2.270	0.085	0.311	0.060	0.143	1.340	0.072	75.62%
DDD(1/3GoogLeNet)	0.289	2.208	0.073	0.260	0.054	0.121	1.247	0.070	77.96%
Gaussian(ResNet-50)	0.296	2.164	0.093	0.292	0.064	0.153	1.273	0.073	76.76%
RS-CJS(ResNet-50)[7]	0.262	1.963	0.071	0.264	0.059	0.138	1.185	0.069	78.10%
DDD(ResNet-50)	0.243	1.842	0.068	0.251	0.106	0.035	1.129	0.066	79.22%
Gaussian(ResNet-101)	0.293	2.157	0.092	0.289	0.061	0.149	1.268	0.071	76.84%
RS-CJS(ResNet-101)[7]	0.255	1.961	0.070	0.262	0.058	0.137	1.183	0.068	78.12%
DDD(ResNet-101)	**0.242**	**1.840**	**0.068**	**0.249**	**0.047**	**0.105**	**1.126**	**0.064**	**79.26%**

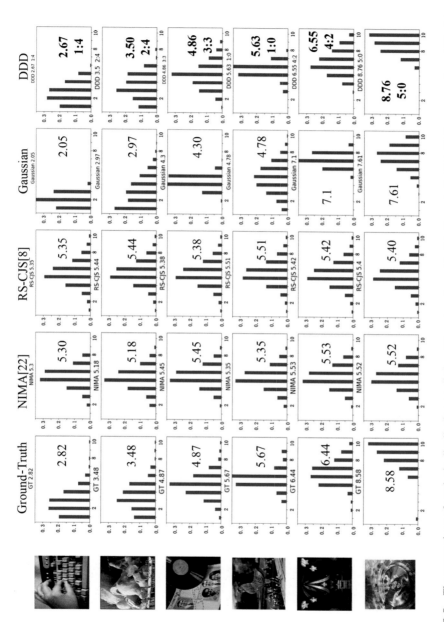

FIGURE 13.8 The comparison of aesthetic distribution prediction. The network used in this figure is ResNet-50. Images are from AVA dataset. Note that different psychological processes can also be predicted by our DDD model with different ratios of m and n.

As shown in Tables 13.3 and 13.4, our DDD model outperforms all the state-of-the-art methods [7, 8, 25, 26, 28, 35] on the aesthetic score distribution prediction task using the evaluation metrics of [7], which contain eight different kinds of distribution distances. All the previous state-of-the-art methods do not consider the psychological process of aesthetics. They only model the aesthetic perception results in the form of score distributions of multiple reviewers.

We also recast our predicted score distribution to a 1-dimensional binary label and compare it with the state-of-the-art methods on aesthetic quality classification, as shown in the last column of Table 13.3. Compared to the state-of-the-art method on aesthetic score distribution prediction [7, 8, 25, 35], our DDD model achieves the state-of-the-art aesthetic classification on AVA dataset. Note that, on the AVA dataset, our DDD model with only 1/3 GoogleNet beats the NIMA model [8] with full Inception-v2 GoogleNet on the aesthetic classification task.

13.5 CONCLUSIONS AND DISCUSSIONS

In this chapter, we found that people have strong subjectivity in aesthetics, and the visual perception process of an image with similar scores varies greatly among different people. This may be related to the dynamic psychological processes of humans. After analyzing the images and the associated aesthetic scores distribution in AVA, we found that there are many problems in fitting the distribution of human scores through Gaussian distributions. To this end, we propose a new model.

We embed the drift-diffusion psychological model into deep convolutional neural networks and propose a DDD model inspired by psychologists to predict aesthetic score distribution from images. The DDD model simulates various positive and negative attractors and a disturbance factor based on the deep image features, which models the processes of aesthetic perception. It is the combination of a dynamic model in psychology and score distribution prediction of visual aesthetics. Through the combination of the number of positive and negative attractors, 49 different psychological processes can also be predicted by our model.

The experimental results in large scale aesthetic image datasets (AVA and Photo.net) reveal that our novel DDD model can fit better than the Gaussian model and outperforms the state-of-the-art methods in aesthetic score distribution prediction.

The original drift-diffusion psychology model has a temporal component of the decision process. In future work, we will build such an aesthetic dataset with score distributions and rating time data, which models the dynamic process of aesthetic perception. In addition, we will explore more psychological processes of aesthetic perception. And we hope to inspire more attention to model the psychological process of aesthetic perception beyond just modeling the aesthetic assessment results.

ACKNOWLEDGEMENTS

This work is partially supported by the Natural Science Foundation of China (62072014 and 62106118), the Fundamental Research Funds for the Central Universities (3282023014), the Science and Technology Project of the State Archives

Administrator (2022-X-069), and the Project of Philosophy and Social Science Research, Ministry of Education of China (20YJC760115).

REFERENCES

[1] Magzhan Kairanbay, John See, and Lai-Kuan Wong. Beauty is in the eye of the beholder: Demographically oriented analysis of aesthetics in photographs. *ACM Transactions on Multimedia Computing, Communications, and Applications (TOMM)*, 15(2s): 1–21, 2019.

[2] J Li, R Datta, D Joshi, and JZ Wang. Studying aesthetics in photographic images using a computational approach. *Lecture Notes in Computer Science*, 3953: 288–301, 2006.

[3] Hao Lou, Heng Huang, Chaoen Xiao, and Xin Jin. Aesthetic evaluation and guidance for mobile photography. In *Proceedings of the 29th ACM International Conference on Multimedia*, pp. 2780–2782, 2021.

[4] Yan Ke, Xiaoou Tang, and Feng Jing. The design of high-level features for photo quality assessment. In *2006 IEEE Computer Society Conference on Computer Vision and Pattern Recognition (CVPR'06)*, Vol. 1, pp. 419–426. IEEE, 2006.

[5] Xin Jin, Hao Lou, Heng Huang, Xinning Li, Xiaodong Li, Shuai Cui, Xiaokun Zhang, and Xiqiao Li. Pseudo-labeling and meta reweighting learning for image aesthetic quality assessment. *IEEE Transactions on Intelligent Transportation Systems*, 2022, 23(12): 25226–25235.

[6] Naila Murray, Luca Marchesotti, and Florent Perronnin. Ava: A large-scale database for aesthetic visual analysis. In *2012 IEEE Conference on Computer Vision and Pattern Recognition*, pp. 2408–2415, 2012.

[7] Xin Jin, Le Wu, Xiaodong Li, Siyu Chen, Siwei Peng, Jingying Chi, Shiming Ge, Chenggen Song, and Geng Zhao. Predicting aesthetic score distribution through cumulative Jensen-Shannon divergence. In *Proceedings of the Thirty-Second AAAI Conference on Artificial Intelligence*, New Orleans, Louisiana, USA, February 2–7, 2018.

[8] Hossein Talebi and Peyman Milanfar. NIMA: Neural image assessment. *IEEE Trans. Image Processing*, 27(8): 3998–4011, 2018.

[9] Ritendra Datta, Dhiraj Joshi, Jia Li, and James Ze Wang. Studying aesthetics in photographic images using a computational approach. In *ECCV, Graz, Austria, May 7-13, 2006, Proceedings, Part III*, pp. 288–301, 2006.

[10] Matjaž Perc. Beauty in artistic expressions through the eyes of networks and physics. *Journal of the Royal Society Interface*, 17(164): 20190686, 2020.

[11] George David Birkhoff. *Aesthetic measure*. Harvard University Press, 1933.

[12] Anselm Brachmann and Christoph Redies. Computational and experimental approaches to visual aesthetics. *Frontiers in Computational Neuroscience*, 11: 102, 2017.

[13] Wei Luo, Xiaogang Wang, and Xiaoou Tang. Content-based photo quality assessment. In *2011 International Conference on Computer Vision*, pp. 2206–2213. IEEE, 2011.

[14] Yueying Kao, Ran He, and Kaiqi Huang. Deep aesthetic quality assessment with semantic information. *IEEE Transactions on Image Processing*, 26(3): 1482–1495, 2017.

[15] Kekai Sheng, Weiming Dong, Chongyang Ma, Xing Mei, Feiyue Huang, and Bao-Gang Hu. Attention-based multi-patch aggregation for image aesthetic assessment. In *2018 ACM Multimedia Conference on Multimedia Conference*, pp. 879–886. ACM, 2018.

[16] Shu Kong, Xiaohui Shen, Zhe Lin, Radomir Mech, and Charless Fowlkes. Photo aesthetics ranking network with attributes and content adaptation. In *European Conference on Computer Vision (ECCV)*, 2016.

[17] Yiwen Luo and Xiaoou Tang. Photo and video quality evaluation: Focusing on the subject. In *European Conference on Computer Vision*, pp. 386–399. Springer, 2008.

[18] Sagnik Dhar, Vicente Ordonez, and Tamara L Berg. High level describable attributes for predicting aesthetics and interestingness. In *CVPR 2011*, pp. 1657–1664. IEEE, 2011.

[19] Xin Jin, Hao Lou, Heng Huang, Xinning Li, Xiaodong Li, Shuai Cui, Xiaokun Zhang, and Xiqiao Li. Pseudo-labeling and meta reweighting learning for image aesthetic quality assessment. *IEEE Transactions on Intelligent Transportation Systems*, 23(12): 25226–25235, 2022.

[20] Xin Jin, Xinning Li, Hao Lou, Chenyu Fan, Qiang Deng, Chaoen Xiao, Shuai Cui, and Amit Kumar Singh. Aesthetic attribute assessment of images numerically on mixed multi-attribute dataset. *ACM Transactions on Multimedia Computing, Communications and Applications*, 18(3s): 1–16, 2023.

[21] Bin Jin, Maria V. Ortiz Segovia, and Sabine Süsstrunk. Image aesthetic predictors based on weighted CNNS. In *2016 IEEE International Conference on Image Processing, ICIP 2016*, Phoenix, AZ, USA, September 25–28, 2016, pp. 2291–2295, 2016.

[22] Zhangyang Wang, Ding Liu, Shiyu Chang, Florin Dolcos, Diane Beck, and Thomas S. Huang. Image aesthetics assessment using deep Chatterjee's machine. In *IJCNN*, pp. 941–948. IEEE, 2017.

[23] Le Hou, Chen-Ping Yu, and Dimitris Samaras. Squared earth mover's distance-based loss for training deep neural networks. *CoRR*, abs/1611.05916, 2016.

[24] Ou Wu, Weiming Hu, and Jun Gao. Learning to predict the perceived visual quality of photos. In *IEEE International Conference on Computer Vision, ICCV 2011*, Barcelona, Spain, pp. 225–232, November 6–13, 2011.

[25] Xiaodan Zhang, Xinbo Gao, Wen Lu, and Lihuo He. A gated peripheral-foveal convolutional neural network for unified image aesthetic prediction. *IEEE Transactions on Multimedia*, 21(11): 2815–2826, 2019.

[26] Gengyun Jia, Peipei Li, and Ran He. Theme aware aesthetic distribution prediction with full resolution photos. arXiv preprint arXiv:1908.01308, 2019.

[27] Qiuyu Chen, Wei Zhang, Ning Zhou, Peng Lei, Yi Xu, Yu Zheng, and Jianping Fan. Adaptive fractional dilated convolution network for image aesthetics assessment. arXiv preprint arXiv:2004.03015, 2020.

[28] Chaoran Cui, Huihui Liu, Tao Lian, Liqiang Nie, Lei Zhu, and Yilong Yin. Distribution-oriented aesthetics assessment with semantic-aware hybrid network. *IEEE Transactions on Multimedia*, 21(5): 1209–1220, 2018.

[29] W. H. Kim, J. H. Choi, and J. S. Lee. Objectivity and subjectivity in aesthetic quality assessment of digital photographs. *IEEE Transactions on Affective Computing*, 11(3): 493–506, 2018.

[30] Tae-Suh Park and Byoung-Tak Zhang. Consensus analysis and modeling of visual aesthetic perception. *IEEE Transactions on Affective Computing*, 6(3): 272–285, 2015.

[31] JA Scott Kelso, et al. *The Self-Organization of Brain and Behavior*. Lecture Notes in Complex Systems, Santa Fe, NM, 1995.

[32] Roger Ratcliff. A theory of memory retrieval. *Psychological Review*, 85(2): 59, 1978.

[33] Rafal Bogacz, Eric Brown, Jeff Moehlis, Philip Holmes, and Jonathan D Cohen. The physics of optimal decision making: a formal analysis of models of performance in two-alternative forcedchoice tasks. *Psychological Review*, 113(4): 700, 2006.

[34] Roger Ratcliff and Gail McKoon. The diffusion decision model: theory and data for two-choice decision tasks. *Neural Computation*, 20(4): 873–922, 2008.

[35] Hui Zeng, Zisheng Cao, Lei Zhang, and Alan C Bovik. A unified probabilistic formulation of image aesthetic assessment. *IEEE Transactions on Image Processing*, 29: 1548–1561, 2019.

[36] Dong Liu, Rohit Puri, Nagendra Kamath, and Subhabrata Bhattacharya. Composition-aware image aesthetics assessment. In *Proceedings of the IEEE/CVF Winter Conference on Applications of Computer Vision*, pp. 3569–3578, 2020.

[37] Weining Wang, Mingquan Zhao, Li Wang, Jiexiong Huang, Chengjia Cai, and Xiangmin Xu. A multi-scene deep learning model for image aesthetic evaluation. *Signal Processing: Image Communication*, 47: 511–518, 2016.

[38] Xin Lu, Zhe L. Lin, Hailin Jin, Jianchao Yang, and James Z. Wang. Rating image aesthetics using deep learning. *IEEE Transactions on Multimedia*, 17(11): 2021–2034, 2015.

[39] Long Mai, Hailin Jin, and Feng Liu. Composition-preserving deep photo aesthetics assessment. In *The IEEE Conference on Computer Vision and Pattern Recognition (CVPR)*, June 2016.

[40] Yueying Kao, Ran He, and Kaiqi Huang. Deep aesthetic quality assessment with semantic information. *IEEE Transactions on Image Processing*, 26(3): 1482–1495, 2017.

[41] Kaiming He, Xiangyu Zhang, Shaoqing Ren, and Jian Sun. Deep residual learning for image recognition. In *CVPR*, pp. 770–778. IEEE Computer Society, 2016.

[42] Bin Jin, Maria V Ortiz Segovia, and Sabine Süsstrunk. Image aesthetic predictors based on weighted cnns. In *2016 IEEE International Conference on Image Processing (ICIP)*, pp. 2291–2295. IEEE, 2016.

[43] Zhangyang Wang, Ding Liu, Shiyu Chang, Florin Dolcos, Diane Beck, and Thomas Huang. Image aesthetics assessment using deep Chatterjee's machine. In *2017 International joint conference on neural networks (IJCNN)*, pp. 941–948. IEEE, 2017.

Printed in the United States
by Baker & Taylor Publisher Services